Portraits in Steel

PORTRAITS IN STEEL

PHOTOGRAPHS BY MILTON ROGOVIN

INTERVIEWS BY MICHAEL FRISCH

Cornell University Press *Ithaca and London*

First published 1993 by Cornell University Press.

"A Worker Reads History" from *Selected Poems* by Bertolt Brecht, translated by H. R.
Hays, copyright © 1947 by Bertolt Brecht and H. R. Hays and renewed 1975 by Stefan S.
Brecht and H. R. Hays, reprinted by permission of Harcourt Brace and Company.

Library of Congress Cataloging-in-Publication Data

Rogovin, Milton, 1909–
 Portraits in steel / photographs by Milton Rogovin ; interviews by
Michael Frisch.
 p. cm.
 ISBN 0-8014-2253-1 (cloth : alk. paper) ISBN 0-8014-8102-3 (pbk. : alk. paper)
 1. Iron and steel workers—New York—Buffalo—Interviews. 2. Iron
and steel workers—New York—Buffalo—Portraits. 3. Steel industry
and trade—New York—Buffalo. I. Frisch, Michael H. II. Title.
HD8039.I52U575 1993
331.7'669142'0974797—dc20 92-56776

Printed in the United States of America

♾ The paper in this book meets the minimum requirements of the American National
Standard for Information Sciences—Permanence of Paper for Printed Library Materials,
ANSI Z39.48-1984.

CONTENTS

ACKNOWLEDGMENTS

MILTON ROGOVIN:

Very often an author will acknowledge specific individuals and institutions that helped make the book possible. When I completed the photographic work dealing with Buffalo's Lower West Side, I struggled for weeks and months for a path that would lead me to a meaningful social documentary series. Bertolt Brecht's poem, "A Worker Reads History," provided me with the key that opened the door to a photographic series that has, many years later, resulted in *Portraits in Steel*.

A Worker Reads History
Bertolt Brecht

Who built the seven gates of Thebes?
The books are filled with names of kings.
Was it kings who hauled the craggy blocks of stone?
And Babylon, so many times destroyed,
Who built the city up each time? In which of Lima's houses,
That city glittering with gold, lived those who built it?
In the evening when the Chinese wall was finished
Where did the masons go? Imperial Rome
Is full of arcs of triumph. Who reared it up? Over whom

Did the Caesars triumph? Byzantium lives in song,
Were all her dwellings palaces? And even in Atlantis of the legend
The night the sea rushed in,
The drowning men still bellowed for their slaves.

Young Alexander conquered India.
He alone?
Caesar beat the Gauls.
Was there not even a cook in his army?
Philip of Spain wept as his fleet
Was sunk and destroyed. Were there no other tears?
Frederick the Great triumphed in the Seven Years War. Who
Triumphed with him?

Each page a victory,
At whose expense the victory ball?
Every ten years a great man,
Who paid the piper?

So many particulars.
So many questions.

After reading this poem I decided to photograph the men and women who did the heavy work in steel mills and foundries. They were the ones who provided this country with the steel for the railroads, the bridges, the skyscrapers. It is to these men and women that I dedicate this book.

Equally important is the help and encouragement that I received from my wife and children. They encouraged me to close my optometric office in order to devote all of my time and energy to social documentary photography. That choice was consistent with my endeavor to help make this a better, more humane society.

MICHAEL FRISCH:

The title page of any book is inevitably deceptive, overstating the role of named authors and obscuring the contributions of unnamed others. Authors regularly respond with tributes to those friends, colleagues, and coconspirators who played parts in shaping the work which only the author can fully appreciate; satisfaction in completion is, appropriately, accompanied by feelings of profound gratitude and obligation.

A collaborative work such as this one heightens this feeling immeasurably in that authorship has, in the deepest senses, been broadly shared in the work's conception, construction, and realization.

My first and greatest obligation is to my coauthors, the subjects of the interview conversations that follow, and to a number of others whose interviews could not be included for reasons of space. All brought a great interest in the interview process and worked closely with me in shaping long conversations—and later much-reduced edited excerpt texts—into narratives that would convey their experiences, perspectives, and ideas. Their belief in the value of sharing these stories of how working people and families experience both work and worklessness sustained me during the long labor of transcribing and editing, as well as during periods when it was not clear that a somewhat idiosyncratic project would be able to find a publishable form.

A related obligation is to photographer Milton Rogovin, with whom it has been a genuinely profound experience to work so closely. I have always been moved by the humanity and depth of Rogovin's work, but his portrait subjects in person provided the most powerful confirmation of these qualities. Nearly ten years after the original portrait sessions, they all recalled him—and his wife, Anne, frequently his partner in the photographing visits—with spontaneous affection, respect, and love. Beyond helping me to open doors to the cooperation of those who otherwise might not have had much interest in the project I was proposing, these expressions drew me back to the photographs on a deeper level, persuading me to make them the basis for the interview discussion and a model for the kind of respectful interaction I hoped to approximate in the interviews.

The process of turning hours of conversation and shelves of cassettes into writing,

editing this writing into readable form, and compressing nearly a thousand pages of edited transcript into a much shorter book of narratives often seemed to me not unlike steelmaking itself. The coke ovens and blast furnace, the melting and pouring, the molding and chipping, the rolling out into various shapes—all have had their analogue in refining the words on my tapes and pushing them through a variety of oral-historical mills. And as in the steel mills the interviews describe, this work is inevitably a social process, shared even if not fully collective. In this sense, I take great pleasure in acknowledging a number of people who have been out on the shop floor with me in various capacities, as well as others who have helped teach me what I needed to know in order to work there.

I had valuable help in reading and editing the interviews from three individuals who will readily note their imprint on the texts that follow. Mia Boynton has followed the project from the start, and brought to it her own rich experience in oral history fieldwork and in studies of Buffalo's steel community. Her insights, suggestions, criticisms, and encouragement have been of immense value, first made manifest in her work on the Mary Daniels interview, published in briefer form in the special issue she edited on industrial folklore for the journal *New York Folklore* (14/2, 1988). This material is reprinted with the kind permission of that journal and its publisher, the New York Folklore Society.

When I had a complete first draft, I really needed the insights of a fresh editorial eye, and Kai Hernandez provided a reading equally sharp on points of substance and points of transcription and organization. I much appreciate her skillful work on a then-ungainly manuscript.

Finally, I note perhaps my greatest editorial debt. Early in the game, I selected Patricia Kozma's firm, Executary Secretarial Services, from the Buffalo Yellow Pages, almost at random, to assist with some transcription. I soon discovered that I had selected not only a crack transcriber but a superb thematic reader as well. Pat Kozma's insightful annotations and memos on the interview texts introduced some new ideas and approaches and helped me first to identify and then to wrestle with some crucial choices about the shaping of the individual interviews and the collection as a whole. Beyond that, she provided an important dose of inspiration at just those points when my energy threatened to flag, for which I remain very appreciative.

Other colleagues—Scott Eberle, Alexander Keyssar, and Robert Westbrook—have

read and commented on the entire manuscript, and their suggestions have been very helpful. Still others have responded to particular interviews or discussed usefully with me the project as a whole; these include Anthony Bannon, Jo Freudenheim, William Graebner, Charles and Angeliki Keil, Thomas Leary and Elizabeth Sholes, Leon Schor, Ramsay Liem, Peter Lunenfeld, and William Siener.

Alex Keyssar helped especially with the Dick Hughes interview, which he published in a theme issue of *Social Research* (54/2, 1987), reprinted here with the kind permission of that journal and its publisher, the New School for Social Research. Alessandro Portelli published excerpts from the Doris McKinney interview in the magazine *I Giorni Cantati* (Rome, II/6, 1988), in Italian translation, and I appreciate his permission to include that material here.

I need to acknowledge two groups of colleagues who, separately and together, have provided me with the tools, skills, and sensibilities that inform my oral history practice. First are those in or close to the American Studies Department at SUNY-Buffalo, where my interest in such work originated and where, in fact, I first met Milton Rogovin when he served as an adjunct professor teaching documentary photography and printmaking. Lawrence Chisolm, Charlie Keil, Elizabeth Kennedy, Robert Dentan, Ruth Meyerowitz, Hester Eisenstein, Endesha Holland, Barry White, Oren Lyons, John Mohawk, Francisco Pabon, June Licence, Rick Hill, and Alfredo Matilla, together with former colleagues Richard Blau, Ellen DuBois, Dorothy Larson, Sharon Leder, and Lillian Robinson: I want you to understand how grateful I am for all you have given me.

And finally, I thank my colleagues in the field of oral and public history, for whom I hope this volume can make at least a small payment on a very large debt: Jo Blatti, John Bodnar, Richard Gordon and Carma Hinton, Ronald Grele, Michael Kline, Alessandro Portelli, Linda Shopes, Daniel Sipe, David Thelen, John Quo Wei Tchen, and Daniel Walkowitz.

Completing books takes more than effort and friends, in most cases, and this one is no exception. I was particularly fortunate to have in Peter Agree of Cornell University Press the kind of editor most authors need but rarely find. He saw potential in a project that other publishers thought too idiosyncratic and technically demanding for a university press, and he has worked patiently with Milton Rogovin and me at every step of the way to help turn our idea into a reality. I am very grateful for his confidence and his unfailingly wise counsel. I am grateful as well for a substantial

grant-in-aid from the American Association for State and Local History which helped cover the costs of transcription, and to Professor William Freehling, my new colleague in the History Department at SUNY-Buffalo, for funds from his Lockwood Chair in American History which helped in the preparation of the final manuscript.

FOREWORD

Robert Doherty

George Bernard Shaw once restated the Chinese proverb "A picture is worth a thousand words" as "A picture is worth a thousand words as long as it has the thousand words to go with it." Words began appearing with pictures in the 1930s, when photographers and writers began a tradition of collaboration on books. The Farm Security Administration (FSA) in 1936 asked Archibald MacLeish to write a poem to be published with a collection of photographs made by FSA photographers. When MacLeish reviewed the photographs, he was so impressed and moved that he labeled the book "A book of photographs illustrated by a poem," and published it in 1938 as *Land of the Free*. In the mid-1930s *Fortune* magazine asked James Agee to prepare an article on the sharecroppers in the deep South. Agee in turn asked Walker Evans, then a photographer for the FSA, to accompany him to take photos for the article. The editorial staff of the magazine had a change of mind and the article never appeared, but Agee continued working on the material the two had gathered and published it later as *Now Let Us Praise Famous Men*. He insisted that this was not a literary work illustrated by photographs, but a work in which the authorship was shared equally by photographer and writer.

For more than thirty years, the photographs of Milton Rogovin have had a profound influence on people from all walks of life. His pictures have a penetrating power that seems to burn into one's mind images that are hard to forget. This power led to the collaboration between Rogovin and Michael Frisch which this book repre-

sents, and in this respect, *Portraits in Steel* demonstrates the validity of Shaw's criteria for words enhancing pictures. Rogovin's work is social documentary photography, photographic work that persuades people to move from one ideological position to another: there has to be a cause. His photographs are propaganda, for their purpose is to alert the viewer to conditions needing change.

Since its advent in 1839, photography has been used as a persuasive tool in the long history of arousing people to action. In the mid-nineteenth century, Henry Mayhew called attention to the poor of London in his *London Labor and the London Poor* by using Richard Beard's photographs as evidence of the condition of the poor. Later in the century, John Thomson, a photographer, and Adolfe Smith published *Street Life in London,* illustrated with dramatic and beautifully reproduced pictures. Both of these historical undertakings established a sound practical pattern of author-photographer collaboration.

Photography for social reform began in America during the last quarter of the nineteenth century. Although Jacob Riis has been called the "father of social documentary photography," a more accurate statement would be that Riis *used* photographs rather than *made* them. Considerable evidence suggests that Riis made few, if any, of the pictures attributed to him. He hired two photographers and used pictures by two others, including Lewis Hine, in his lecture tours. Riis was a newspaper journalist in New York City in the days before it was practical to reproduce photographs in large metropolitan newspapers. The only Riis pictures ever used in the press during his newspaper career were twelve pictures in the form of wood engravings copied from photographs. For more than three decades, Riis traveled the country as a layman with a cause, making photographic lantern slide presentations that advocated slum clearance and decent school buildings and housing (sometimes these presentations were in support of Theodore Roosevelt's political campaigns). He enjoyed considerable success, and much of the building code in New York City was revised through his efforts.

The real "father of social documentary photography," however, is Lewis Hine, who began his photographic work in 1905. Hine and the FSA photographers were "sponsored" by an entity with a cause. Hine worked first for the National Child Labor Committee, and later the Russell Sage Foundation sponsored the six-volume *Pittsburgh Survey* project, the first major sociological study of a great burgeoning

metropolis, with Hine as photographer. During his lifetime, he made more than 40,000 photographs, all speaking to major social issues of the day: child labor, the *Pittsburgh Survey,* Red Cross nursing and health care, women in the trades, World War I, working men and women, Empire State Building construction workers, American craftsmen, and people uprooted by the Tennessee Valley Administration. Although Hine died in poverty, unaware of the magnitude of his accomplishments, he left an astonishing legacy to the people of the world. The National Child Labor Committee attributed to Hine's photographs the reform of the child labor laws that finally took effect in the late 1930s.

During the Great Depression, Rexford Tugwell, assistant secretary of agriculture, formed the Resettlement Administration, later renamed the Farm Security Administration. Under the direction of Roy E. Stryker, one part of this organization, the Historical Section, was charged with collecting evidence of the plight of farmers across the nation. Its documentation was used to create propaganda to support the farm policies of the Roosevelt administration's "New Deal." This single dramatic project had more influence on photography than any other undertaking in history. The icons of the depression that are etched in people's minds are two photographs— Dorothea Lange's *Migrant Mother* and Arthur Rothstein's *Dust Bowl.* In his search for standards to establish his future work style, Rogovin was greatly affected by the FSA photographers. He studied their pictures thoroughly, adopted much of their philosophy, and utilized their purposes and vision in formulating his attack on social problems.

Picture magazines had their birth in Europe in the 1920s. Their American counterparts followed shortly thereafter, when both *Life* and *Look* appeared in the mid-1930s. As FSA photographers moved into prominent positions at these publications, they exerted profound influence on photojournalism. Photo mechanical reproduction, which we take for granted today, was relatively novel in the 1930s, and it is difficult to imagine that anyone could escape the influences of that age or ignore the power of pictures to persuade. Rogovin's formative years of social consciousness took place during this period when the entire nation was immersed in the new pictorial communication media.

With the advent of World War II, the FSA ended. For a brief transitional period, it became an element of the Office of War Information, creating propaganda for the

war effort. The rampant use of propaganda during the war made the word *propaganda* unsavory. But by definition social documentary photography is just that—propaganda.

The FSA project was government-funded. Roy E. Stryker later moved to the Standard Oil Company of New Jersey (SONJ) to direct the famed Standard Oil Documentary project during the 1940s. Ostensibly the SONJ project was a public-relations effort to create propaganda to alter the negative image of this huge worldwide enterprise, but Stryker had a "hidden agenda"—to create a documentary picture history of the nation, indeed, of the world, in the middle of the twentieth century. Thus the world's largest corporation funded a monumental undertaking in social documentary photography.

After World War II, causes increased in need, number, and intensity. Photographers throughout the world sensed these needs and used their cameras to document how people lived, worked, and died in every corner of the earth. Their funding was soon under attack, however, as government agencies, corporations, and social welfare organizations shied away from sponsorship of such undertakings. Several politicians in Congress even attempted to have the FSA collection destroyed because it represented a negative image of America. (FSA photographs were appearing in Soviet propaganda literature as evidence of capitalist failings.) The United States Film Service, which made some of the world's greatest documentary films, was disbanded by Congress out of the fear that an incumbent administration would use the films to perpetuate itself.

With sponsorship virtually nonexistent after the war, photographers sought other means to convey their messages. They published their own books, sometimes mortgaging their homes to raise the necessary funds. Occasionally they were able to obtain small grants from the National Endowment for the Arts and other foundations. Photographers had exhibitions in museums such as the Museum of Modern Art (MOMA), International Center for Photography in New York, or George Eastman House. These institutions published catalogs that helped spread the word about social causes and human needs.

One of the truly monumental exhibitions was *The Family of Man* at MOMA in 1955, which attracted more visitors than any other exhibition in the history of museums worldwide. It was the concept of Captain Edward Steichen for the purpose of seeking a world of peace. During World War II, Steichen directed all documentary

photography by the U.S. Navy, Coast Guard, and Marine Corps. Shortly after the war ended, he assembled an exhibition of photographs from the wartime projects with the intent that if he showed the horrors of war, the exhibition would be a deterrent to future wars. He believed he failed in this and decided that if he could mount an exhibition showing *peace,* people would respond. The catalog of this exhibition made people aware of the power of photography, as book sales reached nearly twenty million. In many respects, the world was well-prepared for the photographs of Rogovin by 1958, when he began his photographic crusades. At the same time, Rogovin had a well-developed tradition for his quest to improve the lives of his fellow beings.

After Rogovin, a New Yorker, graduated from Columbia University, he fell in with a group of left-wingers. He attended their "classes," learning much about unions, politics, and the social injustices of the nation while serving some of their needs as an optometrist. He became active in progressive causes and was subjected to investigation by the House Committee on Unamerican Activities in the 1950s. For nearly two decades FBI agents continued to track his every move. The attendant publicity of the investigation created great social and economic hardship for the Rogovin family. In subsequent years much of Milton's and his wife's energies went into activities that involved social issues and reforms to be addressed through peaceful use of the political franchise.

With an awareness of social needs and the desire to change those things he was concerned about, and denied the opportunity to work for change in a familiar political way, Rogovin turned to photography to carry on his crusade to improve the lives of those less fortunate. Much of the time and energy that had been devoted to political activism was now put into learning about and practicing the art of photography. He sought out the best technical minds, the prominent practitioners, and the great artists of the medium, such as Minor White and Paul Strand, and then established his own direction. Armed with a camera, he set out to gather evidence with which to indict people for wrongdoing. He went first to the hills and mines of eastern Kentucky and West Virginia, where black lung disease was rampant, and documented the miners' lives for more than nine years. Eventually he concentrated on a long and serious documentation of a six-square-block area in Buffalo's Lower West Side. He devoted his Wednesday afternoons off to documenting this neighborhood in transition.

Buffalo's West Side is at the confluence of several ethnic groups. Italians, African Americans, Hispanics, and Native Americans meet at this focal point and provide dramatic and intense subject matter to record. When his office was closed, Rogovin wandered through the West Side with his camera, seeking subjects of a dramatic life. Some he photographed in their homes, displaying their prized possessions. Others he pictured in the streets where drugs and money were exchanged or prostitutes plied their craft. Rogovin gained the trust and respect of those subjects in a way few ever could.

In the mid-1970s, the Albright-Knox Gallery featured an exhibition of Rogovin's West Side photographs. The opening broke all attendance records at the museum, and a great crowd of Rogovin's subjects and their extended families came to admire the portrayal of themselves. In the subsequent two decades, Rogovin has gone back again and again to show the changes these people have undergone. Some of those he portrayed have passed from child to adult and parent and now to grandparent during this time, each change being recorded.

From the West Side drama, Rogovin eventually was led to the industrial work-places of Buffalo's heavy industry. He had a fascination with steel mills, as reflected in this volume, and was particularly aware of the role of women in heavy industry. It was at this point that he conceived the idea of photographing these people in their home settings.

Rogovin, who began his photographic career slightly more than thirty years ago, has documented miners, steelworkers, women at work in heavy industry, the forgotten ones, and the downtrodden, from China to Europe and from the United States to the tip of South America. In the ever-widening search for those people and issues that required attention, Rogovin sought contact with many of the social leaders of the world through his reading and letter writing. One such contact was the Chilean Nobel laureate, Pablo Neruda, who hosted Rogovin's documentary expedition to Chile.

Rogovin's work has attracted enthusiastic response particularly outside the United States and has been widely exhibited throughout Europe. One sometimes wonders if Americans have been less enthusiastic because we don't wish to be reminded of some of the failings in our society. A spectacular view of the Grand Teton Mountains by Ansel Adams on the living room wall is easier to live with and allows us to forget the realities photographed by Rogovin. Rogovin chose to photograph the people most

pretend don't exist. His pictures are not the kind most choose to hang on their walls as aesthetic objects because the images tend to prick one's conscience. It is much easier to believe these people are not there.

Ironically the forum presenting these pictures to the public view has been the art gallery and museum. It is curious that statements of political and social dimensions find exposure in the realm of art. This phenomenon poses difficult questions—how, why, and when does documentary evidence make the transition into the world of art?

To state that Rogovin's photographic work is not art would be a travesty, but that is not the purpose for which it was created. He uses the greatest artistic skill in capturing his images to endow his subjects with dignity. In part, this element is the result of the technique he has chosen, which, like Hine's, involves his use of a waist-level reflex camera, thereby always looking up to his subjects. This device emphasizes his enormous respect and empathy for his subjects and the desire to enlist his viewers in his cause of making life better for us all.

In a study of Rogovin's work, however, we must necessarily consider the pictures from the aspect of their message first, not their art. Rather than look at them as individual photographs and as objects of art, we must see them as a broad continuum with a vital message calling our attention to the plight of fellow men and women. Rogovin's pictures are not manipulated presentations. His subjects choose the settings, the clothing, and the objects that surround them. They take great pride in being recorded.

Although Glenway Wescott's comment quoted in Peter Pollack's *History of Photography*, was about FSA photographs, his words may appropriately be applied to Rogovin's work: "For me this is better propaganda than it would be if it were not aesthetically enjoyable. It is because I enjoy looking that I go on looking until the pity and shame are impressed upon me unforgettably."

Portraits in Steel

INTRODUCTION

Michael Frisch

In a great deal of his photography, Milton Rogovin has explored the possibilities of a deceptively simple technique for moving beyond any single photograph's limits of expression and self-revelation: one of his trademarks is portraying individual workers on the job—in a mine, factory, or mill—and then asking to visit them at their homes, where he takes another portrait, sometimes including the workers' families.

Rogovin's first comprehensive exploration of this approach came in a project completed in the late 1970s and focused on American workers: a remarkable exhibit of paired portraits of some forty subjects, originally shown under the title "Working People" and exhibited in a dramatic 1992 one-man show at the Smithsonian Institution's Museum of American History. A small selection of these portrait pairs was included in the 1985 retrospective collection of Rogovin's work, *The Forgotten Ones* (Seattle: University of Washington Press, 1985). But the larger series has not previously been published.

Most of the subjects pictured in the "Working People" series were employed in iron, steel, and related industries in and around Rogovin's hometown of Buffalo, New York, and *Portraits of Steel* proceeds from the fact that these portraits were taken just before Buffalo's heavy industry tumbled into a catastrophic collapse. This collapse was epitomized most dramatically by the 1983 shutdown of the huge Bethlehem Steel complex in Lackawanna, just south of the city, which at its peak had employed more than twenty thousand workers. Along with subsequent closings at

Buffalo's Republic Steel plant and a host of smaller facilities, the shutdown was part of a much broader change of immense proportion in America's economy and the lives of its working people. By some estimates, over 2,700 plants were closed in the United States in the 1980s, costing some 1.3 million manufacturing jobs. In a once mighty steel industry that had already declined by half from its postwar peak of almost a million workers, another 300,000 jobs were lost, 150,000 of them in the sharpest trough of plant closings between 1979 and 1982.

Thus Milton Rogovin's celebratory portraits, taken between 1975 and 1978, had inadvertently documented a home life and work life poised on the edge of a historic transformation: his Buffalo steel- and ironworker subjects have become, for the most part, ex-steelworkers and ex-ironworkers. They constitute a kind of random sample—selected by the eye of a photographer, not a sociologist or historian—of the people living in and through what has come to be called, misleadingly and antiseptically, deindustrialization.

In the mid-1980s Rogovin set out to take new portraits of many of these same individuals, seeking to add the third dimension of time and change to the home-work contrast of his original pairing. He invited me to conduct interviews that might provide a textual parallel, interviews in which his portrait subjects might discuss the work and home lives documented in the original photographs, and what had happened to these lives as iron and steel shut down in the years that followed. *Portraits in Steel* is the result of our collaboration.

This book explores the capacity of portraiture to address the reality of deindustrialization. It is not a study of deindustrialization in general or of Buffalo's industrial transformation in particular. Nor is it an analysis of the impact of unemployment on individuals and families, or of working-class culture, community, life, or consciousness in a period of enormous stress and change—though we hope it offers insight into all of these. In form it is neither a book of photographs accompanied by captions and text, nor a book of interviews illustrated by photographs.

Instead, the book proceeds from a belief that all portraiture involves, at its heart, a presentation of self. Milton Rogovin is almost exclusively a portrait photographer: he takes pictures of people who quite deliberately compose, pose, and present themselves to him, generally looking directly into the eye of his camera. Their expression and intention, however implicit, is what he receives, records, and conveys in his

photography. I have sought a similar quality in the oral history interviews that provide the text for this book.

To speak of self-presentation is not to deny the complexity of the relationship between the portrait subject and the painter, sculptor, photographer, or oral historian whom that subject is addressing. Nor is it to deny that artifice, interpretation, and even manipulation are necessarily involved in arranging the portrait session, rendering the images presented, and conveying them to others in some form or other. (These matters will be discussed below in comments on the photographs, the construction of the interviews, and the particular form in which we have arranged them in the book.) But portraits *do* represent and express a collaboration of their own between subject and artist/historian, a collaboration in which the subject is anything but mute or powerless, a mere object of study. This presentation is compellingly true of Rogovin's work: he is the sort of photographer who does not "take" photographs; rather, his subjects "give" them to him.

When the issues at hand—in our case the problems of deindustrialization and the lives of the people at its heart—have been relentlessly studied by academics, quantified by economists and statisticians, pronounced upon by experts of all kinds, agonized over by activists, and relentlessly word- and image-processed by journalists and the media, this self-presentation introduces a refreshing and important counterpoint, one I have paralleled in my approach to the interviews. The interviews unfolded as broad oral-historical conversations grounded in commentary on the original portraits and discussion of what had changed since they were taken—lightly structured conversations in which I sought a tape-recorded approximation of Rogovin's portraiture: stories given, rather than taken. In this sense, Rogovin and I conceived this work as one of documentary portraiture rather than description and analysis. We hope our photographs and interview texts convey some of what we felt our subjects presented about themselves and their understanding of the crisis that has so profoundly affected and redirected their work, families, and communities.

In any work based on portraits in a particular geographic and temporal setting, introductions necessarily sketch something of the background against which the subjects are standing and about which they are speaking, particularly if the aim is insight into concrete social circumstances rather than some abstract, generalized human understandings. But this presents a dilemma for our purposes, in that the

more extensively I introduce Buffalo and set its experience within the broader context of the deindustrial restructuring of the economy and society of the United States, the more I risk intruding between the reader and Rogovin's portrait subjects, substituting my own thematic framing for the more open-ended dialogue we hope to encourage through text and photo portraits. As much as possible, we intend that a sense of the context and of the information necessary for understanding it grow out of the portraits themselves, where indeed this sense is often quite explicitly presented by the subjects.

Nevertheless, many readers may bring to this encounter a kind of preexisting "script" about the recent changes in industrial cities like Buffalo, a set of assumptions about the area, its economy, its people, and about the plant-closing crisis in America more generally, that may be unhelpful and misleading as a background for receiving the material our book presents. To offset these assumptions, I see the task of introduction as one of clearing and preparing the ground, removing obstacles so that readers can experience the portraits on their own terms and be better prepared to understand the complex realities their subjects are trying to convey about their lives, work, and communities.

The unhelpful script I have in mind involves several intertwined stories. One offers a general picture of the precipitous decline and transformation of the urban industrial heartland, the cities of the so-called Rust Belt, a term evoking both a geographic and economic counterpoise to the ascendant cities of the Sun Belt. In this story such industrial cities and their people—especially Great Lakes cities imagined as brawny, ethnic giants built around and dependent on heavy factory and mill labor—are the victims of the deterioration and disintegration of American industry, a process for which a variety of sometimes complementary and sometimes conflicting explanations can be offered, among them uncompetitiveness and low productivity, technological obsolescence, corporate and conglomerate manipulation, willful disinvestment, environmental overregulations, too much or too little unionization, insufficient protection from unfair foreign competition, and a general international economic restructuring of both capital and labor. Left behind, whatever the cause, are devastated, abandoned cities, disintegrating working-class communities, and a displaced, devalued industrial work force.

A more recent variant of this story suggests the next historical stage. As the industrial base evaporates, a rising service and high-tech economy takes its place.

After the worst of the plant closings and the consequent deindustrialization take their toll, the change in industry provides a base for jobs, recovery, and revitalization, but only for some and at a vastly lower wage level. A new metropolitan complex begins to emerge—one better suited, in the optimistic versions of the story, to participate in the internationalized economy of the twenty-first century, and one darkly shadowed, in the pessimistic versions, by a profound chasm separating those in the population and labor force who are able to participate in the new community from those who are permanently shut out by lack of education, skills, training, or more general access to resources.

The problem with these scripts is not so much with the truth of the parts—every statement in the paragraphs above is supportable in some respect—as with the sense of descriptive homogeneity and historical inevitability these parts take on when woven into a whole: they come to suggest a story so historically structured and determined, inevitable in its form and processes, as to leave to individuals, communities, and policymakers only the option of adjustment and acceptance. At the same time, this story lends itself to a focus on major actors and factors, exaggerating the most prominent features of a given situation or context: attention to Big Steel and Big Labor, to major plant shutdowns such as the one at Bethlehem's Lackawanna, to major policy decisions in government and the corporate economy, and to stereotypical images of a white male ethnic industrial lunchpail army. This focus can obscure the broader, more diverse, and more subtle web of community, economy, policy, and work within which developments have actually unfolded, as the portraits in this volume will suggest.

The conventional heavy industry/deindustrialization shoe *does* seem to fit Buffalo's recent history, though, which makes it all the more important to appreciate how limited a perspective the above-described scenarios offer on the life of the city and its people. But first the fit. From the late nineteenth century through the post–World War II years, Buffalo boomed as the center of a major manufacturing region—iron, steel, chemicals, automobiles, aircraft, lumber, grain milling. At the peak of war production, over 300,000 worked in its factories and mills, and the vibrant postwar economy stretched this into something of a plateau: in 1950, 225,000 were at work in manufacturing, about 50 percent of the region's entire workforce. Buffalo was the world's leading flour milling center, the nation's largest inland port, its second largest railroad center, its third largest steel producer, and its eleventh largest

city overall. But the factories in the region soon slid into decline, slowly in the late 1950s, more perceptibly in the 1960s, picking up speed during the late 1970s and early 1980s. The 50 percent of the workforce in manufacturing had shrunk to a little over 40 percent in 1970 and 30 percent in the early 1980s, and it dipped below 20 percent in 1990, when fewer than 100,000 remained in manufacturing. During the most severe years of the downturn, from the late 1970s through the mid-1980s, over a third of the area's manufacturing jobs were lost. These figures represent a rate of decline far in excess of national trends in manufacturing: Buffalo clearly suffered unusual impacts in industry. Unemployment climbed over the then-alarming 8 percent in the late 1970s, hitting a peak of 12.5 percent in 1982, at the height of the plant-closings. The rate did not fall below 6 percent with any regularity until the late 1980s.

Meanwhile, the city itself was losing residents steadily. From its peak of 580,000 in 1950, Buffalo's population shrank by a third between 1960 and 1980, to 358,000, and by nearly another 10 percent in the 1980s, to its current population of some 328,000. One of the sharpest drops of any city in the country, the change left the city ignominiously in forty-ninth place: a city whose population was becoming disproportionately old (as younger individuals and families moved elsewhere in search of opportunity) and decreasingly white, black migration and population growth increasing in tandem with white flight to the suburbs. And by 1990, Buffalo was over 30 percent non-white. The picture, in sum, seems the epitome of Rust-Belt America: closed facilities; displaced industrial workers, many of whom desert the city; a growing gap between rich and poor, between black and white, between young and old.

This portrait of decline leads directly to the imagery of Buffalo's more recent service-sector–driven renaissance. By the mid-1980s the industrial recession had, it seemed, begun to bottom out; there was much anticipation of a postindustrial future grounded in a high-tech and an expanding service sector, a broad categorization including most nonmanufacturing and nonagricultural work, including everyone from professionals and teachers to clerks and fast-food attendants. The entire metropolitan region's employed workforce began to grow after hitting a low of 465,000 in 1983, as job creation, mostly in the service sector, came to exceed losses in manufacturing. The workforce rose to 515,000 in 1987, and had reached 550,000 by 1990, the highest ever in the region. Four hundred thousand of these workers—including

employees of seven of the ten largest employers—were in the service sector. Unemployment fell below the national average. And the possibilities of sustained revitalization were given a great boost by the initiation of the Canadian Free Trade Agreement in 1988. As a major border city and part of a metropolitan region stretching, by some measures, all the way to Toronto, Buffalo was becoming a prime potential beneficiary of accelerating trade and economic dealings with Canada. In 1992, 18 percent of U.S. imports came from Canada, and a full 20 percent of these entered the country at the three Buffalo-area border crossings.

By the end of the 1980s, then, Buffalo had become something of a "hot" city in the national business press, which touted its affordable housing, its skilled and relatively cheap labor supply, and its somewhat surprising locational advantages. Population seemed to be on the rebound in the last years of the decade, the 1990 census showing not nearly as steep a drop as had been projected. The stage seemed set: with the slipper of deindustrialization properly fit, everything was ready for the transformation of the Rust-Belt Cinderella into a newly bejeweled postindustrial queen city.

But this simple story of the Rust-Belt milltown turned into miracle mart, in Buffalo as elsewhere, simply does not describe reality, historical or contemporary, and hence is ultimately more wishful than helpful. Certainly the structural changes taking place did not imply a trouble-free future: Buffalo entered the 1990s on a modest wave of recovery built on the strength of banking, among other things, only to become one more victim of the savings-and-loan scandal when the locally headquartered Empire of America, the twelfth largest in the nation, went under in 1990, followed the next year by the city's own Goldome Bank (nee Buffalo Savings Bank, the seventh largest). The employment boom seemed similarly tentative. Of those seven of the top ten employers noted above, for instance, six were in the public sector, including the university system. In total, over 20 percent of service-sector jobs were publicly funded, and public sector workers had become the major pillar of organized labor, with some 90,000 members, 50,000 of them in the American Federation of State, County, and Municipal Employees (AFSCME), far outdistancing the industrial unions of steelworkers and autoworkers that had been dominant in Buffalo for a generation. Indeed, the vaunted service sector might better be called the public sector. This sector was proving, amid the accelerating public fiscal crisis in the beginning of the 1990s, a distinctly unencouraging vehicle for a permanent rebirth of the area's economy.

The real problem with the story, however, is the story frame itself—the notion of a blue-collar industrial city built around large factories, which rises to great heights, collapses in a great heap, and struggles to its feet by transforming into something dramatically different. Given the general appeal of sequence in historical explanation, local chroniclers have imagined several Buffalos marching along in historical sequence: the bustling mid–nineteenth-century commercial inland port, based on the Erie Canal trade and lumber and livestock brought in on the lakes; the industrial and manufacturing city of the end of the century, one increasingly involved in a national corporate economy, exemplified by the 1901 relocation of the Lackawanna Iron and Steel Company to the shores of Lake Erie to establish what was then the world's largest, most advanced integrated steelmaking facility, and by the subsequent absorption of that firm into Bethlehem Steel, one of the country's giants, in 1921; and the postwar rise of the metropolitan suburban complex followed, in the 1980s and early 1990s, by the Cinderella story of industrial death and service-sector rebirth we have noted.

What these descriptions miss is the fact that dramatically changing configurations of business, work, social life, and power have been ongoing and characteristic of life in Buffalo and cities like it. All of these Buffalos have, in a variety of ways, been there all along, intermeshed with each other. Changes in the mix, whether by accident or design, and changes in the ways each aspect is linked to the powerful forces transforming Buffalo, the region, the nation, and the world, shaped the changing patterns of life in the city. Those changes became intertwined in the lives and communities of the people who have worked there.

Buffalo became a major city on the back of business and commerce: with the opening of the Erie Canal, it began to funnel the grain of the Midwest to the seaboard, an especially important concern following the invention of the grain elevator in Buffalo in 1842. It became a leading port for lumber and livestock as well, and in general thrived on the jobs and business activity associated with breaks in transport: places where goods had to be moved from one mode of transport (lake shipping, say) to another (Erie Canal barges or railroad cars), turned out to be good places to provide processing, finishing, and manufacturing. This role was especially encouraged by the skills of the immigrant workers, especially German artisans, flooding into Buffalo in the decades before the Civil War. Thus a local hardware merchant, one Paoli Pratt, moved gradually into making his own hardware castings.

His business soon grew into the firm of Pratt and Letchworth, producing Buffalo's first steel castings and experimenting with open hearth production by the 1860s. His success in industry and manufacturing prompted Pratt to return to commerce and business: he became one of the founders of what is still one of Buffalo's most important banks, one whose name—M & T (Manufacturers and Traders)—comments aptly on the city's mixed economy. At the height of the era of the transshipment-based port and commercial city, over 1,600 workers in a total workforce of some 5,000 were working in iron and steel manufacture, making tools, screws, stoves, forges, nails—and the iron and steel that went into them.

The rise of railroading in the mid- and late nineteenth century permanently undercut the Erie Canal and Buffalo's commercial transshipment role. Expansion of manufacturing became a consequent imperative for the city's capitalists, and the railroads themselves facilitated that expansion. With coal coming by rail from Pennsylvania, iron ore from Lake Superior coming in by water, and labor, capital, and market mechanisms already in place, a large city like Buffalo became the optimal place for the large iron and steel manufacturing operation and the corporate economy it was supporting. Thus the 1901 relocation of the Lackawanna Iron and Steel company from Scranton, Pennsylvania, to a mammoth new facility to be built just south of Buffalo seemed only logical, a move triumphantly engineered by Buffalo ironmen and bankers.

Resonance and irony abound in this story: the same inexorable logic of capital that won for Buffalo its major industrial jewel in 1901 produced the traumatic 1983 closing of that plant by Bethlehem Steel. Yet this very drama obscures the texture of an industrial revolution based as much in a complex community economy as in the world of high corporate finance. Well over four hundred new factories were established in Buffalo between 1890 and 1905, from large plants to small machine shops of all kinds. By 1910 ten thousand workers in more than one hundred fifty iron and steel firms in Buffalo accounted, in sum, for only 10 percent of the city's industrial output. And as the Buffalo industrial region rose to greater heights in the 1920s and then again in the era of World War II, its manufacturing base in general, and iron and steel in particular, remained extraordinarily diversified, woven far more deeply into the fabric of the city's life and economy than the symbolic power of the relatively few giant firms and facilities would suggest.

In more recent decades, the picture is similarly complex. For one thing, there is

nothing new about the consumer-oriented service economy. Such business activity was always a necessarily central component of commercial cities like Buffalo with a web of business and finance to facilitate and large and complex populations to support. Indeed, for all its Rust-Belt image, Buffalo has long been in the forefront of creating precisely the consumer economy now seen as a kind of alien spore taking root in the industrial soil. Symbols may communicate this more than statistics: In its first period of expansion, Buffalo was the city of origin for Wells Fargo, forerunner of today's American Express. In the 1890s, one of what remains the city's great fortunes originated in the S. & H. Knox stores, soon a major component in that great early twentieth-century symbol of spreading consumerism, the Woolworth chain. Another fixture in that industrial era was the famous Larkin Company, a soap manufacturing firm that became famous for pioneering new forms of merchandising and distribution based on coupons, premiums, and a network of teenage door-to-door salesmen. In fact, the firm ended up concentrating more on the production of premiums for its customers than on its primary product—a kind of early indicator of how the tail of consumer taste was coming to wag the dog of manufacturing across the American economy.

And as this metaphor suggests, the manufacturing and the service/consumption economy remain connected in cities like Buffalo. Far from leaving a deindustrialized husk, the dramatic decline in manufacturing jobs to just under 20 percent of the total workforce has simply brought Buffalo closer to the norm for diversified urban economies, a norm in which manufacturing remains a substantial component and an important base for community. Many of the jobs are still in large factories in traditional heavy industries linked to huge international corporations. General Motors is now the Buffalo region's largest single employer, and Ford is not far behind. But among the larger factories employing over one hundred workers, one third of local employment is in plants that are still locally owned, many of them smaller manufacturing shops and subcontractors densely interwoven with the larger manufacturers. This interdependence means, for instance, that some 25 percent of the city's manufacturing base and as many as 150,000 jobs—30 percent of all employment throughout the local economy—are dependent directly or indirectly on the health of the automobile industry.

Buffalo has thus been characterized in recent years by a still complex weave of the national and international world of manufacturing, the local manufacturing base,

and the broader regional economy in all its dimensions. And the patterns in this weave are sometimes quite surprising. It is generally true, for instance, that cities affected by plant closings have predictably been victimized by the shift of ownership from local interests to national and international corporations. One recent study of the wave of plant closings in the Buffalo area showed that plants owned by corporations headquartered outside the region were twice as likely to shut down—but not always. Perhaps one of the most painful and ominous closings was that of a local, deeply rooted company—Trico, founded in 1917 by John Oishei, a Buffalonian who invented the windshield wiper and established what remains the nation's major producer of this essential automobile part. Under enormous pressure from the car manufacturers to lower its prices, Trico decided in 1988 to move almost all of its manufacturing to a new operation straddling the Texas-Mexico border. The company stuck with this decision despite energetic and broad-based local resistance backed up by research demonstrating how illusory would be the cost savings and productivity gains of such a move.

If local ownership has not necessarily guaranteed local industry's survival, outside ownership has not necessarily meant its demise. Consider American Brass, a major metal manufacturer established locally in the late nineteenth century. The initially local firm became part of Anaconda Copper in 1917 and then Atlantic Richfield in 1977. Slated for closing by that conglomerate, it was saved by an unusual local buyout in 1985 hailed as a new birth for resurgent, local direction of manufacturing. But the new owners could not raise sufficient capital, and in 1990 ownership passed to a Finnish conglomerate, Outukumpu, which has promised—convincingly, to local labor and capital alike—to strike a viable balance between local self-direction and stable integration in the global relationships on which manufacturing has come to depend. For the area's major Dunlop tire facility the story has been similar—a local buyout that saved the plant, leading to what it is hoped will remain a supportive international takeover, this time by a Japanese firm.

Such stories underscore the limited usefulness of so many of the categories that structure the received script for American cities in the era of deindustrialization—rustbelt to sunbelt, manufacturing to service, local ownership to outside capital. Taking their place is a far more complex interaction between the forces in the broader national and international economy and what remains the persistent complexity of local communities—a complexity grounded in location, in history, and in the lives,

labor, and communities of the people who are, of course, what makes a city a social and political complex rather than a narrowly economic category.

Location, indeed, is the most inclusive clue to appreciating how all these factors are intertwined in Buffalo's past growth and more recent decline, in its present incipient recovery, and in its future prospects. From the impact of the Erie Canal to the hopes invested today in the Free Trade Pact with Canada, Buffalo's location and Buffalo *as* a location, a complex place with particular characteristics and capacities, have driven the city's industrial history and the experience of those living and working in it.

Nothing illustrates this point better than Buffalo's iron and steel industry in the era of deindustrialization. As we have seen, Buffalo emerged as a major center of metal manufacturing not because it was a factory town but because of the reverse: as a major port, marketing, and finance center it was in an ideal location to preside over the reorientation of the American steel industry from the coal fields of Pennsylvania to the Great Lakes and the Midwest, a position in which raw materials—especially coal from Pennsylvania and iron ore from the Mesabi range—could be brought together more advantageously with the other elements necessary for modern industry on a national and international scale. Buffalo had the components already—skilled labor in abundance and unskilled labor easily attracted to a diverse metropolitan economy; a supportive infrastructure and vast array of services and subcontract firms; financial and administrative capacities for organizing distribution to the expanding markets of the American Midwest and Canada; and the rail and lake shipping transport necessary for both production and distribution. Such an interdependence of place and function wove the industry deeply into the fabric of local life, community, business, and labor at every level.

This interdependence has made the reorganization all the more confusing and difficult—far beyond the usual implications of plant closings—when the same logic of place turned against Buffalo. The same fixation on the Lakes and the Canadian and Midwestern markets that drew Lackawanna and then Bethlehem to Buffalo led them beyond it in due course. Bethlehem's decision to build a major new integrated steelmaking facility at Burns Harbor, Indiana, closer to its major markets, spelled the doom of the Lackawanna plant, though it took a while for this fate to become clear. In what turned out to be a painful and fleeting illusion, Lackawanna's production of basic steel rose to deceptive heights through the 1960s while Burns Harbor was being

built and came into partial operation, dependent on semifinished steel made at the older plant. And while Burns Harbor was turning the old logic away from Buffalo, other broad changes were beginning to create a new economic geography and logic. Increasingly, steelmakers were turning to ores from South America and Africa, brought into the heartland of the United States via the St. Lawrence Seaway, bypassing the doomed port of Buffalo. Production turned toward the sea as well, increasingly centered around markets abroad. These developments turned on its head whatever remained of Buffalo's advantage as a location for concentrating the large-scale production of iron and steel.

When set against the fall of the once mighty American steel industry, this place and community orientation provides a final irony useful in preparing the ground for the interviews and photo portraits that follow. In many accounts, particularly in impacted communities like Buffalo, explanations of the collapse of steel have characteristically centered on local viruses held to be responsible for damaging an otherwise healthy industrial body: excessive labor costs, local taxes, and the environmental regulations requiring expensive modernization. More careful studies, however, show these are at best tangential factors and at worst fictions. Bethlehem's Lackawanna, for instance, was characterized by modestly proportioned and steady labor costs and consistent corporate profits until close to the time when the decision to close the plant was made, and environmental and tax considerations were not really central at all.

The collapse of steel was a more complex consequence of the industry's own growth gone wrong, the victim of something more like a cancer than an invading enemy: excessive growth in production capacity, encouraged by government incentives and labor agreements, in the absence of systematic modernization. The combination left American steel and its substantial surplus productive capacity unprepared to deal with a worldwide weakening of demand brought about both by a turn to substitute products and the rise of foreign competition.

The United States produced 54 percent of the world's steel in 1946, but its share had fallen below 12 percent by 1984 and well under 10 percent by 1992. One of the main reasons was the failure to modernize as aggressively as competitors, especially the Japanese. The Japanese, for example, were much quicker to adopt the more efficient basic oxygen furnace (BOF) method of steelmaking than the United States, whose strategy—the product of a complex government-business-labor interaction—

was to expand the older open-hearth production, a method initially more consistent with preexisting rolling-mill facilities and the organization of work. The same is true with the turn to continuous casting, a process eliminating many of the intermediate cooling and reheating steps involved in the milling of raw steel into various industrial products. As most studies have concluded, the problem with American steel was fundamentally a matter not so much of *dis*investment as of *mis*investment. By the time the failure of the strategy was apparent, it was too late for BOF, continuous cast, and similar innovations to help the United States to compete in a modernized international marketplace—hence the inevitable focus on reducing capacity and protecting markets from foreign competition.

Whatever else might be said about this complicated story, the irony for communities like Buffalo is that the shock of plant-closing discontinuity proved all the greater because it had been built on what turns out to have been a deceptive continuity in steelmaking and steel communities over the years. Though modest BOF facilities were introduced into Bethlehem's Lackawanna plant in the 1960s, and into Republic's plant somewhat later, most Buffalo steelmaking in these giants, as well as in the host of smaller facilities, remained traditional. The links between large mills and subcontractors, the web of skills and experience defining steelwork, the family and neighborhood ties linking generations of steelworkers had not changed very much at all through most of the twentieth century. And the industry's ill-fated expansion, so continuous with the proud and diversified history on which Buffalo's business and industry had been built, sustained both this world of work and the assumptions, economic and social, on which it was based, right up until the time when the plants began to close.

In this sense, rather than in a more dramatic extremity of disaster, the collapse of steel and iron in Buffalo maximized the impact of the collision between systemic changes in American industry and deeply rooted, locally grounded experience—precisely because the impact came not in a narrowly dependent factory town, but in the work, neighborhood, and urbanity of a complex metropolitan community. Such a community provides the setting, the history, and the broad context for the changes addressed by the Buffalo workers whose portraits are presented in this book.

In these introductory ground-clearing notes, I have taken pains to say very little about Buffalo's workers themselves—about their work, their backgrounds, their homes and families, their communities, their experiences and attitudes and opinions

on the job or in the aftermath of losing manufacturing jobs. I have not presumed to introduce or interpret their perceptions of or their responses to deindustrialization, or their understanding of Buffalo's recent problems and its prospects for the future. My aim is to minimize the mediation of historian and photographer and to leave comment on all these matters to the workers themselves—to the implicit dialogue with readers evoked through the words and images our portrait subjects presented to Rogovin's camera and to my tape recorder. For this dialogue to unfold fully, however, it may be useful to locate our photography and interview project against the broad backdrop unrolled in the preceding pages.

When Milton Rogovin took his photographs of Buffalo workers in the mid- to late 1970s, he was certainly not intending a study of the steel industry, much less its demise. The local steel and iron factories were then alive (if not quite wholly well), and because Rogovin's interest was in the faces of working people rather than in systematic documentation of their jobs, work sites, and industry, his portraiture took shape casually as he visited this or that facility, selecting his subjects from among the people he encountered as he moved through each plant.

As it happened, Rogovin had less difficulty gaining access to the smaller plants than to the major facilities that have so commonly been the focus of most studies of steelworkers. He did take a number of his portraits in the Bethlehem and Republic mills, where his main interest was women and minority workers hired there under programs responding to a 1973 Equal Employment Opportunity Commission consent decree requiring that documented discrimination at the plants be addressed by new affirmative action hiring. But the bulk of his portraits were shot at the area's smaller steel mills, iron foundries, and workshops. In fact, a number of his most striking portraits were of a group of individuals working in one shop of one small plant—Shenango Ingot Molds. Although Rogovin's portraits range from unskilled laborers to highly skilled artisans, relatively few of his subjects worked on the imposing rolling mills in the major plants, the operations that seem, for most onlookers, the dramatic heart of steel production. Rogovin's photographically acute but historically circumstantial and almost random selection results in what might seem necessarily uneven documentation, to the extent that one's object is a broader understanding of the world of iron and steelworkers and what has happened to that world in the wake of the industry's collapse in cities like Buffalo.

Yet Rogovin's choices provide us with a fortuitous, unappreciated capacity to move

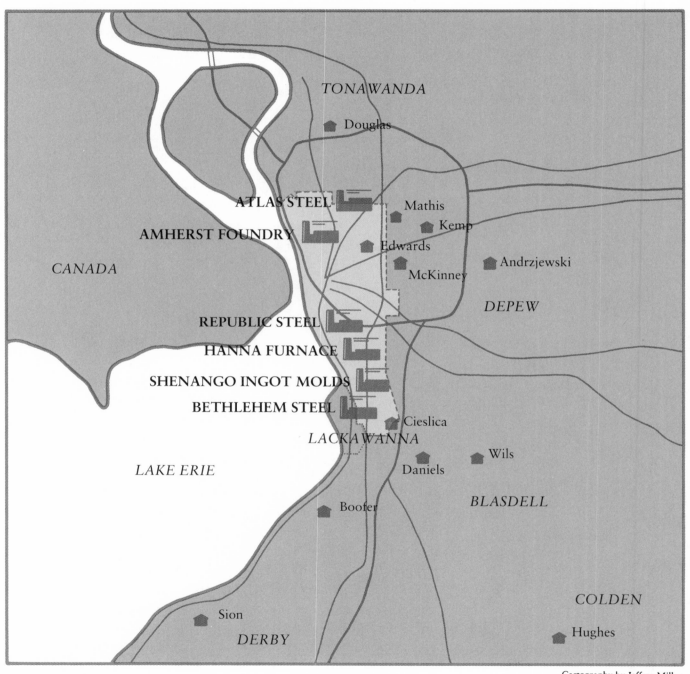

ATLAS STEEL

AMHERST FOUNDRY

REPUBLIC STEEL

HANNA FURNACE

SHENANGO INGOT MOLDS

BETHLEHEM STEEL

TONAWANDA

Douglas

Mathis

Kemp

Edwards

Andrzjewski

McKinney

DEPEW

CANADA

Cieslica

LACKAWANNA

Wils

Daniels

BLASDELL

LAKE ERIE

Boofer

COLDEN

Sion

Hughes

DERBY

Cartography by Jeffrey Miller

BUFFALO
Where they live and where they worked

beyond stereotypical images of hard-hat, rolling mill steelworkers to explore the remarkable variety of people, backgrounds, work, and experience brought together in the iron and steel industry. Just as we need to understand that the steel industry in cities like Buffalo meant something more than just one or two giant mill complexes, so do we need to understand its people as workers in a vast network of interdependency that stretches from the major mills down to the smallest subcontracter or iron foundry and grounds the industry as a whole in the history, the people, the neighborhoods, and the economy of city and region.

We strove to maintain this diversity in the even more unpredictable process of locating original portrait subjects for post-closing interviews and follow-up photograph portraits, and selecting from among the resulting interview texts. About twenty-five of Rogovin's subjects could be contacted; some twenty were interviewed at least briefly, and of these, twelve full interview subjects were selected for inclusion in this book. This final group of twelve interviewees includes nine men and three women, eight whites and four blacks, two Polish-Americans, several young workers and two older ones near retirement at the time of the shutdowns—as it happens, a distribution about as close to the general profile of Buffalo's workforce as might have been produced by careful project design.

These individuals worked at various stages of steelmaking from the furnace to finishing operations and shipping, from labor to skilled and supervisory work. All three of the women were employed at Bethlehem or Republic. Among the men, a number worked at Shenango, a branch plant of a Pittsburgh company established in Buffalo in 1963 to cast large molds used for the bigger mills, especially Republic, as well as for customers in Ontario as well. One man worked at Hanna Furnace, which in turn made the pig iron Shenango used for its molds. Two worked at Atlas Steel, a family-owned firm that supplied castings for rolling mills at Bethlehem and Republic, in addition to other custom production. And one worked at Amherst Foundry, an independent company that had begun as a stove producer in the 1880s and continued as a small specialty shop making tools, parts, and other small castings. The accompanying map locates these now-closed worksites and the homes of the interviewed workers, as well as other features on the geography of the city and region. As this illustration suggests, the text portraits approximate not only the diversity of steel- and ironmaking, but the diversity of Buffalo's workers and communities as well, from the vast steelmaking complex of South Buffalo and Lackawanna to iron

foundries in the heart of the city's older nineteenth-century industrial neighbor-hoods, from homes adjacent to the workplace to homes farther away in a variety of working-class neighborhoods throughout the city or in the country to the south of the major mills.

A concern for the implicit imaginative dialogue between readers and portraits has governed our organization of the book as a whole. We begin with the gallery, in which the twelve interview subjects are interspersed with those whose interviews are not included. Each subject is presented first in the work and home photos of Rogovin's original 1970s portraits, and then in the follow-up portrait taken around the time of the interview. As in all presentations and exhibitions of Rogovin's work, the photo portraits are presented without identifying captions or context annota-tions. His intent has consistently been that his subjects speak directly through the portraits, without distracting mediation; thus viewers can encounter and reflect on them here as they would have strolling through the galleries of the "Working People" exhibition. We then set these portraits in context and in historical motion: each of the twelve subjects reappear, the portraits reprised in the interviews, which give voice to what has been implicit in the photographs.

Successful portraiture requires, by definition, penetrating depth rather than repre-sentative breadth, an insight that helped me to see the value of embracing, not merely accepting, the boundaries of Rogovin's photo portfolio. Thus the interviews begin with the group at Shenango—five superficially similar workers doing the same kind of work in the same room. By permitting a layering of what turns out to be sur-prisingly diverse commentary from a variety of vantages in a setting held constant, the interview grouping intends to encourage a deeper understanding of both the technological and social character of one very particular kind of work and of one plant's history within the broader world of steelmaking. With these connections and complexity so explicit in one instance, readers may be better able to imagine a similar density in other plant situations represented by only one or two interviews.

From this base the collection moves to other plants, jobs, and individuals, in widening circles of diversity and complexity. We hope readers will find themselves moving back and forth among the interviewees, whom they will be coming to know in some detail, and between these individuals as a group and those subjects repre-sented only by the portraits in the gallery—seeing these with a new capacity to read

context and expression in those faces, to imagine more easily the dialogue always implicit in portraiture.

My first conversations with Rogovin's subjects were in the mid-1980s, and most of the interviews were conducted in 1987 and 1988. Ranging from one-and-a-half hours in single-session interviews to over seven hours in several sessions, the interviews followed a consistent format intended, as noted at the start of this introduction, to approximate in oral history the kind of self-presentational portraiture Rogovin "receives" in his photography. I chose not to approach each interview with a schedule of particular questions. Instead, I simply invited each subject to discuss his or her original portraits on the job and at home—to annotate these for readers, and thereby to unfold in some detail the context of work and home life in the 1970s. We then moved on to discuss the plant closing; what each worker had done during and after the shutdowns; the experience of unemployment and the search for new work, together with the impact of all these on spouse and family; and perspectives on deindustrialization more generally, especially in the context of the future of cities like Buffalo. This general framework proved open to diverse extrapolations in each setting, in terms of what was discussed and even who joined in—my initial intent was to interview only the worker pictured originally, but in some instances spouses who had been listening joined in the interview quite actively, and have been included here.

I have tried to preserve the detail and focus of each self-presentation in editing the interview texts for publication. This editing has been necessarily substantial: the texts here reduce the original transcripts to as little as 20 percent of the original. In no case does the published interview represent more than about 60 percent of the original. Such compression exacts costs in terms of coverage and continuity, costs which in turn demand aggressive editing and even manipulation of the transcript in order to fashion a coherent, readable document. Accordingly, there has been a good bit of rearrangement and focusing of material in structuring each text, work I like to think brings the result closer to the texture and voice of the original taped interview as a whole.

This is a natural process in oral history documentary, but also a somewhat mysterious one, rarely discussed in detail. I have sought to remove such editing from this "black box" in a chapter of my recent book, *A Shared Authority: Essays on the Craft and Meaning of Oral and Public History* (Albany: SUNY Press, 1990), titled "Pre-

paring Interview Transcripts for Documentary Publication: A Line-by-Line Illustra-
tion of the Editing Process" (pp. 81–146). There I offered as a case study two
versions of the *Portraits in Steel* interview with Dick Hughes—the fully edited text
more or less as presented below, and the original full, rough transcription of this
interview. Each version is fully indexed to the other, so that it is possible to see
exactly which passages in the original were selected for the edited version, and
exactly how passages in the edited version were compressed, or in some instances
assembled, out of material drawn from the original interview. Together with the
chapter's commentary on some of the issues raised by editing oral history, these
documents offer a kind of workshop for exploring such textual processes. The *Shared
Authority* chapter as a whole might make a useful reference for readers of the present
volume interested in exploring how the edited texts here came about, and what they
do and do not represent.

There are two aspects of that broader discussion that must be noted here, however,
as they return us to this volume's central intention as a work of portraiture rather
than investigation and analysis. The first is the decision to refrain from annotating
interviewee's descriptions of the steelmaking process or specific references to events
or issues in the local context. While some descriptions might well have been clearer
or accessible with a glossary of technical terms or local references and diagrams of
processes and economic relationships, such additions would have inevitably involved
substituting my professional authority for the authority the speakers themselves
present, a very substantial risk considering that modern readers are so regularly
invited to defer to the authority of academic experts. Such annotation, I concluded,
would exercise a deflection of attention far outweighing whatever clarity it intro-
duced. Better to permit readers to listen directly to the workers, to build their
understanding of steelmaking and steel communities on what they hear. By and
large, especially as the interviews crisscross increasingly familiar ground, descrip-
tions and references become clearer and more accessible—the same thing that hap-
pens as we come to know new people and contexts in our daily lives. Readers may
have to struggle and stretch in order to grasp things any steelworker understands
through intimate experience, but, given our society's general disrespect for the au-
thority of worker's experience, that strikes me as not necessarily an undesirable or
unproductive outcome of the encounter with these interviews.

Related to these claims for the implicit dialogue across the boundaries of class is

the decision to retain the question-and-answer format rather than to craft interview material into a narrative presented only in the speaker's voice, the more usual approach with long oral history texts. Although my presence as a relatively conversational interviewer has been reduced to a minimum, I believe at least some of this dialogic dimension should be preserved. The subjects, after all, were speaking not to an abstract public but to someone specific; they were addressing me as directly as they addressed Rogovin's camera, and the relationship this process created, one involving and sometimes engaging substantial differences in experience and perspective, is embedded in the interview texts and is frequently explicit in the subject's comments. With this dimension of conversation intact, the interviews can more easily embrace readers themselves in an active if implicit dialogue.

Milton Rogovin's special gift as a photographer has been his capacity to promote just such a dialogue. As an historian who has studied many of the issues of community, urban history, and deindustrialization, I hope these oral history companions to his photography help readers to appreciate what Rogovin has always known and celebrated: the capacity of experience, given voice and expression through the portraiture of working people, to contribute to our understanding of these issues, and each other.

PHOTO GALLERY

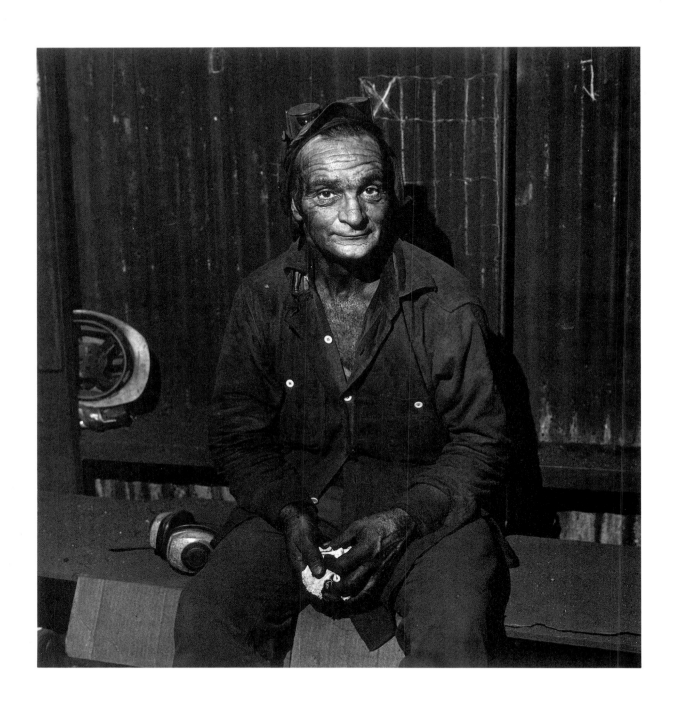

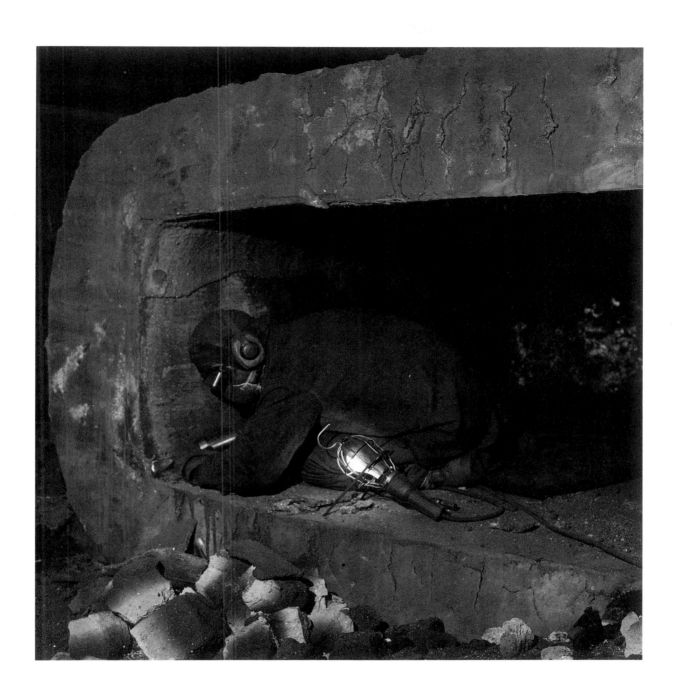

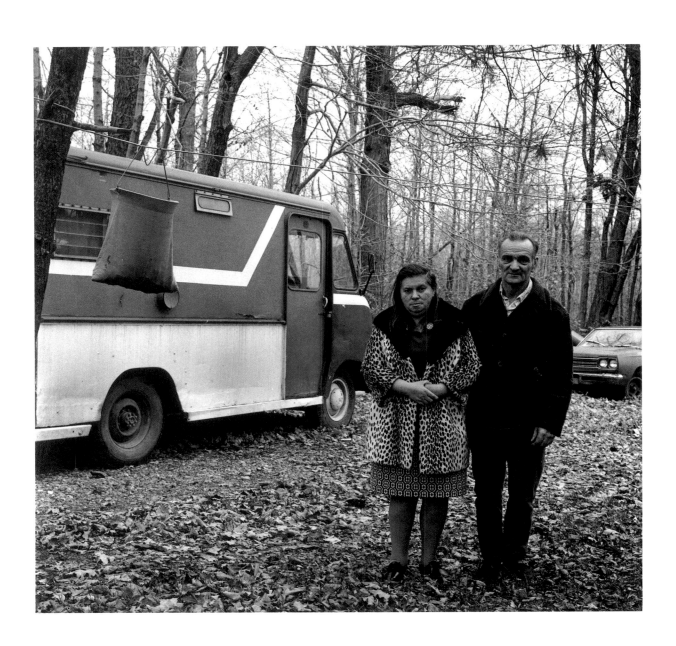

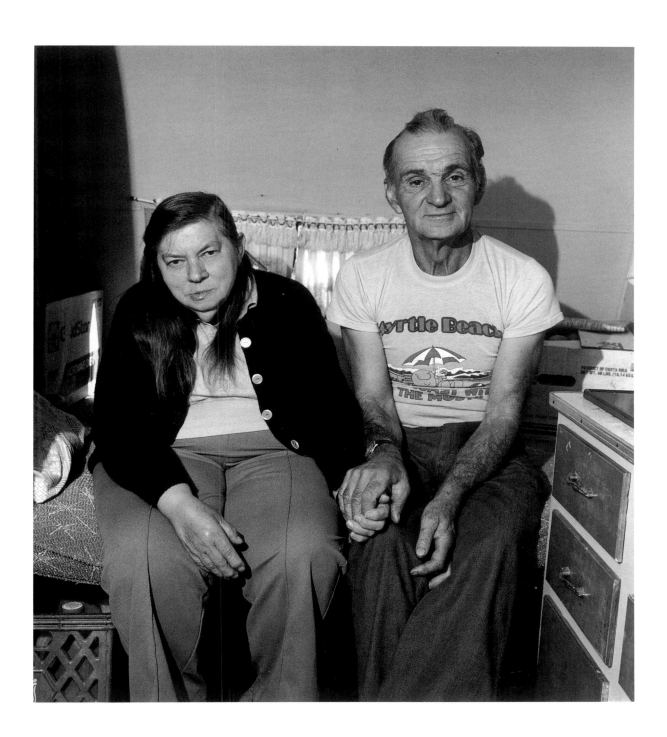

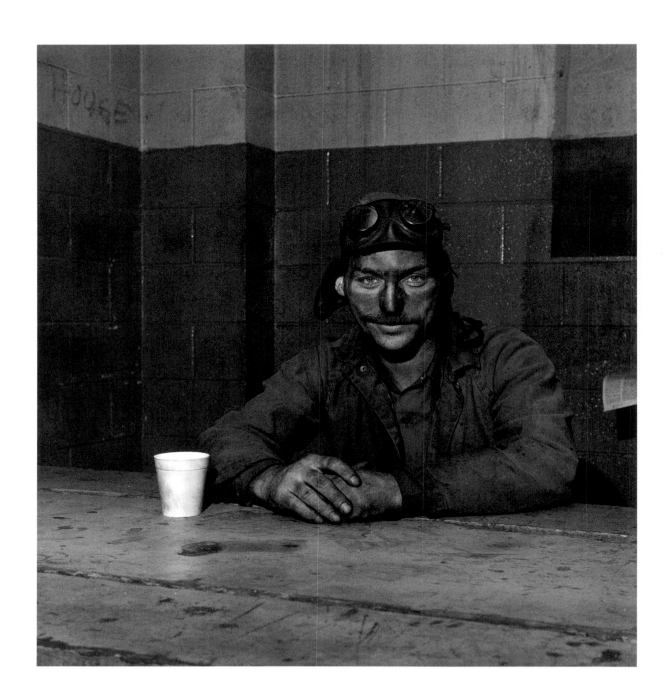

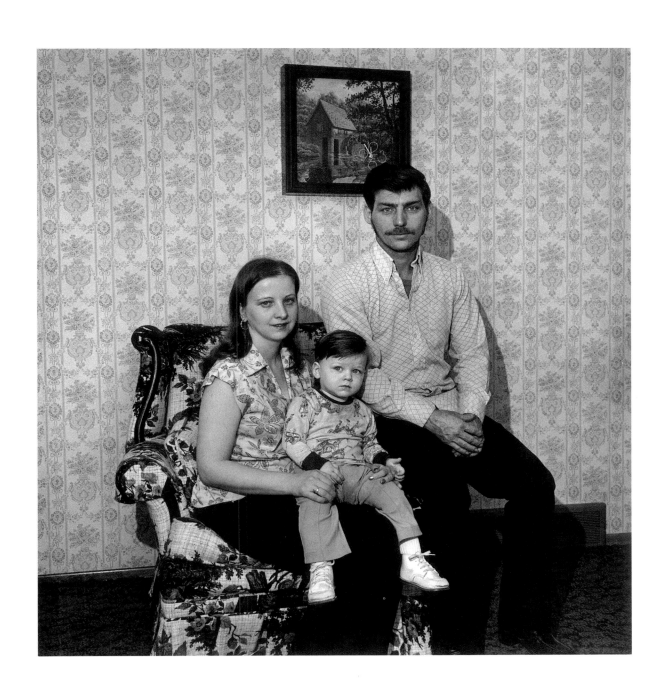

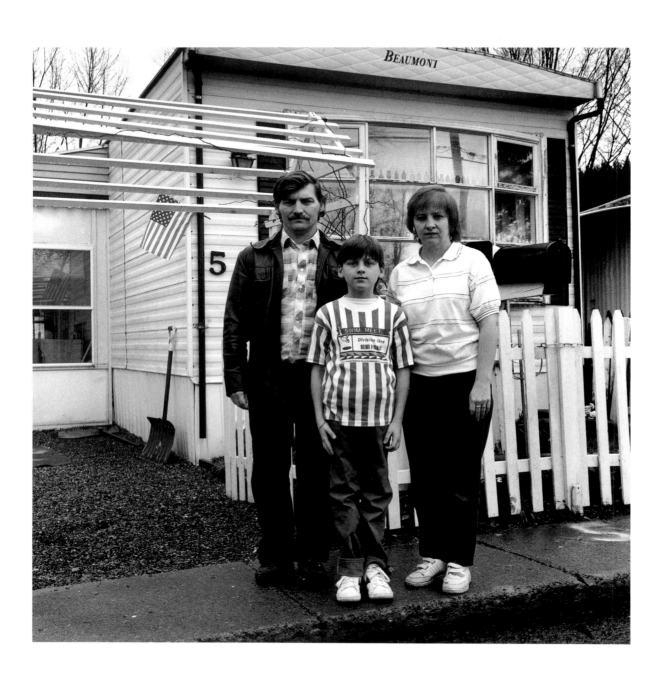

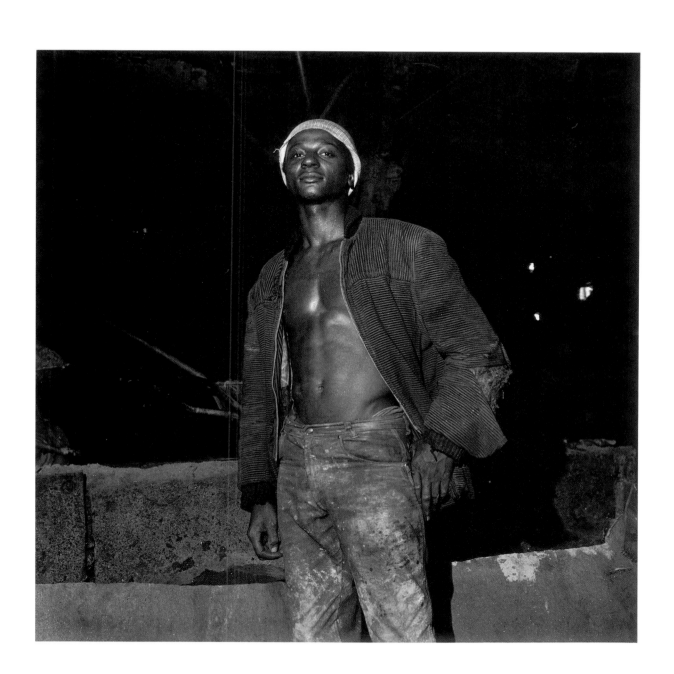

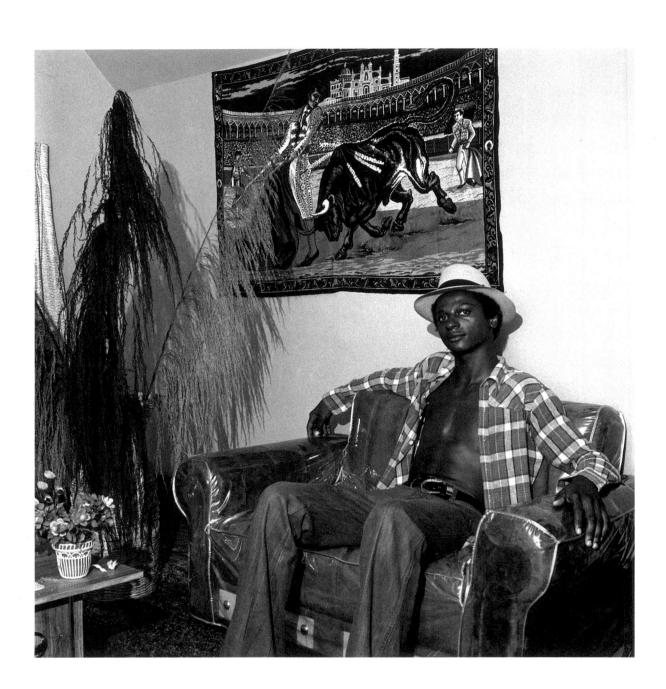

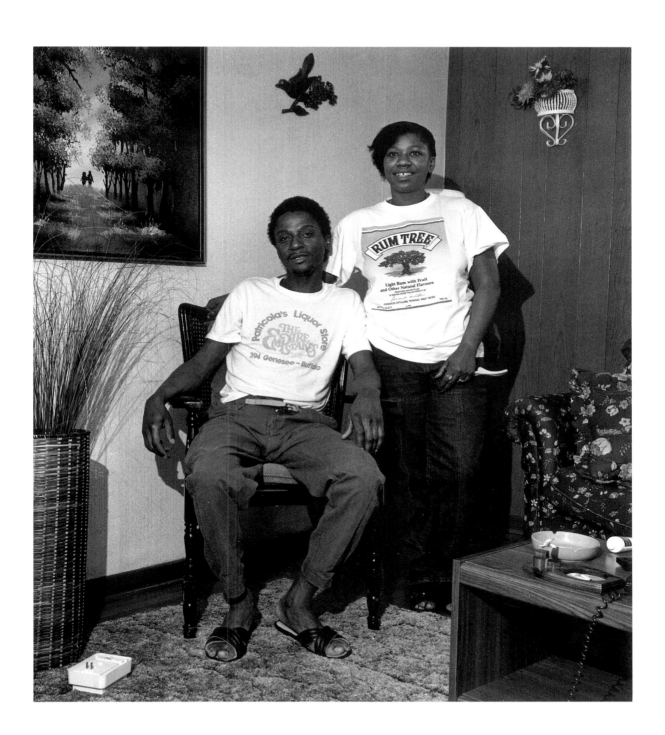

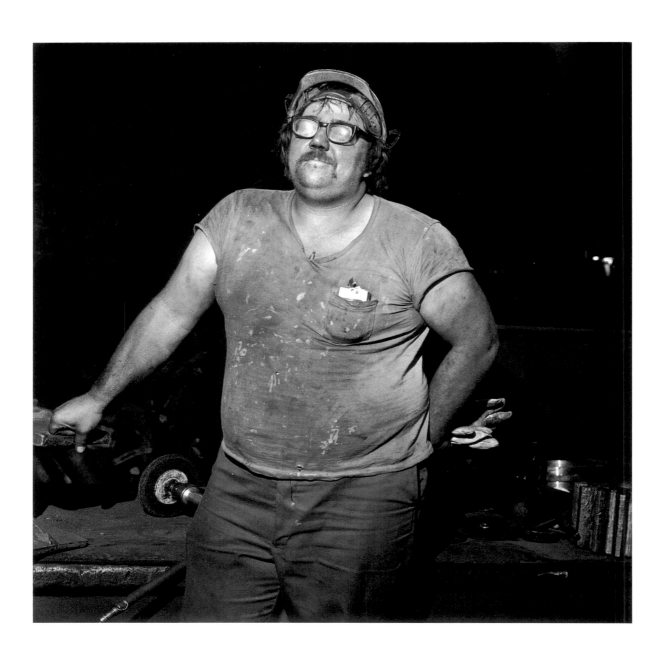

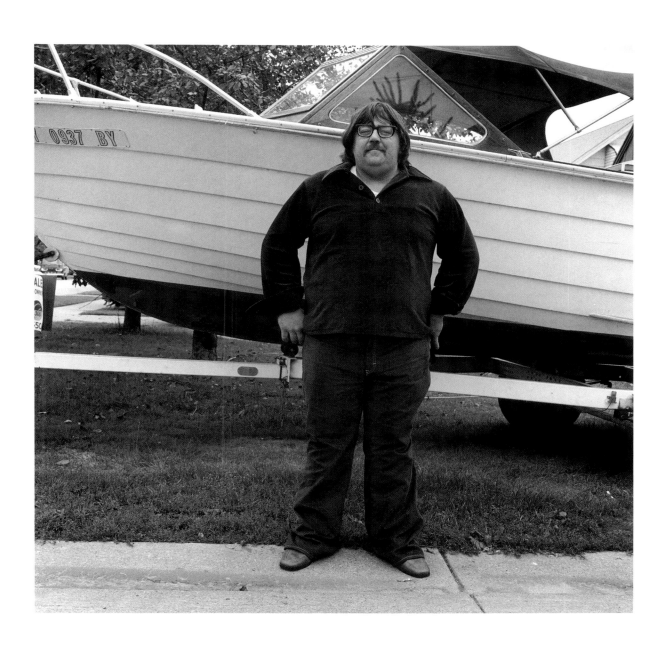

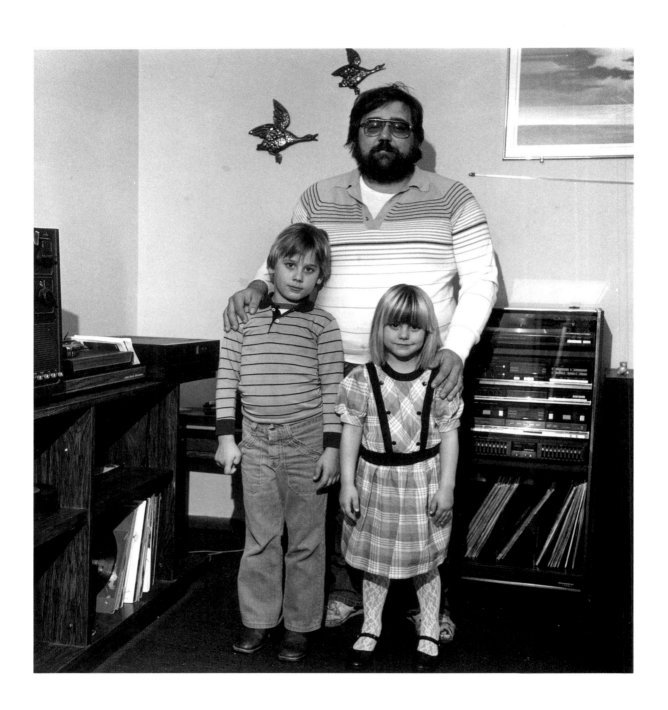

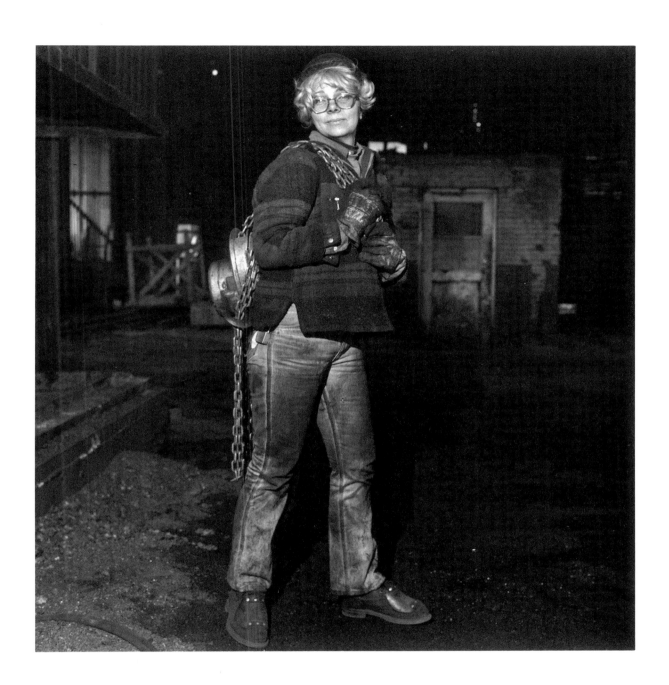

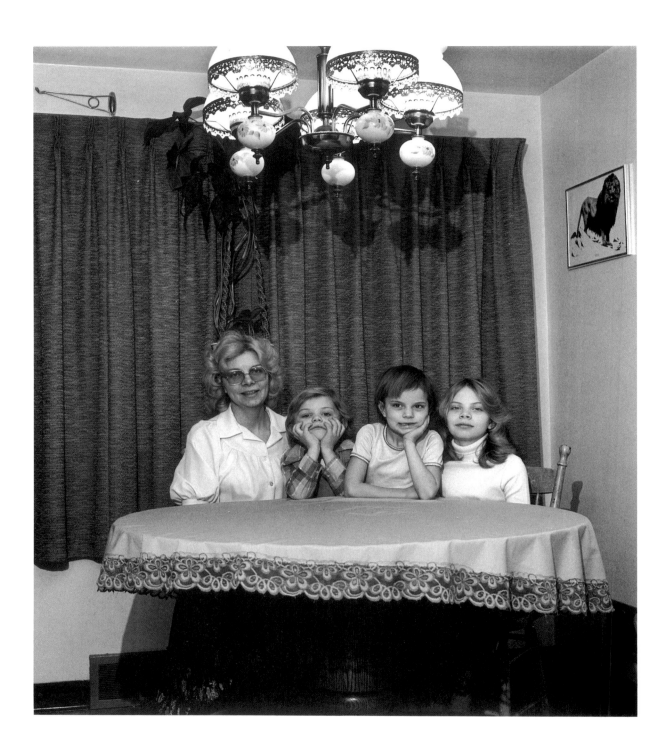

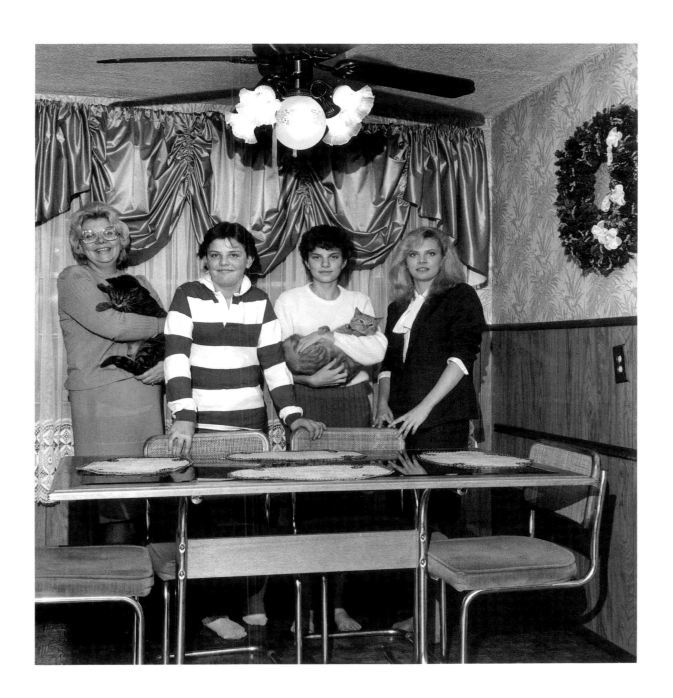

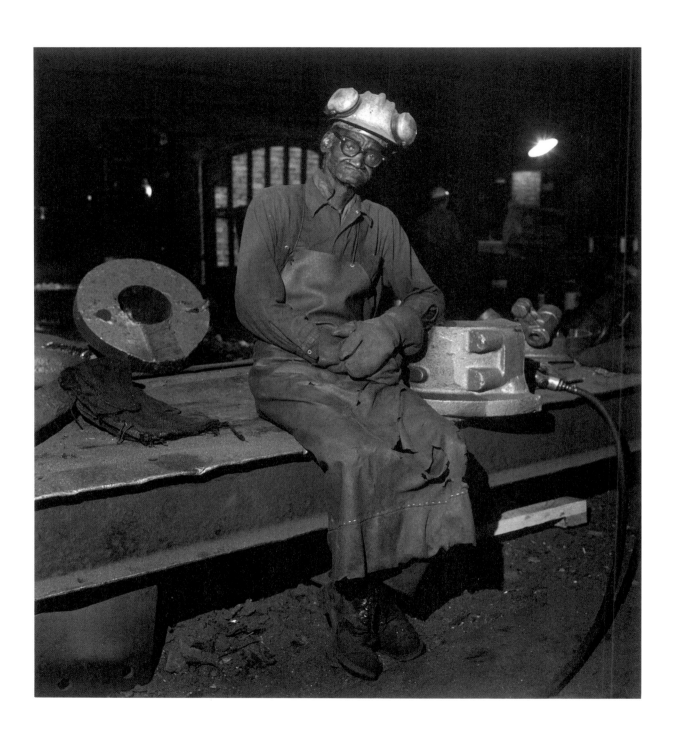

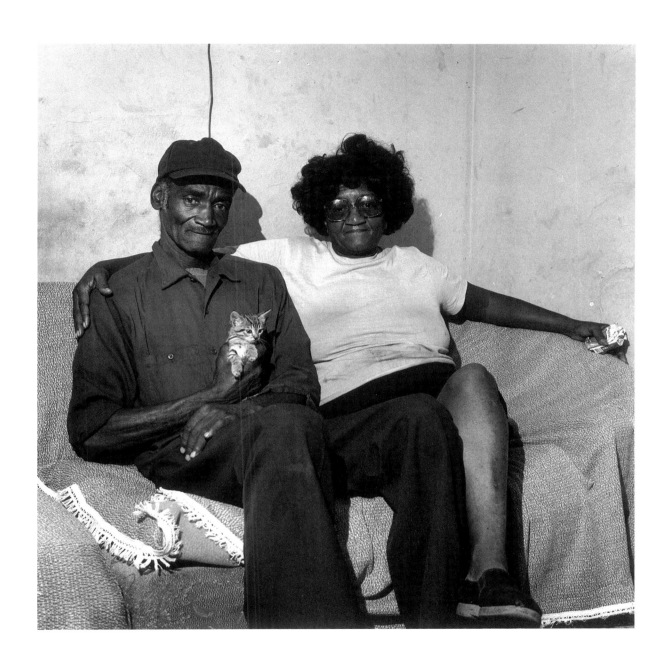

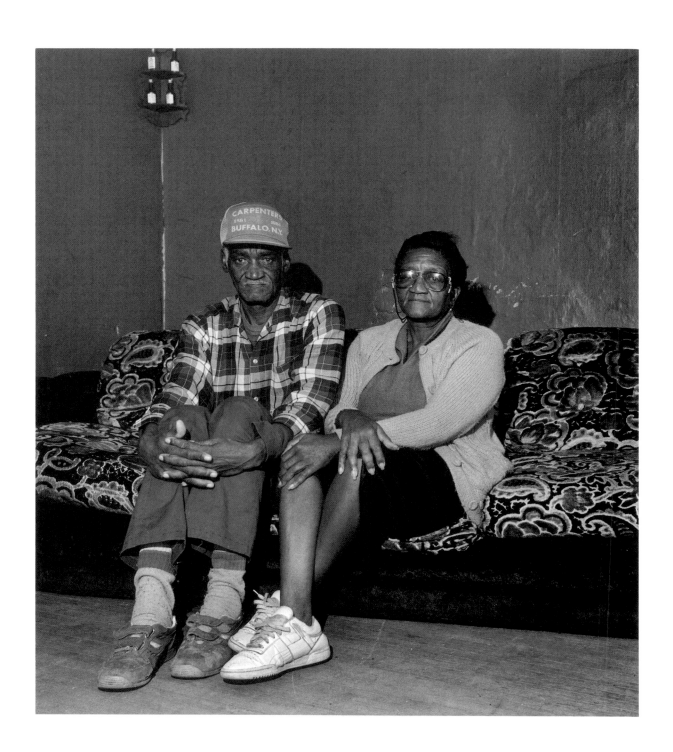

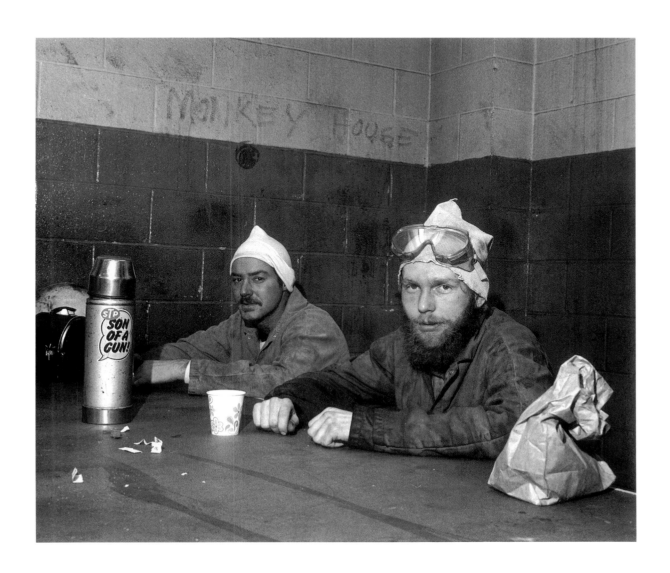

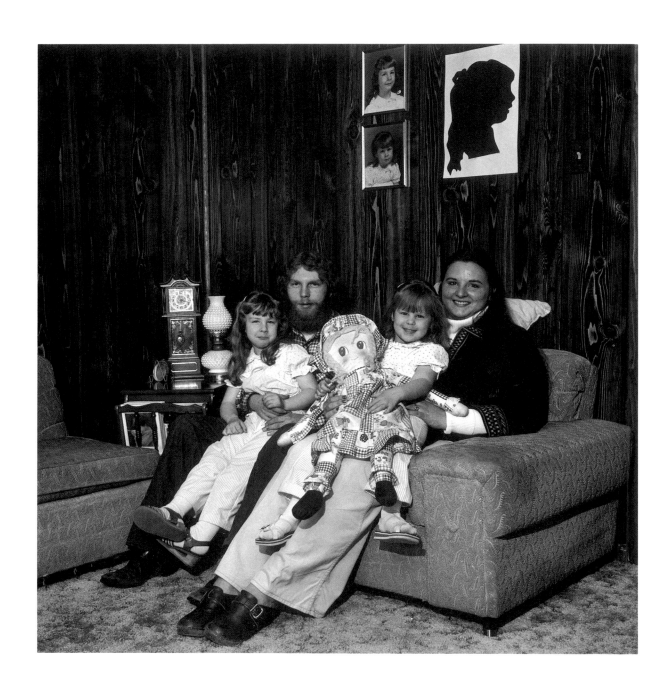

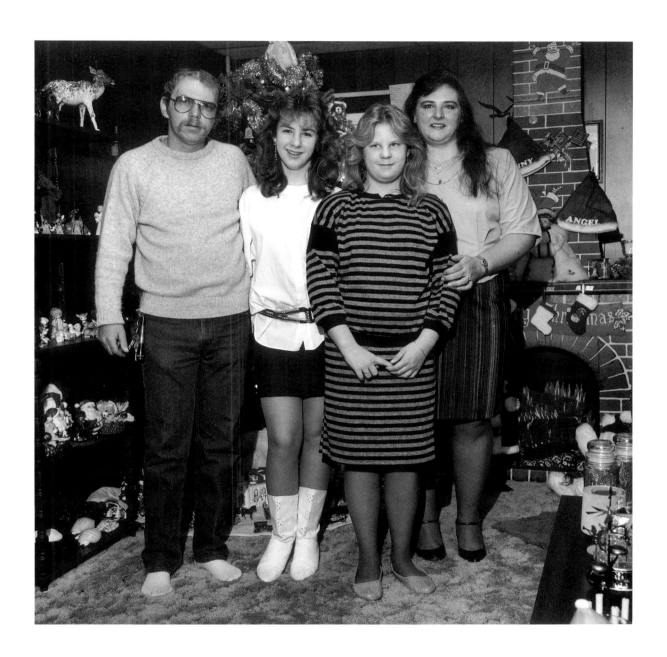

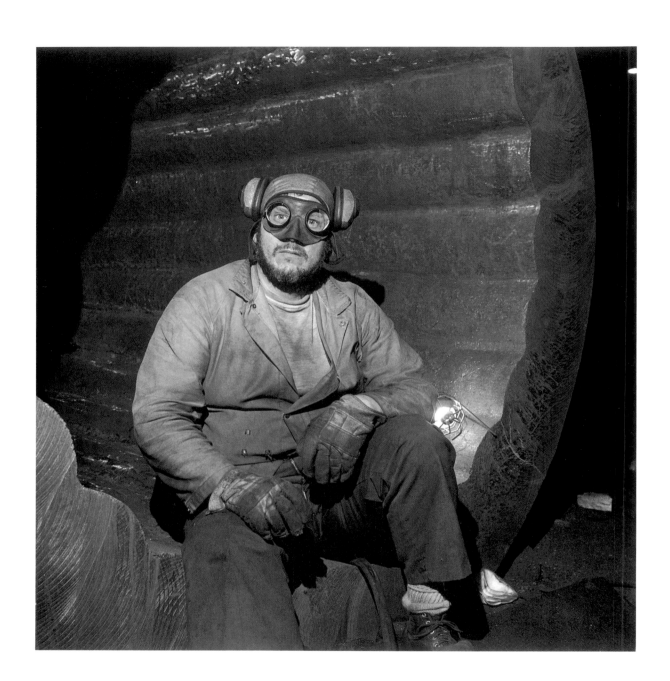

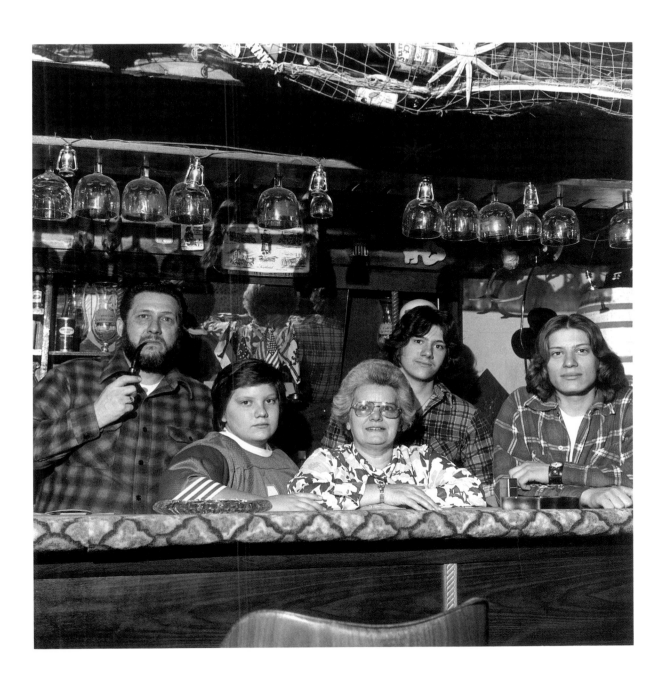

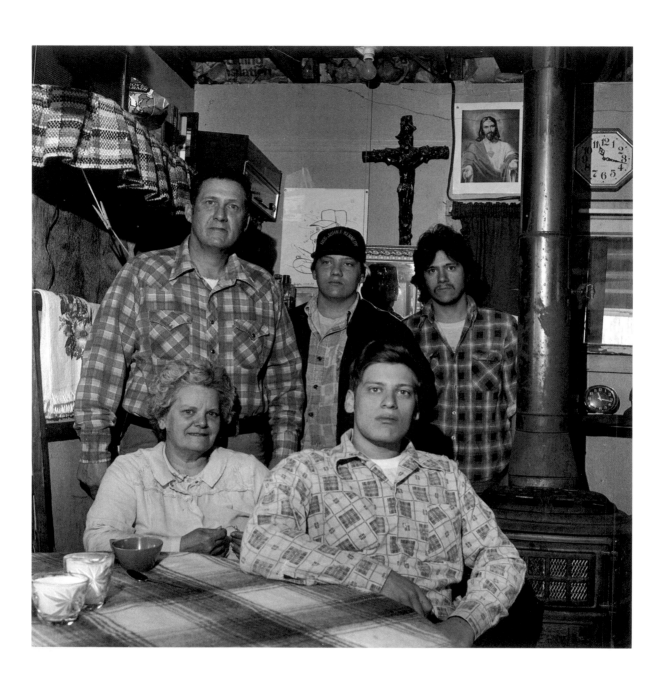

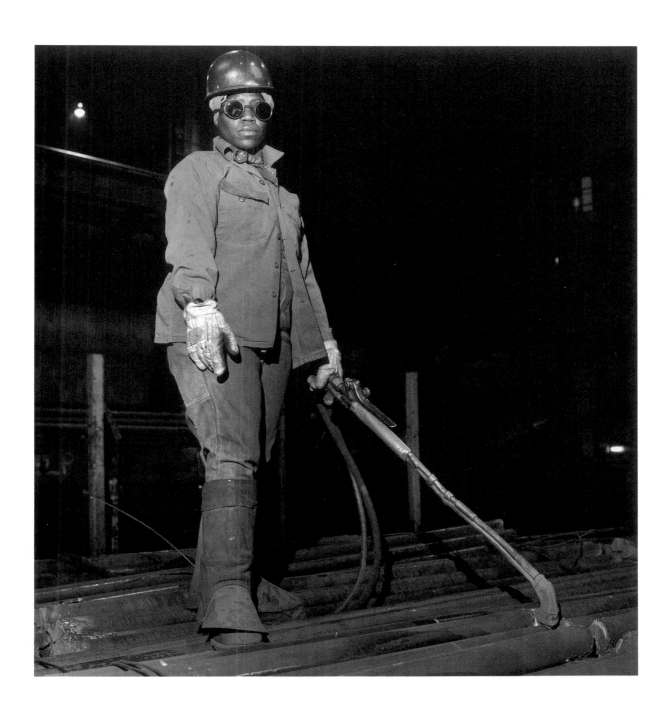

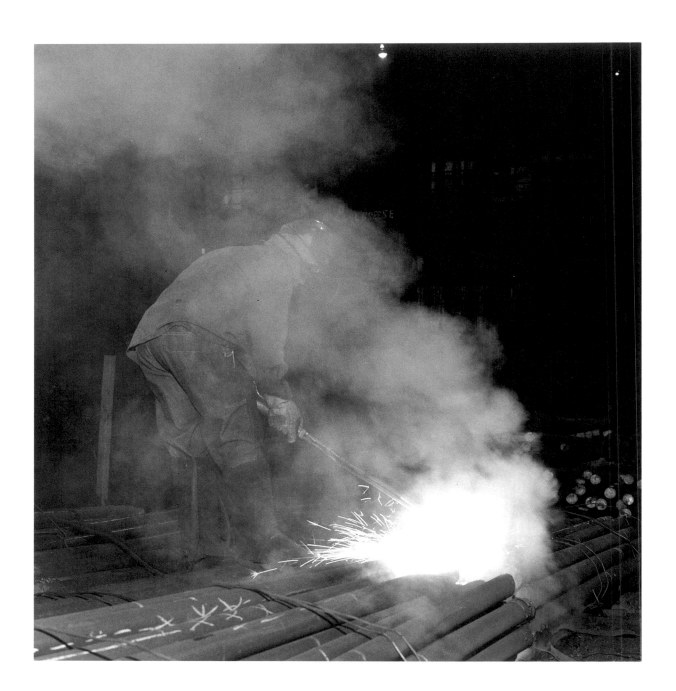

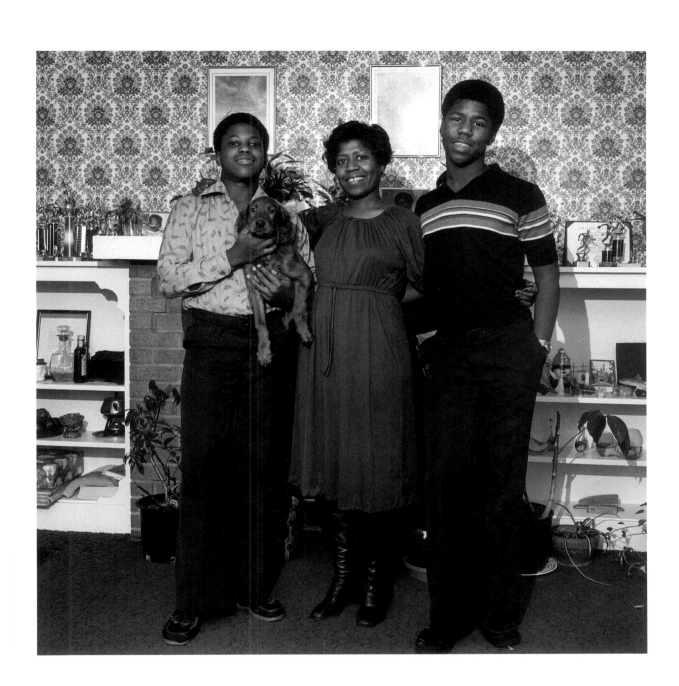

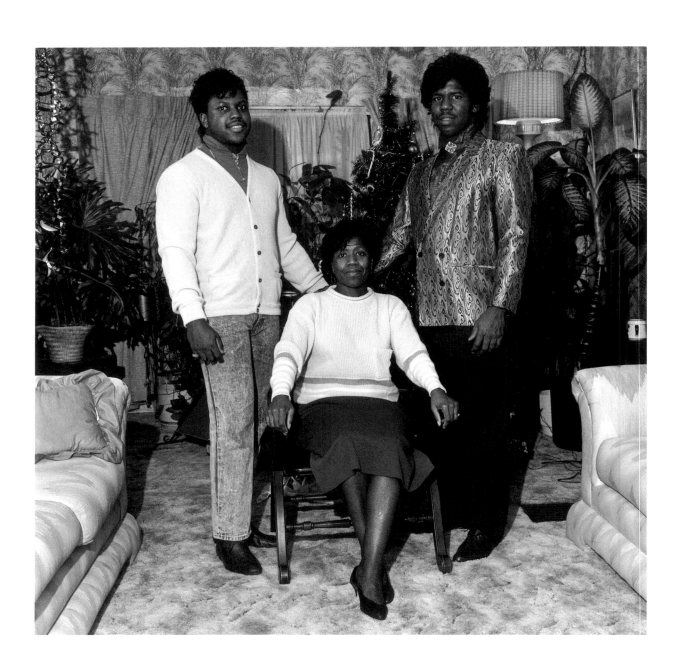

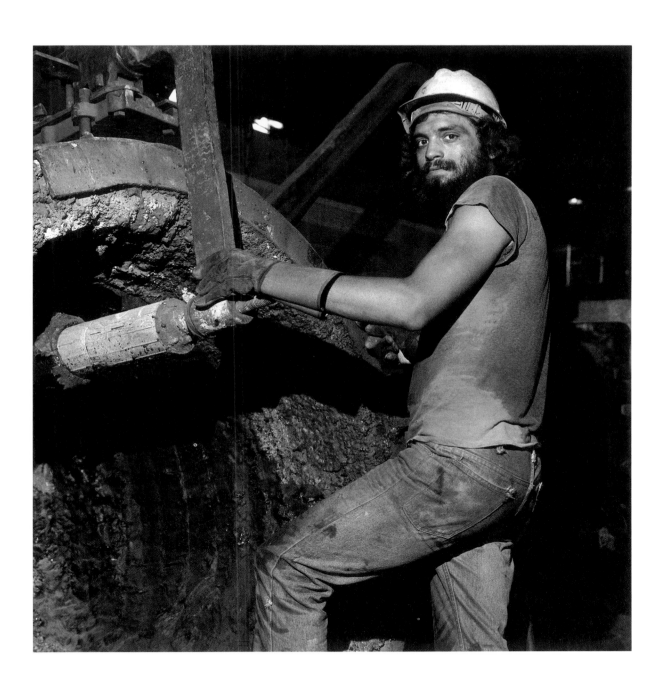

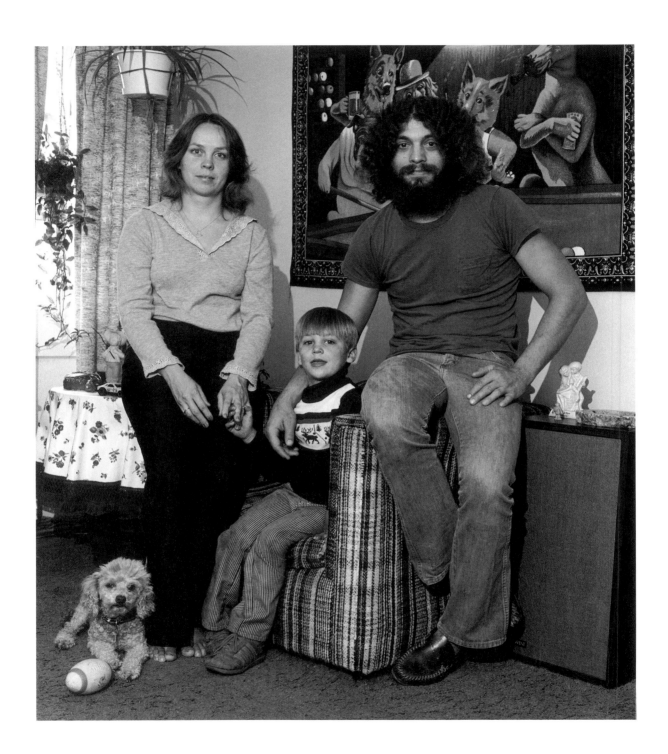

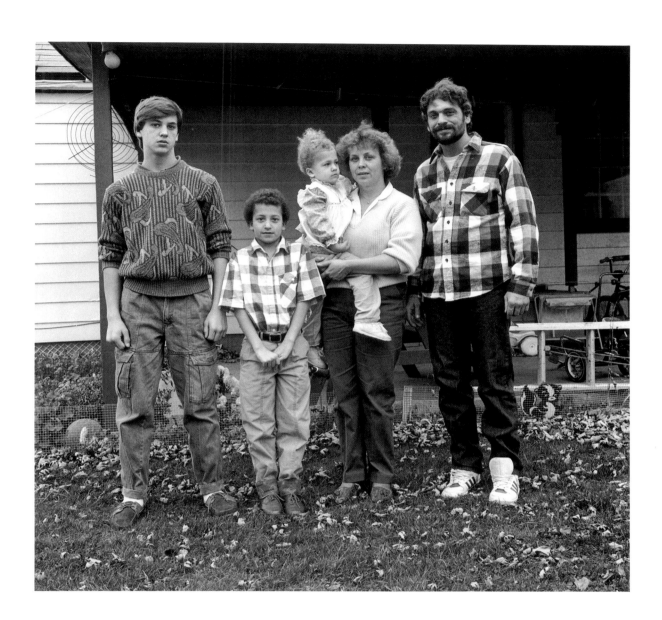

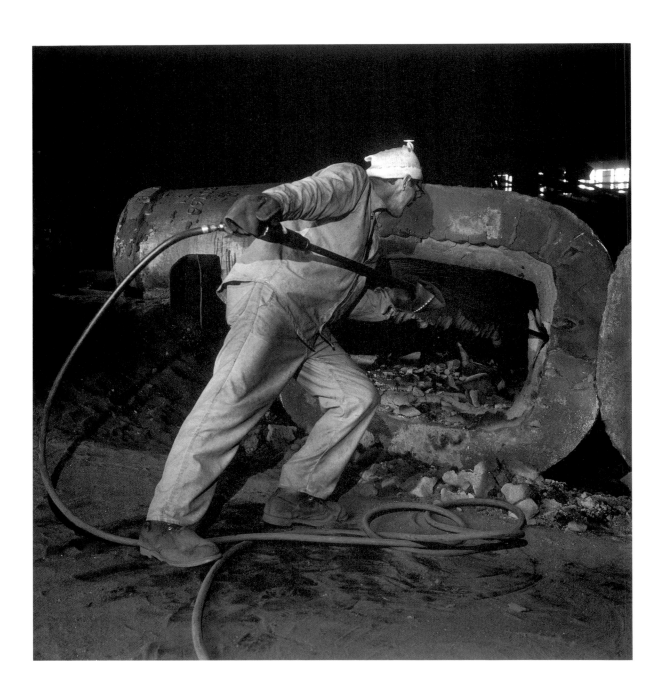

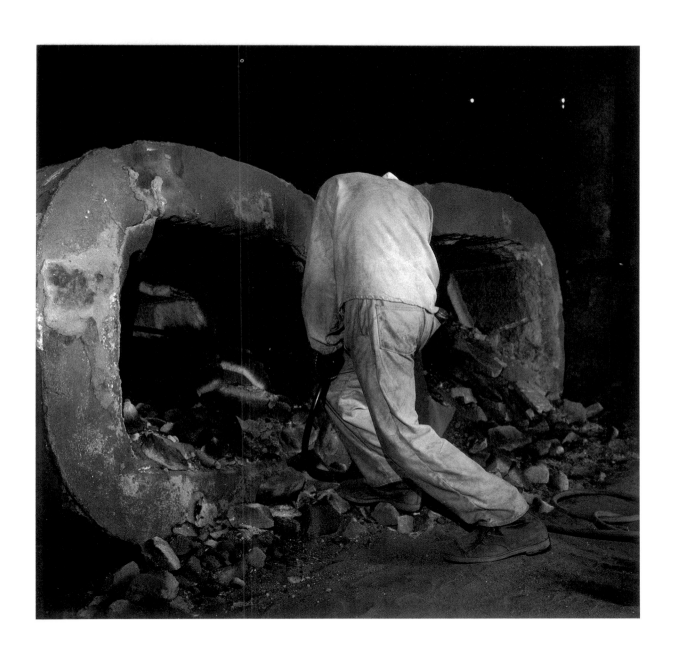

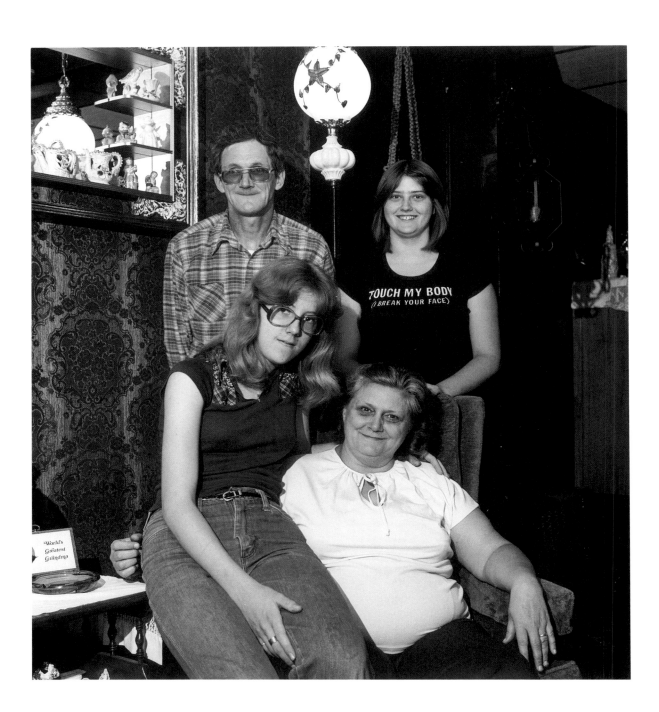

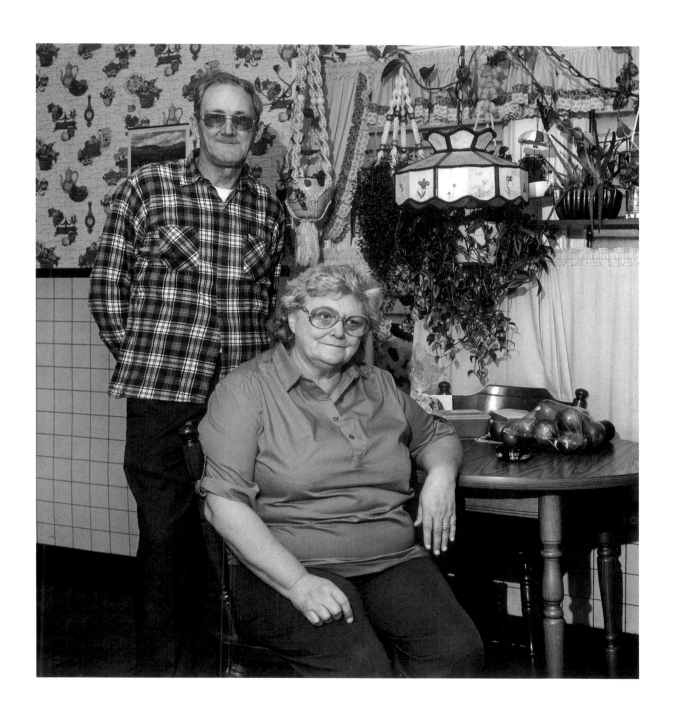

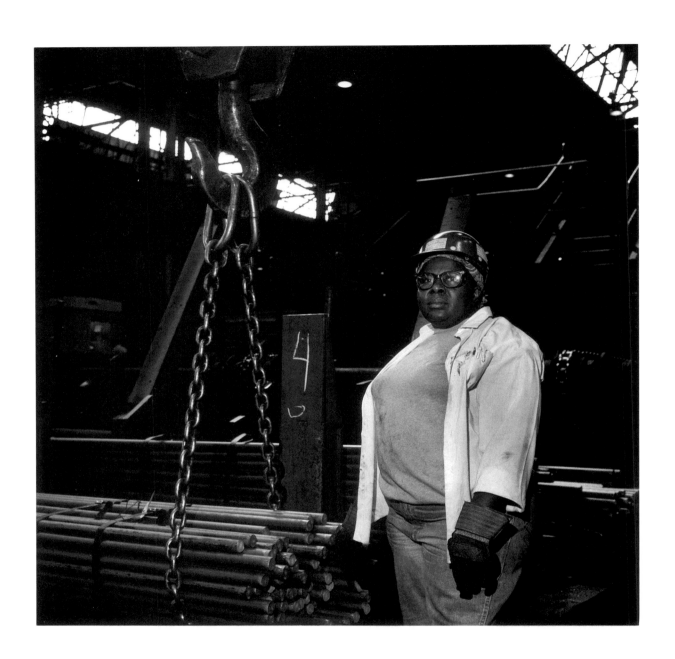

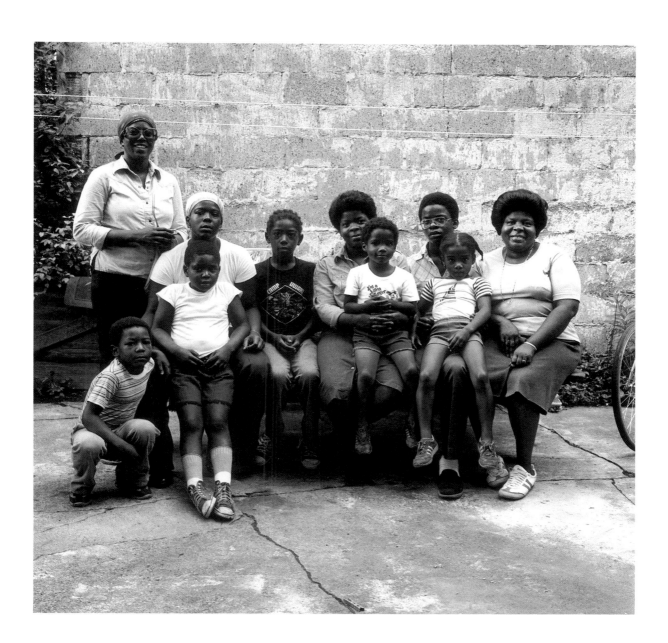

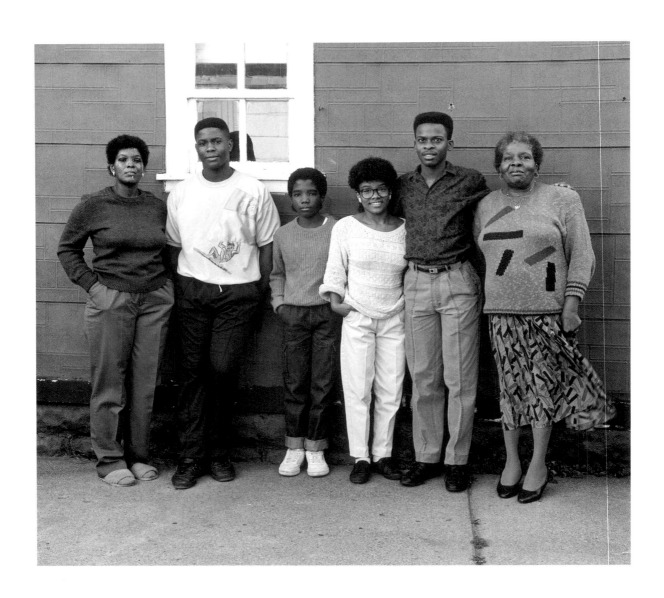

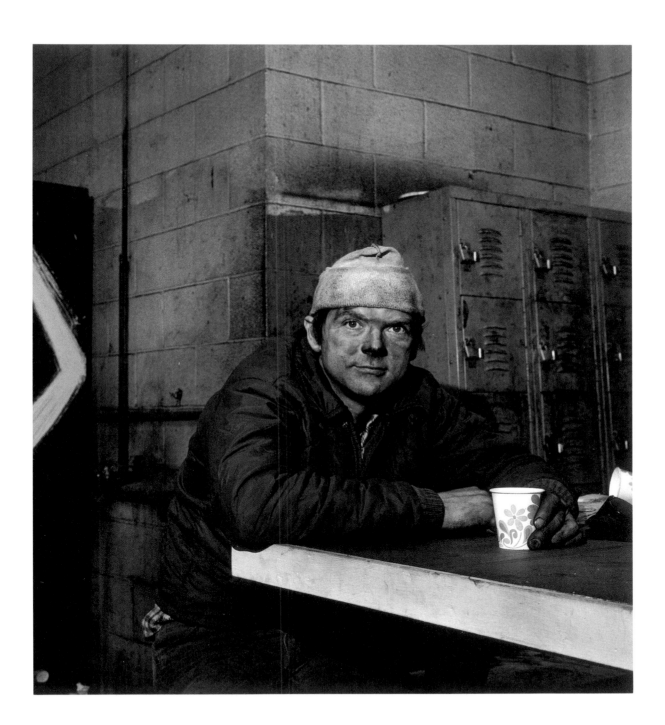

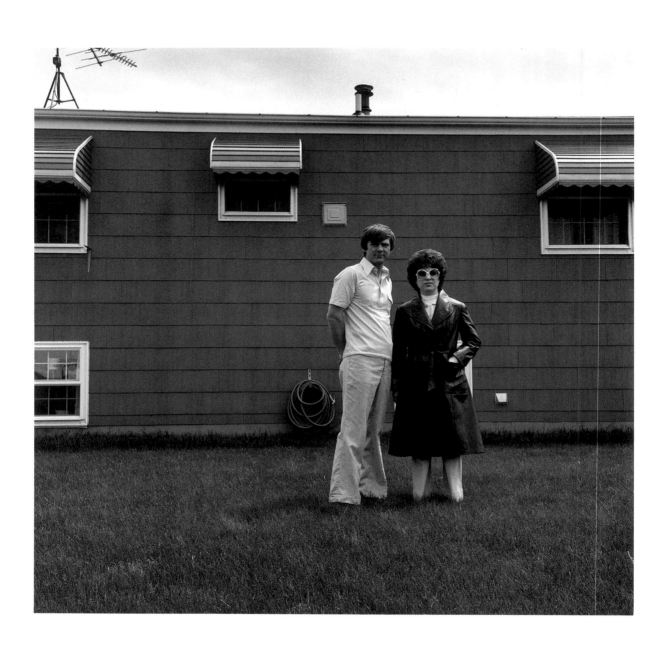

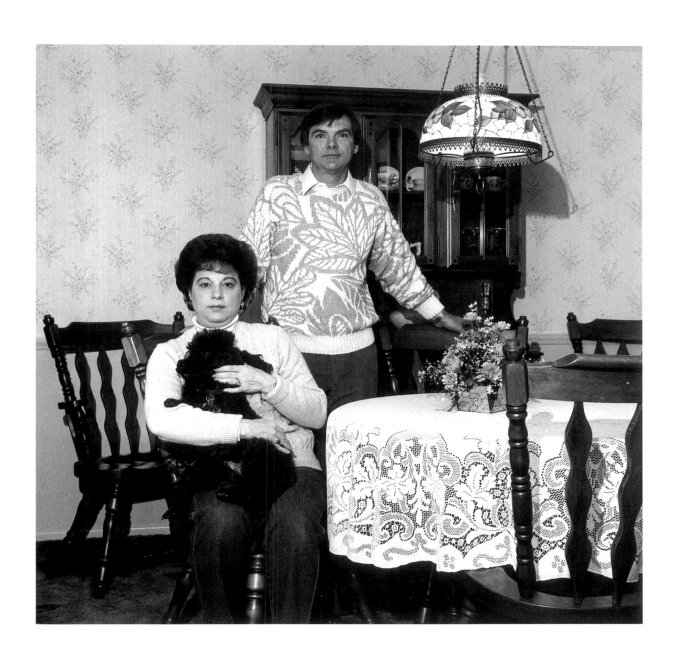

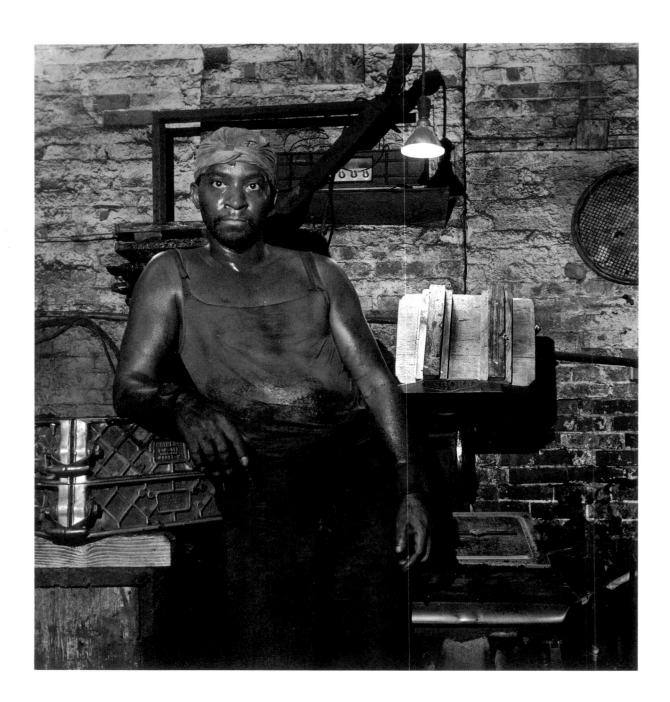

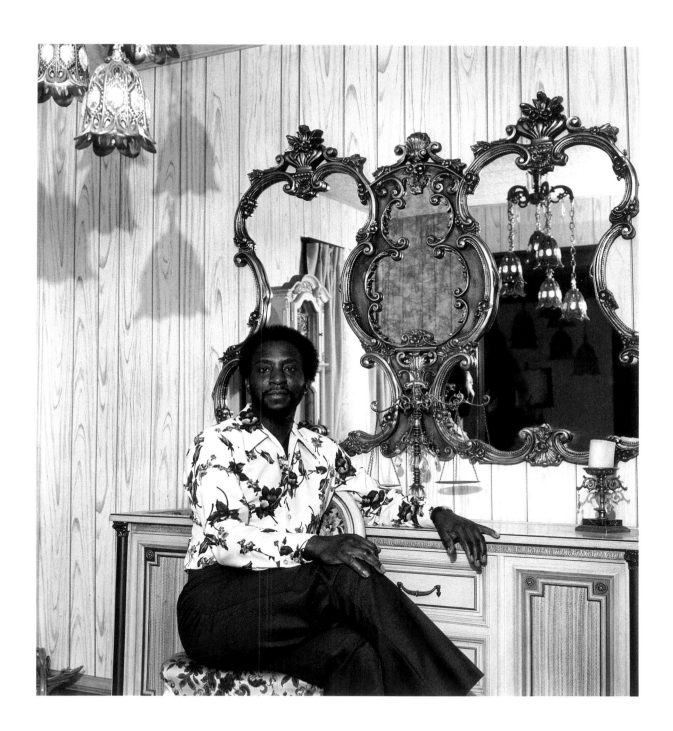

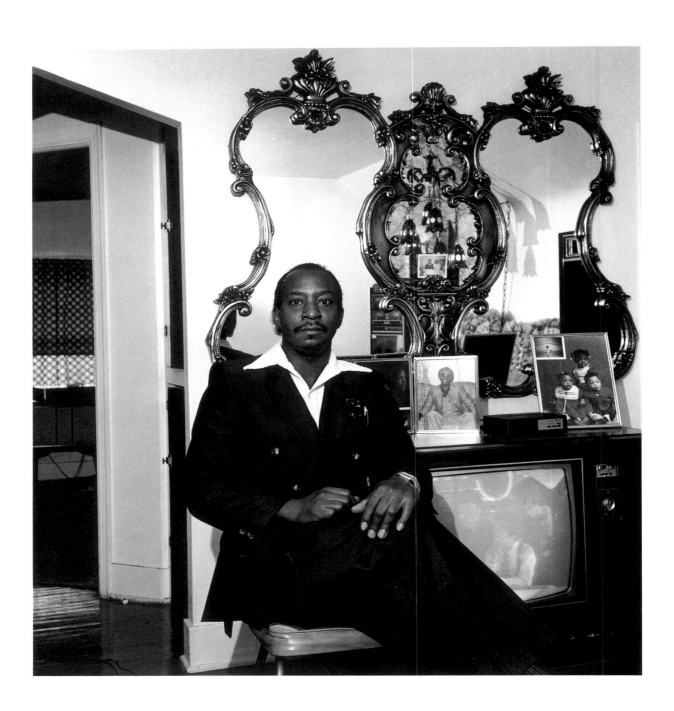

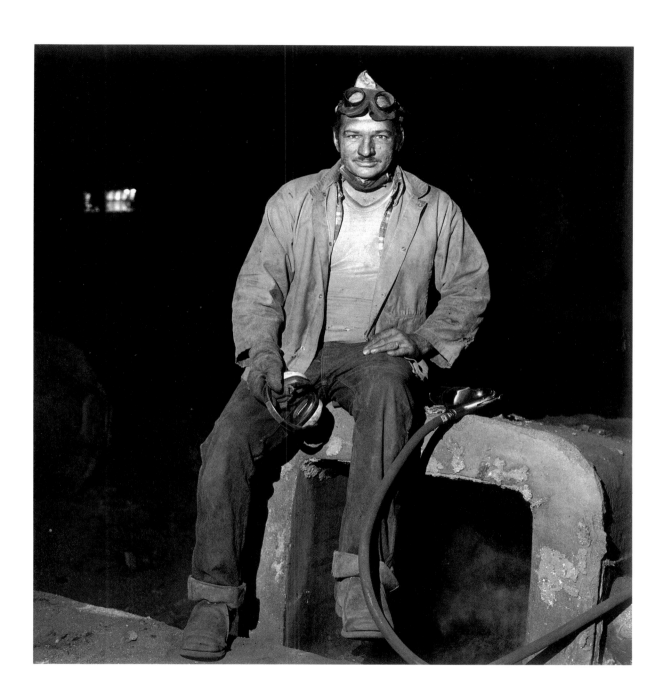

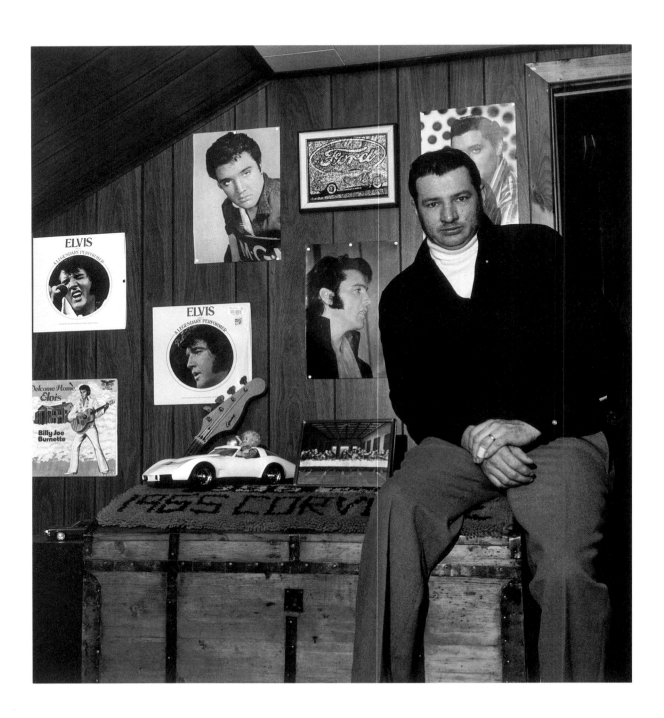

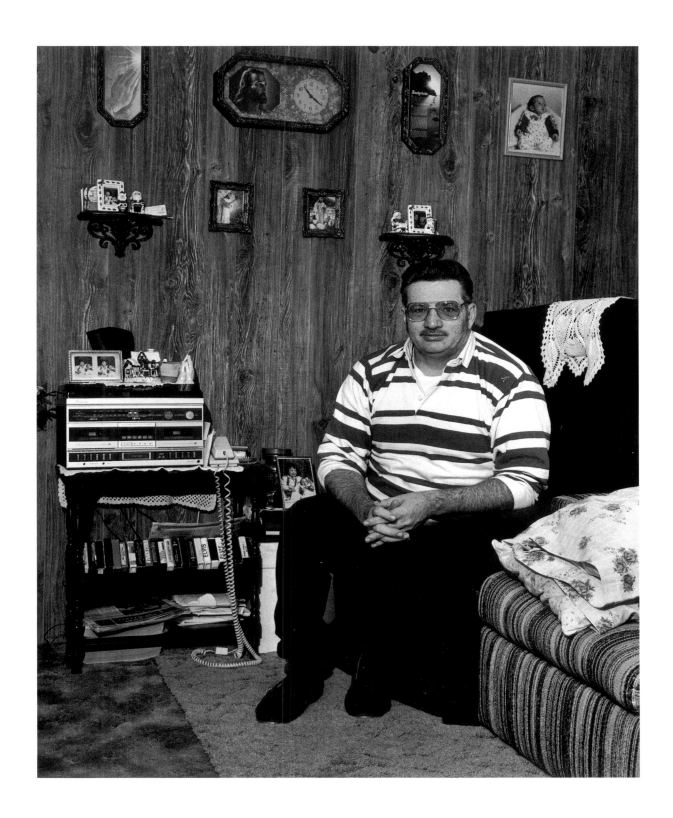

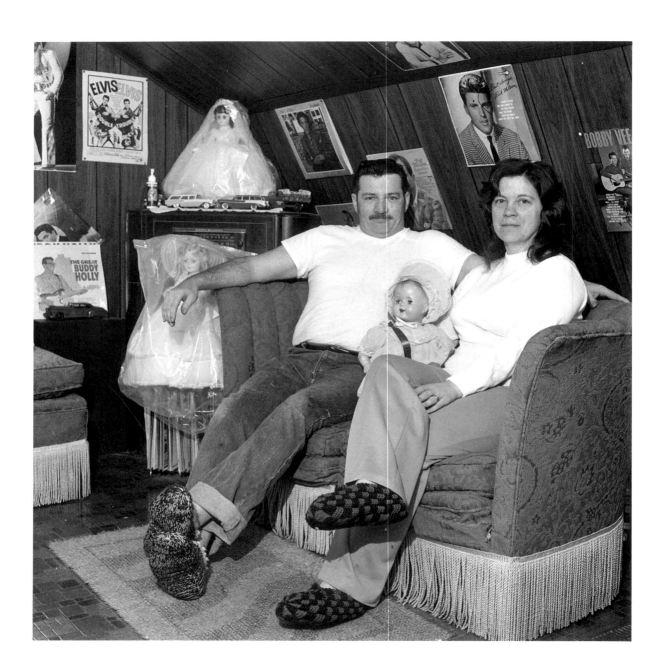

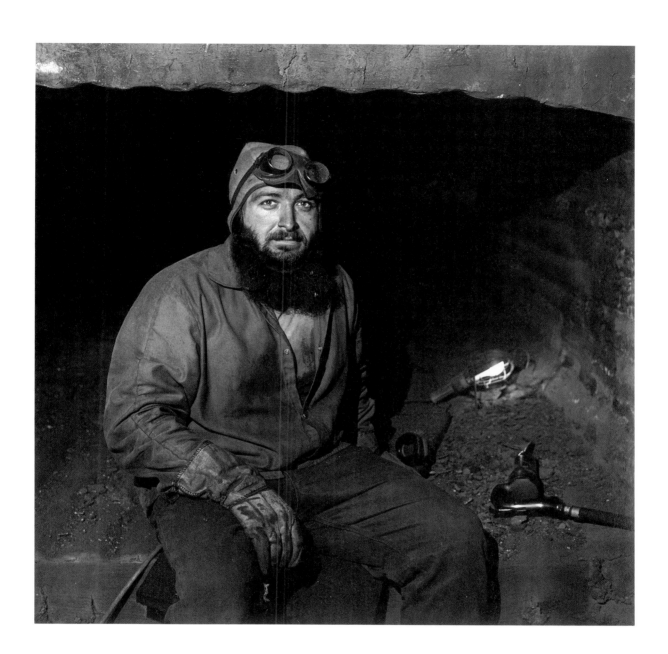

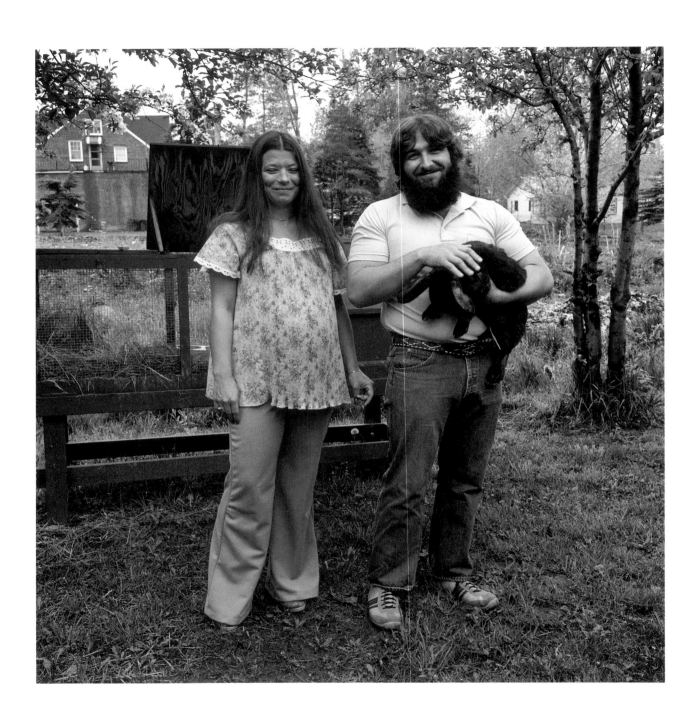

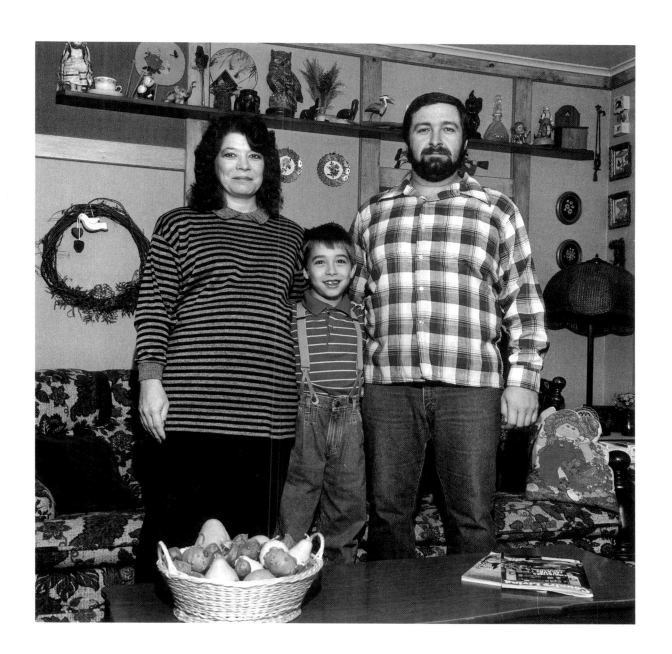

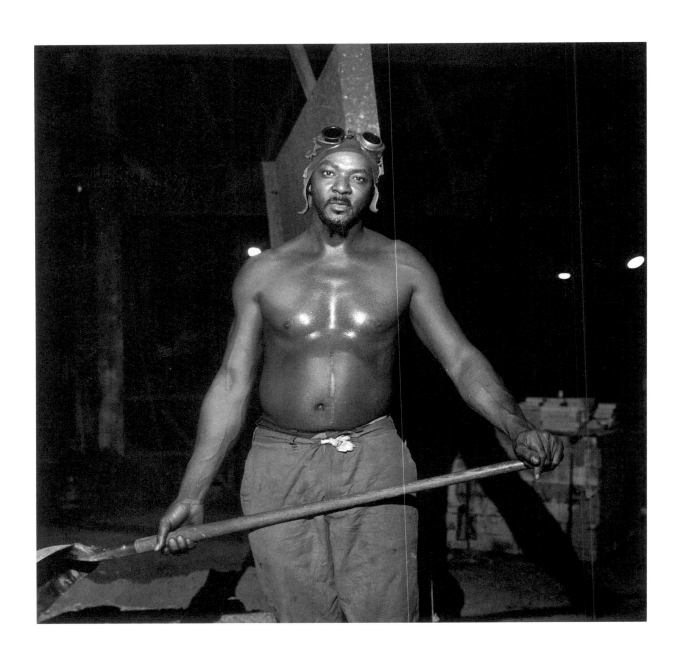

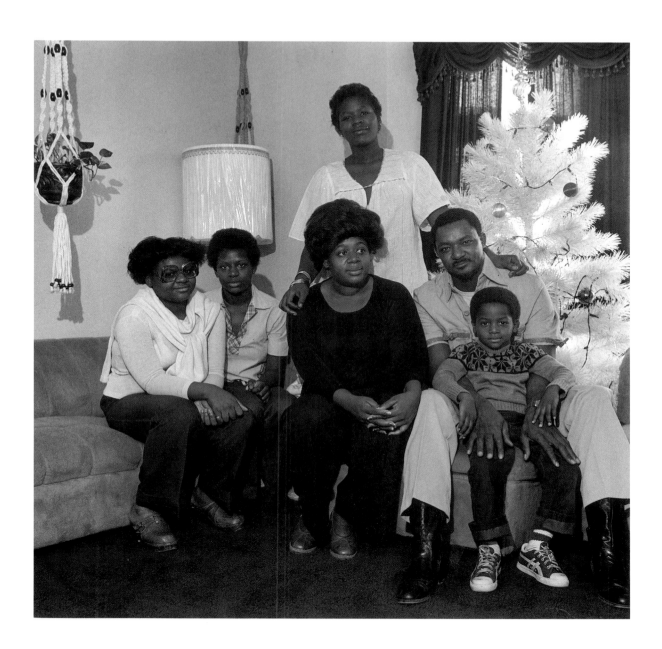

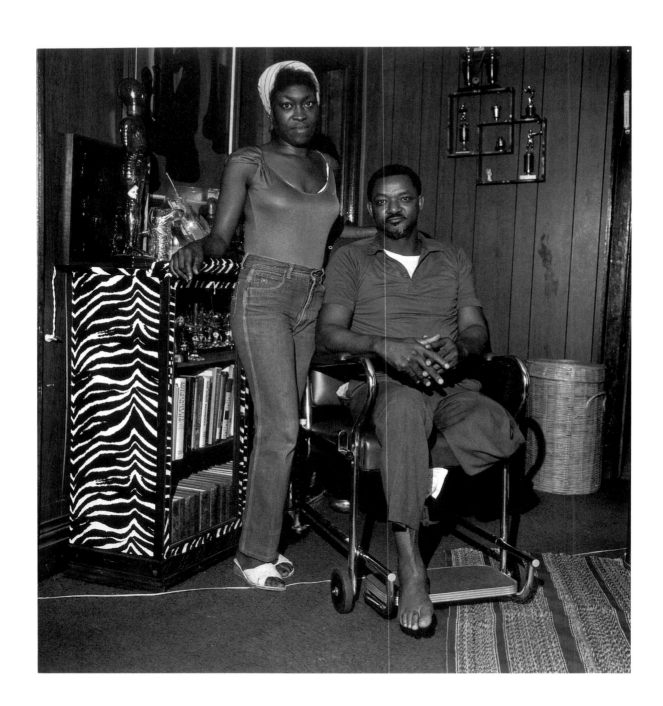

PART ONE

THE CHIP SHOP

1 / BENJAMIN BOOFER

MICHAEL FRISCH: Well, I'm here in Lakeview, New York, on a beautiful sunny day sitting in the cab of a pickup and talking to Benjamin Boofer. We'll start with these two pictures, one of you on break and the other one of you not on break. Tell us a little bit about what your job was and then we'll trace it back and forth.

BENJAMIN BOOFER: OK. My job at Shenango, I was a chipper. They made these ingot molds and they don't come too perfect. The chipper tries to make them perfect by cutting the bumps off of them with a air hammer and a chisel and make them come like they ought to be. That's what we do. It's my job to make it right, except for the welding. I take the bumps off it, and the welder fills in any holes.

MF: Would you work with a variety of different tools?

BB: Chisels and grinders. My chisels are, the biggest one is about two inches wide and it had all different shapes in it. Every chipper might shape his chisels a little different than the other one. How it fit him to work best. Everybody sharped their own chisels. I took care of my own tools. And you know, that's a funny thing, but you would hit days that you couldn't sharp a tool right. You could—you know, you'd know it in your work and you just had to go back and sharp 'em again. You do it everyday, day in and day out, and there'd be days that those chisels . . . [laughs]

MF: How long would it take you to do a mold, let's say like the one we're looking at in this picture?

BB: On the average, two to three of them a day. We work on an average of about fifty ton of iron. Now, maybe I'd get a bad mold one day, and I would get through but maybe one of those molds, and maybe not even one. But, somebody else would get some good ones, and we worked as a group, so you could average out.

MF: And these molds are products that are made for the steel mills?

BB: They are a product made by a foundry for a steel mill. That one in the picture would be our average mold. By the looks of that it's about a twenty-ton mold. We made them up to thirty, we made them down to about eight. They pour the steel in them to make an ingot. All those molds are made like a thimble, they're bigger at the open end than they are at the other. But it will have to be smooth enough so that it'll come out. That's why we work in them, to take the bumps off so they won't stick the ingots when they go to come out.

MF: So, that's not just to make them pretty.

BB: Not to make them pretty. Pretty has nothing to do with it. Really, the thing is the quality they want to get.

MF: Now the chip operation's a pretty big operation in a place like Shenango? Are a lot of guys involved in that?

BB: Well, Shenango was a small place to begin with, like say two hundred men. I suppose we had at least thirty men, between thirty and fifty men out of the two hundred that worked there. So it was about one-fourth for finishing.

MF: And how is it set up? Does a small group of guys do the chipping on one, let's say, or do you do . . . ?

BB: Each guy does his own mold. We work as a group but you work your own piece and you're responsible for the piece to be done right when the inspector inspects it.

They know who does it, it's got a number. [laughs] If the company didn't like our stuff, we wouldn't sell our stuff—Shenango put it that way. So the worker has to have a little pride in his work and do the job right.

MF: And you had some sort of incentive pay system, right?

BB: Yeah, we did, and you worked in a group. Nobody made individual incentive. That's why I say, if I only got one a day, the other guy picked up the difference that day. See, if it was individual, everybody would be fighting over the bad molds and the good molds. They cool them off and set them back there and you'd go back and look at them, you got to pick your own mold out of the pile at that time, unless they need the molds real bad, one particular kind. On an incentive group like that, everybody tries to do their own work, but that's one thing, well, you got to bring these guys down and learn them to chip. If we don't, if a chipper as a group don't want somebody, they usually don't put them in the shop. So this way we worked with the incentive of the group.

MF: So, you could keep them out just by saying . . .

BB: He can't do his work. He can't do his work.

MF: So you're really in charge of your own work, of the whole operation.

BB: Yeah. A good chipper knows more about what should be done than the boss, as far as that goes. The boss got to make sure that he does it, that's all. If he does it right, he don't need no boss.

MF: Looking back at this picture again. You're just sort of starting, would you say? Can you tell from the picture?

BB: Well, some guys did the inside first and some did the outside first. Now I do a good bit of my work on the inside first. I'm on the inside work, you see—. When the outside work is done this bump should not be here. That should be a little more smoother.

MF: He's pointing to that bumpy line at the top of the outside of the mold. And what about all these cracks and stuff here?

BB: They send that to what they call a post mill, it cuts that off. Just like a great big saw. Now, some of them are smooth enough they can send out. But they are mostly wavy. They'd set these molds down on a stool, if this is an inch higher here than this is over here, the mold ain't going to set level. That's the reason they got to plane them, most all of them. They always got a perfect set then.

MF: So you started on the inside of this, and I guess when it's done this little ridge that we're looking at on the inside, that would be gone?

BB: Yeah, that's probably sand sticking. That's what comes out. Most of it comes out pretty easy, and then some you got to get right in there, now, I'm cutting that. That's where she got to be cut with a small chisel.

MF: I saw a picture of this other guy and he had a long thing about twelve feet long.

BB: That's a pokeout bar. It works as a gun, the same as the chisel and it's long and it won't cut iron. Well, it would cut iron but it's too long, you couldn't control it. But it's basically the same thing. Your pokeout comes before the chipping. When they come, this will have sand like all the way around here [pointing to picture] and this is what they get out with the pokeout gun. That's sand. And, there's the iron in there too, we cut the iron out. You take this little bar and knock it out—you're closer to your work. The closer to your work you are, the easier it is to do. Handwork is that way.

MF: So the pokeout is just getting the easy, the big stuff off?

BB: Yeah, [laughs] it's just as hard a work, but it's different—he don't put much time in a mold. In fact, they have one pokeout man poking out for all of us, mostly, for the whole crew.

MF: Your chisels are also connected to an air hammer too or are they hand tools?

BB: They're hand tools. You've got an air hose to it, it's like a jack hammer. You turn it on with the air, but you stick the chisel in it and they can't turn in there. Then you can guide it. You push it. The harder you push it the faster it will cut. You push it down instead of pulling. You use the air hammer to run them, but they don't fasten. We tried some of them fastened to the gun, like they use in body shops, they have a spring that goes around them? But they pinch your hand. And they can get away from you. It didn't work with that kind of chipping.

MF: How heavy is this? The hammer is pretty heavy?

BB: Approximately nine pounds.

MF: Now when you're doing this you're actually cutting iron.

BB: Oh, yeah, basically that's my job, to cut iron. And iron with sand in it. Which is harder yet than iron, it's harder than steel. They both mold together. And then they dull your chisel faster. If it's pure iron, it cuts pretty good; if it's sand in it, it doesn't cut so great.

MF: Let's look at what you're wearing, here. How do we know that's you in the picture, that could be anybody!

BB: [laughs] It could be anybody, yeah. That's what we had to wear. We had to wear earmuffs and this is the thing that keeps the dust. That thing is white when you get it new, but after working in that dust, it turns black.

MF: Do people usually wear them when they were inside a . . .

BB: Yeah, that was the rules and regulations, to wear them. Sometimes I cheated on the dust mask. A chipper knows how long it's going to take him to cut a piece of iron, and maybe you're only going to be there for a minute or two for this particular piece. And then maybe you'd have a place you can go in there for an hour—better have the dust mask on. Of course, I wouldn't cheat on the dust mask when Milton were taking my picture, you know. Because I'd have a tattletale on me. [laughs]

MF: You're getting pretty dirty here, it looks like.

BB: Yeah, really dirty. Because us chippers got so dirty, they gave us a locker to keep our dirty clothes in and one to keep our clean clothes in. So we didn't have to hang them in the dirty locker. You left your work clothes there.

MF: And basically you liked doing this?

BB: Oh, yeah, I kind of liked it. I called myself a good chipper. I think they did, too. I did their patterns, or my share of them. Some guys didn't work on patterns. These are to ram the sand on. They make them out of wood too. But, if you are going to make a lot of molds, got to make them out of cast iron. It was different than the others. It didn't matter about the inside, it was the outside that had to be perfect! That would have to be *really* smooth because the sand went around it and got pulled off. They put that sand on it and if it ain't done right when they pull it apart, it will all fall apart. I liked the fact that I could chip a piece of iron and make it smooth, you know. Anybody can cut a piece of iron, take a chisel and cut a groove in it. But when you cut several grooves in to take a bump out of it, then you've got to flatten all them grooves out so there ain't no bump there no more, and no holes either! So, that's something to do. That's the reason I enjoyed it. They come down and the boss said, Ben, I got this for you to do and I got that to do. That made me happy; I figured, I must be able to do it. I was one of the good chippers.

MF: You did chipping all the time you were here at Shenango?

BB: Well, first I had to labor, as every place you go. I didn't chip before I came to Buffalo, I was a laborer all the time. I worked on the railroad cars. Well, that was basically my job, I did other jobs too, a laborer does everything. Ordinarily the union says, you got to come in as a young man. The only way that you can come in is to start labor. They put the job up for bid, and if you have enough seniority, you get a chance to break in on any job that comes up, which is a fair way, *I* think. And they teach you. I mean, in my mind I thank Shenango because they taught me how to do this job. Besides paying me, they teach me how to do something I didn't know how to do. A lot of people don't think it that way, but I do, I think, well, Shenango is

teaching me something I didn't know, at their expense. Shenango was pretty good that way. If they had a job up and you wanted to go look at how it was done, they would let you go look, they would give you time to go down to see what it looked like. So now I know where this stuff comes from, and I know where it's going on to, and I know what we're doing.

When I was becoming a chipper, it used to be *big* guys done that chipping. I was little—five foot five. At that time I weighed a hundred and thirty-five, that's what I weigh now. They put that job up for bid and all the guys said, "Oh, you'll never make a chipper." They didn't realize that I was a coal miner before [laughs]. I said, "I'm going to give it a try." Well, we had done a little mold, it was about twenty-four inches across. I had it over him, I'd go clear up in the end and turn around and come back out!

MF: So why did they think you had to be big and strong to be a good chipper?

BB: You got to push that hammer. That's one thing, the guy who teached me to chip, he was a very nice guy, and he told me, he said, "You can do this chip in two ways," he says. "You can just push and push hard like all these guys here do, or you can sharp the chisels right!" He said, "You know how to sharp your chisels, you don't have to push that hard." And then he said, "Another thing, don't try to cut more than you can cut. You do it right and," he said, "you ain't going to be aching harder than anybody else, a day's work won't hurt a bit." And he was right. Your learner teaches you how to sharp chisels and of course, you can learn more as you go. That's the first week, that's about all you do, you sharp chisels. He'll dull them and take them to you, you go back and sharpen them.

MF: How often would you have to sharpen a chisel? Once a day, once a week?

BB: Oh no, I sharpen chisels, usually, twice to a mold. You chip awhile and then you'd go back sharpen some chisels up. It would be a good time to have a little break, anyhow.

MF: Now in this other picture, you're on break here?

BB: Yeah, just resting. That there is out in the foundry. This is where our workbench was, where I put my tools in. See my hat laying up there? That was just something

there to set on. And the earmuffs—I threw them down beside me, let my ears rest a little bit. I still got my goggles on. Never went nowhere without my goggles on me. I put them on because if you even walk somewhere you might get something in your eyes in the foundry. I had all this stuff in my eyes. You'd be wearing goggles and they get right in here, you know, that's how it got in there, it's right up through there. You know, that stuff comes off like a bullet almost. And you would get it right in the corner of your eye.

MF: One guy told me he got iron stuff in there and then it starts to rust inside your eye.

BB: Oh yeah, I know! When I left up there, you know, it wasn't hardly a week didn't go by that we didn't see the eye doctor. He said that I have a lot of brown in it. That's from rust.

MF: Were they able to clean that out? You didn't suffer any permanent damage?

BB: No, not that I know of. But I would say about the most dangerous part I thought I had on my job was possibly losing an eye. The breathing, wouldn't have very many going out with that there black lung. It was a dirty work, but I know the coal mines gave you black lung. I have no black lung. There ain't nothing wrong with my lung. I worked in the coal mine and Shenango, both, my entire life. I'll say I either had a good healthy system or it didn't bother me. We had some accidents with the hammer. One of these chisels, like I say, will get away from you. I was chipping on top of a mold, like this one, going this way? Now, there was a guy over here working, he was in a mold same like I am. My chisel got away and hit him right on top of the head. He had two stitches in his head, but I mean, that's about as hard as it could hit him, that's about the most damage that chisel would do, a couple of stitches.

MF: So you didn't think of this as highly dangerous work compared to the other, like pouring.

BB: No, it was nothing like pouring. I worked on the bench one night, that's where they poured the iron, and that was enough of that for me. See, they sent the laborers

up there to fill in jobs and I thought, I'd just as soon never go back up there. I tell them how I felt about a job. The danger is the hot metal flying around. I didn't know much about it and I didn't like it at all. I didn't want no part of that. I had to hand it to them guys, they had a job that I didn't like.

MF: Did you have much contact with management? Did you tend to know them on a first-name basis?

BB: Well, yeah, I did. That thing about management—some management ain't the same as others. When we had the first guy, when I went there, his name was Paul. I called him Paul. Then another guy came and replaced Paul, his name was John. Well, I called him John. But it didn't feel the same when I called him John as it did when I called the other guy Paul. There was a difference. I called everybody by their first names, but, it didn't feel exactly the same.

MF: Were you involved in the union much?

BB: I didn't get involved in the union much. Well, we went out on a wildcat strike once. I was in on that.

MF: About a guy got fired?

BB: Yeah, from the post mill. We went out for that, some of us.

MF: Yeah, I spoke to him, too. And you know, when I asked him that same kind of question, what kind of a plant was it, he said, "Well, I'll tell you that when I was getting fired for something I didn't do, those guys stood up for me and I got my job back."

OK, let's sort of take a running start backwards. We'll get a sense of how you got to Shenango.

BB: I'm from Pennsylvania originally. Near Butler. And I grew up there, and then I became a coal miner there. That's quite a coal mining area, you know, near Pittsburgh. You know, Pittsburgh was one of the coal mining capitals of the world at one

time, just about. This was when coal mining was done more or less by hand. The old-fashioned way. I learned from my dad—my father was a miner all his life. I worked there, in small mines, you know, no big mines. They still got some big mines, deep mines, yet. But I didn't work very deep, just underground. Maybe two or three hundred feet, maybe not even that much, maybe fifty feet in some of them mines. Well, when the strip mines started coming out, I didn't want to work in the strip mines because it was all machinery. I was a hand worker, I hoed my coal by hand. I shoveled it in the car. When I first started, I dug it with a pick!

That was back in '42, then of course, I went off to the service. I was in the Pacific. D-Day in Okinawa, D-Day in Lady Island. I was a gunner in there, with a big gun. Never got a scratch on me. Well, I got one thing out of the war, I was always wanting to go to Hawaii, and I made it there, at their expense.

And then I come back, they had started to modernize the mine, to where they cut the coal underneath like a chain saw cuts wood, and put a big cart and they blasted it down, all you had to do was load it, you know, and take care of your place. That was a lot easier. I worked there and then I started strip mining and one day I wakened up and I think, well, this ain't gonna work, these mines are going to finish out and I ain't gonna have nothing to retire on, because they didn't have no retirement plan. They come in nonunion, some of them, most of them still's nonunion. Ain't going to be *nothing*! So, I said, I have to hunt another job, I'm gonna hunt a job in construction. I didn't find none, and I had a brother-in-law that was working in Shenango. So, I said, Well, I think I'll just go up there and see about a job. I didn't even tell him I was going, I just went up to Shenango [laughs], and went in and they gave me a job that day. This was in '56.

MF: And at that point you're still living in your hometown?

BB: No, I lived in West Sunbury, same place I live now. At that time I had thirty acres, I got twenty-four acres now.

MF: Were you farming it while you were working in there?

BB: Well, I had one cow and a few chickens. Not farming, just piddling around [laughs]. Now, I've got one turkey and one goose. I was there when I first started for

Shenango and I stayed there until I come up here. I drove forty-five miles a day one way to work in Chartsville. You go in to Chartsville, still there, and one in Neville Island, Pittsburgh. Shenango is a Pennsylvania company.

MF: Where does the name come from, do you know?

BB: I think it's a family name. . . . No, Snyder was the family name, it must be. Hmm—you know, I don't know where they got the Shenango, then! Yes, Snyder was the family name, because, when the old man himself died, the founder, we all got a day's pay and no work, when he passed away. That was pretty nice of him. Of the company as a whole. It's pretty much family-owned as far as I know about it.

MF: And were they doing the same of kind of operation there as up here? Were they making molds?

BB: Yeah. Now down there, they had their own furnace plus their own foundry. When I first started working for him, I worked in the furnace. But I still stayed away from that fire. I unloaded railroad cars, and other labor. I enjoyed it more than I did the coal mine. What I liked is there's a few more people for me to know, as I think of it now.

MF: Did you get married down there?

BB: I got married in 1942 before I went to the service—. No, I got married right after I come out of the—no, let me think now a minute. No, I got married in '42, before I went to the service. [laughs] I always have to think sometimes when you go back that far!

MF: And your family, kids?

BB: We raised four children. None of them worked in the foundry. My one son worked in the foundry, at Shenango for the one summer he was going to college. He went to college. Both of my sons tried Shenango and my other son, he worked at Shenango and his health wouldn't hold him. They had to get rid of him. He got the asthma. He couldn't breathe.

MF: Well, that's not a good place for asthma, I wouldn't think. What has he ended up doing?

BB: He ain't. He's got asthma so bad, he's on disability. He's back in Pennsylvania, he's got a trailer on my farm now. They kept him as long as they could. That's one thing about them, they work with you pretty good, you know. *I* think they did, anyhow.

MF: And the other boy?

BB: That is my son who lives in this house here. They got four children. He works at Tops Supermarket up here and he's working his way into the postal department. He wants to get out of the store and get himself something more permanent. He's starting to deliver mail, he's breaking in.

MF: And you had two girls, too.

BB: Two girls. The one's staying with my cousin's mother and the other one got killed in a car wreck. She was 32 when she—. I want to put it this way: we raised her through her life, you know. We really completely raised her, if she was 32 when—. And we raised a foster daughter from the time she was a year and a half until she was sixteen. She's just about like one of our own, too. She's in Florida now.

MF: How did you come up to Buffalo? What was that all about?

BB: Well, see, Shenango built this plant up here in Buffalo. They could bring so many people but they had to hire so many people. So I was a laborer down there, I never made it out of the labor department. They didn't need laborers up here, I mean, they were getting them out of the people they had to hire. So they had to bring in people that knew how to chip because they needed chippers bad. But, I didn't know how to chip so I didn't qualify for that. So, it took me two years to get up here. Finally they got an opening up here and brought me up. I got off laboring as soon as the big job come in the chipping shop, I grabbed it.

MF: Down there, had they been slowing down or did you just figure there was going to be better money up here or what?

BB: Well, the money would be the same, basically. The thing was, the plant I worked at in Chartsville, Pennsylvania, they weren't doing nothing. Because, our biggest order was in Canada. Before they were making it in Buffalo, they were shipping it from down there in that plant. Well, then they made it up here and they didn't have to ship it that far. For a long time after they opened this plant there was only enough work for two plants, Buffalo and Neville Island. Chartsville didn't do nothing. Well, then things got to booming pretty good, then all three plants'd be going like crazy, then things fell apart completely one day.

MF: You came on up here around what year?

BB: Around '63, could have been '64.

MF: Was that a big change for you? I mean, you're a country boy who's been from a small town and you spent most of your life in Pennsylvania, though you've been overseas. What was it like coming to Buffalo?

BB: Driving was crazy for me. The city was like something—they'd never seen the lights till they come up here, some of the guys I worked with. Well, I fit in pretty good, I guess. I got to liking Buffalo. I'd rather live up here myself than down home. I moved right here, where we are now. I roomed awhile in town. Not too long, until I found a house.

MF: And were you looking for a place out here in the country? This must have been pretty. It's still pretty country.

BB: Yeah, my wife, she definitely said she don't want in the city. You have an expression, if she wanted to call me a name she didn't want everybody to hear [laughs]. So I come up and she stayed down there with the kids and one day I was off I looked for houses. I told her, "I'm gonna find you four houses that I can buy, that might suit you," and I said, "You are going to have to pick one of them." So I brought her, looked at all four of them, and this is the one she decided on. This is where I stayed. It's eleven miles from here to work. She liked this place and I liked it, it's a nice place. And another thing, we wanted to stay on this side of Buffalo because we knew we would be going back and forth to Butler a good bit, where it would be ten miles closer on this side, instead of ten miles further on the other.

MF: And that second picture Milton took, that's here?

BB: That was taken here. At that point we were still working good. I had that car, Shenango was going good. When Milton took them pictures, Shenango was doing real well. Everybody seemed to be happy with their job. Shenango was a good place to work.

MF: Well, let's talk now about when things started to go bad. Did people see that coming? Did you see it coming?

BB: Quite late it come when I seen it. They didn't think it would come as quick as it did.

MF: What was the main problem, do you think, that caused that plant to go under?

BB: I'd have to figure that out. Well, continuous cast hurt us a lot, I think, make the iron now without using the ingot mold. That's just my opinion. Yeah, we weren't any happier with the continuous cast then I was with the strip mines [laughs]. We could see that it was going to take our work, or some of our work. If you want to make good iron, you got to have ingot molds and make ingots. But they're getting by with iron that ain't near as good, and I guess it's doing the job so they recommend these continuous casters, which they have improved a lot on them, too.

MF: Why does it make a difference to have the ingot molds? Does that make for a better steel?

BB: They can control the mixture of it, I guess, better. I worked in the furnace down the other plant, and if they had a cast of iron coming out, they tested that iron. They run it down a runner, see, into these here transfer molds, and if they weren't right they threw other pig iron in them runners of a different quality, analysis, to make it what they want. They'd send some of us guys over there and say, "Throw so many of these in as that runs through." You stood up high, and you'd drop them in. They weighed about eighty pounds. They'd melt and mix right in with it. Just like putting some hot water in some cold water, it's all mixed together. It's basically the same thing. I don't know if they can do that in the continuous cast, if they can control it like that or not.

MF: And other signs—was business starting to go down, were they losing orders, could you tell things were slowing down?

BB: Well, it slowed down awful quick, you know. It just seemed like one day there was no more overtime. Then, about two years, there wasn't no more work. It seemed to me like it took about two years. Some of the guys came back, very little. Then you'd see a bunch laid off, and then two years later, I wouldn't say exact, but the place was done. We were still hoping that it wouldn't happen.

MF: When the plant went down here, did you count your seniority from down there or how did that work?

BB: Well, there's a little bit that I can't understand about that. When I came up here, I brought my seniority with me except for vacations and retirement. Now, for bidding I was a young man compared to the guys that were from up here. In other words, I had nine years down there but somebody up here could have just started and only had one year, it's usually one year for a bid, he'd have more seniority in Buffalo than I did. If a job came up, he would get it ahead of me. But when it came to kicking us out, that's the way I put it, kicking us out, that's no fault to the company, that's just the way I put it, he went out before me.

MF: When it finally closed down for good, you had twenty-five, twenty-six years then. Does that mean you're pretty well guaranteed a pension from that?

BB: Yeah, I get five fifty a month. See, when they first closed down I was only fifty-eight years old, fifty-nine, somewhere around there. So I couldn't get no Social Security. The missus couldn't get no Social Security. So all I got was what I got from Shenango. Out of my five fifty I only get four hundred dollars because there's this to take out and that to take out, you understand. Plus they gave me four hundred dollars up front instead of Social Security, until I got Social Security. So I got approximately eight hundred dollars a month.

MF: And Social Security kicked in when you were sixty-two.

BB: So I had three years till that. It was pretty hard going. I had to go into my savings really heavy, eat the savings up, you might say. At my age it was hard to find a

job, so I just went cutting wood. I started cutting firewood down in P.A. before I finished up here, I hauled it up here and sold it, then I went back down. My blood pressure got on the borderline for a little while and they told me that was causing that, but that went back to normal. I could see the light at the end of the tunnel. See, I'm a good bit older than like most of these guys down here. I'll be on Social Security a long time before they get that far. But they did have a little bit better break than me in one way, because people would hire them. I tried, I tried a little bit. With the government agencies. I made three trips to Buffalo, and I got to figuring my gasoline out, I was losing too much money. If they call me in there and send me out on the job interview in a day, it would have only cost me like ten or twelve dollars in gas. I kept doing them and I said, "Well, I ain't getting nowhere." They sent other guys out younger than me, of course, they have a right to, you know, I said, "I'm going to have to get away from them and go on my own somewhere." So, I went out into the bean place.

MF: Tell me about that, what were you doing there?

BB: Well, it's a cannery, Bison, they can green beans, right near here, and the beans are grown here. They can all kinds of beans, but I only worked on green beans. That's seasonal work, but that's enough for me. When I first went out there, I was in pretty good health. I'm still in pretty good health. So I dumped beans, for eight hours I could dump the beans but they worked ten or twelve hours. It bothered my back a little bit. I just was out this morning and got my job, we start about the eleventh of July. Like I say, that catches you up on your back bills and will give you little bit more money.

MF: And the firewood, you're still doing that?

BB: Yeah, I still cut firewood. Not very much, enough to make me a living. I cut it, and split it, and sell it. Now I sell it on a contract, I don't deliver to people. I wanted to get away from that. I got a guy come in and he buys all my wood.

MF: This is on your own land in Pennsylvania?

BB: I haul it into my own land, but I cut it from wherever I can buy it.

MF: And you buy what, whole trees?

BB: No, mostly tops. You can't afford to buy trees and cut them into firewood. They took the big part of the tree and left the tops, all the limbs and stuff, and I used to cut them off. I get them right in the woods. I get the hardwood. Hardwood has more limbs. In other words, when they get done with a pine tree, there probably ain't too much left, they are easier than hardwood, they don't grow crooked. When they are crooked, they aren't no good for logs. Maybe they'll cut a tree, a nice big tree down and go up fifteen or twenty feet, they start getting crooked. But they're maybe that big around yet. So I cut that all up. I'll buy it outright off of them. Then I got to keep it all summer, and I split it in the fall.

MF: Well, there's been real big changes in these last few years and you can look back over your life and you had certain opportunities at different times. Now the world's changing pretty—

BB: Pretty much faster than it was back in my time, it seems.

MF: I guess. You know, it's one thing to watch your own plant close down, you could say, well, it's the continuous cast, but then you look around and you see Bethlehem's going and Republic's going and all across the country these things are going. How do you make sense of that? Why is all this happening? What do you think these changes all mean for some of your kids or grandkids growing up today? Do you think there's less opportunity for kids than there was when your kids were growing up?

BB: Well, I don't know. I'm sure glad I raised my children when I raised them instead of having to raise them today. It seems to me like it's harder. I guess there's good opportunity if you can get a good education. But it looks a little bit to me that everybody is going to have to be smart and then the ones that get it are going to be lucky. But most of them—they ain't going to get the money we used to get. There's lots of work, you know, but who can live on five dollars an hour? You can't pay your rent.

MF: So how are people doing it?

BB: Well, they're trying. But from the news, it seems that a lot of them ain't getting it done. You've got so many people on welfare—we're better off just not to work and get welfare, you get more money. Because if you're working for five dollars an hour and somebody gets sick, you got to pay the doctor bill. But if you're on welfare and getting the equivalent of five dollars an hour, and if somebody gets sick, *they* pay the bill. We need some changes there. But the younger people, it seems to me like some of them think the world owes them a living. I shouldn't say that maybe, but that's the way I feel. The world don't owe us a living. A world should put a place there for us to make a living and we should go out and get it. I think that's important, that you got to go out there and do your share if you want a living. That's what I believe on.

MF: When you talk to folks that you know, are people optimistic or do they really think we're headed for more trouble?

BB: I don't talk to very many, I'm kind of a loner. I do go to the V.F.W. a couple of nights a week but don't talk that much. I don't even stay very long.

MF: Well, there's two ways you could look at all these factories closing. One is to say, you know, it's just like a phase, society is growing up like a kid grows up, we did steel industries and coal mines at one period and now we're going to something else. The other is to say that somehow things have gone wrong. Something's gone off the track and there have been some mistakes. If you had to say which of those two—.

BB: I would say neither one of the two, I think there is a little bit of them both.

MF: Yeah, but which part is one and which part is the other?

BB: Well, there's going to have to be change. I mean, like I dug coal with a pick at the beginning and then after a while we had a machine that done it halfway, now they do it all with a machine practically. It got to be changed. It has to always be changed.

MF: Right. But it's that same problem: is the change dragging us or can we do any steering?

BB: Well, I think we import too much. I don't begrudge them people a job, do you understand me? Them people there, they're worse off than I am, basically, and the

stuff we buy makes them a job. But I'm just talking about us Americans now. If we had less import we'd have more work for our people. Sure, if I was a company and I could be buying stuff and selling it, why wouldn't I buy it someplace where somebody is going to work for half of what the people here work for? It makes sense for the company—but it doesn't make sense for the American. Pay those people more for the stuff that they ship in, then maybe it will work out better and we will start making some of our own.

MF: Where do you spend most of your time now, in Pennsylvania?

BB: Oh, yeah. I stay right around the farm now, except for when I'm up here to work at the cannery. I'm back where I intended to go anyhow when I retired, back to P.A. That was our plan, that's the reason I never sold my little old beat-up farm. I figure I didn't do too bad for an old dummy.

MF: Well, I don't think so dumb. But how old are you now?

BB: I'm sixty-four.

MF: And then did you sell this place here to your son?

BB: Yeah. See, when I sold my son my house I had this job in the cannery, and I told him, I wanted a room until I finished that job, so I come up and can beans, I have a place to stay. I get four twenty-five out there, that's pretty good for a little job like that. I'm not faulting the man, you know, I thank him for the job, in my mind. If it wasn't there, I wouldn't have nothing. But if I was coming up here and paying rent, like the average guy, I might as well stay down in Pennsylvania.

MF: And then your son lets you come up here and . . .

BB: I hold the mortgage, he better let me come [laughs]. This trailer here in front is mine, the other one's him. I'm taking it out and going to Arizona on the seventeenth. With this truck. Last year I went in a motor home. You see, that's what I do with my money I make over at the cannery. These are the things that you could get along without, but I'm able to work. Why not work, and have a little fun with the money!

That's what I told my wife. She says, "You don't need to work." I said, "I know I don't need to work," but I said, "I couldn't go on vacations if I didn't work." I said, "If I get all my work done, I have no reason to live. I could set here in the house and look out the window," I said, "but I like to work."

Now I'll probably give the wood up, it's a lot of headaches. But I think I'll stick to this canning job for a long time. It's an easy job, it's steady. I don't bean now—he put me on sweeping floors. He said, "That's a good job, I know you work," he said, "I don't have to worry about you and it's good for me and you both. You do your work and we ain't going to say nothing to you, and you get the same pay anyhow."

But you know, there's a job I really wanted there, I keep bugging him for it. And last year, when we finished up, he said, "Benny, are you coming back?" I said, "Well, maybe, if you let me rake the beans out like I've been wanting to do." You rake the beans out of the bins and put them on the grill. "Well," he said, "Benny," he said, "I suppose I could, but you've got a better job," he said, "You've got that sweeping job, you do it good and nobody bothers you." After we talked, I said, "Well, you convinced me that I got the best job here, I'll just stay on the job sweeping the floor [laughs], I get the same pay anyhow." But see, he knows me, if a belt breaks or something I still go out there and work at it, clean up the mess. I could go anyplace. If the beans start running off, I get the shovel and get them gathered up so somebody don't tramp them all. I sweep floors, but anyplace they need me, if I'm there, I go.

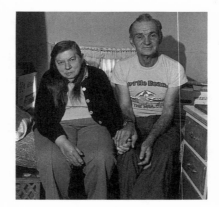

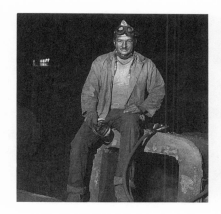 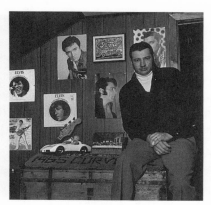

2 / DICK HUGHES

MICHAEL FRISCH: Well, we can start with the work you were doing, or—

DICK HUGHES: Well, I could say the last four years since being out at Shenango, the most I made, for money, was about $4,000 a year, just working minimum wage jobs, security jobs, nobody wants you, you know, just can't find a job. Other jobs would pop up, being with the economy so bad as far as mechanics' jobs, they just want to pay you minimum wage. Carpenter's job, I think I worked for what, five bucks an hour, they just want to work you to death, work you six days a week and ten hours a day, and pay you forty hours no matter what you did. And knowing that you're hurting, and that they can take advantage of this, you don't have no choice, you just have to either work the way they want you to, or take a walk—they pick somebody else up that's in the same boat. That's about it.

MF: Well, tell you what, I'd be interested in first getting a sense of what you were doing before, and then we can talk about what's happened since. So, let me just start by asking if you could talk about the picture Milton took of you on the job, and tell me what you were doing—what's going on, what kind of work you did at Shenango.

DH: OK. What Shenango consisted of, we were making ingot molds for the steel mills. What an ingot mold was, was to hold the steel until it cooled, and they would re-use the ingot mold and keep just getting castings out of it.

MF: And exactly what part of the process is that picture getting, you're just sitting on a . . .

DH: Oh, that's the finished product, that's the product before it goes into the railroad car to the customer. What we did here, what my job was, was to chip out the excess iron in there, grind it, smooth it, clean all the excess sand off, and it went to one other guy, and he painted it, and into the railroad car.

MF: And then it goes to the steel mill?

DH: Right. Because when the blast furnace was going, you have to have someplace to put the steel, so that's what the purpose of the ingot mold was. So what they would do is pour the ingot mold, wait for it to cool a little bit, then you put it in a tank, bump it out, and then that block of steel would just sit in the yard and they'd just go back, get another one, pour it, and—and all that steel would sit, and when they wanted to bring it into the rolling mills, they would bring it in, heat it, they would get the blast heat and get it real soft, and they'd start sectioning it off, they would chop it, and that piece would just keep rolling down to the size they'd want, whatever tubing they wanted to make, or sheet metal, whatever they wanted.

MF: What other kinds of specialties did your place have, so someone looking at the picture would have some sense of what goes on?

DH: Well, actually there's three main departments. There's also the casting department, which casts the molds that you see in the picture, and the stage before that is the ram department, where they ram the sand, to make the mold, that goes in the oven. They put the sand in, ram it, finish it with a blackening, which was wet, which would dry to a hard finished product.

The thing what happened was, the continuous cast came in to the steel mills, you know, trying to keep the steel flowing, keep it going, and stamping everything out the way they wanted it. So they didn't need no ingot molds, so they wouldn't have to go around buying ingot molds, so that became an expensive operation, and that's what knocked us out of business.

MF: The plants here didn't completely go over to continuous casting, did they? I mean, they still use the—.

DH: They still use ingot molds, yeah. Continuous cast you got to have temperature going exact all the time, temperature in the whole place got to be exact to keep it going. Now they're finding out that it's pretty expensive, in fact. We heard of continuous cast and everything, but we figured, well, that'll just be for small products. We figured for big products there's no way that they'd be able to heat these buildings at an exact temperature, it wouldn't be feasible. The mold business would stay in business forever, all we would lose is the small products.

I mean, the steel mills would be OK if they weren't getting the flood of the foreign steel. About four or five years, just before they closed, like we were selling molds to Canada, too, and they were getting molds from England and they were trying to make a comparison, you know, how the mold would stand up under the castings of the steel being poured in them. And the English molds were only getting like about ten castings, where our molds, they would get about a hundred and five, hundred and ten. And then the guys started talking about, well, jeez, you know, if they're trying to make molds to be competitive with ours but they were only getting about ten heats out of them, we'd say, well, there's nothing to be concerned about.

MF: How come there was such a difference in quality? Was it the nature of the materials, or the skill, or what?

DH: What it was, was the temperature and the amount of iron and steel that you mix in to make the iron. What they were doing was making a softer ingot mold, they were just burning the heck out of the mold, they were just cracking them, they just wanted to get the heat out of them. Where our molds, you know, it was more like a secret, you get the exact part in the lab, how much steel, how much iron mixed into it, and what the heat should be at.

MF: Is that something you can tell on the floor, when you're chipping on one of these things?

DH: Oh, yeah. Hey, if there's too much steel in it, it just breaks your chisel. It just comes to a halt and just sits there and vibrates—it don't move, it's like a diamond. What it is, is it's too hard, there's no give in the mold. So when they get a casting out of it in the steel mill, the chances are it'll break open, it may kill somebody—you'll just pour it, and if some guy's there in the steel mill, chances are that mold'll open up and crack, and the steel'll come flying out.

MF: How long did you work there?

DH: Ohhhhh—eighteen years. Eighteen years and I didn't get nothing.

MF: Yeah, I want to talk about that. But first, the eighteen years—was this the kind of shop that tended to have a really stable workforce, that people had been there ten, fifteen years, twenty years?

DH: Yeah. A lot of guys came up from Pennsylvania, and they had, oh, anywhere between ten and twenty years. You know, they told us because we're from up here in New York, they'd say, well, if you get ten years, you got it knocked, nothing will happen to you, just ride it right out, and retire and have a good pension. Which it didn't turn out that way.

MF: Was it pretty steady during most of those eighteen years?

DH: Well, I was never laid off. Never laid off. They were working six, seven days a week, a good business. As long as they're making cars and, you know, pouring steel, there's no problem, you just keep making molds. It falls right back to the automobile. They made the steel and supplied the automobile places, they'd stamp them out and everything, so it all leads right back to that, the car. But it's the foreign competition.

MF: But during those years you liked your job, you felt pretty good about being a steelworker?

DH: Yeah, I enjoyed the company and the work. You feel a part of the company, you know. Some guys would take time off, didn't care, but the guys that were serious— you feel it's a part of your life, it's a part of your body, you're dedicated to the plant. Me, I only missed six days in eighteen years there. Like I say, you couldn't go in there all the time happy, because you're working in the steel mill foundry and it's dirty and filthy and hot and freezing during the winter. But I went there every day for eighteen years, except for the six days I missed.

MF: Had there been labor trouble there, any strikes?

DH: Yeah, we had one wildcat strike, it only lasted a little while, couple of days, but the company was really disturbed over it. I think that was in '75, '76. They were

trying to fire a couple of guys, and—they just wanted to have control, the company. And the union just wanted to be in control of the company, the union wanted to do what they wanted to do. The guy down in Pennsylvania was disturbed over it, they were going to put the electric furnaces in up here, make their own steel, so when they went on that wildcat strike, he was so teed off, he said he'll do everything in his power to close that Buffalo plant.

MF: So the union was strong in your plant?

DH: Well, it was. It was too strong, yeah, that's what put us out of business.

MF: Really, how so?

DH: Oh, they just wanted too much, you know, pushing too much, they didn'twant to bend, they didn't want to give up nothing, they didn't believe in no changes. It was a case of playing it the rough guy, you know—your father did it, he gave up a lot, and he had to buckle down in Pennsylvania and Ohio, and he went through the hard times, and they made the unions, and you know, we don't want to hear no sad stories from the company, they're just pulling our leg, and, you know, why give up what your father struggled for, you just keep going forward, keep pushing, get everything you can. The unions, they didn't want to really sit down and hear the story. Company says, hey, foreign import's killing us, we're going in the red, we need concessions, breaks, we got to be competitive. There was no trust.

MF: Was that a real division, these guys who'd come through the struggles of the thirties, forties, had one way of looking at things?

DH: Yeah. They'd remember how, when they'd started the unions, they'd get beat up by the cops. The older guys down there really went through heck, you'd hear the stories about getting hit in the head with billy clubs by the local police and everything, when they were starting off. You worked down there, there was no union, and you walked out the door sick, and that was your job, too, they had fifteen guys waiting. So the union was the right thing, it was the right thing. The union would protect you and keep your seniority, otherwise the plant wouldn't have to pay you no benefits, no retirement, you know, kick you around. But then the union got too

powerful, they didn't know when to stop. I mean, I'm still a union man. I think union is right in a lot of points. You know, you have certain protection plans, through the union—that's where the union should draw their line, not try to operate the company. I mean, if the company says, you want to take a cut in pay, then come up front and say, give us good cause, show us your books, show us something.

But the union didn't do that—the union just showed strength all the way to the end, and they just died with it. You just get the attitude, you don't give up nothing and you don't want to listen to the company's side. Which was bad, because they were hurting. They wanted them to take a cut in their incentive and everything—not hourly pay, but just the incentive, it was more like bonus money. We were out of work for so long, I think there was thirty guys working in the plant, and we were out in the street, see, so when us younger guys said, "Well, let's hold a special meeting"—you know, we were still talking to the company, I was talking to this guy, he said, "Jeez, we'd like to have you guys all back to work, this plant up here would be the number-two plant if the guys would take a cut in pay, in incentive, and why don't you guys vote on it." We went back to the union, said, we'll hold a special union meeting, we want to vote on this and get back to work. So we went up to the union hall, told them what we wanted, to get back to work, and the thirty older guys that were working say, "Well, you guys ain't allowed to vote!"

MF: Why was that?

DH: You have to work five consecutive weeks in a year. They said, you guys don't have no say in it. They said [abruptly]: "We're not giving up nothing. You guys don't have no word in it." So now everybody's out, the union's all done away with. And we seen some of the union guys [mocking, dreamily], "Oh, I thought the company was bulling, huh, well, that's the way it is." Instead of saying they were wrong—"Well, that's the way it is."

MF: Was this just your local, or was it pretty much the Shenango local down in Pennsylvania too?

DH: No, just the local here. The union down in Pennsylvania, I think they more or less understood, they seen the writing on the wall. The company more or less told them first, "Look, we're going to shut this plant down if you guys don't take a cut."

Well, so what if they took a cut, they kept working. And they gave us the same option, and the union said, "No, we're not taking no cut and that's it." And they said, "Furthermore we want to see your books and we want to take you to court," so they wanted to go through arbitration and take them to court—that just blew the company's mind, company said no way, you know.

MF: When did it go down for good?

DH: Eighty- . . . two, August of '82, they definitely closed the plant. And, as I say, I had eighteen years, so I didn't catch the pension; twenty and you get the pension. I was shut down, I didn't draw nothing. Nothing for nothing. Just got unemployment until that ran out, no food stamps, no gas assistance, no nothing. When you're shot down, you're owing so much, and then when you need some assistance from the government, they tell you, you own too much, you got this, you got that, you got to sell it before we can do anything for you—that's about the hardest part. They tell you sell your houses (because I own two houses) sell your house and we'll give you some assistance. It's just more or less. . . . You know, if you work eighteen years or fifteen years someplace, you got to show something for it. And what the government's saying, that you should have worked eighteen, fifteen, twenty years and showed nothing! Then we'll give you something. That don't make sense. What they're saying is, you should have drank all your money up.

It gets you. When I went down to try to get some assistance, I know a couple of guys that are collecting welfare, and OK, their rent payment was three hundred something dollars a month. I told them, my house payment's only two twenty-five, but we can't help you because you own two houses—it don't make sense! You're going to get three hundred something dollars here, four hundred, pay the gas, pay the electric—and all I'm asking is for two twenty-five. But you say, can't do that, we'd rather pay the four hundred something than pay the two twenty-five, the difference is I own this, and that person rents. You know, that don't make sense. If I sold this place, stuck the money someplace, ran down and rented an apartment for four hundred dollars, and wasn't working, they would pay!

Well, when Nancy was at work, I had a hearing down in East Aurora about food stamps. They did all the book work, then I went in, asked the guy, I said, "Well, how did I make out?" He says, "Uh, we turned you down." I said, "Why?" "Well, you know, you're wife's working." I said, "So?" "Well, can't give you nothing." Well,

before I leave, I says, "The guy sitting out there, he's a Cuban, right?" He says, "Yeah." I said, "How'd he make out, did he get it?" He said, "Oh yeah, he got it." So I said, "That's nice, he gets it, he's not a citizen or nothing, couldn't even speak English, and I've been working since I was seven years old and I get nothing." "Well, I feel sorry for you," he says, you know, his hands are tied, he's got to go by what rules the state and local government gives him.

MF: So you'd done a lot, you had something—and yet you can't use that something to help rebuild yourself. And the point ought to be to help you through until you can really get something else going.

DH: Yeah, keep you going. Well, with the unemployment they got a deadline, twenty-six weeks. It's not that the people are taking this hundred and twenty-five dollars, whatever it is, now—they're not taking the money and putting it away, they're using that to survive. So it's keeping the economy going, even though it's a little bit. That guy's spending a hundred twenty-five dollars every week, buying food or paying his gas and electric. It's keeping something going, the whole economy ain't stopping. You're going to have your little cheats, no matter what you do, but a majority of the people are really benefiting through the federal government, state, or your local government assets. You know, they're trying to use it the right way.

MF: So did you go into a kind of tailspin after you got laid off, or sort of a crisis period?

DH: Well, I was bad, oh, I was bad. I think if I didn't have accepted the Lord and everything, and being laid off one year, or hearing the news that Shenango was going to close, I probably would have robbed someone, just kept robbing off the rich—you know, being mad because they're the ones that have control of it. The last four years the gas company just started coming out with fantastic gas bills, shortage of gas in your car and your taxes are skyrocketing, it just seems like somebody, they started the bandwagon with the canning jars, the canning lids, the shortage, and it just started from there, everybody making up the shortage, to get rich, and before you know it we're running out of natural gas, we're running out of oil, we're running out of everything.

And just everybody got on the bandwagon—just when the country needed help, all those businesses jumped in and made it worse. Instead of saying, let's lock our

horns together and get out of this crisis. They all just jumped in, and the telephone company, everybody. It seems like they want to take every dollar they could take from you, they just use that word, there's a shortage, instead of saying OK, we're all Americans, let's show that we can all pitch in and help each other, rich businessman can hand out a little bit where it ain't going to hurt him and use it as a tax write-off, and everybody can help each other and we could all get back on our feet. Because if people don't have money to spend, the economy's only going to get worse.

MF: You mention a religious conversion—how did that happen, was it right after the layoff?

DH: No, it came—. You know, there was no definite thing that Shenango was going to close. We were on a layoff, and kept thinking we were going to get called back, and I was collecting unemployment and some SUB-pay. I was working up in East Aurora, working in the Antique Barn, there was a Christian family, and they kept telling me about the Lord, and I says, "Get out of here! Wacky, don't want to hear that stuff." They'd play music, and I'd go turn it on rock 'n' roll or country and western, and they'd turn it back. And then, all of a sudden they bought me a Bible. "What's this?" "Take it home and read it." All right, brought it home, I wouldn't read it. And then it kept going on and on for a couple of weeks, and before you know it I started going in there and I started turning on the Christian music, and humming it. So it kept going on, they kept talking more about the Lord, every day and every day and every day, and it just happened. One day, it happened, outside.

MF: You were brought up Catholic?

DH: I was brought up nothing. Protestant, yeah, but I didn't believe in nothing. No God. I just believed that you make as much money as you can, you live as good as you can, and you die. I just didn't believe in nothing. Then I just changed around, you know, reading the Bible the right way, accepting the Lord, and knowing that Jesus died for them, the only way to Heaven is through Jesus Christ. After I got affiliated with the Church there, these new guys I know, they said that 95 percent of the Church is Roman Catholic. I was really shocked at that, I said, "That's really something, if they can do that—." You know, to convert a Catholic is hard, it's hard, you know, to get the Catholics to see the right way. Here they sit and listen to Latin, they

don't understand Latin, they believe in the Virgin Mary, and it's nice to believe in it, but they worship her! Not to worship Jesus Christ, just knowing Jesus Christ is something different, knowing that through the Son you will go to Heaven.

MF: What kind of difference—how has it made a difference?

DH: Oh, it made a big difference. Kept me out of jail! [laughs] No, it made a big difference—now I don't think about stealing. We got Bible study, and we help an alcoholic, he lived here. You got to struggle through hard times, and helping somebody out, you got him on his feet, going in the right direction. Just help somebody else and take some of the pressure away.

MF: Are you from out here, both grow up around here? [Hughes's home is in Colden, New York, a country town in the hills to the south of Buffalo and Lackawanna.]

DH: I'm originally from the First Ward of Buffalo. And I used to shine shoes when I was a little kid up there, worked, and from there we moved to Orchard Park. We come from a big South Buffalo Irish family. So we had to work all the time, since I went to school from eight to eleven, then I had to go to the greenhouse, so I only had three hours . . .

MF: You finish school?

DH: Nope. I quit my junior year. That was strictly because I had to work all the time. That just drove me nuts, I was helping to support my father's family.

MF: When you were growing up there, was steel one of the things you thought about going into? You can't be too far from steel when you grow up in South Buffalo.

DH: Who, me? The steel mills? No, I was thinking about being in the Mafia. [laughs] Being a crook! [laughs]

MF: [laughs] And they didn't have any openings for you?

DH: They didn't have no openings.

MF: Oh, I hear they're recruiting all the time!

DH: [laughs] No, I never really thought about it. It never entered my mind.

MF: So how did you get started at Shenango?

DH: Well, Nancy's brothers worked there. Most of her family works in the steel business. Down at Ohio Tool, family, and uncles there, most of them went into steel. You heard the same thing from them—you know, when they started off they got their heads pounded in, went through the hard times. It's like getting a part of your stomach cut off, if the plant closes. You know, if the plant just says you're on layoff, there's always a chance you're going to go back. But when it shuts down, closed . . . whew.

MF: You mentioned these two houses—where were you living during most of the time that you were working there? Were you living in South Buffalo, or were you living out here?

DH: Well, a couple of years up on top of the hill in Boston [New York], and we lived with my mother-in-law about for a year. But we've been out here for thirteen years. The second house is right behind us, on the same land. I rent that out.

MF: Living in the country here is real different. Was that a goal of yours to get a place out here? How did you choose out here?

DH: Well, you see the hills out there? That's your answer. I just like looking at the hills. There are the hidden parts of the hills that really have nice places. And I like a small town area, such as this, a town that never really is going to grow. This town will stay like this for years and years. There's no subdivision or nothing like that. It's mostly old families that were here—all interbreeded and that. Their mothers were here. Most of them are rich, well-off people. You have a lot of doctors out here, lawyers. They're more or less looking for the same thing. Most of the people are nice. You know, every town you have so many bad people. If you live in a small town, you got less bad people, I guess.

MF: So has the community been supportive when you've gone through rough times like this? Do you think it's been easier in a place like here than it would be someplace else?

DH: I think it would be easier on ourselves if we were in Buffalo. You know, you can look for a job you don't have to drive the distance. That part would be better. But as far as helping—how much can you really help, it's not that some guy'd come up and just offer you a job or just give you money.

MF: You said a lot of the people are wealthier. Does that make it hard? Do people look at you look at you like, oh, there's so and so, and he's going to have trouble paying his bills?

DH: Some of them do, some of them don't. Only a couple, I'd say a handful that know—neighbor, the girls up front, the guy in the post office, a couple of guys in the gas station. But, no, 90 percent of them don't know, that you're going through hard times, having to struggle. . . .

MF: Do you have this place pretty well paid off now? You must be close to it.

DH: Oh, $15,000, I think it was, fifteen something. But the only thing is, you can't do repairs now. You can't do the things you want to do because it costs money, you just can't go out and buy stuff and do what I want to do. Now I got the time, but no money to do repairs.

MF: OK, let's look at these other pictures Milton took at your home. I see cars, I see Elvis, and I see, in the other picture—who is it we got there, Buddy Holly?—and these dolls. So I'm curious about the dolls, and the music, about Elvis. When Elvis died, was that something that you were involved with?

DH: [laughs] Well, I was into antique cars, you know, Corvettes and stuff, and when Elvis died, she [Nancy] freaked out, yeah, she was all broken up, so I had to go out and buy all the Elvis, listen to records, keep her going. But yeah, yeah, it hurt. It hurt more to find out that he was on drugs, and he wasted himself. At first when he died, you know, they tried to keep it hush-hush, and I says, it's a waste that he killed himself, he's so rich and he made his life so miserable, by being so protective of himself, instead of going out in public and associating, he just grew too big.

MF: What's your theory about why his music was powerful for so many people?

DH: Oh, it was from the heart, the soul. Soul music, the blues mix. Yeah, he wasn't like a white man singing colored music. He just . . . he was a country boy, he wanted things to happen, he was young, and he loved his mother and father. He didn't want to go out where the big wheels were, he didn't want to go to Hollywood—but he wanted the money and everything, he knew he was going that way. He come in with the sideburns, changed things around. I think it was a good thing to call him, you know, the king of rock 'n roll, because he did break it wide open for everybody.

MF: Now what about the dolls, it's quite an impressive collection. Are these old dolls, or any kind of dolls?

DH: No, those are mostly newer ones. Madame Alexander's Collectibles. This is what rich people buy their kids to play with. She come over from Germany, her father was a doll doctor, and he died and she took over, and she's a real old woman now. What she does is, make them for the richer kids. But she'll just make so many and there ain't no more, and you send in your order, whoever, first come first serve. And if the stores want more, there is no more, that's it.

MF: Did you used to have a few of these Corvettes, that you'd bought up and then worked on the engines?

DH: Yeah, but they're gone. I sold those, I got one car left that's a fifty-eight Chevy, plan on selling that. So most of the rest is gone, just to pay the taxes. Like now, by the fifteenth of this month I got to come up with a thousand and ten dollars to pay the school tax, that I don't have. So I don't know what's going to happen there.

MF: What do you do when you're not working these days?

DH: Not a heck of a lot! You know, really—just worrying, thinking, get the pen out and figure out how you're going to make it, and writing down figures after figures, hoping everything turns out right. And I go back, worked at the racetrack, being a guard, minimum wage, it's not a heck of a lot. The thing is that you do work, it's minimum wage. When you get into construction, they throw that salary stuff at you: we'll put you on salary, but we'll work you sixty hours a week. Just take complete advantage of you—. They really know you're hurting, and they can get everything they want out of you.

MF: Do you have any long-range hopes, if the economy starts picking up, where things might . . . ?

DH: Well, I'm just hoping that they don't destroy all our steel mills, in case we really need them. Because you're dependent on foreign oil, and they're going to lock themselves into dependent on foreign steel, and then you're getting into a crisis. They'll just raise everything else, they control the world market on steel prices, and— well, over here they can just knock us out of the ballpark. I just think if they can keep the steel mills going, get them back on their feet.

MF: I bet you must feel good that way back when you socked some stuff into a place like this out here. Well, like you were saying, if they're not going to give you anything after eighteen years, at least you know you've got this really beautiful house and land. . . .

DH: Well, I can sell it to you, Mike! [laughs]

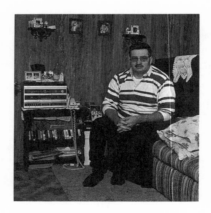

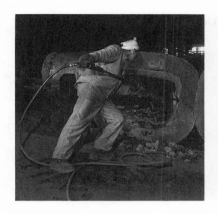 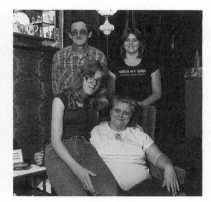

3 / RALPH AND ROSE WILS

MICHAEL FRISCH: Well, tell me a bit about what you did at Shenango, about what's going on in this picture. It's a little different than many of Milton's pictures. Usually the pictures are just people looking right at the camera, so in this case he must have found it real interesting, what you were doing there, so tell us about what's going on in there.

RALPH WILS: Well, this is poke-out, knocking sand out of an ingot mold. The steel industry uses the cast ingots for making steel bars and plates. They had two sizes. They have a smaller one, behind me there, it's a Republic Steel, and this mold here is a Great Lakes mold.

MF: How can you tell that?

RALPH: By the shape and the size. The mold weighed probably about thirty-three tons.

MF: OK. You've got this thing that you're holding, tell us a little bit about that.

RALPH: Well, this is an air gun with a steel rod probably twelve-foot long. And what I do is, the sand, like, bakes, so I have to knock all the sand out and then it goes

on down to the next step. At the bottom of the picture, that's the sand that I knocked off the side. It's sand and molasses—what else do they use on it?—something like graphite.

MF: Actual molasses, same as you'd use at home?

RALPH: Right.

MF: And that's basically what it picks up from the mold itself—the mold for the mold. That mold is made of sand, is that right, and the sand mold has to be made new each time?

RALPH: Right.

MF: There's a number of guys like you on a crew?

RALPH: No, no. One on each shift. I'd probably go through maybe twenty molds a day.

MF: I notice you're wearing ear stoppers?

RALPH: No. . . .

MF: Were you supposed to be wearing ear stoppers?

RALPH: Yes. [laughs]

MF: [laughs] OK, you're not wearing a hard hat either.

RALPH: Impossible. Every time you bend over it's on the ground. I'd be spending more time picking my hat off the ground then I would have it on my head. So I wore a soft hat, there's nothing above me.

MF: Yeah, and are you wearing safety glasses?

RALPH: Safety glasses, right. Definitely. Still got stuff in your eyes. The job that I had before this one, I was running a post mill, and it was real fine iron dust and I don't care what you wore, you still got it in your eyes.

MF: You're not wearing a breathing thing there, are you?

RALPH: No. If there wasn't no wind blowing, then I wore it. It got really dusty. Usually the wind's blowing through and blowing the dust away.

MF: So this is like a big shed that you're in?

RALPH: Right. Big metal building, probably sixty foot high. In the wintertime it was cold. In the summertime it was hot. There's no in-between.

MF: In the winter would you have, like, fires?

RALPH: No, we had gas heaters.

MF: And in the summer you just had to . . .

RALPH: Grin and bear it.

MF: So this is pretty noisy, dirty work. Did you enjoy this job as much as others, less than others?

RALPH: Sure, as much. It was a challenge all the time. It was never the same. One mold was never the same as the next one, even if it was the same shape. One would go easy, the sand would fall right off, and the next one you worked. If you get a crack in the sand and the metal gets through the sand then you got to work.

MF: Let's say you came in in the morning. Would there be a duty order there or you just sort of see things there?

RALPH: No, just tell the crane what you want and he'd bring it over for you.

ROSE WILS: Don't ask what they said. Some of their language was bad. You wouldn't want to hear some of the things they would say in there. He'd come home from work and he'd go to sleep. And he'd be talking in his sleep and some of the language he was saying—he was repeating his day over at work—wasn't very nice.

RALPH: I had rough days.

MF: What made some days rougher than others?

RALPH: Mold problems, that's all. It wasn't the people at work. Just some days nothing would go right. You just worked.

MF: OK, well now, tell me maybe a little bit about your own background, your family, growing up. You grew up here in Buffalo?

RALPH: Blasdell.

MF: And were your folks from around here too?

RALPH: Right, Blasdell. Probably grandparents and great-grandparents, too.

MF: And were your folks and grandparents also working in steel?

RALPH: My one grandfather, I don't know what he done. He passed away when I was just a baby. And my other grandfather, he had a gas station and store. My father was in steel. Bethlehem Steel. He was a foreman. Blast furnaces.

MF: So, if I can ask, you were born around when?

RALPH: '32.

MF: '32. OK, so you're in school into the '40s, and at that point, if somebody said what are you going to do when you grow up, you would've said I'll be at . . .

RALPH: Bethlehem Steel.

MF: Did you finish high school?

RALPH: No. I started out, I worked at a bunch of different jobs. If you didn't like a job, quit it and you got another one tomorrow.

MF: So how come you didn't end up at Bethlehem?

RALPH: I got blackballed. My father and my uncle. They told me that I'd never work at the steel plant as long as they could have anything to do with it. I went there and applied for a job and never got called. So I think my father and my uncle had something to do with it. He didn't want me working in steel because he worked it all his life. He figured that I could find something better than steel industry.

MF: So instead you just bounced around and then what?

RALPH: Then I ended up at Lehigh Cement, right across the street from Shenango. Went in the service for a couple years, went back to Lehigh till they closed down, and then to Shenango. I was about eighteen and a half years there at Lehigh.

MF: How did your father feel about your working at Lehigh? Was that what he had in mind? Did he think it was like higher status or something?

RALPH: I don't know, I really don't know. I never discussed it with him. It was, the steel plant was out, so whatever I done, I done.

MF: How did *he* feel about working in steel? Did he hate it, or he was proud of his work but he just didn't want it for you?

RALPH: Right. He figured I could do better someplace else besides steel.

MF: So he would've retired about when from Bethlehem?

RALPH: He died in '69, so he retired in '68. Made a year.

MF: He's working, really, right through the golden years of Bethlehem. How do you think he'd feel about everything that's happened since then?

RALPH: Well, he always said that it was going to come to an end. He was going to work till he was sixty-five. He figured it's not going to last, why waste three years, go now, so he went out when he was sixty-two.

MF: What did you do at Lehigh?

RALPH: I worked in a lab, running tests on raw materials for cement. Limestone, gypsum, shale. I run tests on the raw material before they burn it to make cement powder.

MF: How did you get into that?

RALPH: Oh, just watching. I started in the labor gang and then I went on the slurry pumps. Slurry is the raw material going into cement. And they burn it in a kiln. And I went from there to tank man, I was making sure the tank levels were right and blending the mixture to make certain mixture for burning. And then I went to the feeder floor which fed the mixture into the kilns and then I went in the lab.

MF: Was that interesting work?

RALPH: Sure was. It was something different every day. Never the same.

MF: And also they had to really depend on those tests, I would think.

RALPH: Right. If I messed up then the product's messed up on the other end.

MF: Right, some building's going to fall down [laughs].

RALPH: [laughs].

MF: What was happening when Lehigh closed? Why did it close?

RALPH: Economic reasons, old equipment. They didn't want to modernize. They were from Pennsylvania. Main office in Allentown, Pennsylvania. They built a new

plant down in Florida, closed this one. Things start slowing down and went into work one day and they had the notice on the board that effective da, da, da, the plant was gone. There was nothing you could do. We got kind of sold out. Almost everybody felt the union sold them out. Some of the guys said "Ah, they were paid off." The company and the union made an agreement that nobody would be allowed to transfer to their Florida plant. The new plant was out of state. That's the reasons they give us, it was out of state. And they didn't want people coming from the Buffalo plant down to their Florida plant and forcing people down there out of work. So I had eighteen and a half years, and I needed six months to get a pension from the plant, immediate pension. So instead I just got the vested pension.

MF: The difference in the vested pension and the regular pension is . . . ?

RALPH: All right, a vested pension you have to wait till you're sixty-five to collect it; it's frozen at the rate when they close the plant down. If you get an immediate pension and other plants are still working when they negotiate a contract, usually your pension will go up according to the new contract.

MF: So at Lehigh you missed it by six months?

RALPH: Six months. I only needed six months. Couple of guys missed it by two weeks. Company wouldn't give it to them. I was pretty angry, too.

MF: In a way you went through the whole story early, you're getting a pretty good preview of coming attractions in 1969. Was it rough after that getting other work?

RALPH: I kind of loafed around till my unemployment run out. Then I run into a guy I knew that worked over at Shenango and he told me, go over there. So I went over there and put an application in, went for a physical, and started work. I was there eleven years, 'til they closed. '69 to '81.

MF: OK, and now let's look at the other picture, with your girls, and the background. When did you get married?

RALPH: First time, 1952. I had five children, four girls and a boy. There was a period of eight years between when my first wife left me and I remarried Rose. 1977.

Eleven years last month, Memorial Day. Rose's husband was my first wife's brother. We lived in a two-family house, Rose lived downstairs and I lived upstairs. And I married Rose, she had three boys and a girl. So, at one time there was all nine of the children with us together. Yours and mine but no ours.

MF: So who's this in the picture?

RALPH: OK, this is my daughter Nina, on the left, and this is my stepdaughter, Tina, on the right.

MF: Where are your kids now? Are a lot of them around here?

RALPH: There's three of them in Buffalo, one's in Texas, and one's out in Salamanca. One of Rose's boys is out in Washington state. And my one daughter is in Texas, and the rest are around here. But none in the house.

MF: Talk about the empty nest!

RALPH: Oh boy, you better know it. Lot different.

MF: And what kinds of things are they doing?

RALPH: My boy, he just got through going to school for building maintenance, so, he's going to get into that. And all the girls are married. Between Rose and I there's twenty-one grandchildren.

MF: So your first marriage, in terms of the shift from Lehigh to Shenango, those things were happening around the same time?

RALPH: Uh-huh. My first wife left me just before Lehigh shut the doors. In '69.

MF: So '69 sounds like it must have been a rough period for you. Your marriage is breaking up, your father's passing away, and your job disappears. It's not just that you went through the plant closing once before, but you went through the kind of

things a lot of younger guys are hitting now, where everything seems to be coming together. When things started to go bad at Shenango, you're a guy who'd already been through this once. Did that make you different?

RALPH: Yeah. Guys didn't really think Shenango was going to close. I knew they were going to close. The way things were going. I seen it through Lehigh. I kind of realized what was happening. When the company started giving the union a little more of what they wanted—something's wrong here.

MF: Like they're setting them up?

RALPH: Well, when we got done with our work we used to scat, and somebody would stay and take care of the cards. If we get done early, like 9 o'clock, 10 o'clock, take a shower and go home. One guy would stay and punch everybody out. OK, so towards the last contract before the shutdown the union says, "Well, if our guys give you what you want and get done early, can they leave?" Company says, "Sure, we'll give you that in the contract." So, when you got done, you took your shower, punched out, and went home and got paid for eight hours. It was kind of the same at Lehigh. The company started giving the union a little more money, real easy stuff. Stuff that years prior to they fought for, you know, "We're not going to give it to you, no, you're not going to get it." But when the union goes in and says, "We need a thirty-cent raise," company says, "Fine, you got it"—something's wrong.

MF: Why is that a bad sign? What is that telling you?

RALPH: Something's going on. Either they're going out of business or. . . . I don't know, when the company starts not repairing this and not repairing that, you know, when the company decides they're going to go, they're going. No matter what.

MF: Were you involved much in the union at Shenango?

RALPH: No. As a matter of fact the only reason I was in the union is because you had to be. I had no use for a union. I still don't. Toward the end there we went to union meetings, and you were still employed by the company but you were laid off,

not paying union dues, so you didn't have no voice in the union. Didn't do no good. Just sit down, you're out of order, you have no say in this matter.

MF: Then you got laid off and it's finally . . .

RALPH: . . . close the door. After Shenango, I rode my unemployment out again. Then I went to work for Pinkerton Security, nine years. Minimum wage, nothing. Now I work for Topnotch, they're a janitorial outfit, over at PBS Chemicals. Security, janitorial, go pick up parts, whatever they need. I'm working this one place steady, I like it. I'm around people all the time. New challenges almost every day. I'm up to five dollars an hour, Blue Cross and Blue Shield, with major medical. So I'm in a little better shape.

MF: Rose, I just heard the story of the "Brady Bunch" here. It must be quite a change to go from nine kids—.

ROSE: Yup, down to none. It makes a big difference. I can't adjust to it. It's lonely.

RALPH: It's harder on her with the kids all gone than it is me. I go to work, she's here alone.

ROSE: I tried going to work, after the kids went. I been home so many years work's not. . . . It's not for me.

MF: Well, tell me a little bit about your family and where you grew up.

ROSE: Oh, I was born and raised in Lackawanna and that's about it. It was nice. A lot of pollution but we lived with it because we knew that that job was there to keep Lackawanna going and then people started yelling about pollution. Well, now the air's clean and we have nothing. They had to pay all that money to keep the pollution down. How can you put millions of dollars into machinery and pay people not to work, just because of a little pollution? And I think that's what the whole thing come to.

MF: So you're resentful about that?

ROSE: Right. Yeah, life goes on, right?

MF: Well, the world that your grandkids are growing up in is sure a lot different than both of you came from. Any thoughts about what all this adds up to? Some people say, "Well, it's like a natural phase that we go through that, you know, there was a period when we had all these plants and then there's a period when we get onto something else." And other people say, "Well, it's not so natural, we've really gotten off track somehow, our kids aren't going to have the chances that we had and we ought to do something about it." So if you had to say which of those two sides you're on . . .

RALPH: We got on the wrong track someplace. Too many jobs gone because of foreign imports. If it's not foreign imports the plants are moving where there's cheaper labor, Mexico. And I think the environmental got way out of hand. I see it every day. I work at a chemical plant, and there's so many different laws that's coming in every day and so many different regulations, so many different permits you got to get. They're just pricing industry right out of this area. Last one out turn out the lights.

MF: Do you think there's any way we could get any of this back, or is it really gone forever, do you think?

RALPH: I think it'll come back, but I don't think it'll come back as strong as it was. It's coming back at low wages. There's a lot of service industry, banks.

MF: In terms of what that means for, let's say, for young kids coming out, does that mean that they can get some work but they're not going to have those kinds of opportunities?

RALPH: They're not going to be able to do some of the things that I think a kid should be able to do because with these service jobs, three, four dollars an hour, they're not going to be able to afford to do it. They're going to exist; that's it.

ROSE: I'm thankful that it happened that our children were, I didn't have to put them through school, because we could've never afforded it.

RALPH: Now you're either poor or you're rich. No middleman no more.

MF: You mean the middle class is—

RALPH: Is going. They're almost gone.

MF: This thing about the middle class: when you were working at Shenango, if somebody said, "Well what are you," would you say "I'm middle class"?

RALPH: Middle class.

MF: And why? Because you owned a house?

RALPH: The wages and owning a house. What you can do, it's nothing to take vacation and go down to Florida, or out the West Coast. I figure I'm middle class.

ROSE: Yes. I've never felt like I was a millionaire or if I was rich or anything. I just thought, well, I just live. Nicely, let's put it that way.

MF: Yeah. But you're saying that's one of the real changes that you've seen, that whole sense of that middle is—

RALPH: The middle is gone.

ROSE: Right. It's all over the place, 'cause I watch different programs on TV and it's the same thing going on all over the world, it's not just Buffalo, I don't think. Down there they're fighting for the coal mines or the steel plants or so forth. I just wished I could have had a crystal ball to see all that, but I had no idea. You live day by day.

MF: What would you say was the real low point for you, the Pinkerton?

RALPH: Pinkerton. Minimum wage, no benefits. And the job itself. I worked security at Shenango for Pinkerton, there was still guys working there. I knew the guys and I talked to them about what was happening. That's before they really locked it

up. They had the same feeling I had. Something you can't do nothing about. I felt kind of bad thinking I was there for three thirty-five an hour where you used to be making sixteen dollars an hour.

MF: That's what you call ironic, that there you are guarding a factory that you're no longer working in.

RALPH: I spent seven years working security at Allied Chemical, over here on Lee Street. Allied Chemical, they closed down. Now I start wondering, am I a jinx? [laughs] I stayed there about a year and a half, then I went over to Republic Steel for six months, still with Pinkerton.

MF: And Republic at that stage is completely closed. So you're just guarding—

RALPH: An empty plant. On the graveyard shift. Just walking around, checking, make sure everything's all right. Turnkeys. Empty buildings. It's really weird. Stop and think of one time how many guys were working there and what was actually going on. It's really kind of spooky. Get out the turnkeys and sometimes you turn around and you think you hear something. There's nothing there.

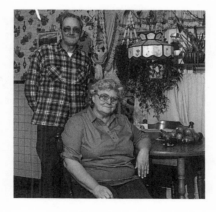

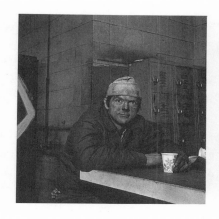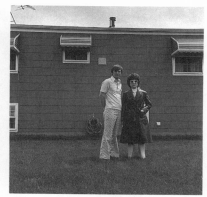

4 / KENNETH AND MARY GRACE SION

MICHAEL FRISCH: Just to get things started—the first part is mainly about Ken's work, but Mary Grace, if you have anything to say, don't hesitate at all. Why don't we take off from this picture in the Shenango plant? Tell us about where that is in the plant and what you were doing.

KENNETH SION: Well, this picture here was taken in the coffee shop, down in the chipping department. I started at Shenango in 1965 and I stayed in that department all that time until 1982. The plant closed in, I think it was 1982, but a lot of people got laid off in November of 1979.

MF: And what exactly were you doing there around the time this is taken?

KS: Well, the job description is chipping—we were cleaning out cast-iron molds. We get them from another department that makes them and we have to go inside and clean them out, get down to the cast iron and shine them up and paint them up. Then we ship them out by rail and some went out by trucks. What it was, this job here, was some of the sand used to stick to the cast iron and we used to have to use these little air guns and chip it off, you know. We used to have these little grinders, we used to have to go in and grind them real smooth. They didn't want no rough edges on them. We used to have to wear goggles, dust mask, scull hat, and we used to have to wear these ear muffs.

MF: What are you wearing here?

KS: Yeah, these are our head sock, keep our heads warm, you know.

MF: OK. I've been learning bit by bit about this process of sand molds and so on which is not *un*complicated—as I understand it, in the casting department the iron would be poured into a mold which originally was built on a wood pattern?

KS: Well, right. Originally, see, it starts at the ram department. OK, the ram, they have these forms, they used to have to ram sand around this form.

MF: So what you're left with is a mold made out of sand, then, right?

KS: It's made out of sand, yeah, it's packed real hard. You have to have the inside core and the outside core. And then they used to go to "set and cast"—they used to set the inside core down and set the outside core down over the top of it and get a real good seal around it. Then Hanna Furnace used to push molten steel, or molten iron, over in what they used to call torpedo boats, looked something like a torpedo with a hole in the top. They used to fill them full of molten iron, push them around behind the canal, run them across the scale, they have to weigh them. Everything had to get weighed. Then they'd push them back into Shenango. Then the molten iron used to go down into a ladle and he used to fill that up and the crane would have to pick the ladle up, go over to the cores, you know, and fill them full of molten iron.

MF: Did you do the breaking out too?

KS: No. We used to call that poke-out [laughs]. When it was cold, they used to take the big long bars, get up in there and knock all that sand away and the crane used to come along and pick them up and dump the sand out and we used to go clean them up further.

MF: Why is chipping so important in this kind of product?

KS: Well, see, when they used to send it to the steel plants, this is iron and what they used to pour in these is steel. That's why it wouldn't stick. But if that wasn't cleaned

out real clean and smooth, when they wanted to pick this mold up off, it wouldn't come off. The steel ingot would hang in there, it wouldn't slide out. Which is what you didn't want because those things cost a lot of money and they didn't want to have to bust those down. So this was critical—the molds had to be smooth inside. And outside too—we would use a post mill; it's still in the chip department. What it would do, would smooth off the end of the mold even more, from the outside. I'll show you in this one of Dick Hughes [see Chapter 2]. The post mill would smooth this all off, you know. I used to go around like this, and smooth this all off real smooth because they set a hot top on top of there.

MF: What's that?

KS: It's a piece that sits right on top of here, then they pour the steel down through and they used to pour it up into the head of this thing. All the impurities used to come up into this head, you know, and then they'd just chop it off. This here was a mold for Republic Steel, it was only an eight-ton mold. But this picture here of Paul Trembeth [see the second-to-last subject of the Photo Gallery], this was a Great Lakes mold, this is probably a thirty-ton mold.

MF: People looking at that would think that he is in a brick oven or furnace but that's actually the size of the mold itself.

KS: This is the inside. See how dirty it is here, all that stuff that stuck to it, and he was chipping this thing all smooth in here. And see, this one here would have to be machined, too, all those ridges would all have to come out. This one has a hole in the back here but you can't see it. They poured steel through this hole and fill that all full of steel and then they used to probably let it set for eight hours and a crane would come along and pick this up off, and it should slide right off.

MF: How long would it take to chip out something like that big one?

KS: Oh, if the ram crew did a good job in ramming, and when those cores went over to set and cast and they weren't bumped or knocked, no sand knocked off, it shouldn't take too long, maybe a couple of hours. But if they knock some of that

sand off, and there is a big hole in there—once that sand fell out, iron ore would get up in there and you used to have to chip that out and make it smooth, it could be two, three days to chip that out.

MF: And the smaller ones, like the one that Dick Hughes is on, that would take a couple of hours?

KS: Yeah, if a good job was done on it right from the beginning. These here, [looking at Hughes picture]—see how those aren't open? This is closed in back here and you used to have to crawl way up inside there and clean all that out.

MF: So—he looks like he's king of the mountain, sitting on top of that, but when you're working he would actually be crawling in there with this little air gun?

KS: Yeah, this little air gun. He had a little light cord up in there so you'd see what you're doing. Then he'd do just half of the mold and then do the outside, trim it all off.

MF: So you would do the top half when you're in there?

KS: No, the bottom half. That thing is too heavy to possibly chip up! That's about a thirty-two pound hammer! And that thing bounces all over when you're trying to chip inside, so you do just the lower half, clean it out, then grind it out, chip around the outside, smooth all the edges off and the crane will come along with a magnet and roll it over for you and then you do the other half.

MF: When you say an air gun, it's driven by compressed air. It's actually got a blade, like a chisel?

KS: It's a chisel. That was your main tool.

MF: So, when you're doing this, talk about noise, I mean you're inside one of these things and you've got an air gun which is making noise by itself and it's going off of cold metal.

KS: No, there's only, tops, probably three hundred men who worked there, which is small. I knew them all. We used to get around. We used to have a picnic once a year. Then you used to have your union meetings, you know. So I knew them all.

MF: Were union meetings a big thing?

KS: No, it was kind of on the low side. Used to have ten, fifteen guys at a meeting. Except if something important come up. Contract time, well then it seemed to be full. A normal monthly meeting, maybe twenty guys.

MF: In terms of management—were you supervised pretty closely? Were they looking over your shoulder a lot?

KS: Not too much. We really were pretty much left alone. Especially when you've been there for a long time and you knew the job.

MF: A lot of people, they have an image of a factory—but there are factories and there are factories. One guy's working on an assembly line at Chevy, for instance, and another guy in a steel mill, and it's like night and day. On the line that thing is coming every second. It's a lot different than . . .

KS: It's hard to work assembly, I think. This wasn't assembly-line work. We used to work on the incentive program. Before we could start making any incentive at all we used to have to chip what you call eighteen ton for the company. Now this one here only weighs eight ton. So just about every day we'd have to chip one of these first. Then we used to have to chip another one finally to get our eighteen ton. Then we go into the big stuff. That's where you start making your money, and some of the molds used to go all the way up to forty, forty-five tons. Some even went above that.

MF: Was there ever any tension between wanting to put out a lot more work and still having to get it at a certain quality? If you put it out you'd get the incentive and so on, but if it starts coming back then . . .

KS: Yeah, then you'd—. See, you'd have to do a fairly good job. You'd have to do it right. There'd be like six, seven guys and you used to have to, at the end of the shift,

keep track of the molds and the numbers, we'd have to figure out what the weight was, what the tonnage was and we used to have to subtract eighteen ton from each man in the group.

MF: So between that and overtime and so on, each week's paycheck must have been totally . . .

KS: Yeah, it'd be like working at a different place. Sometime you'd have a good week and sometime you'd have a poor week. And we got a lot of overtime. It goes by seniority. See, they have a roster and say you got asked to work a double shift, well, it would go on the roster. So next time another guy would get asked. The oldest man would get asked first then they would keep on going down the line. Some people like to work and make the money and some didn't want it.

MGS: But jealousy reigns high when they were asked to work overtime. That was another point—some got very jealous and pulled tricks. When we were first married and we lived in the apartment right over here on Erie Road, just a mile down the road. He came in just about 10, 10:30 at night, he had worked a double and I guess he had been working quite a few hours. So he was scheduled to work Sunday morning. He walked into work and they almost fell over, they said, "What are you doing here?" And he said, "What do you mean?" And he said, "Well your wife called last night," just the time that he was walking in the door of our apartment, somebody had made a phone call, claiming to be me, his wife, and said that he had been in a serious accident and wouldn't be in to work. And they had called another guy in.

KS: That just happened once.

MGS: Well, they horsed around, but it was resentful.

KS: You always get horsing around when you're working. Joking around all the time, you know. Cussing at one another, so on and so forth.

MGS: But that's not all either because they used to, you know, call him names, they resent the fact that he was done with his work, that he was reliable and dependable.

I've seen him work two, three shifts, nobody else wanted to work and he would take it and he'd come home and he'd be on another planet, he wouldn't even know what day it was. It was double and triple shifts.

KS: No, it wasn't triple. Couldn't work a triple. But sometimes we used to work seven days straight. Sometimes two or three doubles. I did a lot of midnight doubles. I made up my mind that's what I was going to do. I have three kids. Everything was booming, and all of a sudden it stopped, just like that.

MF: Did people see trouble coming then?

KS: Mostly not, no. As I remember it, in November sometime we all got laid off just for a short time, that's what they said. But they never said nothing. Never said a word. Great Lakes Steel was our biggest customer and they put continuous casting in, so that took our job away. That's what knocked Shenango off. That was the biggest reason. But, then, of course, Republic closed down, too, so there's no need for the molds.

MF: OK, a little bit of background now before we get to what happened after the shutdown. How did you come to be working at Shenango?

KS: Well, I had my own farm at the time, but it was real small, you know, there's no chance of staying in it. So, then I was looking for work, and I know somebody, he says why don't you go down to Shenango? The superintendent's name was Paul De Santis. Yeah, it was funny: I walked in and I didn't know from nobody. He was just sitting down at the desk, you know. I says, "I'm looking for work, are they doing any hiring here?" Well, he says, maybe, you know. So he starts talking to me, he wanted to know where I was from and what I did before. I says, "I worked on a farm." So he says, "You're from a farm, you're a farm boy? You're hired!" [laughs] Just like that, that's what he said! He said, "I like people from the farm because they know how to work." So that same day I went over to the clinic for a physical and the next day I was there working. Just like that.

MF: And this was a family farm—are your folks still . . . ?

KS: Well, no, my folks have been dead, passed away now for quite awhile. My father died in '45, and my mother died in '71 or '72, so they have been passed away now for a long time. My brother ran the farm, he's fifteen years older. The oldest is my sister. She's in her 70s. And my brother, he's going to be sixty-five and my other brother is fifty-nine or sixty. He just made it through, he retired from Bethlehem with full pension.

MF: When you were growing up on the farm, though, did you think that that's what you wanted to do and stay in it, or did you never think you were . . .

KS: I didn't think. Too much can happen and you can't think that far ahead. I got out of high school in '57. And then I went into the Army for a couple of years. I was in Germany for eighteen months and then I came home and bought my own small farm. But there was no way I could stay in.

MF: Was that a complicated transition for a farm boy to . . . ?

KS: No, I didn't have any trouble, no. This is a lot easier work than farming, that's for sure.

MF: Where are you both from, and how did you meet?

KS: Well, we're both from North Collins. I was living in Springville. Then I was divorced, then got remarried again in '75.

MF: And you, Mary Grace?

MS: I was teaching. Sixteen and a half years. Second grade. It helped us gain what we could. We were married a year and then we went to buy the house. I didn't have his children then, they still lived at home with their natural mother. She had custody of them, but as they got older they were more and more here. But I had them from twelve, thirteen, and Donna was what, sixteen? So, we had them very young. And believe me it was rough. The two girls gave me the roughest time that you ever want to hear. And, here I'm fairly young myself, I'm just barely ten or twelve or whatever

years older than they are. I'm in my 20s and I'm trying to cope with teenagers and the marriage. But my stepson was a very open young man. A very good son.

KS: Oh, the best thing he did was he went to college. Let's see, I forget what year did he go in, about '82. Now he works for an insurance company. An insurance adjuster, for cars.

MF: So you get married in '75, and by then you've made this transition pretty well, and the farm is way back in your background. You were then living out here? This is—we're in Derby, which is one of a string of outlying country communities down here. One of the interesting things about Buffalo is that those steel mills are right there between the country and the city, really, they're on the outskirts of the city. When you chose to live here, what were among the main factors?

KS: She worked in Angola and I worked in there. So, we had to get halfway in between.

MGS: It was a compromise, the situation where we could still be near our families, too, in case anything happened. It gave us enough to be separate to lead our own lives, but yet still be close enough to have family ties, to be together in case anything happened.

KS: We stayed out here and bought this house a year later, in '76. No, I didn't have any trouble going from country to city. In fact, it's a lot easier.

MGS: He's kind of laid back, he can take things in stride, he really is, he takes it with a grain of salt, where I tend to get more hyper [laughs].

MF: When the plant started to go down, was that a real stressful period or . . . ?

KS: Yeah, it was stressful, not knowing where you're going to end up working. Because it wasn't just Shenango, it was Bethlehem, Hanna Furnace went out. After I got laid off in '79, I got a job at Worthington Compressor, I worked there for three, four months. They have a chipping department, but theirs is more of a steel alloy and

boy, that was hard work—cast iron is more brittle and it has a tendency to break, where steel peels, you know. What happened was, after maybe about three months at Worthington, Shenango called me back. So the foreman at Worthington said, "Oh, man you better stay at Worthington," he says, "That Shenango, they're going to go down again." I said, "No, I got too many years, I don't want to lose the years." I had eighteen years at Shenango. So, I went to Shenango and that lasted about three months. So then I was going to go back to Worthington and one of the guys there, the next day he called me up and he said, "Forget it, I'm laid off too!" [laughs]. Now Worthington, they're closed down. Then everything went down.

MS: So if you'd stayed there . . .

KS: I would have lost everything. I was better off going to Shenango and getting a vested pension. I got to wait until I'm sixty-one or sixty-two and then I can start drawing my pension. A vested pension is like when the plant closes and they're gone and then your rights are what they call guaranteed, or invested. Well, like your regular pension would be, if the plant is still working. They base it on the last three years of your salary.

MF: What was the cutoff to get this vested pension, how many years did you have to have?

KS: For the vested pension I think it's fifteen. Like Dick Hughes—him and a whole bunch of guys fell just under fifteen years.

MF: OK, so then what happened?

KS: Worthington went down and Shenango went down and I drew unemployment, and that would run out and then I would get a few other jobs, you know, and then I would be back on unemployment for a while. Then I would help my brother out on the farm, I went and helped him chop corn and stuff, mainly to keep the wolves away.

MGS: Well, it's not even keep the wolves away. I think that was more to take him out of a state of depression so that he didn't—. His attitude was changing, my husband's not used to being an idle man.

KS: Oh, yeah, it was hard. She worked through it all, so that was the main thing, we weren't destitute.

MGS: But what was the supplemental salary when I did it, now became the main salary.

MF: Well, that's a kind of critical transition. By that point you had a pretty good base for yourself, you have been able to get the house here—you'd have had to say, "Well, we've done pretty well, you know, and I'm making good money and we've got a two-career family," and you've got kids who are grown-up. So what was your sense of things, if you can reconstruct the way it looked then around that time when everything started changing?

KS: Well, we didn't know all that's going to happen. Simple as that.

MGS: It affected the whole neighborhood when it started. It affected our whole street. Starting with two houses down, the guy worked at Ford, laid off, the next guy over here and our neighbor, Jim, Bethlehem Steel. Kenny worked at Shenango, this guy over here, I don't know where he was working, somewhere else, and the guy next door to him was at Ford, too, or Chevy. It just went continually down the street. It would hit one or two houses and then skip the one. It was wild.

KS: Tom across the street, he got affected, too. At Hanna Furnace.

MS: We would spend time talking about it because it meant a change in the men in the neighborhood. It affected the wives, too, just as much as the husbands, you would see them dealing with it, too. There would be a state of depression that their husbands are in, instead of work, and you couldn't go around yelling and screaming and doing all that stuff and say, "I have to put more pressure on him that he has to find some kind of work," because that would only make him feel guilty for something that wasn't his fault.

MF: And was there a lot of that pressure among some of the people?

MGS: There must have been, but I think pretty well this neighborhood was fairly stable. The people that we have around here as neighbors are really a stable community.

MF: So what's happened since then, have you gotten anything?

KS: Yeah, I've been working steady since '83. Driving truck. For a microfilm company in West Seneca. Completely different!

MGS: He hauls microfilm.

MF: So it isn't a big semi.

KS: No, it's a small truck. It's just pick-up and delivery. Like microfiche, and I pick up records to be microfilmed, you know. Get into a lot of buildings, get to meet a lot of people.

MS: It's an interesting job. He meets a lot of interesting people. He's met the mayor and Scotty Bowman [then coach of the Buffalo Sabres hockey team].

MF: How did you get this job?

KS: When they had that worker reemployment center at Federal. They had a bunch of jobs up on the wall, you know, so I just went around. That's how I got the job.

MF: That's interesting—a lot of guys are real cynical that they set up these job services but there really aren't the jobs.

KS: A few got jobs, most of them didn't. What the worker reemployment center did was teaching how to write a resume, we made some resumes out, that's just about all it was and they had a few jobs up on the board. I was lucky I got a job through them, it's just that I happened to be there. I'm making nowheres near the money, and not too many benefits. But the job's clean [laughs], steady days, and I got the weekends off, you know. At Shenango you worked all the time, anytime, you know.

MGS: You know, he's not afraid to work, that's why I think we've made out as good as we've done. Because where most men have not been offered jobs he's had two, three different offers. They may not have been as high-paying as what he's used to but

because of his reliability and dependability and good recommendations, I think that's opened a lot of doors. I said you should be grateful because some didn't even get offered one job.

KS: Yeah, that happened with a lot of people. Only a few got good jobs. Only just a very few. Paul Trembeth's brother, Tom, he got a real good job, he works for Niagara Mohawk as a welder. Well, there's quite a few men that I worked with died already. Yeah, there was a couple of crane operators. A few people in the department have died, I don't know from what. Some knew how to handle their money and some just didn't know how to handle it, you know. Like gamblers, you know.

MF: So some people have come unraveled a bit?

KS: Oh, they *really* unraveled. Oh, man . . .

MGS: But he was always able to find work, so we were always able to have something to live on during the summer. Because I didn't work during the summers, I felt those were my times. He got jobs gardening and he was willing to take anything that came along, he wasn't afraid, or saying some job was too small or too little or "I'm not going to get my hands dirty" or "This isn't paying enough money." We knew we had a responsibility and you face that and that was it, and we didn't go running home to momma and daddy.

KS: We made it through, we kept our bills paid on time. So that's the success right there. Keep your bills paid on time. We never missed a house payment.

MF: You must be proud of this house—it looks like you got a lot of work done in here.

KS: Yeah, I did all this. I put that wall in there. The cedar closet. The carpeting, the paneling. Put the ceiling in. I insulated first, there's nothing but the two by fours, you know when we bought it, so I insulated it and dry-walled it all. I did all this when I was at Shenango.

MF: And you've been able to hold onto it. And what do you do for recreation?

MGS: Well, we enjoy exploring new restaurants and finding different places to eat [laughs]. We used to bowl, we just stopped last year, we bowled for four years on a league, the Saturday night mixed couples league, every other Saturday night. In fact, we just ran into our partner, too; he was the one at Worthington. They went down, so he's working in the town of Hamburg now.

KS: Yeah, he's working on the highway. So we used to bowl. . . . We go all over. We go out for fish fry, we usually go to Callahan's which is in the township of Hamburg, we go there for fish fry every Friday night. I don't get into the city too much.

MS: We go shopping a lot, we go to movies, we like to ride our bikes around the neighborhood and sometimes we go for walks because that's supposed to be good, walking. A lot of family activities to do. We're more family-oriented.

MF: Your story is an interesting one because it's like half of American history right there—you start off on the farm and did industrial work and now you're working for a company that's involved with microfilms and microfiche, so that's like the information age. And you haven't been alone. We're all going through this big change where the world of steel mills in cities like Buffalo is not there. Any thoughts about what that all adds up to when you look at it?

KS: Just something that happened. We had no control over it. Absolutely nothing you can do about it. I suppose a lot of people go through it but when it happens to you, it's another story.

MF: I've heard two different ways that sometimes people have talked about it. One is a sense that it's a natural process, like a kid growing up, that an economy goes through certain stages and we had our industrial stage and we've got to go through the growing pains and move into something else. The other view is that there's some real mistakes being made and we're ending up with a society where you have some people who are on the gravy train and other people who . . .

KS: The laws on imports from this country aren't fair at all. Just don't make sense. They spend all our money for foreign aid. In Japan they built all those steel mills over

there at the end of the war, you know. Everything is modern over there. Naturally, they have low labor.

MGS: Yeah, but where did they learn the technology from? They picked the technology up from this country. They took it over and applied it and they turned around and they sent it back to us and ruined us. That's not fair. So now there's an upper echelon, there's no more middle class anymore—you either have it or you're down below, there's no more middle anymore. I've even seen that with the people coming in when I'm teaching, it's a lower class, lower strata that you're dealing with. And if we're compared with areas like Williamsville [a prosperous Buffalo suburb] and so forth you can't even begin . . . with that social strata, with the backgrounds that their parents have, they're doctors, lawyers, and whatever.

MF: But you've always had richer people and poorer people—

MGS: But you always had a middle ground where you could stay and keep your head above water. Now there really isn't. You either can go very high or you fall very low.

MF: That must be something for you to think about—I mean, you've done OK and you've been able to do well with the kids, but if you were twenty-five years old now driving that delivery truck, you know, and saying where's this going to go for thirty-five or forty years.

KS: No future at all. You'd have to go on welfare.

MS: Either that or you'd have to go to college and think about a whole new career. And that would take money and time and by that time you'd have to be working and struggling all the time.

KS: It's not easy. For somebody twenty-five years old that's got kids to raise, go back to school . . . ?

MF: What about your own kids? Where do you see them . . . ?

KS: My son's doing real good. Of course, he's got a college education.

MF: And your daughters and their husbands?

KS: One is in the Air Force, he's a captain, so he's doing OK, he's career. They have three kids. The youngest one's, she's two years old, we're having a birthday party for her tomorrow. My oldest daughter, she's going to have a baby in September or October. They live in Wheatfield, Town of Wheatfield, and her husband does collision work. She drives a coffee van, so they're doing real good. They have a little bike shop. He goes out every night when people have stuff set out for the garbage for stuff to pick up, you know? He picks it up, brings it back and sells it [laughs].

MF: So you're a grandparent now. Any sort of final thoughts, looking down the road at the kind of world your grandkids are growing up in?

KS: Well, they have to be well educated, that's for sure.

MGS: I think they're going to have to be willing to relocate. I don't think it's going to be like before, where a family stuck together and you could get jobs. That was the steel industry—if your father worked there or your uncle worked there you came out of high school or college, you had a job waiting for you, you went. And now that isn't anymore.

KS: My son-in-law he went to St. Bonaventure so when he graduated he couldn't find a job so he joined the Air Force, went to officers' training. So now he's a captain, but they have to relocate all the time, it's continually. They start out in Phoenix, from there they went to Texas. Now he's going to go to Florida. He's already gone to Iceland.

MGS: And your son, he's not afraid to move and have mobility, he's already been out to New York City and stuff, but he always wants to be home. He wants to be home. He did so well in one evaluation, they said, "What can we do to make you happier?" and he said, "Please send me back to Buffalo."

MF: Well, in that respect do you see any hope for an area like this? Do you have any sense that there would be a possibility of keeping some of this industrial base or do you think it's something we're going to have to outgrow?

KS: We're going to have to outgrow. They're never going to come back. No way. Like steel mills, you know—steel coming in from Japan, now it's Korea the big thing now. Those people, they work for nothing down there, you know. It's never going to change.

MGS: The days of unions, I think, are over, and big money, I think, it's not there, and it's going to have to come full circle before there's going to be that amount of money made again, really. I think you have a President there that really is anti-union. And I feel that he, when he was poor everybody else was poor. Now that he's got it, well, I see what end of the scale we're on and where he is.

KS: Oh, he's threatening to veto this free trade bill. I can't believe it, you know. I mean, he's unreal. He wants to veto the whole bill because of that little plant-closing clause, that you should have sixty-days notice. What's wrong with that? Now, they don't have to do nothing. Good-bye, you know?

MF: What about locally? Do you think local leadership has much room to move?

KS: I don't see how they have much at all. I really don't. Look at all the industry that's moved out of Buffalo.

MGS: Years ago, I remember being in college and they said, "Well, oh, pollution from the steel plant, oh, this plant there it's doing this, it's doing that." That pollution was people's livelihood, that was their living. Without that pollution you have nothing, and now we're suffering for it. And those people that said that, they came from other states to go to college here.

MF: That's a classic dilemma. I was in Maine, up in the mountains where there's a big paper pulp mill, Boise Cascade, in Rumford, and you drive through there—I don't know if you've ever smelled a pulp mill up close, but it's really something. But I was talking with this guy from there, you know, and he says when somebody asks "How do you stand this?" he always says, "You know what that smell is?" He says, "That's the smell of money. It may smell like something else to you, but to us it smells like money."

KS: That's the way Shenango was: it was dirty, but it was money.

MGS: That's the way the steel mills were. With all that smoke coming up that was money. But that wasn't *just* money—that was people's livelihood, a way of living. That was people's livelihood. It's a whole different style of living right now.

MF: Any final thoughts for the record?

KS: Yeah, we're going to make it.

MGS: It was hard going. You have to hang in there and work together and that's it. I think our same values and working-hard background, you know, that's said a lot. I think that's why we've been able to maintain. Get by, get through this.

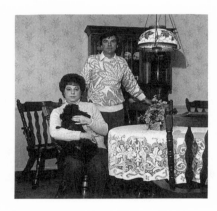

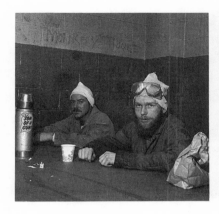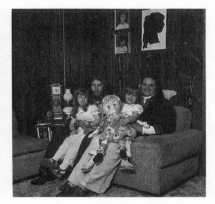

5 / MARK AND LYNN CIESLICA

MICHAEL FRISCH: Why don't you tell us a little bit about this picture of you at work. Obviously you're not in the middle of working right there.

MARK CIESLICA: Well, this was our lunchroom, not as clean as some of the ones you must have probably seen. That was one of the guys I used to work with down in the chip shop department, we're just taking a coffee break. I wore the hat on my head. My hair was long then [laughs] and the goggles, it was just part of the job, you know.

MF: What was your job, at that time?

MC: I was a post-mill operator. What we would do is cut the bottoms and the tops of the molds down to size, so when they would pour the steel into them at the steel plants, you know, it wouldn't run out. After it's knocked out and then chipped, after that it's brought down to the mill. It's set down on, well, we called them pedestals—like giant horses. And it was clamped up, we'd line it up as best as we could straight, and then each mold had to be cut to size, you know, certain lengths. And that's basically what my job consisted of.

MF: And basically you had to know what that mold needed done to it?

MC: Oh, yes. Only in some of the forging molds, you know, we were told. Or they'd go dig out the blueprints and then even the foreman, they had a hard time sometimes [laughs]. Really, the hardest part of the job was figuring out exactly what to do.

MF: And this post mill—what kind of machine was it? Is this like a saw? Could you describe it?

MC: How can I describe it? Well . . . if you worked in a machine shop at all, it's like a horizontal mill, like where it has a head flat and. . . . Hmm . . . it would go up and down vertical and it would be horizontal too. And . . . Whew! Wow, it's really hard to explain it! The mold is clamped down. There's carbide cutters, carbide steel inserts on what they call a head. And then the head of the mill, the cutting part, it was like on a long shaft that turned the head. It was what, about fifteen, sixteen inches in diameter, a good size shaft. And it had an angle like, you know, you would turn it, where you'd be able to cut so much off at one time.

MF: OK. So how big is this whole machine?

MC: I'd say fifty, sixty feet long if you count the bed of it too, you know, because it would move back and forward, the whole machine itself moved on rails. If you just counted the machine without going up to the top of it, it would probably get to be around twenty-five, thirty feet high. And counting all the controls and everything else, it was probably, what, ten, fifteen feet wide.

MF: Fifty or sixty feet, that's not a little jackhammer!

MC: Oh, no [laughs]. It took a few cranes to put it in place. And there was a platform with the controls on it, where you'd stand. You would crank the head out until you touched the mold and you can cut anywhere like from a quarter inch to an inch of iron off of it at one time. There could be anywhere from thirty to sixty teeth on a head and it would cut little steel chips depending on how much you cut off. It would look like slivers, giant slivers. We used to have to wear eye protection, which is there in the picture, you know, and ear protection—it's very noisy and very danger-ous. Like over the last eight and a half years, I just think back all the times how easy

you could have been killed in a split second. And you just done it and you never thought about it, you know.

MF: Is there an air problem in a shop like that? Is there a lot of stuff floating around, or not as much as in other places?

MC: No. A lot. Quite a deal. Because if you would breathe iron dust, iron has a tendency to rust real fast, and we always had to wear a respirator whenever you were on the machine. You know, in fact that was one of the big problems we had with the mill I ran. It was supposed to have like a suction device that would suck up a lot of the iron dust and that. From the day I learned that machine until the day I got laid off it never worked right. OSHA would come in and they says, "You know, that machine's not supposed to run." We told them [Shenango] we refuse to run it. "You refuse to run it? Go home."

MF: Now your job was considered a pretty skilled job, post-mill operator?

MC: Yeah. It was a class nine job, it was pretty high.

MF: Did you have to work to get up to that? What did you do when you first started out?

MC: Labor. Sweeping, shoveling, you know. The easiest way to explain it would be, we had like conveyor belts and they went into basements where they would sift sand, because sand is used in making the ingot molds. And whatever would fall off the conveyor belts, we'd have to shovel and get it back into the conveyor belt, because they'd try to save as much used sand as they could. It wasn't too bad. Three years, I was on the labor gang. But I wasn't learning anything and getting anywhere, so when you were high up on the labor list you learned jobs in certain departments, you know. You would be paid a learner's rate. And if somebody reported off or somebody got hurt or something, you would fill in for them. Or when somebody moved to another department, you can move into that job if you knew it. And I figured well, I don't want to be a laborer for my whole life, and a few of my friends were down there in the chip shop, so I figured I'll go give it try. In the chip shop for the post-mill operator.

MF: So this learning system is a way to give guys who were coming in at the bottom a chance to really learn some skills.

MC: Yeah. And to see what you would like, if you would like to move into that department. You could learn basically any job in the plant, almost.

MF: When you got the job, did you work day shift most of the time?

MC: No.

MF: Night shift?

MC: No.

MF: Swing?

MC: Swing. Nights, afternoons, days; nights, afternoons, days. We'd rotate, one week at a time, I suppose they wanted to give everybody a fair shake. So, when you started you knew you'd be rotating.

MF: When you shift from one to the other, is that like putting two together?

MC: You mean would you have to double back? You would have to double back. You'd be working days, afternoons, nights; then you would go back to days. So if we were working Sundays, you would have to work Sunday night and then Monday morning. And when you worked Sunday night, actually over eight hours is supposed to be considered time and a half, but when you doubled back and you had to work Monday morning, they says, well you're starting a new work week so we're not paying time and a half. So we says, either we stop working Sundays or we're not going to work Mondays. So he devised a thing of, well, you'll swing backwards, from nights to afternoons to days and then back to nights again. You'd get some break. That was the only solution I think they could come up with that everybody would more or less agree upon. In my opinion.

MF: And how did overtime figure in all of this?

MC: On my job, overtime would come in if we were running six days or seven days a week, you know, or if somebody would report off, you know, if they needed a job filled. I've worked—. One week I put in eighty-eight actual working hours. I worked six days and I worked five doubles so that means I worked, out of six days I worked sixteen hours on five of them days. But it was worth it, you know. I think so. I'll say base pay was around between three hundred fifty and four hundred dollars towards the end, and then with incentive added in there, you could earn more, you could earn a couple of hundred dollars a week in incentive.

MF: How did this incentive work?

MC: Well, certain molds earn you more incentive than others, they involved more cutting. Some days we can make good incentive, some days, depending on what they needed cut, it could be poor. I don't think there was ever two work weeks where I earned the same thing, you know. But it averaged out to be pretty good for the most part.

MF: How many guys did you work with on this crew?

MC: If you count the crane man, basically four guys. You got a crane man, you'd have a chain man and he would direct the crane man and then tell him what to do. And actually there were two mill operators on every turn.

MF: The crane operator, is he flying stuff all around from the chipping area to the . . . ?

MC: To the welders, to the post mill, all over. It takes a lot of learning, a lot of practice. How to set things down. It's not as easy as it looks [laughs]. I've seen walls knocked out. I've seen trucks destroyed, just flattened right out, yeah.

MF: And why were there two operators on the mill?

MC: One guy would run the mill, he would do the cutting. The other guy would do the lining up and the general maintenance on the machine and everything, like if it

needed hydraulic fluid or the head had to be fixed or something he would do it. Other than that, we'd have to blow the whistle for an electrician. But I'm telling you, they really never had nobody who had good knowledge of that machine. I think it wasn't designed right, either that or else it wasn't designed to be in the environment that we had it in. Because it was constantly breaking down. Constantly. I think it was cheaper for them just to keep throwing oil in or fix whatever they could for the time being than to shut the machine down for two weeks and do it over. Where they would be afraid they would get too far backed up, railroad cars would be waiting, they had to pay the railroad. Trucks would be backing up, you know. It would be like a whole line of progression being tied up. So, I think that was their solution to solving the problem.

MF: Sounds like there was a lot of concern about maintenance of the machines and whether they were taking as good care of them as they should.

MC: Yeah. It was a big issue. Especially with me. I was fired over it. Back in 1976 I was fired, in September. It wasn't too long after I just learned the machine. I was working afternoons. I come in, you know, fix up the head, whatever it needed, and my shift started. I started cutting the mold and the machine died. Didn't know what was the matter with it, so I told my partner, I says, "Go call the electricians, the machine died." So it was broke down for a few hours, and the electricians couldn't find nothing wrong. They called the millwrights, the millwrights come down and it was maybe six, seven o'clock in the early evening they finally got it running. So I started cutting, finished up, at the end of the turn we'd have to get everything done that we had to because of the breakdown. Nothing was said.

The next day I come into work, and one of the foremen, they told me I had to report to the office up front. They says, "Bring a union man with you." I didn't know what they were talking about. So he went in with me and they says, "What did you do yesterday?" "Nothing," you know? I says, "I come in, the machine broke down," you know, "got running after and just finished up, like late." He says, "You didn't do nothing to the machine?" "No, why?" They says, "Well, we think you broke the machine down on purpose, we're saying that you broke the hydraulic valve off and threw it away." I go, "Come on," I says, "I just learned the machine not that long ago." They says, "Well, we're giving you five days off subject to discharge." I says,

"Well the machine ran when I was there, for a little while." And they says, "Well, if it was running when you started your shift, you had to do it." So I had three days off and the union president called me, he says, "They want to have a meeting with you on Friday." So I went in Friday morning, it was eleven o'clock. Went in with the union president and my union man for my department. They said, "We're going to fire you." I says, "Come on, I don't believe this, I'm telling you I didn't do it. I'd even take a polygraph test if you want me to." They said, "Well, we're going to let you go."

So this was Friday at eleven o'clock. The meeting ended at eleven thirty. Half an hour later the whole plant walked out. They had a wildcat because they fired me! It really surprised me. I knew the guys were pretty close, but I never figured they would do that. The wildcat only lasted a couple of days because the union said the company wouldn't even talk about giving me my job back until the guys would go back to work, which they did. And they come up with a proposal that I could have my job back if I wanted to. So in all I was out of work for a few weeks. See, it was definitely clear that somebody done something to it, but it was proved that even if you turned the valve off there would be enough hydraulic pressure in it to move the machine for so long. So they more or less figured that they could have been wrong, that somebody else could have done it inbetween the first shift and the second shift. So, my union president told me, he says, you know, "They'll give you your job back—no questions asked. Otherwise we can go back and fight it."

MF: So the deal was you get your job back but you don't get anything for . . .

MC: No. I'm not going to get nothing for all my lost time. And I was scared, because I was married, I had two kids. I didn't know what to do, so I told my wife, I says, you know, "I'm going to take it." I said, "The union said they would fight for everything come next contract time." So I took my job back. Come to find out, you know, like that was one of the issues dropped in negotiations. . . .

MF: You mention this wildcat strike, and somebody sabotaging the machines—did people take things into their own hands a lot?

MC: Sometimes. Basically, the big thing would be like a slowdown. Like, if there were complications or conflicts, everybody would just slow down. The union

couldn't tell you what to do. It was just something that was, you know, more or less you agreed upon between the guys.

MF: Were there other day-to-day issues that you all had to fight for?

MC: Well, there was the clothing. See in the picture, I'm wearing protective clothing, to keep the scraps and the chips and everything off you. Well, we had to fight for it— they didn't want to give it to us in our department. At first it was basically just for the cast bench, where they used to pour the iron; the clothing was fire-retardant. We started fighting because we were just getting our clothes ruined, because of the breakdowns. Like the mill and the hydraulic systems were in such poor shape, they used to leak so much oil and lines would break, high-pressure lines, you know, blowing out hydraulic fluid. It would be nothing to put, like I said, fifty gallons of hydraulic oil in a pump in one turn. It would be leaking all over so bad and when you're just wearing blue jeans, one day and you would have to throw a pair of jeans out. Because you couldn't even wash them. So we started screaming and eventually we got the clothes that they would supply for us, they gave us the clothing and the goggles and the helmet, you know.

MF: And in what ways did the union make a difference in these things?

MC: Some good ways, some bad ways, you know. Unions aren't a cure-all, they're not. They can't cure all the problems. Sometimes they create a lot of the problems too. They have their good points and their bad points.

MF: What were some of the best points from your experience?

MC: From my experience, like come contract time, you know, the money we made. We couldn't complain. Where else could you go, right out of high school? In fact, a lot of guys that I worked with went to college after high school and they wound up coming back and working in a steel plant. So, like I said, it has its good points and its bad points. I suppose technically the union got me my job back.

MF: And the bad points?

MC: I think when you had a grievance, depending upon what your grievance was, the union just couldn't do as much as, supposedly, what it would be like on paper.

They just wouldn't have that kind of power. It's not like back in the thirties when things were forming, you know. It got to be a lot of bureaucracy, I think. Basically, everybody started going to most of the meetings when things started to get bad in 1979. I admit, myself, that I didn't go to a lot of meetings before that.

MF: OK, well, before we talk about the shutdown and what that looked like from your vantage point, I want to get a little on your family and background and how you came to be working in Shenango.

MC: Well, let's see. I graduated from Lackawanna High School in June of '73. I was trying to get into the mills ever since I got out of school. I started working in August at a place downtown, making rubber stampers and police badges. That was for minimum wage and in the meantime a friend of mine, he started at Shenango and after a couple of months he asked me if I wanted a job and I said sure, so I went in and filled out an application and a few weeks later I was called. So let's see, that was in November of '73 I started working at Shenango as a laborer. In fact, a month after, Bethlehem Steel called me, I took a test for millwright when I applied earlier for a job and I guess I did well enough on the test for them to call me. But I figured I wasn't going to quit one job for another.

MF: Even though the wages were really higher at Bethlehem than at some of the smaller shops? Was that not true for Shenango?

MC: Not true. Once you got on a job, like I was a post-mill operator, we were doing as well as them if not better. With the incentive and that, I thought we were making a pretty good living. I couldn't complain at all.

MF: Did you grow up here your whole life?

MC: In Lackawanna? I grew up my whole life in Lackawanna.

MF: Yeah, and was your family in steel?

MC: My uncles, my grandfather. My father, after he got out of the service, he tried it and he didn't like it. He liked a change of environment, you know, like going from

one place to another and not doing the same thing everyday. So he started his own business, he installed furnaces, heating systems.

MF: Were both your folks from here? Or were they immigrants?

MC: They were both from here. It would have been my great-grandparents who came over. From Poland. They died before I really had a chance to know them, but my father's father, he's still alive, he's eighty-one and he still looks good. He had, oh, forty-some years in Bethlehem Steel when he retired. I'm pretty close with my grandfather, since my dad died.

MF: Were they living in Lackawanna when your father was growing up?

MC: They were living in Lackawanna. Right next door from where we are now. That's where I grew up and that's where my father grew up. My grandfather built a house during the depression, he said he started in '29. Well, like growing up in Lackawanna, you know, most of the kids, their father worked in one of the steel plants, either in Republic or Bethlehem Steel or that. Back then you could get by with, after graduating from high school, going in and working at the steel plant. I figured well, according to the way the contracts were reading back then, thirty years and you could retire, I would only be forty-eight and that wouldn't be too bad. Or else maybe keep working.

MF: What was life like growing up as a kid in a steel town like this? What were the things you and your friends did, and your family?

MC: Oh, the big thing for me was like we had a cabin in the country, in Angelica, south of here, and we used to go out there a lot. We still do. We have 110 acres my family owns, my uncles and my grandfather. My grandfather bought it, let's see, thirty-seven years ago. It's mostly all wooded now, pines and hardwoods. And that was the big thing, growing up, whenever my father had some free time we'd go out there and fish. We used to have a boat. Hunting, too. That's the big thing for me. Deer hunting particularly. I like my deer hunting, every year I'm gone, Lynn doesn't see me for at least a week. I like the peace and quiet even if I don't get anything, it's nice just to get away. No phones, no kids, no wife, no nothing, you know, the solitude.

MF: Did your father hunt, too?

MC: Yes, he did, except he died before I was old enough to start hunting.

MF: How old were you when he died?

MC: Thirteen. He was thirty-nine. But, you know, I was brought up hunting and fishing. That's what I enjoy.

MF: Let's look at this picture of you and your family Milton took the first time. This is taken around '78 or '79, so you're about . . .

MC: Twenty-four.

MF: And the kids are . . .

MC: Jennifer and Angel. Jenny's the older one, on the left. And that's my wife, Lynn. I've been going out with her since I was seventeen. We got married a year and a half later. I was married young.

MF: Is she Polish too, and also from a steel family?

MC: Part Polish, like maybe a quarter. She's German and Irish and I forget what else. Her grandfather was a steelworker until he retired. Other than that, I don't think anybody else in her family was involved in steel.

MF: And is your mother still alive?

MC: Yes, she is. She's right next door. And Lynn's mother lives across the street [laughs]. I have both mothers, one living next to me and a mother-in-law across the street.

MF: Well, that's almost like a situation comedy right there.

MC: I know, well, sometimes it is. It gets to be aggravating, too, once in a while.

MF: At the time this picture is taken, you're in the same apartment here?

MC: For the last ten years now. I didn't think we'd be here that long. My uncle used to live here and he was building a new house, so I told my mom, I'm going to move in, you know until I save enough money for a house, figured in a few years, well, get out, you know, either buy or build a house. It helped a lot, you know. The rent was cheap, and I helped out my mother whenever I could, since my dad died. That was in '78, and then in '79 things fell apart.

MF: And you didn't see any big storm clouds on the horizon, then?

MC: No, nothing like this. Every year, you know, like towards the end of the year, like come November or December, you'd get laid off. But we always got called back in January, so it really didn't bother me too much at first. The longest one before that that I remember is I got laid off in June of '74 and I didn't get called back until January '75. I had like a week or two left of unemployment. It was always, you know, everyone will be called back. It was more or less, from my opinion, that the company just didn't want to get stuck with a lot of things at the end of the year, they didn't want to like stockpile a lot of things at the end of the year, so they would just lay some of the guys off. I suppose to their way of thinking it was logical.

MF: And to your way of thinking?

MC: After a few years it really never bothered me, you know. I figured it was more or less like an extended vacation. Always get by. So when I got laid off in October of '79, you just figure, well, it's the end of the year, I'll have time to do whatever I want for the winter. So I never seen it coming. But then comes January, nothing, February, nothing, March, you know, everybody's starting to get worried now because it never went that far into the year. What's going on and how come we're not getting called back? So that's basically when a lot of guys started to really get together and start pushing the union meetings, find out what's going on. We were told so many different things, you know—orders were bad, a lot of our orders went to Canada, the Canadian dollar was at such a low here they couldn't afford to pay the difference and everything.

MF: This is what the company's saying, or what the union's saying?

MC: Both. We were wondering who was telling us the truth and who was lying because we kept getting the runaround from everybody. The union wasn't giving us any answers. It just seemed to be the same old thing: "We don't know what's going on, we don't know what's going on." In the meantime they shut one of the other plants down in P.A. and things were really starting to get bad, you know. It's really hard to remember a lot of the details now—I've tried to forget a lot of it. Because after a while we figured, well, we have rights for severance pay: Are you going to shut the plant down, or what's going on? But the company, they just kept on saying that as long as there's even one guy who was there working, it's just a layoff—the plant has not shut down. So they dragged that on for, what was it, almost five years.

MF: And the reason for that was just to put off the inevitable and having to pay off a lot of the obligations they would have at that point?

MC: Yeah, that's what the majority of the guys thought. I had went to, not our local union, but the international steelworkers, to find out what was going on. We got a lot of runaround from them too, you know. I guess the unions don't have as much pull as they think they do, you know. The company is the company. They're going to do whatever they want. Like after a year or two, you know, everybody wanted the severance pay, and it was '83 or '84 before we got anything. And we had to fight for it, we had to take the company to court because they said like after two years you don't have no more rights so we don't have to give you anything. The arbitrator ruled in our favor that you still do have whatever you have coming. So we finally did get our severance pay. Not that it really—. I shouldn't say it didn't help, but it didn't help all the feelings, you know, and all the problems it brought around between the guys and the company because it took so long to resolve.

MF: And people hadn't felt that bad about the company earlier?

MC: No, not in my opinion, not at first. But when they told you you have no more rights, we don't owe you anything, you know? You can just throw fifteen or however many years you have away? And there's nothing vested? That burned a lot of people,

especially in Lackawanna. There's I think, like, per square mile, there's more bars in Lackawanna than there is anywhere, and after you got out of work everybody went and had a beer. Between the bar talk and the corner restaurant or something, it's all anybody talked about for a long time. Now a lot of them are shut down.

MF: And the tone of that talk was, what?

MC: Probably anger for the most part, wondering why they did this, why did they let the imports, and why did everything shut down just like that, you know. Bethlehem was the second-largest steel plant in the world. And now there's just about nothing. They've been tearing it down for years now.

MF: So what happened to you after that?

MC: Well, before I ran out of unemployment I started really looking for a job. Between March and May I think I put in over a hundred applications all over, anywhere, just about anything that would pay decent. And there was nothing. So I went and applied for what was called the CETA program, while I was still on unemployment, and they says, "Well they're going to be having a school taught by Moog," you know, for machinists, mill operator, lathe operator, things like that. Well, that don't sound too bad, so I applied and took the test and they says the program will be starting in May.

In the meantime unemployment runs out. We have to go and apply for welfare, there was nothing else. All the savings, everything was gone. Welfare was a bitch. When you told them you were a steelworker they says, "Well, why didn't you find a job?" You try and tell them nothing around, I says, "Hey, I got nothing, everything I have is gone." And welfare gave us one hell of a hard time. In fact, I almost got thrown in jail for threatening to kill a caseworker. The caseworker I got stuck with, I says, "Hey," I says, "I need something this week," and she told me, "Hey, it's May, the dandelions are out, feed your kids dandelion soup." That's when I lost it. I told her I'd kill her. That was it. "Feed your kids dandelion soup"! Well, when they called the sheriff, you know, I calmed down; it helped since I knew one of them, he was a friend. Eventually, we did get on welfare for, what was it, four months. It was either welfare or nothing. In the meantime Lynn figured, well maybe she'll go out and try

and find a job. So she took the test, you know, at West Seneca Developmental Center, where my mother has worked on and off for twenty-three years. She's a therapy aide.

MF: Up until then Lynn had been at home with the kids?

MC: Yeah. I told her when we got married, I says, "You don't have to work, I don't want you to." But she says, "If that's all we can do, you got to do what you have to do to survive." So in August of '80 she started working over there. I was still going to school, it was a six-month program. So it was September, I finally got into that program through CETA and I was doing pretty good in that. I was like halfway through school, I got sick, I was in the hospital for a week and a half, I had kidney stones. According to their rules they set up absences, you know, like if you miss so much time. "OK," he says, "you got a legitimate excuse." So I finished the program, I had like a 92 average in everything. At the end of the program they were placing people in jobs, and they told me, "Well, because of the time you missed, you know, we got to place everybody else on the program before you." I said, "Well, why didn't you tell me that before? You were having a hard enough time trying to place people. So, more or less, I went through the program for nothing." So I tried to go out on my own and . . . nothing. The program ended in November of '80 and April of '81 I was going through the paper and they were looking for security guards. So I went down to Pinkerton and put an application in. They gave me a job working as a guard being paid minimum wage. I figured, well, it's better than nothing. I work nights, 12 to 8 so, well, I'll just keep looking for a job, now I got a little bit of experience, security guard, maybe I can find something better.

So there was an ad in the paper looking for armed security, which happened to be the Federal Reserve. So I went down and filled out an application. A couple weeks later they called me in for an interview. Never heard of anything for a while, for a few weeks. So there was another security job in the paper, they wanted security where they were building the condos on the waterfront. I went down, the guy told me, "Well, you got the job." So I come home in the afternoon and told my wife, told Lynn, "I got this job," and in the meantime when I'm telling her the phone rings and it's the Federal Reserve saying we want you to come in tomorrow for another interview. So after the interview, you know, he says, "Well, we'll let you know." I says, "I don't mean to be nasty, but I have to know today." I says, "I got another job I was

offered. Either you got to tell me yes or you got to tell me no, because I can't afford to lose this other job." So, they says, "All right, you have the job." It paid better, it paid a decent wage, it had benefits and everything and it was in July of '81, I started working for the Feds. So I worked for them until July of '82. During that year I missed a few days of work, it come out to be like nine days of work. There was nothing I could do, I was sick. Well, they fired me. For lost time. I says, "I can't change it, you know, I was sick, twice." I had teeth pulled, I was bleeding, you know. I have sugar, I'm diabetic, I've been since I was a kid. I had problems so I couldn't go in, unless they wanted me to bleed all over. So they fired me. I went to the National Labor Relations, they said, "We can't help you."

So, went on unemployment again, unemployment run out. In the meantime my buddy knew this guy who was head of security at the racetrack so I got a job working security there part-time, worked there from July of '83 until February of '84. In the meantime I've been taking my civil service test, I've been trying to get better jobs, like for corrections officer, Erie County sheriffs, state police. Well, it was in August of '83 I got a letter from Albany saying you done well enough on the test we want you to come in for a physical for an interview, for New York State corrections officer. It starts out at real good money, good benefits working for the state. So, Lynn and me went to Albany. Went through the physical, they called me into an office, they says, "We got to turn you down." I go, "For what?" He says, "Because you're diabetic." And I says, "Well, wait a second, before I even applied for this I talked to people in civil service, they said it didn't make a difference." Started a big battle. I wanted to know how come I was told one thing and they do another thing, after I went all the way to Albany, just for a physical. They said, "Well, you're disqualified. We're saying you can't work 'cause you're disabled." See, they don't want to hire anybody who has sugar, who has any problems.

MF: You mean they knew you could have done the work but they don't want to have to worry about paying benefits?

MC: That's it. See, that's another whole story. Before I started at Shenango, I was turned down for a few other jobs when I went for a physical and they said, you know, "Do you have sugar?" I go, "Yeah," I figured it wouldn't make any difference. They says, "Well, we can't hire you with it." "An insurance risk," they said. So after I had my interview for Shenango, they says, "Well, tomorrow you go for a physical," and I

was wondering, what am I going to do? So I found a way to beat the system that time—I just had my brother pee in the bottle for me. They says, "All right, we need a urine sample. Go over to the john." So, that's what I did. I just went in the john and I gave my brother's urine.

So I got the job, and I was a steelworker all them years and it never bothered me. So I figured, well, I could do the work now. But everybody kept saying, "Well, you're disabled, you're handicapped." I was running into a brick wall, so I went to the New York State Rehabilitation Program and the lady got my medical file, and she says, "We really don't know what we can do. You should apply for Social Security disability." And after that I says, "Well, if they won't give me a job because they're saying I'm disabled, then they're going to give me disability." If I can't beat it, I'm going to join the system. But then—Social Security said no! They was saying I could work! So from '84 on, and '85, I had to fight for Social Security disability.

MF: So first they didn't want you to work because you were disabled, then they didn't want to give you disability.

MC: I could fill up ten tapes telling you what I had to fight through for Social Security. It was quite a battle. I called lawyers, I called civil liberties, I called everything. Nobody wants to hear nothing. If you would have came a few years ago, before things started to pick up, I would have just told you to get the hell out, I wouldn't have wanted to bother because there would be nothing good to say, it would have been just too painful to even want to look at. In the meantime, I started to have problems with my eyes, I've had them operated on eight times. I had laser surgery. Circulation with my feet, you know, it's bad. The high blood pressure, meantime my kidneys are starting to dysfunction.

So in July of '86 I finally won my case, and I'm on Social Security disability after fighting for two years, being rejected, going to court, going to see psychiatrists, all kinds of different doctors. It helps support the family. It's not what I want to do, but right now I can't work all day long. Like, it's an effort to cut the grass, I can't go out at night anymore, I can't drive because I can't see. I'm tired, you get tired real easy. I limp because of arthritis and the nerve damage. When I wanted to work, when I *was* able, they wouldn't let me. It's hard to beat the system.

LYNN CIESLICA [who had been listening in at the end of this interview and during a break requested another session in which she would join, focused on the home and

family]: You'll get the other part when we talk next week—because it wasn't just fighting the system, it was at home.

• • •

MF: You mentioned that you wanted to talk about things inside a family and the kids, in adjusting to the plant closing.

LC: The biggest change, I think, is just so many doors being closed in Mark's face. And now we've reached a point after all these years that, you know, you're afraid to take any chances, because you've been shot down so many times. Oh sure, a steelworker. I mean, how many skills do you really have as a steelworker? All you know is steel, so then when it comes time to move on to something new you have no skills and then with his health problems, you know, it was twofold for us. Now I'm working and he's getting Social Security disability but you still never feel stable. You always feel like that rug could be pulled out from under you at any moment and where do you go from there?

MC: Well, the last year's been pretty good. It's been better.

LC: With your Social Security it's been better financially, but the personality changes are still always there. And then me *having* to go to work when I still had the two small children at home. We had planned on, you know, the typical thing—when he was working at Shenango we had decided that he was making plenty of money at the time, so I didn't have to work. If I wanted to work that was fine. And I chose to stay home and raise the children, at least until both of them were in first or second grade where they would be in school all day. And it didn't turn out that way. Jenny and Angel were how old when Shenango closed, three and four years old? We were just scraping by.

The one good thing during that time was renting from his mother, which we still do now. We had family to help us through those times, and not just our own family. Like when they had that wildcat strike and all the wives got together and we were all on the phone with each other wondering what was going to happen and they were all calling me, asking me, "Well, is everything OK with Mark and do you need anything?" Who knew how long he would be out of work with this thing? And it was really amazing, you know, just that bond, you were like one big family.

MC: Well, a lot of families fell apart. A lot of the guys, they—how could I say it?—they more or less lived for Shenango, you know. In a sense we all did, it was the way we survived. And when that fell apart, everything that we liked to do or could afford to do, you just couldn't do it anymore.

LC: And living in Lackawanna, you had Shenango Ingot Molds, Hanna Furnace, Bethlehem Steel, and the list goes on and on, right around the city of Lackawanna. And Lackawanna thrived because of the steel industry. Now that was going downhill and I can remember Mark and I talking about the possibility of Lackawanna becoming a ghost town and what would we do. You know—it wasn't just losing the job in the steel industry, but your entire life, maybe your whole city. The place that you grew up in was going to be gone.

I think all of the wives, and the older children, we were all trying to encourage our men to get out there and find something else. This isn't the end of the world, you know, it's not Mr. Gloom and Doom, there are other things that you can do. In the beginning there was a big effort, all of us getting together and saying, "Look," you know, "You live in the United States. That door is open to anything that you want to do." And then after a couple of years of pushing this, some of the wives just got tired of it. The husbands were just, "That's what I wanted to do. I wanted to be a steelworker. I don't want to go back to school, wear a three-piece suit," and Mark was quite like that. He felt that there were no other opportunities, he blamed it on the whole government and said, "The United States itself doesn't offer me anything."

MF: And how would these kinds of tensions affect a family? Would either the wife not be able to take it or the husband would crack or people just would split apart?

LC: Yeah. Yeah. I mean, we did go through that whole time, like every other day, "I'm leaving. I can't take it anymore." One or the other of us. I can't say what it was that kept us together—we love each other, but the tensions were so great that it amazes me that we stayed together through that time. We were just building our lives at that time so there were a lot of things that you just had to learn to live without. And it wasn't easy. You wonder who to blame. You wonder what to do when you go out. You can't find a job. How're you going to support your family? You don't know who to turn to or what to do.

When I first had to go to work—had to, not by choice but out of necessity—for a couple of years I wasn't too easy on Mark either. It was like, "Why do I have to

work? I can't stand it. Why aren't you out there doing something?" Now it's reached a point even if he did get a better job, and were able to support the family just on his income, I would still choose to work. The kids are in school all day, what would I do with my time, you know.

MF: Tell me a little about what you're doing.

LC: Mental hygiene therapy aide at West Seneca Developmental Center. It's for mentally retarded patients with a lot with behavior problems. There's probably about eighteen hundred clients out there now, or two thousand. We had to go through like four months of training. What it is, is basically teaching the kids day-to-day living skills. Some of them can read a social studies book and answer any question about it but yet they can't tie their shoe. So this is where my job comes in. To tone their reading skills, if they have the reading skills, and to also teach them how to tie their shoe, to feed themselves, dress themselves. I work night shift, eleven to seven, which he's not too happy with but it gives me more time with the family. If we want to do family things, I'm here when the kids come home from school, so it works out very nice.

MF: The medical problems you talked about, Mark, do you trace any of that to the work in Shenango or this is from the diabetes you had from childhood?

MC: The only thing that I might be able to trace back to Shenango would be my eyes. Running the post mill, sometimes you would get iron dust from it on your eye. And if you didn't know it was there or if you think you got it out and it was still there, why that iron would rust. After twenty-four hours, it would kind of just go over your eye like a film and maybe for a week or a month it wouldn't bother you and then all of a sudden it would just get so irritated it would really get bad. So you'd go to the eye specialist and they'd try and scrape it out with a needle. It was sort of painful. But other than that, I really can't attribute my health problems to Shenango.

LC: [to Mark] You're being kind of light about it. I would say, yes, definitely. That the closing of Shenango and not being able to stay in the field that he chose to stay in did create a lot of the health problems that he has today. His doctor even told him, just not working and not being active for those couple of years, that's not good for your system. He got to a point where all he wanted to do was sit on the couch and

watch television or sleep half the day away, you know. He just felt like every effort was so futile, why bother? And that's when that whole role reversal thing started. Now he does the laundry, he runs the vacuum, he does the dishes. I go out to work, I cook the meals, and I do the grocery shopping. So that whole distinction of who's supposed to do what in the household has completely changed over the years. Neither one of us would have chosen this role reversal [laughs], if given that choice we wouldn't have chosen it.

MC: I think maybe—I'm not saying it would have never happened, but I think I maybe could have been productive a lot longer. It's hard to say now. Well like my blood pressure, for instance. The first time I ever realized that I had high blood pressure was when we went to Albany.

LC: It was right after the thing with the corrections department. We had made so many phone calls to make sure that this door was going to open, we were going to walk through and move ahead. We had put so much faith in that, just like with the steel industry at Shenango, we had so much faith in that and that didn't pan out, and now this is time two with the biggy. And we went to Albany for the physical and the doctor said, "Tough. You're a diabetic." And it was like, "How can you say this?"

MC: I told him, I said, "I'd waive all my rights, whatever I'd have coming."

LC: And I had agreed, too. But they were saying like, "What if he's in a hostage situation and he can't get his insulin and he dies?" That's the example they gave us! I got on the phone and just started calling law firms and asking them would they take a case, us against the state with this diabetes thing. And every one of them asked me, "If we take this case, are you sure that you and Mark want to get into that field? Because it's going to be hell for you. You might win, he would probably get the job in corrections, because it was a discriminatory thing as long as his doctors could show that he was healthy and normal in every other way and able to handle this position. But it's going to be hell. He might have it for a year or two years and then be fired for some other bogus reason." So that's when we said "No, you know, maybe the only route we have is to fight for the Social Security." Which we did. And we got it, finally.

MF: Well, now that you have the disability if you're sort of beginning to come out of the worst of it financially, that may translate into a bit more stability on the health

side, too. And if you get stable, then at least a few hours a day there may be ways you can get some work that can be done at home. Are you still able to do the things that make life enjoyable for you? You mentioned hunting before—can you still go out and hunt?

MC: Oh, yeah. There's ways to get around a lot of things. I can't walk so I bought myself an all-terrain vehicle to get around. I can't see as good so I have to put a scope on my gun.

MF: A lot of the families I've been speaking with, there's been a little cabin in the country, the guys are involved in hunting. Tell me a bit about that.

MC: Well, ever since I was old enough, I've been hunting. I used to hunt for sport because I enjoyed it, I was brought up on venison and rabbit and squirrel and everything.

LC: When deer season is coming up and especially during the real tough years when we were going through the aggravating things and no cash flow, I looked forward to that two weeks when he was going to get away because that was something he loved to do. When he would come back, if I saw him pulling in and he had those deer tied to the truck, I thought, we had food for the year, he's happy, he got his deer, and we would also go through a few months where there was very little arguing or worrying about anything. It was just such a release.

MC: I'm not saying we eat deer meat three times a week, but like once a week or every ten days or whatever. There's different ways of preparing it. You know, there's steaks, there's chops, there's roast, there's hamburger. There's no fat in deer meat. Very lean.

LC: So it's well worth it. It's not just the sport and release for him, but it was food for the family for those couple of years, like on welfare, no income at all and it really helped a lot.

MF: Was that true for a number of people that you know around here?

MC: I'll say. At Shenango, I'll bet you half the guys were hunters.

LC: Instead of taking big vacations, we would go out to the cabin for a few days, like Easter time, go out there for three or four nights, you know, and it was just excellent. I mean, to us, going to the cabin is like somebody else packing up their bags and going to Disney World for a week. We are outdoor people. We've even considered, where we usually go in the Adirondacks, the guy that owns the place is very, very old and this year he is too ill, he's not going to open the place. So I said to Mark, "Well, I'll send him a letter and tell him that we'll come and manage the place for him if we can live in one of the houses." And I told him I will just transfer from West Seneca to Tupper Lake, there is a mental hygiene facility at Tupper Lake. And that would be our ultimate dream, to be able to move up into that area. But the point we're at now, with me working and his Social Security, we're just looking at what we have now and our next big plan is buying a home. Getting out of this apartment and getting a house and getting the kids off to college; Jenny is fourteen.

MF: This whole period must have been really hard on your family.

LC: It lasted a couple of years. I think being so young was a big factor, too, and why we got as depressed as we did. And having two children. The kids are only a year and a half apart.

MC: It was like seven years wasted where all we did was, how could I say, just vegetate, you know. Where it wasn't like a lot of growing or anything, together. There's things we didn't do that you would always plan on doing with the family.

MF: How about with the kids? It can't have been easy for them.

LC: They came through it pretty well because I can remember Christmastime for a couple of years, beg, borrowing and stealing, you know [laughs]. Now this new picture Milton took was this past Christmas, and we didn't have to borrow a dime to make sure that the kids had a nice Christmas.

MF: So some other Christmases a picture wouldn't have had as much stuff in the background?

LC: It was there but it was either borrowed from someone or the money was borrowed so that I could go out and make sure that the kids didn't feel that impact. Or even other things, you know, when the kids were little and wanting to take lessons. Oh, Angel wanted to take piano and Jenny wants to take guitar and it's like the money just isn't there, I'm sorry, so for Jenny's birthday we did buy her a guitar, you know, and I bought her the Gibson Book and I thought, "Well, it's not the same as lessons three days a week, but here it is." And, for Angel, we got her involved with Girl Scouts which was very inexpensive but they do a lot of field trips and that type. We've always tried to find an inexpensive answer to the things that the kids have wanted.

And they understand. They know we don't have the money to do a lot of the things that they want and they know the whole situation with Shenango and the corrections department and all that, and why Mommy had to go to work when I did. They know all that. We're very open and honest with our kids. But I think the way they perceive the situation is his health problems—Daddy can't work because he's a diabetic and he has all these other problems and that's why he does the housework and Mommy goes to work, you know. Now I see them picking up a lot of the things around here that Mark always did. They're trying to help him out. "Daddy, why don't you go sit down and we'll do it." You get a lot of that.

So they understand. Jenny said to me one day last week, she said, "Mom, I really want to take guitar lessons from somebody professional," she said, "I'm just not learning like I want to from this Gibson book and my little folk guitar that you bought me. I want my electric guitar and I really want to go to lessons." And I just looked at her for a second, and she said, "But I don't mean that you have to pay for it. I'm going to get together with Angel, and maybe we could use the typewriter and print up some flyers and start doing yard work in the neighborhood." I just hugged her and said to her, "Sweetheart," I said, "that's probably one of the best gifts that you could give Mommy." At least I know that she realizes that as a family unit everybody has to work towards it.

And now that they're twelve and fourteen they can do this. They have that sense of value, and I'm real glad that they do because with us blaming the system for so long, a lot of people don't want to raise their kids in the system. But, I think for the most part the system does work. There's a lot of things that do need to be changed, you know, especially when it comes to things like diabetes, the handicapped, these people

can work and can be productive and I think that society as a whole needs to learn to open up those doors for them.

MF: Well that can help us turn this outward a bit. The term "the system" keeps coming up in what you both say. As you think about it now, what does that really mean to you? And from there we can talk about your sense of where the whole society is going now and what the implications seem to be.

LC: Well, the United States itself has gone through so many changes, it's been such a short time. We're only married fourteen years, and in fourteen years you've seen so many industries go down the drain. In my opinion, the United States needs to get back to some of the old values. I really feel that we've kind of lost sight of who and what we are, and we are a great country, you know, but we tend to take more in from the other countries then we are actually putting out and our people are suffering because of it. Even some of the small little businesses and stuff that used to be around years ago, that were putting out things for export, you know, they're gone.

MC: I just don't think that with this country, the way it could be, there's no reason for people to be starving or not working. We're supposed to be one of the most highly advanced countries in the world, and yet what is it, more than 10 percent of the U.S. population is on poverty scale.

LC: We're thirty-two, so in your fifties and sixties that's when people are thinking about retirement, and, you know, what are we going to do? What do we really provide? This country really does not provide for the people and even for those who want to make an effort to better themselves, the doors keep closing in your face. Industry has just turned around completely, and being a middle-class family we aren't seeing a lot of what we are reading in the paper—like the computer industry, okay, that might be great for part of the population, but we are not actually living it and touching on it. We are what most people describe as the American people. We are the hub of America. But yet we aren't actually touching on all these major changes, they aren't touching our lives.

And somebody says, "Well, what do you think the answers are?" I have no idea. You know, you have the right to vote. That doesn't seem to help. We have the right to

free speech. You write letters to everybody, you go and knock on doors, you try to find out what can we do to help, you are even willing to offer your services. You *are* America, and you want to get out there and you want to help, but where do you go? Mark and I have always looked at it to—. It hasn't only been to better ourselves and our family, but what about our children and their families, and their families to come after them? We have to set some kind of standards and precedent and I think a lot of the old values are the best. I really do.

MC: The majority of the people are for themselves and that's it, they don't want to get involved, you know, when it comes to helping somebody else. Forget it. They usually don't stick together anymore, the way they used to.

MF: Was that what you meant when you were talking about the older values?

LC: Right, right. Like with Mark, when he was at Shenango and they had the wildcat walkout—to me, that is a big part of what America is supposed to be. Everybody sticks together when you have a problem in a community or in a household, the whole community knows and they all stand behind you. You're not ridiculed or put down or doors closed in your face because of the situation. Everybody stands behind you and they work together.

MF: So in terms of the broader situation, rather than saying that the society is simply going from the industrial age to the postindustrial age, it sounds like if we had a sort of dividing line, you're both more on the side that says something's gotten off track, that we're losing a lot in the process?

LC: Oh yes, I think definitely we've lost an awful lot in the process. You know, we're still middle class and we're still living in the same community that our parents lived in and some of us their parents before them. Just working to live, enjoy life to the fullest and make a living. But now, you're either up on top or you're going to be on the bottom.

MF: And being middle class has meant what, to you?

LC: OK, we have a home, we have food on our table, we've been able to do a few things, vacations or like I said, the cabin, you know, just the basics. That, to me, is middle class. You're here, you're in America.

MF: Some people say, well, there's working class, middle class and upper class. If you've got a blue collar, you are working class, and you've got a white collar, you're middle class, and maybe if you don't have to worry about collars, you're upper class. Yet that doesn't seem to be the way you see it. The fact that you're wearing a blue collar and working in a foundry doesn't mean that you didn't think that you were middle class.

LC: No, I don't base it on the job. I think everybody works at living, you know, and whether you're out there on the streets with no roof over your head and just collecting your welfare check, or whatever you're doing, you're still working at living. Middle classes, which is as I describe us, you're a little more comfortable with your situation, you know the roof is going to be over your head and you know that somehow you're going to be able to put food on the table. And then you've got the upper class. And to me those are the Yale graduates and the people living in the $500,000 homes, but their money and their survival had to come from someplace. They are also working at life, you know. But it's just that we all do it in different ways and I think right now you have a definite dividing line between the three, you know. You've got those people out on the streets. You've got people like us. And then you've got the people above us who are comfortable financially.

Now we're at a point in America where the middle class, I think, it's going to be real hard for us to hang on to and to see our children hang on to this type of living that we had made for ourselves. You can't take life for granted anymore. It's a definite struggle. I mean America was always the melting pot, there were so many different opportunities that everybody could find focus. Everybody could find something out there for them. But now, it's not a line anymore, now it's become almost like a crater between the two—you either have to be making an awful lot of money or you have to be on the edge wondering, "Can I keep a roof over my head or am I going to be living in my car tomorrow?"

MC: Like they say the unemployment rate is so low now. Do they consider like, what about all the people that ran out of benefits? Or they're on welfare now. Are them people counted in the statistics? Or all the people that are working now for three or four or five bucks an hour that before were making a good living?

LC: All of our friends, we discuss this and it's like when we were growing up we knew that we had so many different choices out there, you could still stay in that

middle-income bracket, you know, with hundreds and thousands of different choices. Now, so many of them are gone in the United States, and a lot of kids won't have the opportunity to go to a good college and maybe take up, like, computer science. So where does that leave our kids?

MC: Last year, some twelve- or thirteen-year-old kid, they busted for selling drugs. He never went to no classes, but he was always in the school—the only reason he was going to school was so he could sell all his drugs, and he was making one thousand bucks a week. And they asked him why, and he says, "Why should I go to school and be a dummy like my parents and work and have nothing, when I'm making more money than they are and I'm not doing nothing?"

LC: And I think for our country, when we were in our greatness, years back, your politicians were not afraid to stand up there and say these are our people, we're so proud of the American people. Now, what you see is they are so worried about pleasing the other countries' needs and if we give them what they want, they'll like us more. It is still a great country, but we need to focus more on where we are at in this country, not what is going on in the rest of the world. We need to build here.

MC: It's more or less like filling the gap back up, filling in the hole. Things are always going to change, but when things start changing faster than the people can adapt, then there is something wrong.

LC: Like my grandparents—my grandfather was born in Pennsylvania, but his parents came from Czechoslovakia and Poland. During the war, he was a coal miner in Pennsylvania and then they had to move up here because the opportunities were better with Bethlehem Steel. And he said during that time he went through the same feelings that I did: Where is America going, what the heck is going on here in America? And he says "You will get over it, you will survive, your children will survive." But then I say to him, "But Poppy, where's the focus?" I would like to know that my kids have something set for them in their future.

MC: I think this, in the last ten years, this is the first time in three generations where things have really changed. Where there was a big change.

LC: Yeah. It's been drastic and very quick. If you look out our kitchen window, you could, until they started taking them down, you could see all the stacks from the steel plant, we used to watch the smoke. And it's all gone now—it's kind of amazing to look out that window now and there is nothing there.

MC: When you drive over the Father Baker Bridge into Lackawanna, and you look and there's nothing there, Bethlehem's half knocked down.

LC: Shenango's not there anymore.

MF: And that was your place, right there—you came down that bridge and saw the big Shenango sign on the side of the plant.

LC: Well, when the two kids and Mark and I, are in the car, Mark and I sort of look the other way, we watch the waterfront. And then you'll hear from the back seat, "Mommy, wasn't that Shenango?" And you look at each other and it's like, "Yeah! That's where Daddy *used* to work," you know, and you don't want to look that way. It's like, you know, it's in the past and leave it there.

Mark Cieslica died on September 6, 1990, two years after these interviews were recorded.

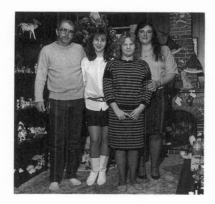

PART TWO

WOMEN IN BIG STEEL

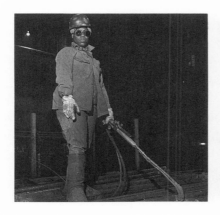 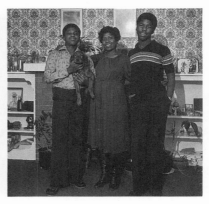

6 / DORIS McKINNEY

MICHAEL FRISCH: First of all—what's going on in this picture? A lot of people looking at it would not really know.

DORIS McKINNEY: No, they wouldn't. Most of my friends that saw this picture, they'd say I look like I was from outer space. But at the time, I was working at Republic Steel and I was a burner, so this is my burning outfit, because you have to have long sleeves, because the sparks are flying, shields on the shoes, you know. And this is a burning torch, and what it is, is these are pieces of steel that haven't met up to the specifications, they're quite long, so they burn them in sections so that the crane can pick them up, and they'd be placed in boxcars and shipped out. I think they melt them back down. And there's the burning goggles, and the reason the hat's sitting so high is I guess because I had my hair rolled up [laughs]. Because you know, when you get off from work, you always still try to be a lady, even though you're working in a man's job, doing a man's job, when you take off all of this here, you still want to be a woman.

MF: Could you tell me how Milton Rogovin came to take this picture?

DM: I had no idea. All I know is, I was burning steel, and they were calling my attention, because I had my head bowed down, paying attention to what I was doing,

so I looked up and my foreman said that he was going about taking pictures in the plant, and did I mind him taking my picture, and I said no. It wasn't a pose or anything, I was just doing the job. He didn't ask a lot of questions, just took the picture and asked could he come by my house to take another one. And I guess it's a good thing he did, because nobody knew that the "before" picture was me, until they saw the "after" [laughs]. So it was good that he took a "before" and "after."

MF: Would they always be tubes like this you burned, or are there different kinds of things?

DM: Oh no, this is just for burning scrap. I couldn't tell you the degree of the heat, but it literally melts it, melts the steel, you can see, just see the steel running down, it can be frightening. This is why it's called a burning bed, because they have certain gravels and stuff up under it, so that when the steel does melt down it wouldn't start a fire. Then after it gets hard they collect it up, they have this big, huge round magnet that picks it up and it's re-used, nothing is thrown away. It's really something to see the process.

Now, I used to burn with a bigger torch, too, it would sit right on the steel, on big steel blocks. We had to cut the ends off, on these blocks, and that would be an all-day thing. Sometimes they were so hot that we would have to put boards on them to stand on, because it would burn our feet. Because you're standing on the very steel itself that you're burning the ends off of. The scrap is not as bad, because the scrap you can burn any kind of way, but the other burning is precision. The order is for a specific size, and it is measured by the foreman and drawn on, and the burners— which is myself—we cut it off. So it has to be a smooth cut, there can't be any gashes in it. So this is time-consuming, it's hot, it's back-breaking, and the only thing you can think about is making the perfect cut.

MF: Now in terms of where this is taking place inside a mill like Republic, this is part of what department—?

DM: This is a finishing department. They chip steel, and they inspect steel. And they also saw steel, too. When the steel comes to us, it's already finished, as far as the texture. Then we inspect it, and when it leaves us, it usually goes out on the truck.

MF: And within the department, are the particular skills themselves a little sub-department, was there a group of burners with their own foreman, and that's who you worked for?

DM: No, uh-uh. It wasn't every day you burned. There might be days where you wouldn't burn for maybe a week or two, it's whenever the order specified. You would do different things. Other times I hooked, I hooked steel. That meant I would go in the boxcars, no matter how much snow, or how deep it was, and we would hook up steel to be picked up and carried to the various units. The hook is the hook that you use to get the chain through the steel. The steel is placed in a boxcar, on four-by-fours. Supposedly. Sometimes the wood is smaller. When you continually pack steel on top of each other, the pressure—

MF: Yeah, a four-by-four's going to be a two-by-two before long.

DM: Yeah, and it cracks, you know, it sometimes cracks the wood. So you throw the chain over the steel to be picked up, and you put the hook—which is just a long metal piece of a wire that you've curved and made a hook out of it, and you pull it through out from underneath. Then you hook it up, onto the crane, and they pick it up and take it to the designated places.

MF: And underneath is supposedly four inches off the ground?

DM: Yeah, but which it's not [laughs]. Quite often. Most often. Never [laughs]. Oh, my! In the snow, and you're cold, and the wind is blowing, and you're just trying to get this here chain, your hands are about numb, and all you want to do is to hook this chain, and no matter how you try it seems like you can't hook it [laughs]. So, it's an experience, it really is. Now you finish unloading that car, then when they finish inspecting it or whatever then it comes back to you, you have to wire it, get it ready to be shipped out. And that's an art, believe me—it seems easy, but it's an art to get this wire—it's quite thick, like the size of a pencil, but it's flexible, so that when you throw it over, you bring it around and then you have to throw it again. Now this calls for muscles, this is not something that just falls into place, it doesn't happen that easy.

MF: So when you entered there . . .

DM: I was a laborer, and that's one of the main things, to be a burner. That was the first level. And then from the burner to the hooker [laughs]. Sometimes it's easier to say you're a burner, then you don't have to answer so many questions. If I say, "I'm a hooker," "Oh, in a steel plant? All of those guys?" [laughs].

MF: Did you work pretty regular shifts?

DM: Nope! [Laughs] We worked swing. At one time I worked maybe three months, from four to twelve, then sometimes two months from midnight, then sometimes seven or eight months days. But other times, every other week I was changing, there was no consistency. You never would know. It went by seniority—the only way you would know how you worked was to look at the board Friday, before you left. *Friday* would tell you how you worked on Monday. Or maybe Saturday. Or maybe Sunday—they might call you up and tell you come in on another shift.

MF: How many people worked on a shift with you, and did you move with them, or get to know everyone else with all the switching?

DM: I would say around thirty or forty on a shift. Sometimes you wouldn't see people in your department for six months, except when you'd be passing them. Then there would be some times you would work a shift and you wouldn't know anybody, if you're in somebody else's place due to sickness or something. But sooner or later you would tend to know everybody. It got to be, a lot of times, just like family— sometimes you saw those people at work more than you saw your own family. And when you did see your own family, you were tired or asleep [laughs]. But I liked it. We worked hard, it's not an easy job, but once the job was done you could have a few minutes to yourself, and sometimes you could pace or time yourself, too, and just take a break. I think with me, the way I am, is that I could make it better in the steel plant than at Chevrolet or Ford, you know, assembly line, they're much more confining. Like with a steel plant, you had a little more leeway, you didn't have just like a nine-to-five job with a ten-minute break at this hour and a ten-minute break at that hour. So if I had to go to the bathroom, I just went—if they seen me going, they knew where I was at [laughs].

MF: What's the story of how you got started there?

DM: Well, the story of my getting started there was that I was on welfare, and they had the WIN program, and they sent me to Republic, and I filled out the application, and a week or two later, they called me. I remember at the time that I got hired, that it was all women, mostly women that were hired. I guess maybe that was the time, in '77, was the big push to hire women. From that time, from '77 on, to '78, a lot of women was hired.

MF: That's a big change from welfare to . . .

DM: It was, it was. I'd been out on many, many interviews before, and I didn't think anything was going to come of it, you know—wasting my time, that's what I thought. And when they called and said that I was hired, I was just excited, elated, I said, "Gee, my prayers have been answered."

MF: What was it like starting out there? You'd never had any experience anywhere close to a steel mill, I guess—or had you?

DM: Nooo! [Laughs] No way! It's a lot of resentment. The men resent the women, for being there. There still was a resentment that the women were taking away the jobs from the men. So I just told them, I says, "I never really wanted to come here, you know, just nothing about this place excited me, but I was sent here." And I says, "You know, I have two children and when your kids go to the football games, mine'd like to go to them, too, and mine like those sneakers same just like yours. If somebody else was buying them, then all well and good," I said, "but my kids are no different than yours. If they had a father, or that man to be there to take care of them, I wouldn't be here! But since they're not there, I want to give them the same thing that you're giving yours." And from then on I never had any more problem out of them. And they turned out to be some really great guys, they were very nice, very nice people to work with. But sometimes you have to let them know that—you know, some people do come with various attitudes [laughs]. You have to clear the air. They know nothing about you, nothing whatsoever. It's just something that they've formed. And being that you were a woman in this situation, you know, men would try you, and if you carry yourself in a ladylike manner, they respect you, they do.

MF: You didn't have to try to be one of the boys?

DM: No. If you wanted to be one of the boys, they would tend to treat you like one of the boys. I didn't want to be one of the boys. I wanted to be one of the girls [laughs]. But I also socialized with the men, too, because a lot of times, when you're working very close with a man, when you have a break there is no woman to talk to, there is only that man. But we talked about family, we talked about kids, and how you were raising them, and what they were going to school for, and things like that.

MF: And the women in your shop, when you were first getting there, did they tend to be really helpful?

DM: Not really, no. Not really at all. They were more or less sitting back watching you, you know, to see what you were gonna do. And I would talk, I'm not—. When you're going on a new job, you know you're very, very scared, and especially in a steel plant, you're scared of everything, so you tend to sometimes try too hard, or you're maybe too friendly, or ask too many questions. And when you're dealing with a lot of people, you're dealing with a lot of people and their personalities. Everybody are not talkers, and everybody are not open, so you find the ones that you can talk to, that are drawn to you, and in the end they will be the ones to clear the way for you. I remember that the burning torch that I was telling you about, I had to learn how to burn the steel. And we had three months before your probation is up. And I could burn the steel, but the torch still seemed too heavy to me to pick up, and I would kind of drag, and pull, and drag, you know. And the guy that I had been working with, he was giving negative reports about me, that I couldn't pick up the torch and everything. So one of the other foreman said, "Well, she can do her work, I think." So I had about a week to go, and it was going into something like Labor Day, he brought me in the office and he said, "Well, if you don't pick that torch up when you come back from vacation you're through." Just as simple as that [laughs].

And you say, going from two—let's see, I think how much I was making, maybe three hundred a week, and the thought of going back to the welfare and making three hundred a month—the whole weekend, I cried and I cried [laughs]. When I walked in there Monday, I could pick the torch up and walk with it and anything else. Because it was psychological, you know. I knew that I did not want to go back to

living like I was. And if there was any ounce of strength within me, and if other women could do it, I can't see why I couldn't, and so I did.

MF: So did he call you in and say that's OK?

DM: Oh no, no, no, no, no, never! Their main job is to try to make your life miserable! [Laughs] Oh yeah, I made it through the probation, and after that, you know, it was OK.

MF: What happened around the time the place was shutting down? Is that something that got talked about a lot before it was happening, did it catch people by surprise?

DM: No, that's something that in the steel plant, you hear all the time. All the time, even when you're working real good, there's always a rumor going around that they're going to lay off, you know, and then, well how long would it be, oh, maybe two months, maybe three months. But no one really thought that it would be this long, no, or even that it's a possibility that the plant might not even open back up.

MF: And when it happened, did they generally tend to accept what they were told? Were there different thoughts about why it was happening?

DM: Well, they tend to accept what they were told, but the idea was still there very strongly that this was just for seven or eight months. Then when it started dragging out to be longer, that's when fear set in, and therefore the unity was gone. Because, you know, the people that you would work with eight hours a day, now you might not even see them unless you were down at the unemployment line or something. You would see maybe five or six people, and then there would be times over a month you might not see anybody that you had come in contact with.

MF: So you're saying, if it had been announced at one time, then everybody would have been together?

DM: Oh, yeah, it would have been a massive thing, I think it would have been, oh. . . . But then, what good would it have done? Look at Bethlehem. They announced

it, they said what they were going to do, and they did it. But with us at Republic, people would work maybe two or three months, and then get laid off again, come back maybe work a week, and get laid off again.

MF: So that really keeps anybody from having a sense that it's happening to everybody.

DM: Yeah! Right, because you don't really know! I think when the realization really struck them that this was really happening, was the fact the canteen closed down, and the nurses and even your security guards, they were being laid off. Then you had that feeling of doom, you know, that hey, this place is gone.

MF: Let's look for a minute at this other picture with your boys, here. Could you just tell me a little about yourself, and your own family, and where you come from?

DM: Well, I was born in Alabama. And we moved, I did most of my schooling in Cleveland. I married in Cleveland, I married my high-school sweetheart. And we— my husband he was in the service and went to Germany, and my oldest son and I, we followed, and my youngest son was born in Germany. And when we left Germany, we went to California. And in California, my husband and I separated and then I moved here to Buffalo.

MF: Do you still have family in Alabama?

DM: Yes. My grandparents stayed down there, but my mother and father came to work in Cleveland. I guess they were looking for the northern horizon [laughs]. Even when I was going to school, I remember, all the younger people moved from the South to the North, and generally the older ones stayed, or else they would move to the North and then come back.

MF: Was your family farm people?

DM: No, we all lived in town, but it was a rural town—Bessemer, Alabama, it's twelve miles from Birmingham.

MF: So—there's plenty of iron and steel work around there!

DM: Yeah, it is. Now my grandfather, he used to work in the steel plant, and my uncles, and I have a couple of cousins that still do, but I think they have been laid off the past couple of years, because they're not doing any steel there either, you know.

MF: And how did you like living in Germany?

DM: Oh, I loved it! I'd never been away from home, no more than travel back and forth to Alabama to see my grandparents. We had three years, and we stayed an extra year. I got to go to a lot of places, I got to go to a lot of countries. I went to Spain, Paris, Copenhagen, Denmark. And I wanted to make every effort to get to learn German, which I did. Even my oldest son, he was going to a little kindergarten, and it was all Germans, and that's all they spoke. We had the opportunity to move on base, but I didn't like it, I liked being with the people. And my landlords downstairs, they didn't speak any English. They used to call them Oma and Opa, they used to pick my son up at school, and one day they were late picking him up, but everybody in the little community knew who he was, you know, and they would take him home and wait for the Opa.

MF: And then you came back to California. How did you come to Buffalo, did you know people here?

DM: Yeah, I knew some people here, and so I said, well, after my husband and I separated, California was so far from my family in Cleveland, so I wanted to be closer, but I didn't want to be right *with* my mother [laughs]. And I knew friends here and they keep encouraging me to come and give it a try. And I've been here fourteen years now.

MF: You went to Erie County Community College; I see your diploma sitting back there.

DM: Yeah. And took up occupational therapist's assistant. So when I graduated there, I started working at Republic.

MF: And you were on welfare before then, and also while you were in school?

DM: Yeah. Let's see . . . I graduated in '77 . . . so it was the last of '74, '75, things started changing. Things were really tight. I couldn't find anything, couldn't find nothing, absolutely nothing.

MF: Did that feel like a defeat to go on welfare at that time?

DM: Um-hmm. And not only that, it just felt like you know, you always have higher hopes for the future, and when you're reverting backwards, then you feel like you've got on the rock bottom, so it was a very depressing time. And there was nothing to foresee anything that was going to be different. So I had made up my mind that I was going to go back to school. And that's what I did. And this steel thing came up [laughs]. I graduated in May and I started working at the steel plant May 31, 1977.

MF: You mean you had no chance to work in occupational therapy?

DM: None whatsoever.

MF: So was going to work in a steel plant also a step backwards, or in other ways it was a step forward 'cause it was such a good, high-paying job?

DM: It was a step forward because it was a good, high-paying job; it was a step backwards because it was not the kind of job I wanted to do. So it was very depressing for me. And then to have to keep the job—it was by no means helping a patient recover from a stroke, or a mental patient do something with their leisure times. This is what I had been trained to do, plus I had gotten a job offer from Niagara Falls, at Memorial Hospital. But the wages were starting out very low. And we had been deprived for a long time, and the money outweighed the experience. And who was to say that the other job was going to work out? So, once I took the job at Republic, you know your whole mentality has to change in order to keep a job, you can't continue to see yourself doing something else.

MF: You can't say, "I'm 'really' an occupational therapist. . . ."

DM: "Really." Yeah, just doing this temporarily. No—you got to be all or nothing. I thought that you could keep up with reading, and keep up with your *AJOTs, Journal of Occupational Therapy*, journals, you know. But you can't keep up unless you're actively participating in it. So then you finally make up in your mind, you say, "Well, as long as I'm going to be at the job I'm going to do my damnedest to keep it, and get some of the things I want, and if the time comes, then so be it, I'll go from there." And just as it happened, when I got laid off, then I said, "Well, maybe it's time to see if I can get a job in my profession."

MF: So when the steel job finally ended, you had another rough period before getting your therapy job?

DM: I can't say that it was rougher, because [laughs] it wasn't. I was finishing drawing my unemployment, but this job came before that ended. I went out and filled in an application at State Hospital. And they called me, for the interview. At first I thought they were very prejudiced towards me—not because of color, but because of where I had worked. Because the people that were sitting there interviewing me, I had made just as much as they were making. And then, you know, they would ask me ridiculous questions, "Well, how are you going to live now," making— I think the beginning salary was like $11,000. And oh—they made me so angry, I was so upset [laughs]. They just think, you've been used to making so much x amount of dollars. But you didn't make it all your life! It's so funny how the world has changed around. Because the people that were used to making a lot of money now are right back to making minimum wage. And they're living. You ain't found too many of them have jumped off the tower.

MF: So what kind of job is it, this is in the state hospital, the mental hospital, what kind of program are you . . . ?

DM: Well, I work with geriatric patients. And I do various crafts and arts with the clients. And leisure, and some are constructive. Oh I love it, I love it. I can't tell you how happy I am to be doing it. I feel like I've come full circle, now. It took a lot of detouring, and stuff, but I feel that this is what I would want to do for the rest of my life.

MF: Now tell me about your boys a bit. I probably wouldn't even recognize them, since this picture's now, what, two or three years ago, I'm sure they're probably up to here. . . .

DM: David, the bigger one, he's out of school now. He went to McKinley High School, he's working at Anaconda Brass now, and he's been there, I think, two years.

MF: And the young one, what's his name?

DM: His name is Donald, he just finished high school in June, and now he's in the Job Corps in Cassadaga, New York. They had an article in Sunday or Monday's paper about them. They give you on-the-job training for better jobs like carpentry or word processing or plumbing. Plus, they give them like an allowance, and they stay the whole week, so they get a lot of discipline. He's up at six, and he has to be in to bed at ten, and then if they, you know, earn the discipline and school work and stuff, they get a weekend pass home, so he's home every weekend.

MF: Do they tend to be optimistic, the kids, given all the ups and downs they've had with this, in terms of . . .

DM: Well, I guess it's more or less patting on the back, but I think they have a good outlook on life. They know all the ups and downs. My oldest, he has a fantastic work record, I don't think he's missed two days in two years, he likes what it has to offer. He moved out in September, so he's got his own apartment now.

MF: Does it feel a lot different, now you've got them both out of the house, that must be a real change, because you've been with two kids for a long time.

DM: Oh . . . twenty years! [Laughs] So, it's a change, it's a transition that I'm still adjusting too. I haven't really met the completeness of it, because after you've been around someone, even if it's your child, for twenty years, to be alone is something that's quite different. And I'm still trying to learn the right way to adjust to it. Because I always worked or was going to school, plus raising two kids, so now I only have to work and take care of myself, and I have a lot of time—and I don't know

what to do with it! [Laughs] So I've been reading a lot of books on this new transition in life, what is it they call it, the mid-life crisis, and passages from, you know—out-of-the-nest syndrome, empty nest, yeah [laughs]. So, I've been reading some of this. I just haven't found it yet.

MF: Do the boys both think they'll be staying in Buffalo?

DM: Oh, I'm sure of it. Unless something happened, but I'm sure the oldest would stay, and even the youngest, unless he goes into the service. You have to have roots someplace, and I like to establish roots and stay around them. I could leave, the kids are grown. But then you figure, well, you want to be around your grandkids, you don't want to be so far away that you're isolated from your family and your kids. And I like my job and I don't want to leave. I like my house, I like my neighborhood, and one thing about it, my neighbors look out for me. You know, even though I'm by myself, they know my comings and goings. We see each other an awful lot in the summer, but very little in the winter. But we're still aware of the foot-tracks in the snow, and how many's going, just little things that make you feel a part of it.

MF: You think Buffalo's going to come back up?

DM: I think it's going to come back up, I think that it has a lot of potential. You just all can't run to the southern states. I know people that just picked up, and they're right back here—because it was harder there than it was here. Well, one thing about it, you got to have hope [laughs]. Like at work, they were saying, at the rate we're going we'll probably have a war and then you won't have to worry about it, because it'll all be booming again. But that would be the last thing that I would want, because I have two sons, I'm not interested in any wars. Really. But it was so sad, I couldn't help cry for those families on the TV, just before. Because those were middle-income kids, middle-class income, and young. Right out of high school, nineteen and twenty.

MF: What, the people in Lebanon, you mean?

DM: Yeah, the Marines that got killed. Nineteen and twenty, you know. Just out of high school.

MF: When you think about all these shutdowns we've had, what do people tend to think? Is it just the way the business went, do they talk about foreign competition, do they feel the companies made as good an effort as they could have to modernize the plant, or what?

DM: Well, with Republic I think they felt like the company did make a good effort to modernize, because I remember, they put in I don't know how many thousands of dollars for this new blast furnace, they've got a lot of new equipment in there that I don't even think has been used. So that they had been pouring the money into it. I think they more or less thought the real reason was foreign steel. The cars, the autos, that they weren't selling a lot of automobiles. The unions did try to get the TRE for Republic—you know, the subsidized money to train you in some other field, because of the foreign imports. Well, let's see: General Motors got it, people at Bethlehem got it, but Republic did not get it—each time it's been denied, because they were saying that their steel was virtually sold in the U.S., so they don't feel Republic was hurt by the foreign steel.

MF: There seems to be more anger about the company at Bethlehem than at Republic. In general you had a good relationship with the company during most of the time you worked there?

DM: Oh, yeah! I thought it was a good company, I thought it was a very good company. There was hope that maybe it would open back up. I don't foresee it for Bethlehem, but I do foresee it for Republic, because it's a smaller plant. I don't think the people are angry with the company. I don't think they had an answer, really—it was just the economy dropped. I don't know, it's a little too high finance for me [laughs]. Now they're handing these people these four-dollar jobs. But at least that's a start. We just have to do the best we can. It's better to say, "Oh, God, I hate to get up this morning" than to say, "What am I going to get up for, I don't have anything to do."

I've had it both ways. I've had it handed to me where you're just terminated, just like that. That's a terrible feeling, like where would you start again, you have to start from the beginning. But maybe that's better than this thing we had at Republic, chipping away at you, and you're given a little bit of hope, and fed at you all the time

that you'll still have a job, still might be called back from time to time, so you haven't lost all sense of ground and security. It was a slow nosedive, see, that just chipped away at your savings, your life. When things are cut and dried, then you know what you have to do. But when things linger on, you're afraid. And I think it made a difference in people accepting you for another job—what do you want this job for, as soon as Republic calls you back you're going to quit. And *you* know you're going to quit, *they* know you're going to quit, but the fact still remains that you need a job, whether it's paying four dollars or three dollars, or twelve. So it might have been more easy to accept the fact that this job is shut down, I'm not going to go back anymore, and now you got to go on.

MF: Well, there's no good way, I guess.

DM: Well, no, no way is a good way to lose your job.

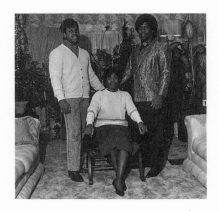

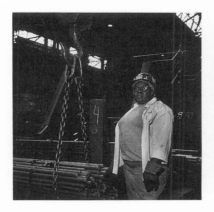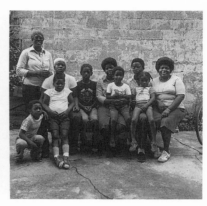

7 / EFFIE EDWARDS

MICHAEL FRISCH: Let's start by talking about this picture of you working. You said you were at Bethlehem Steel? What's going on, what's happening when that picture was being taken?

EFFIE EDWARDS: I was working on the cradle, banding up lifts. It's the thirteen-inch mill, at Bethlehem. I was banding those lifts up. You band them up, then the crane takes them away. See the chains there? We hook them up and the crane takes them away.

MF: These are solid tubes? Or were they hollow or what? And what would they be used for?

EE: No, they're solid. I think they would use them like in building these through-ways, you know. Now they may not need one that long, they cut it to whatever size they needed, you know. It comes, it would be a bar, I don't know how long, and then the shear operator cut them up. Slip-maker weigh them up. And we have to put so much weight into one lift. And then trucks come in and they load them onto trucks and take them to different cities.

MF: And is that the thing that your mill, this thirteen-inch mill, usually turned out, or did they make all kinds of different . . . ?

EE: They make all kinds of different. They make flat bars, those are used for springs on a car, and they have some bars about, oh, I guess they runs about as big around as my arm. One thing going at one time. But then they can change this mill, they have what you call a roll change. And when they have a roll change, whatever size of bar they need, that's what they change it to. Either flat or either bigger round. We would get big orders from Ford and Chevrolet, we would be on that order for maybe two days or something. And we would run into small orders, too, maybe four of five bars and then they'd change.

MF: And what other kinds of things did you do aside from this or is that what you did most of the time?

EE: Well, this is working on the cradle. And I did slip-making, we had a scale, we weighed it on it, and then we would write down the weight, the length, and the slip number, the number of this steel, the heat, and all that. And I did heat chasing—you pick up the heat slip and bring that down to the slip-maker, you would give the operator one, he would have to know what is coming down, you know—what grade of steel and who it's for and everything. And I would sometimes work in the billet yard, getting these billets out, you know, before they go into the mill, get them lined up before they go into the furnace.

MF: And is that in a different building or just a different part of this building?

EE: Different part, in the same building. But you take, for instance, it may start from, let me see . . . which way did you come into here?

MF: I came down St. Louis Avenue, off of Genesee.

EE: Well, we probably start rolling from like Genesee to here, about two or three blocks. That's where they start. First it goes through the furnace and it stays in there 'til it gets red-hot. Then it starts rolling it. It's soft like a cube. Maybe that cube is as long as from that side of that house to this side of this kitchen. But when they get down in toward the end, you's amazed how they can do it. Maybe they would want something small as my thumb. Mill it 'til it gets down there.

MF: Now when it comes out, is that when they cut it—while it's still hot?

EE: Uh-huh. It have a cooling bed it goes on, and maybe sometime when you get through racking it all in, it come to the shear operator, maybe done got cool a little bit, but it still be smoking and hot. When it come out the mill, it is red-hot. Red-hot! When it gets down to us it's cool.

MF: So it gets picked up and brought to your area?

EE: No, it don't get picked up. It's still on some kind of roller until it gets to us, and when the shear operator cut it and it come down to us and we finish it, *that's* when it gets picked up. Right there is the last stop, what I was doing that particular day.

MF: And when you were doing, let's say the weighing, would the crane move it around, or did you actually have to pick up these things and move them onto a scale?

EE: Did *I* have to pick them up? [Laughs] No! No, a lot of people will ask you that, you know, if they found out you were working in the steel mill they would get curious about it. "How do you, how can you do this?" We didn't pick up any of this. We was taught when we first went into safety class, they didn't want you to pick up anything that was going to hurt yourself. See that? You hooked that up there and the crane take it away. No, you can't lift that! See this, right there? That's another one right there.

MF: She's pointing just right in back of where she's standing. . . .

EE: They roll that down and they dump it. They had some little arms come over, you push a button, it would go up, drop it over in the cradle, and when he get the amount of weight over in there, then we would band it up, you see those are bands. We had a band gripper, we'd tighten it. Then we had a clipper, we would clip that band on there and, let me show it to you, it had a little clamp we'd put on there, we'd clamp it with that band, and that would hold it, it wouldn't bust. Now since they put that new mill in there, remodeled the mill, the only time we had to work with the hand bands is if it get out of order or something. But now, they got it where the new machine, it

puts the band on itself. Then we put a tag on it, like, for different companies. Put the tag on there, put the number on there and you have the heat on there, length and the grade of steel.

MF: What would you say was the hardest part of this job?

EE: Well, I tell you, it wasn't too hard, you know, if everybody worked together, it wasn't too hard. Now some people will monkey around and you have all the work to do, but this really wasn't too hard. Like, now, when we would do like Chevy, Ford—maybe they wanted eight bands on their lift, so that's why you had to have more people to do that.

MF: And did you enjoy this work?

EE: I enjoyed it, I loved it. The money was, you know, you made a pretty good buck there. And like I say, some days you had to work kind of hard, according to what products you're making, you know. This [photo] is taken in the daytime, and it's the early part of the spring. I don't have on much clothes here, but during the winter you'd have to be bundled up so, it would be like you was outdoors. The little heat they had around there, you can't keep warm by that, you know. And then before they put this new mill in there like when we was rolling cores we had to band those cores up—hot, it would be *red-hot* when they come around to us. You would have to get out there and band them while they're still hot. Go out there and do it and get back! Because it would be burning up.

MF: When you first started what was the first thing you did?

EE: When we first started, for about like a month, they just had us like cleaning and then, after the month, they start to swinging us. You would work days, evenings, and midnight. Like I worked 7 to 3, 3 to 11 and 11 to 7 in the morning. That's what you call swinging. Work in the morning one week, next you could change shifts in the middle of the week. I liked the midnights.

MF: What did you like about the midnight shift?

EE: Well [laughs], I don't know, maybe I shouldn't say it, you know, the big wheels wasn't around and it was nice.

MF: How did you get started doing this work?

EE: Working in the steel plant? Well, a friend of mine called me and told me they was going to start hiring at Bethlehem Steel, and I went out and put in an application and I got hired. They was going to hire womens. Republic Steel had hired some womens but at Bethlehem Steel they said they wasn't going to hire any womens but they changed and said they would.

MF: So you were one of the first women in that plant then?

EE: I was in the first group. It was the 15th of September, 1969, that's when we started. I never had did any work like that before, you know. Mostly I had been working in canning factories, in apples, and I worked in the pickle factory for a while. I used to work in there during the summer months, evenings, you know. My husband would be home with the children. Then in '69 when I went to Bethlehem Steel, John was six years old so he was in school all day.

MF: And did you feel nervous going in there at first with this change?

EE: Ah, you know, you feel a little nervous. Wherever they needed you, that's where they would put you. We were so many womens we'd be on each shift, you know. There was quite a few of them. But after you'd been there for a couple of days it was all right. Once they show you, you know, it's not too hard. Because they always have somebody to show you for every job if you've never been on it before, whatever job it is, they had someone show you. They was pretty nice. I give them credit for that, it was pretty nice, it really was. Well, I feel good laying down in my bed at night, you know.

MF: And did your kids find that strange that they had a mom who was a steel-worker all of a sudden?

EE: Yeah, well . . . like when we'd get laid off, they would say, "Mama, don't go back. Don't go back." They didn't want me to go back but you know, I went on back. I enjoyed it.

MF: So how long did you work at Bethlehem, in all?

EE: Oh, I started in '69 and I came out in '85. I took that early pension. And in July we'll be able to draw my pension from downtown, from Social Security. I already put in for it.

MF: So you're starting in 1969 and '70, you were there from the period when it was really going pretty strong to watching it slow down and slow down and slow down. What was it like, to see that change?

EE: Well, you know, it was a sad situation. We had quite a few layoffs, in between, from '69 to '85. The bar mill really didn't get shut down completely. Maybe they was shut down for a while but the older guys would be working, you know, they would lay off the younger people. When the storage beds and the twenty mill was rolling, maybe they would send you over there and you could go over there and work. But them departments is completely closed down.

MF: So then what you saw during those years was on and off and on and off and so forth. Did you have much sense that the thing would close down completely?

EE: No. No. No! Didn't anybody expect a place like Bethlehem Steel to really close down like they did. Mens had been out there for thirty-some years, you couldn't imagine it going down like that. You wouldn't have thought *Republic* would have went out of business like that, I had quite a few friends working over there and you wouldn't have thought those places . . .

MF: What did people think was making it happen like that? Did they blame the company or the union or the Japanese or what?

EE: The Japanese, I think. Steel from overseas. I think that's what it was. And they were feeling like the company wasn't doing their part about it, you know. They were letting it slide. Like going in Pennsylvania, they're still working, so now why couldn't they stay over here? And the union, they didn't think they was doing their part. I would go to the meetings. Arguing. Arguing. A lot of arguments, you know. It was

really hard for a lot of the people, because they felt like they been out there all those years and they couldn't get no job, no decent job here in the city, you know. That was really hard to take. The years you been in the plant they add up, and I think you get so much points. Then you would take on retirement if you want it. That's the reason I come out. A lot of people took it. I came out in '85. They had shut down a lot of departments when I did that.

MF: What's happening in these steel mills in Buffalo has happened a lot of places. What do you think about where we're going with all this? When you look at your grandkids and the world that they're coming into and they're not going to have these opportunities to get good paying jobs in the steel mills . . .

EE: Uh-hum. Unless some other company come into the city and open up something. But mostly the young people, I don't think they would want to work someplace like that. You know what I mean? They want office jobs. They don't want to work in no place like that. Because they don't want to get dirty [laughs]. To them it's a bad thing. And some of them don't want to work like nights, you know, or evenings. They want to work days and come home at night. Those are the kind of things they want to do.

MF: Well, what we want to do and what happens are sometimes two different things. If you were talking with them, do you see how they are going to get to be able to do that? There's a lot of talk that new things are opening up but they are things that you really have to have a lot of technical skills or computers or something. Some people are afraid that instead of the whole society moving on up, that there are some people up there who are going to be working on the computers and there are other people who are going to be working at McDonald's, or doing these service jobs.

EE: Oh, yeah. You know, computers—that's a good job, you know because everything right now is going into computers. Like when they put that new mill out there at Bethlehem Steel, most everything on that is computerized. And it's a good thing if they do go take that up, you know. It's still open if they take advantage of it. They're going to have to stay in school. I advise all young people to take advantage of it, you know, and try to get an education.

MF: OK. Now let's shift and talk about your family in this other picture, because this is made more or less around the same time, right?

EE: Right. The same year, around the Fourth of July, or Memorial Day. This is my daughter, Brenda, and Felicia . . .

MF: She's going from the left. The tall one standing up is Brenda?

EE: Yeah. And this is my second daughter. This is my third daughter. This is my fourth daughter. She lives in Louisiana. Her husband, he worked for Chevy, he was transferred out of town with Chevy. And this is my youngest son. I have four sons. This is the youngest, John. That's me right there. And that's Daniel, you saw that tall boy when you came in, that's him. This is Felicia's son, Andre.

MF: So at this point everybody was living in Buffalo?

EE: Yeah. Four sons and four daughters. They're working in different places. Some is laid off. My oldest grandson, he just came home from Alaska. He did three years in the service. He's out now.

MF: OK. Let's, just to make sure we got it straight here, let's connect these people here. So we're looking at the new picture, and I think you stood them all more or less in the same order?

EE: Yes, that's my youngest, John, he's that fellow there, he'll be twenty-five in November. He's working for Sears and Roebuck and he goes to school nights. And this is Latasha. That's my granddaughter. This is Daniel, just come in the door. That's him right there. This is Andre.

MF: OK. So we're moving right across the whole picture. Right? The tall fellow there, Andre, is the one in the old picture who's . . .

EE: Sitting on his mother's lap, Felicia. You see, he still got that face.

MF: The grandkids are getting almost as big as the kids. You must be pretty proud.

EE: I am. They are really nice to me. You know, I used to go out shopping for yourself and things, I don't do that no more because they is always giving me something. . . .

MF: Well, that's quite a crew. Why don't you tell me just a little bit about your own family background? Were you born in Buffalo or . . . ?

EE: No, I wasn't born in Buffalo. I was born in Georgia. Washington, Georgia. That's down . . . you ever heard of Augusta?

MF: Sure.

EE: About forty miles from Augusta. And about a hundred fifty miles from Atlanta. I got married in '48 and I came to Buffalo. My husband was, when we got married he was living here. He's from my hometown, too. We went to school together. He had a brother living here and an uncle. So he came here to work. In the beginning, when we first got married, you know the Statler Hotel? He was working for them at that time. I came up, you know, I like it so far. And I'm still here. This June I will be here forty years. And I will be married forty years.

MF: What kind of other things do you do? Are you involved in church things, for instance? What kind of things did you like to do most when you had some spare time?

EE: Oh yeah. Well, I'm still involved in church. I go to Friendship Baptist. That's my church. I work with the women's days, salad bar committee, ushers. In the south I was a Sunday School teacher and secretary. I always go to church. And well, we'd go on picnics. My husband used to fish a lot, but he don't fish too much anymore. I play bingo.

MF: At the church, is that?

EE: No. My church doesn't have bingo [laughs]. I go to mostly like Catholic place and the V.F.W. posts. I go to Canada. I used to go out to the Indian Reservation there quite a bit.

MF: Do you still have family down in Georgia you're in touch with?

EE: Oh yeah. I have relatives—sisters and brothers, cousins, I go back. And then we have family reunions. Oh, last year we had a family reunion in Florida, I went there. People from all over. I got relatives in just about in every city. This year we's having it in Detroit, and next year we's having it in New York City. And the year after that, I don't know where they're going to have it. Whatever city it be in—the family there, they're the ones sponsoring it. All we have to do is to send money for the food. You know, I would really like to go back down South. People in the southern states are really doing good. I think when I was there if it was like it is now, I don't think I would have ever left. You know a lot of John's friends is moved, quite a few of them have moved down in Atlanta and got jobs. A lot of them is leaving the city. Young people will go and try it, you know.

MF: That puts you in a tough position because of course you'd like the kids and grandkids around, right?

EE: What are you going to do, you know? Well, see now, they got their life to live. He said he's going, he's moving south.

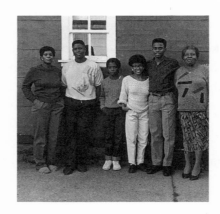

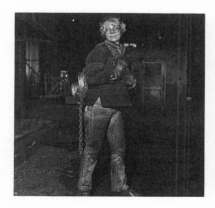 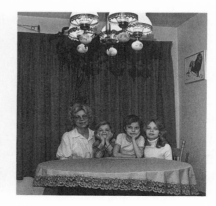

8 / MARY DANIELS

MICHAEL FRISCH: Let's talk first about the picture of you at work, and then we'll get some of the background.

MARY DANIELS: I was with a first-class rigger—I only made it to helper, I never made it past helper, there was never an opening for me to move ahead. As you can see, I was carrying a chain-fall, that's just one of the tools that we normally work with.

MF: And this is at Bethlehem?

MD: No, this is *Republic* Steel. My husband worked at Bethlehem, and I worked at Republic, oh, let me see, I was in the rigger shop about four and a half years. Mostly, a rigger is a mover. We'd take anything from a motor, a crane, whatever—it had to go up, it had to go down, we had to move it into position. We had the method of either physical force or we used rollers, or dollies, or cranes, or cherrypickers, or chain-falls. Besides that, we did cable changes on the cranes, or hoists, or anything like that. We were a part of central maintenance. We went wherever they needed us, throughout the plant. We had a shop in the maintenance building where we did splicing, or small things that we had to take out into the field, but most of our work was done in the various departments throughout the plant, whether it be the bar mill, the blooming mill, the BOF [basic oxygen furnace], wherever they needed us.

MF: Where was that taken and what were you doing there?

MD: That was a finishing department off of the blooming mill. A blooming mill is where they roll out your ingots into your bigger billets, and then from there they're rolled into smaller things; either customers buy them up in billets, or they have them shaped in the bar mills. I'm carrying a chain-fall. We had to lift up a cover off, it's to cover hot steel, to keep it so it cools at a slow rate, it keeps it from having flaws or cracks.

MF: Now this kind of work—would you work with the same crew, did you have a kind of regular group of you?

MD: There was, I believe, I'd hate to leave anybody out, I'd say twenty-two riggers, OK? And one day, you might work with another group, depending on the job, how many men were sent out. There could be anywhere from two men to maybe sixteen, depending on the job. It was a family. I always called that my second family. I just can't explain it, it's like you knew that no matter what, whether you didn't like your partner, or not like what they did that day, or whatever, you always knew that you could depend on them for your life: if something happened, and your life depended on them, you—knew—you—could—count—on—them.

One time I fell, you know, it wasn't that high up, it was only about ten, twelve foot. The night that I fell, they had a breakdown of the blast furnace. They had called me in for four o'clock, and it was about eleven o'clock, and they asked me if I could work over, which would have been another eight hours, and then I was scheduled to work the next day, which would have been a straight twenty-four hours. You just knew that there was going to be hours, and hours, and hours. The steel plant depended on our blast furnace, we only had one working. And I fell just before midnight. Oh, I couldn't believe it, the guys were carrying me out, they wanted to know if I could move, they wanted to put me on my back on a stretcher, and I says, "Oh, my back, I can't handle it, the pain is too bad," so they lay me on my side, which is bad enough in all the little kitty-corners they had to go around to get me down, and they were absolutely white, they were absolutely sheer white, and I looked up and I says to them, "Where the hell's your sense of humor?" [laughs]

Well, we had some—they're all strong, even the small men in our shop. The last boss I had, he was just prouder than the dickens of his men, he'd always say [gruff

voice], "The best workers in the plant are the riggers" [laughs]. He really was all gung-ho, he was really a good man to work for. I mean, he worked you hard, too, but he never asked nobody to do nothing he wouldn't do himself.

MF: So it sounds like you had a real spirit about the work, then, which tends to bring that family feeling.

MD: Yeah, I did. But I say family, I don't socialize with the men outside the plant, you know. I mean—I'm a woman, they're a man, you can't really socialize too much.

MF: Were you the only woman in the shop?

MD: The only woman—ever. I was [laughs] so proud, I'd say, I worked hard enough, I guess they couldn't throw me out.

MF: What are the different kinds of jobs in there that people would have, and where did you fit into that structure?

MD: Oh, a helper was usually a second or third person on the job, and they would move them up to third class, second class, first-class. You were supposed to be able to do certain things in order to become a first-class rigger. I was up to see the rigger bosses once and they read me a list out of a book, so I went quickly and got some schooling, I figured I'd need some blueprint reading, make sure I can burn, and I can do this, I can do that. Then I never got my raise. And we had fought for it, and my ability was there, they couldn't disprove that I could do it. But that wasn't it, they never disclaimed that we couldn't do the work of a first-class rigger, there was simply no openings. They said that they did not have the opening, OK? Well, I mean, you can just have so many chiefs and, you know, so many Indians, I guess. I wanted my raise because I felt I was doing the work. It came right down to that, I was doing the work, and I wanted the money. Maybe I wasn't ready for first class, but I think I was ready for the next step up.

MF: Yeah, it sounds like on those kind of small jobs, that line between who's the first class and who's the helper—

MD: Let me tell you, who's the helper is the one who goes for coffee [laughs]. I had to do that coffee running. Of course, the lowest man in each group, no matter—he could be a first-class rigger, and if he was the youngest man there, he went. Although I will say, sometimes it was, "Well, I'll give Mary a break, I'll go for coffee," or something like that. That's why I say, there was good feelings, most of the time. I mean, there was people in our shop, that maybe I didn't agree with completely, and I'm sure there was a lot of them that didn't agree with me completely [laughs].

MF: You weren't the model of a soft-spoken . . .

MD: No, no [sweet voice], "not always."

MF: How'd you get to the steel plant in the first place?

MD: How'd I get to the steel plant in the first place. It was 1976 I started there. There was a big article in the paper that said they were hiring people at Republic Steel. My mother-in-law called me up, right away, you know, "There's openings, you going to go? You going to go?" See, she wanted her youngest son to get in there, and he didn't drive, so she figured, "Aha! I'll get my daughter-in law to go to work." See, I know my mother-in-law's thinking [laughs], she's cute. And so, I says, "You know what she wants, John, she wants a ride for Bruce." So I took my brother-in-law, and we went off and we made out forms at the New York State Employment Service and there must have been [grandly] hundreds of people in there, you know [laughs]. Then I got a referral slip to go down and put an application in down at the steel plant. My brother-in-law never got one. They had x amount of women they had to fill in there, x amount of minority, x amount of Vietnam vets, the whole bit. They went that route first, and I was just lucky I happened to fall in amongst the females. So, I went down, and I made out my application, and they did a little interview.

MF: What was the interview like? Did you think they took you seriously?

MD: Yeah, they knew there was a lot of women there that were serious. They wanted to know if I thought I could handle weight, and more or less a rundown of it wasn't going to be a glamorous job, we would have to wear steel-toed shoes, with metatar-

sals, and there wasn't going to be any jewelry on you, and you weren't out there to have a good time. Hey, man, for that kind of money [laughs], I could look like a real grump. And the first day on work, I was, too.

There was this other lady, we started out in the blooming mill together, and it was the funniest thing, because her birthday and mine were three days apart, and although there was eleven years difference in our age, I always said, us girls never got over twenty-one. See, it was a joke—that when it came down to seniority, two people starting the same day, starting the same time had equal seniority, so when it came to a job to bid, to get who had seniority, they went according to the birth date, right? OK, so she was eleven years older than me, right? But my birthday was three days before hers, so I'm three days older than you! She was always telling me she was an old lady, and I says, "Certainly not," I says, "I'm three days older than you and I'm not an old lady yet."

MF: So you started off in the blooming mill working with her and . . .

MD: Shoveling scale out from underneath the hot bed, that's the first thing we did, and then they stuck us underneath the flying shear where we had to dig out all these butts and stuff and the grease was halfway up your leg—I mean, there wasn't a white spot on me, I could have been a real soul sister. But you did feel that you were being tested. And she and I looked at each other, and you know, she was a beautiful woman, and I never figured she could handle that, I'd be going "What the hell's she doing in here?" you know. Me, I was a tomboy when I was a kid, I had four older brothers, two younger brothers, and a sister. I don't know of too many women that worked in that steel plant that hadn't at one time been a tomboy. It's kind of psychological. It's kind of a proving ground [laughs].

MF: How long did you work there?

MD: In the blooming mill? I was hired in April, and I got laid off in October. I had bid, in September, over into their maintenance shop in the blooming mill, as an oiler. And I figured I'd make my way up to be a millwright, that's actually what I wanted to be. Mechanically inclined, I am. Then when I got laid off I lost my bid, because you have to hold it for forty-five calendar days in order to keep it, right? Next time it

came up to bid, and I had gotten called back to the plant, then I bid on it again, but one of the women with more seniority than me got it.

MF: These bids, were they for a woman's position, or did it just happen that . . . ?

MD: It was an open bid, right? And you have to move so many minority in, right? Now there was, let me see, Spanish-surnamed men, black men, and female, OK? And the female took it, simply because there was no females in maintenance, then. She made the first break by being the first female oiler, then I had made another break when I went into central maintenance. We were a token, that's what they figured they'd do, is put us a token, into the riggers shop, too. I had bid on that oiler job, again, because that woman didn't keep it. It came open, and they asked me, do you want the oiler in the blooming mill, or do you want the rigger shop? And I thought: try the rigger shop. Because the blooming mill, I would always be in the blooming mill. But I said, if I'm in central maintenance I will get to know the whole plant. That's basically what I wanted to do. I would have liked to have been a millwright, though. But I'm proud of what I, even if I only got to be helper.

MF: When you got the transfer over to the rigging shop, did you have to go through the testing again, when you had moved to be the bottom man?

MD: A little bit, a little bit. Carl, he took me and the other gentleman our first day as helpers, he was going to show us the different things that riggers did. And he proceeded to climb a column. Put one hand on either side, and two feet up against it, just proceeded to climb it, just like that. And then he shinnied on down, and I go, "Oh my God, I've met my Waterloo already, I ain't even been in the shop twenty-four hours." And he says [stern voice], "This is what you'll be responsible to learn." And I'm thinking to myself [whining voice], "Oh, God, I don't know if I can do that," you know, but [strong voice], "I ain't gonna let nobody know that I don't think I can do that." So then later he introduced me to one of the riggers and sent me on a small job. We had to open up those doors, or outside covers, for your bar mill—they're like a wall, you hoist them up and you did it with chain-falls, and then you blocked them into place. He gave me the chain-fall, and he says, "You might as well learn how to carry one of these," and he showed me how to throw it over my shoulder, and I was

off and going, that was it! And the rigger I worked with, he says, "You want me to carry it?" I says, "Nope, this is *my* job."

MF: So did you ever have to shinny up the pole?

MD: Nooo! [Laughs] I got some of the guys, finally, after I made friends amongst them, I said, "When are you going to teach me how to shinny up the column, because," I says, "I can't wait until I can go to Carl and say, 'Hey, I want to show you something,' and go shinny up the column." They says, "We can't do that!" And I says, "You can't? He said you got to learn!" And they says, "No, it's against safety procedures in the plant!" [laughs]. They did do those things at one time. And Carl would be the first one up and the first one down, let me tell you.

MF: So you, generally, picked up the kind of skills you needed just from going on these jobs, and people would—they were pretty good about showing you?

MD: Yeah. Yeah. The desire to learn made them want to teach you. Once in a while—I can remember one welder, he had had a bad time with a divorce, right? He'd always pick on women being in the steel plant, he said to me [stern voice], "What are you doing here putting a man that's trying to support a family out of work?" Well, at that time my husband wasn't working, he was on another layoff! And I happen to see this guy standing, smoking a cigarette, and I says [snooty voice], "What are *you* doing there taking a job away from a woman trying to support kids?" And he laughed and we got to be good friends after that. But I was trying to point out that women support families, too. I won't say all of them, but most of the women down there are supporting families.

MF: You spoke about working at night. Did you and your husband often both work nights? Did you have any control over that? Could you go in and say, "Well, he's working this and we both can't be . . . "?

MD: It depended. I had a mostly day shift; when they had a big job or something it would be nights. When I first started in the blooming mill I worked a swing shift. I worked ten days of one shift, then ten days of another shift, and they'd give you a

long weekend every third weekend or something. But [hushed voice] I could never handle the nights! I honestly fell asleep! On the job, standing up, holding on a pipe. They actually come over and go [deep voice], "Mary, wake up!" And you know, you could be fired for falling asleep on the job, but that's if you were sitting or you were laying down. But they never seen anything like it, they said, "We heard of horses that stand up and fall asleep . . . " [laughs].

MF: When you went into the rigging shop, now there you're the only woman, right? Was it harder being sort of the only one there?

MD: I don't . . . really know. I think the fact that the ice was broken, these men had seen me work, there was going to be a certain amount of testing. I know they really wanted to set me up for a real bummer, at first—they'd be the first ones to admit there was a few of them wanted to set me up, and I just went in there, and did my best, and they just didn't have the heart to do it to me, I guess [laughs].

MF: Did you miss not having another woman sort of side-by-side?

MD: No, I used to drive to work, and I used to pick this lady up for work, and there was women in the locker room. All the women throughout the plant went to the same women's locker room. I saw most of them, it's just that I didn't get to really know them real well. I didn't usually eat with the women, I used to eat in the shop, mostly with men, because there was nothing to keep something from breaking down, and you'd be in the middle of a lunch, and the boss would say [snaps fingers], "I want you three guys and you're going to go here and get this set up." Sometimes you had control over your lunch, sometimes you didn't.

MF: Were there ever times when there wasn't work to do, or pretty much they had stuff for you to be doing all the time?

MD: Mostly, they'd have set up the day before, who's going to go here and there. And then there's a certain amount of men in our shop who go out trouble-shooting, if anything breaks down, you know, sometimes you'd be on that crew. I hated cleanup. My first boss, he was always sticking me cleanup, he had a certain area in

front of the shop that it was our job to keep it clean, especially if big shots were coming in. So I'd be— "Mary, here's the broom," you know [laughs]. But when I got Carl as a full-time boss, he broke things more even, that everybody got their shots at everything. He said [deliberate voice], "I don't play favorites here," and I preferred that. I think my first boss thought he was doing me a favor, but I really wanted to learn, I was eager to learn. And most of the men were eager to teach, as long as you wanted to learn.

One of our first-class riggers was a splicer. There were three splicers in the shop, and he was the oldest, he probably was about third down in seniority in the shop. I called him my idol, I says [gruff voice], "I'm going to grow up to be just like you." Well, he was short, you know, he'd always laugh about it, he'd say, "You do, I'll paddle your buns" [laughs]. But he really enjoyed teaching somebody that was eager to learn. And some of the times if maybe everything was quiet, he'd say, "C'mon, I'm going to take you somewhere, you're going to have to come across this some day, and I'm going to teach you—right now." He was magnificent, a magnificent man.

I remember I came home one day, I'd go [excited voice], "Guess what I learned today! I learned how to splice cable!" And my husband he'd go [bored voice], "So what?" He learned all that in the service, see? I went crazy! I was so proud of myself [dignified voice], "Not all the riggers can splice." I was all excited and everything, and he's . . . blah. You know it's really funny—after you've spliced a cable and you have to cut the ends, you take a chisel, and you take a hammer and you go like this, and it's all right . . . as long as you hit the chisel! It's when you hit your hand [laughs]—I go, "Oh, booo," I can remember yelling, he says, "Well, if you just hit the chisel instead of your hand, you'd be all right."

MF: And after learning that, did you do much splicing on these other jobs?

MD: No. I was just a helper, I wasn't a splicer. Riggers were supposed to all know how to splice, that was part of the job description. OK, we had three, what they called standard splicers, three men, that's what their job was. The mills ran on a cable, OK, it turned everything. Now you take a cable, and you got to marry the two ends together. Well, you have to weave them all in, and that's what a splicer did, and it was hard work, and your hands were like this [indicates gnarled hands] you know, long before their time. It was a hard, hard job. I wanted to learn it for the knowledge,

in case I ever needed it. I learned how to splice slings, chokers, or whatever. And I always try to make sure that I do it the best I could, because—a lift might be over my head [laughs] with them things holding it.

MF: This rigging and splicing—it all comes from ropes, so a lot of this comes from sailors, I would think, and ships?

MD: Well, you know where the original riggers were? They were the slaves of the pharaohs, that's what they believe! Because how else could they get those mighty stones and things? They figure that they had to put your large slabs on rollers, almost like pipe, or even if it was a tree, just to move it up. They had people pulling on it, and people pushing on it, and then other people taking those and moving them around to the front—it's all a form of rigging. And the longshoremen, they were a form of rigger. In fact, my aunt was a longshoreman. She lives out in Virginia, she's in her sixties or seventies now, and every once in a while, when I found out about that, I go, "You were honestly a rigger? Isn't that great, we're keeping it in the family!" [laughs].

MF: Well, speaking of family, let's turn now and talk a little bit about your background, just so I'll have some sense of where you come from.

MD: My family has lived generally in the Blasdell area, right here where we are now, since I was about six years old. Prior to that, I lived in Allegheny County. My father's family was from Battle Creek, Michigan, and they had a lot to do with establishing a Christian community, a Wesleyan Methodist community down in Houghton, New York. It was kind of a wayward town back before Christianity came in. The Genesee River flows through there, so you imagine a riverfront community is sort of rowdy. The Christian community is all involved around Houghton College there, which they founded. My uncle was the President of Houghton College for thirty-five years. He still lives in the community, he does Bible transcriptions now. And then another uncle was a professor at Houghton, and my one aunt is an English teacher, and another aunt is now a nurse. I think two or three of my uncles are ministers.

My parents, they met in Houghton. My father's family was a well-established family, and *exactly* what my grandmother wanted my mother—she was adopted

when she was a child—to marry into. They were married twenty-five years, somewhere in there, and unfortunately they split up. My father lives in Florida with his second wife, and my mother lives in Lackawanna.

MF: And was your father a preacher too?

MD: Who, my father? No [laughs], my father did work. He worked at Snyder Tank, he was a welder. And he worked at the Ford plant. He commuted—well, we had a farm down there, but a small self-sufficient farm isn't really all that sufficient, you know, so he did work up here. Then he bought a place here, in fact just about a mile away, and he rented the farm out, and we first moved here. He worked two jobs, but mainly at the Ford plant.

MF: And you went to school around here, to grade school?

MD: Right over here, where my son was going. It was a good school, I liked it, I got a lot out of it. I wasn't your center-of-attraction type person, but I liked the school system, I liked most of the teachers. Then I went to Fredonia State for six months, in conjunction with Gowanda State Hospital. I was going to be a nurse. Imagine—a nurse, and now a rigger! [laughs]. But, well, I went to work, started making money, then I got married, started a family—you get swept up in it all.

MF: How did you meet your husband?

MD: Well we lived in Woodlawn, my mother and us six—the younger of us children, when my parents split up, and then John's family moved in just next door.

MF: Oho! The boy next door!

MD: The boy next door. And my brother married the girl on the other side of us! [laughs]. Kind of earthy people we are, I guess. My husband's family is from Pennsylvania, his mother's from, I believe, the Duquesne-Warren area. But then down there in Pennsylvania factories were closing down, and the war and everything—my father-in-law was a gunner in World War II, and there was nothing down there, so he moved

up here and started to work at Bethlehem Steel, and he learned his trade and become a welder. Funny, that my father and John's father should both be welders, huh? He became a welder, and then opportunity allowed him to go to work for Chevrolet, and he was working when he died, same year we bought the house, 19 . . . 78.

MF: Did he go to college too, your husband?

MD: Noo, my husband quit high school. He went right into the service. That's why when I'd tell him what I learned about rigging, he already knew because in the Navy, everything that I had been through, he'd already done. Then he came out and, well, he went to work at another small thing and it was not exactly what he wanted, then he went to work for Bethlehem Steel.

MF: Well, to move towards the situation more recently—. From inside the plants, did you and your husband see a lot of this coming over the years, or did it catch you and other people by surprise?

MD: Well, maybe it was about ten, maybe eleven years ago, when Bethlehem Steel opened up Burns Harbor, in Indiana, we kind of figured then that there would be a close-down of the plant here. In 1972 there was a long layoff, and we packed up and moved to Pennsylvania, right back to John's old neighborhood, south of Bradford. His family had owned a summer home there, so we moved down and he really thought he'd get into something like the gas company, you know. We were down there about six months, trying to make a living down there. Then he got called back to Bethlehem in late . . . '73, it would have been, so we made our move back up here, again. As if we were vagabonds, huh?

But at that point, because before they had been talking, you know, about closing this plant down, completely, so when that *didn't* happen we figured they'd just do away with some of their more, uh, terminally ill divisions and keep going with the moneymakers. And now we find out we were wrong. Actually, John hasn't worked as much as I have since we've been back. And with Bethlehem closing, we don't know exactly what his options are going to be. We know he will be entitled to some kind of retirement, but it's only going to be a small amount.

MF: And were there warnings that Republic was going down too?

MD: Well, we make up very specific kinds of steel, and we would make it in smaller quantities, and thus we could make it cheaper. Where the big company that, maybe they needed 50,000 ton, and they have to make 150,000 ton in order to pull out the 50,000 ton, then they're at a loss. Whereas us being smaller, we could deal in that. We made very good steel, and I always told my husband, we made better steel than they did at Bethlehem [laughs]. They wanted continuous casting at Republic, one long assembly from the start of your steel right on out to your rolled product, it cuts down a lot of the reheating of your steel, it cuts costs. We were just kind of hoping that we'd get the bid, here at Buffalo. But we didn't get it.

MF: So when did you think that your plant was really in trouble, locally?

MD: When did I think it was? When they told me to come and clear out my locker! Up until that time, I just figured it was a layoff, and I would eventually be called back. We were waiting for orders to come back to the country. Now everything's going to foreign steel. *Sooo* much cheaper. But when it comes right down to it, when nobody makes steel in the United States anymore then the prices will be up there back again. Supply and demand.

MF: And what about the union? Did you feel they did the best they could in trying to keep it open?

MD: Oh, I think the union has really tried; the international itself has given up concessions like crazy. The only thing they never did was—the company was not willing to protect the rights of the people that worked there, giving up all these concessions. I really would have liked to have seen some protection for jobs—some job security.

 But I guess there isn't anything to protect us from a plant moving to where they can get cheaper labor, maybe cheaper taxes, or who knows what. I really can't say. Republic itself was there for a long time, Bethlehem was there for a long time, and I never, in my wildest dreams, ever expected, never ever expected Republic to say, "We aren't going to open this plant ever again."

MF: You mentioned the foreign competition. What are some of the other elements that you think were part of the problem?

MD: The companies aren't putting the profits back into the company. When you're only doing necessary maintenance, instead of preventative. You take your car—the only time you put oil in it is when the oil light comes on? Preventative maintenance is checking your oil before you have to worry about problems in the engine. So that's just a small part of it. Modernizing would be another part of putting money back into the company.

But actually, I can only deal on the small things—Republic was putting money back in, I noticed that in the whole period. I do know that they were putting a great deal of care into water pollution, and they put in the BOF, which is real progress. So I don't know, even being there, I can't say what would have helped, completely. I don't think it was just one thing, I think it was just too many things. It's just trying to compete with—now, your foreign companies, most of them are so modern it's unbelievable. That's a big part of the problem.

I think there's a lot of things that are part of the problem. They say, "Basically, we're too highly paid." You don't find very many people that say that wanting to work under the conditions that these people have had to work under. I know a lot of people used to tell me [shocked voice], "Oh, such income you make for a woman! Oh, we don't even know men who . . . " But there've been men who walked away from jobs like mine. In fact, when there was a problem with the blast furnace, once, a man clocked himself in, he found it was a blast furnace, he just turned around and clocked himself out, and he says, "You call me when the blast furnace is repaired. I don't want to be anywhere near it."

Most people that work a job like that, they have a family to support, a lot of them never had any help. There are the thoughts that now they want to turn around to help their own children, so their own children don't have to end up in there, so they don't have to have seen what's going on in the steel plant. Industry is not exactly the same as sitting behind a book. I mean there's a difference! I'm not saying that it's not mentally much more taxing to work behind a book, but your physical hazards of constantly looking at potential disaster is much greater in a physical kind of job.

I think, now I've kind of settled myself around thinking that no matter what, somehow, I'll make it. You just have to kind of think positively, or you could get into such an emotional depression—I mean, the depression, people were jumping out of windows. Those were rich people! Now it's the poor people, or the middle class, who's going [choked voice], "Aaagh. Where is me, where am I at?"

But somehow, I'll struggle along. It's not what I planned. My husband and I both wanted to work only thirty years. I figured that by thirty years I would be fifty-eight years old, then there's a job opening for the next kid that's coming up. I believe in leaving something for posterity, I don't want it all for myself—what am I going to do, take it with me to the grave? I mean, yes, I've got a family to take care of, and yes, I'd like see my kids through school, that's one of the big dreams I had, that maybe my children won't have to work in a steel plant, but that job opportunity would be there for somebody else, who maybe didn't have a parent that could see them through.

Well, I don't think my world is going to fall apart if the steel plant folds under, although it was our way of life. I got to know more what my husband had to face every day, where a lot of women would never know, never could possibly appreciate what their husband ever had to work with. They have no concept! If you're on a job, and things aren't going well, makes no difference to somebody who doesn't see it than if you were on the same job and everything went well. All it is to them was—you worked in the blast furnace that day. It could go great and it could go terrible, and you never have any idea of the obstacles you're going to run across. But I know—and I think he appreciates a little moral support [laughs].

MF: And what's your husband's situation now?

MD: Well, sometimes, you know, you can get pretty depressed. My husband's put sixteen years into a plant and by the end of the year, they won't even know he existed. He's looking for other jobs, but I can tell you right now, there just—well, I mean, why should they take a man who dropped out of high school, when they can have a man with a Ph.D., and pay him the same price? His main thing has been the steel plant, and that's about all he has done, and to sell yourself, now at this stage in the game, when you're a few pounds overweight, and you're competing against kids that are all built like Hercules and they're willing to kill themselves to get recognized?

So he applies for jobs, and sometimes he works on the house. Right now, a neighbor of ours has him fishing. It gives him productive things to do without letting him dwell on the fact that he's laid off. Everybody says [snooty voice], "He went out? Why should he, he's not working!" But it's kind of a release to me to know that he can enjoy himself. To see him sit and worry—it never bothered him like it's bothering him now, he knows that it's a permanent status for him. I always tell him—all the

time when he'd get laid off, I've always done all the bills, you know, because I knew he couldn't handle the stress of it, of that worry, constantly—I'd say, "Don't worry about it. We'll make it." I have to say these things to him—because he'll have me so worried I won't be able to sleep or anything else.

It's bad, it's bad. My husband once said to me when this whole thing happened, I really don't want to repeat it, but he said to me, "I think I'll go [whispers] . . . kill myself." And I says—you know, there was desperation inside of me, and I says [false-bravado voice], "Why would you want to do a thing like that to me for?" I says, "I haven't got a clause in our life insurance policy that says suicide," I says, "So you'd stick me with all the bills!" I was trying to put him into a situation where he wouldn't think he was giving me relief. Because, yes, I *have* a suicide clause in it, but *he* doesn't know it, he's never read the policy. OK. But see, I have to think positively. I would be willing to bet at one time or another, most everybody's contemplated suicide, you know, but I—didn't—need—him—thinking that was the only way out was for him, to help us by being [snaps fingers] first in the life insurance. So I just let him think that we would be ten times worse off.

MF: Have the kids gotten through all this pretty well, do they have much sense of what's going on?

MD: The younger two, I don't think they realize, they just don't know what it is. They were very small when I went to work for the steel plant, so I was always bringing in decent money from the steel plant no matter what, I only had a couple of layoffs, and they've always just seen what the results of that have been. But the oldest one, she's fifteen—she has. Because she's been through it, where my husband was laid off, and there wasn't food in the cupboards. She's been through Christmases where there was one or two little things under the tree. She knows where our money comes from—she managed to buy herself her own television when she was eleven years old, she had saved, and saved, and saved, it took her a couple of years. But she knew what it took. She is my Rock of Gibraltar, because she always says, "C'mon, Mom, we can find a way of saving money." She's the one who got me into couponing!

MF: All of this must have quite an impact in Blasdell. I mean, this is a neighborhood really in the shadow of the steel mills.

MD: Well, I would say a lot of people worked in steel, a lot of them on this street alone. The man next door used to—he's retired now. Beyond that, the man that used to own this house, he was in steel, the young man over there [points] works at Buffalo Forge, this man works at Chevrolet, this one up here Buffalo Steel. You know, I mean it's all kind of that kind of industry-type thing. There's a few business people on this street, but mostly a lot of people depended on steel. The Ford Stamping Plant is here, my father worked there for a long time. Generally most people lived and worked pretty close, I would say in less than a ten-mile radius.

I've seen a lot of people pack up and move. And when they got there, then they want to turn around and come back. See, my husband says, this house is mine because I've never asked for anything before in my life. And this is home, to me, I want to see my grandchildren come here. I could be content to live here until the day I die. Right now, where I want to be is here. When we had to sit down and decide what our priorities were, to stay here, we had to decide for seven months to take our vehicles right off the road because we couldn't afford the insurance. We could walk, most everything here is in the village, that's why I like it here.

I could probably pack up and move tomorrow. But essentially, I'm a New Yorker, OK? I somehow feel that the climate and everything, the whole way of life, is me. I need my white Christmas and my warm summers [laughs]. And you know, if you don't have the security of a job, you really need the people around to give you that sense of security, people that care about you, can give you a sense of security about yourself. When the newspaper article came out about us and the plant closing down—it sounded desperate. People that we know, just friendly neighbors, "Hello," and "How's your garden," and stuff like that—they called us up and said, "Is there anything we can do? Can we lend you some money, can we drive you here, can we do this for you—if you ever need us, we're here."

It was nice to know that there was people there that cared about us, and, yeah, my family knows what we're going through. But we weren't desperate. I don't think everybody's desperate. Everybody could be desperate, if they'd allow them to, but I think somehow they'll make it. I really think people in the United States are much more flexible and can bend a little more than people give them credit for.

I always said, as long as God has left me my hands, making things or doing something. Everybody says [silly voice], "Oh, you're so creative," I say [stern voice], "I don't do anything anybody else can't do." They'd say, "What would you do if you

didn't have your hands?" and I'd say, "Well, I'd learn to knit with my feet" [laughs]. You have to think positively. There's people out there ten times worse off than we are. Everywhere you look. People are worse off. And somebody who maybe financially is better off, maybe they're worse off in another way.

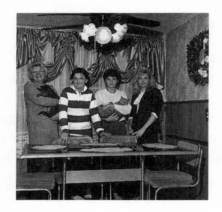

PART THREE

FOUNDRYMEN

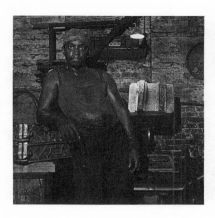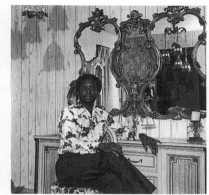

9 / JAMES MATHIS

MICHAEL FRISCH: I'm talking with James Mathis on Wyoming Avenue in Buffalo, and James, just to get us rolling, the way I've been starting most of these is to look at these pictures that Milton took seven, eight years ago to get a sense of what your work was like, you know, because a lot of people out there, they read these things in the papers but they don't really know—

JAMES MATHIS: Know what's going on.

MF: Yeah. So we'll have you look over their shoulder at the same picture and tell us where you were when this was taken and what's going on in it.

JM: OK. I started in Amherst Foundry in 1962 and I'm a squeeze molder. We made molds for fence posts and made molds for guard rails. I make the molds and then I set them down and then I had to pull them off myself. And I stayed there for sixteen years.

MF: Let's start with the picture. What's this thing there? Is this one of the molds you were talking about?

JM: No, this here's the pattern. This here's the flask, this here's the squeeze board, and this machine back here's what squeezes the mold. You want to know all that, too?

MF: Well, yeah, people will be curious. So first you pointed to this thing down here. He's talking about the bottom right-hand corner of the picture, right by his left hand. So something like that would be a pattern for what?

JM: For fence posts. Go around the fence posts. And over here, this here's the pattern and this here's the flask. You got a cope and this here's the drag. So you make the drag first and after you make the drag you flip it over then you make the cope. And after you make the cope you put the squeeze board on it and then, right here on the corner, you squeeze the mold, that makes it nice and firm. After you squeeze the mold there's a button you got to cut in for the iron to run in. Then you have to draw the cope back out first, then you draw the pattern back out. Then you blow it out, then you put the cope back on the drag, then you take and set it out. On the floor. And after you set it on the floor, two o'clock, they start pouring the molds. That mold it took about, maybe, a minute and a half to make. But you have to shovel sand. Got to shovel it in by hand.

MF: What does the sand do in this process?

JM: The sand's what makes the mold nice and smooth and when you pour the iron in it won't bust out on you. You peen it with the shovel. Pack it in sand. Then you set it down on the floor.

MF: So all of this here that we're looking at, you're getting the mold ready to get poured?

JM: Right. We pour cast iron. The iron go in the center. Then the iron run off from this side here. And after it runs then that be the mold that you make it.

MF: Hmmm. Let's see, I'm just trying to make sure I understand it because if I don't understand it maybe the people reading the book wouldn't understand it either. Now you put these things around it and you pour the metal in?

JM: No, you have to put a weight on it and a jacket. The jacket what make the mold won't bust out and the weight keep it from, when the iron's poured, lift it up. And

then you pour maybe about twenty out of a five hundred–pound ladle. The ladle. Where you pour the iron in. Holds five hundred pounds. And you make 175 molds, you might get twenty or twenty-five out of five hundred pounds. This here the ladle—that's what Johnny Rosenthal do, fixing the ladle. [He points to another portrait in the "Working People" section of *The Forgotten Ones*.]

MF: I guess I'm still trying to figure out this thing. When you pour, you'd have a whole number of them set up and then pour them all at one time?

JM: You take a mold like that, we make two or three hundred order on it, two or three hundred molds on it. Most of the time I make about a hundred seventy-five to two hundred molds a day. If I don't finish them one day, I finish up the next day. So after you fill the floor two o'clock, then you pour one at a time. So any day you got 175 molds on the floor, right? And you got ten in a row. After you get your row poured, you go back over here and you pour ten more. And while you're pouring ten more, there's guys shifting weights on the jackets. So then you pour one layer off, maybe twenty, twenty-five molds, then Johnny Rosenthal bring the bull around with five hundreds pounds of iron in it, you pour another twenty, twenty-five. And you keep going around till you get them all poured off.

MF: And Amherst Foundry, their whole business was pouring this kind of . . .

JM: Pouring this kind of metal. But we had—like they make big molds, too. This here was a squeezer, this is a small one. Then they have medium-sized molds, then they had large molds. And then they have loose patterns. But see, right here in the center, that where the screw go in there. After putting the screw in there you take it out and then the iron run from this side and this side and that would fill the fence post up. After the fence post gets filled up, you could see because you got a dish up here, that would hold the iron in. And then after it gets full up you go to the next one.

MF: So you'd have to have a pretty good eye for that?

JM: [Laughs] Oh, no, you can see it, because when it's filled up, it's like pouring beer! You could tell when beer's running over. So you got to stop. You keep pouring it, it'll run out, like beer do.

MF: OK, so let's say if you came in for a shift and you'd have to get all these things set up, right? And then you'd pour them. How long is the whole process, a couple of hours?

JM: No, we started work at eight o'clock. And we worked from eight to two o'clock or sometimes quarter after two. They started melting the iron about maybe 12:30. And then it would be ready by 2:30. And then we start pouring. And that last 'til about four o'clock or 4:30. Then it's time to go home. They had another crew come in about 4:30, shake them out and then put them in the sandblaster and clean them. And then they go through inspection, make sure they're all right.

MF: What did they use for the iron?

JM: They had pig iron, coke, and then they had iron to melt, because we had an old-fashioned cupola, we had no electric furnace, had one of the old-fashioned cupola, we had to put pig iron and coke in it.

MF: Cu . . . cu . . . ? [Laughs]. Well, I'll have to figure out how to spell it out.

JM: [Laughs] You know, cupola, you put the coke in there and after the coke get hot, then you put in the pig iron and then you start putting the melt in there to melt. Your coke was put in there first for a bed to get everything hot. They get it lit by gas, you know, to get it going. Then after they get it going they got a blower to keep it hot. And they got an open chute for the air pollution, you know, keep it from going up in the air. After the coke gets hot then you throw the metal in there. And then as you keep going you add a little bit more coke when they burn up, keep it hot. And then after that they tap the front out. When the iron started melting everybody got to be ready. Because they can't stop that iron unless they plug it up, and they plug it up and they don't take it back out it would freeze up or overflow. The iron's got to come out.

MF: So how big was the furnace? How much could it melt down or . . . ?

JM: In one day? About fifteen thousand in one day. It's a round furnace, and I would say at least as big as a car almost. But it was one of those old-fashioned furnaces. One

furnace did all the jobs. Did everything. And then when the end of the day come and they get finished melting they dropped the bottom and everything come out. The coke and everything and then the next day they repair them over again.

MF: So basically you had some guys who were on the whole melting operation.

JM: Yeah, everybody, like, separate. The molder was separate, the grinding room was separate, the core room was separate, the cleaning room was separate. Everybody had their own job to do.

MF: And did you spend your entire time there in this part of the operation?

JM: Oh no, I started off cleaning. I started off inspecting castings when I first went there. I didn't start in molding 'til about maybe eight years. The way I got that job, I was working the cleaning room. At two o'clock I had to go out and shift weights and jackets. So I asked my foreman, "Can I make a couple molds every day?" So he told me, "Yeah." So in about four months the guy retired and I was the one that got the job. They figured I was qualified for it. So I've been in there ever since. I molded for eight years there. In that one spot. It were a pretty nice shop. Paid pretty good, too. At the time they were paying real good. This is like on piecework. The more you produce, the more money you make. They go by the mold. And then if the casting ain't no good, you have a lot of scrap, they deduct it out of your paycheck every week. You might get eight pieces out of one mold and you make out one out of eight ain't no good, so you got seven good ones, one bad one. So you're trying to do the best you can so the scrap won't be that high.

MF: So would you say when you were in the mold shop, is that pretty hard work? You enjoyed that more than what you'd been doing before?

JM: It ain't—when you get used to it it's not that hard. But summer it is kind of hard. That picture, that were the summertime. It were hot in that plant. But after your body get used to it you're on your way [laughs]. It's more easy than grinding. One thing, you don't get all that dust. Ain't no dust in the plant by molding. Most times it'd be clean in there. It looked kind of dirty in the picture, but it be pretty clean in there.

MF: How big a foundry was this? Amherst Foundry is a pretty small . . .

JM: They were a pretty small place, yeah. We had about eighty-four employees, one time. It were like a small little plant, but, we had work when other foundries didn't have work. And we would still be working there now if the plant would never got burned down. Because we had the work.

MF: We'll get to that fire business maybe in just a bit. But while things were going good, in a shop like this almost everything is really for customer orders, right? Who are the customers for a small foundry like this?

JM: Well, we had Wynn Smith, we did a little bit of General Electric, and Houdaille, we had Wilmington, doing a little stuff for them, we didn't depend on one organization keep us in business. We did all different kind of pipes, some kind of pipe we made for Houdaille, some part of a car but we didn't ever figure out where it go on a car. And then we made them the wheel for trains. We made a little bit of everything.

MF: OK. Now let's get a little more personal background so people know who this guy is who they're looking at the pictures of. And then from there we'll talk about what happened when the plant closed, OK? So tell us a little bit about where were you born, stuff like that. You from Buffalo?

JM: No, I'm from Lackawanna, New York. Got out of school when I was in eleventh grade and then my brother worked in the Amherst Foundry and I started there when I was nineteen years old.

MF: And are your folks from Lackawanna?

JM: Well, they were born in Clinton, North Carolina, my mother and father. And we came here in . . . in 1939, we came up here. My father came here first to see if he could find a job. So he came here and found a job and about three months later, then the rest of the family came up here. I got five sisters and four brothers. I was born September the 6th, 1944. My mother, she passed too about five years ago. My father, he passed about two years ago.

MF: And where did he work?

JM: Bethlehem Steel. He had about twenty-eight years there. He worked in the coke oven.

MF: A lot of black people, back then, got jobs in Bethlehem in the coke oven. That became a problem there—you couldn't transfer your seniority to other parts of the plant, they couldn't get out of the coke oven.

JM: I know. When you get in there, in fact, you're stuck in there.

MF: Do you still have family down in North Carolina?

JM: I got my uncles, and two of my aunts. I go down there, oh, once a year. And we have a family reunion every three years. We really be looking forward to it. We have it every three years. This time it's going to be in Washington where my baby sister is. They be real big. We got a big family. Got a lot of nieces and nephews and great-nieces and -nephews. We got a big family.

MF: Was Lackawanna a good community to grow up in, do you think?

JM: Oh yeah. Real nice, yeah. It wasn't like Buffalo. In Lackawanna people more friendly and stuff, and you wouldn't hear about nobody killing nobody because they stepped on your shoes or all that fighting and stuff people have in Buffalo. We didn't have that kind of stuff. Everybody loved each other.

MF: And you didn't finish high school, you said?

JM: No, I dropped out in eleventh grade. At that time I thought I was grown when I shouldn't have been too grown [laughs] . . . I wish I'd stayed in a little longer. When I got out of school I didn't have no job for about eighteen months. Well, I had a little job when I was going to school, I was working at a barber shop, cleaning the barber shop, five dollars a day. Five dollars was nothing, but it was big money in them days!

MF: And around the time you were in school, and then when you were dropping out, if somebody had asked you then what you thought you'd be doing in a few

years, did you think then you'd end up in the steel mill? Or did you have other ideas about what you'd like to do?

JM: Well, I know I was going to get a job somewhere. If I had to go to Bethlehem Steel, I would have went there. If it came to push to a shove, I would've went there. I might've worked in the strip mill, there, and I *know* I could've got in the coke oven 'cause my father was working there. But I really didn't want to go that route, that's dirty work. And in those days I was young and I didn't want to work in no three-to-eleven, eleven-to-seven. I only wanted to be working day shift. I don't like no evening shift or night shift. And I didn't want to work on no weekends. That's how come I didn't want to go to Bethlehem Steel. I would've had to work three-to-eleven, eleven-to-seven, be off on a Monday or a Tuesday, work on weekends, something like that. So my brother, he was four years older than I was, been talking to me all the while about he was going to try and get me into where he was. In Amherst Foundry, yeah.

MF: Did that tend to be what happened a lot there? Did they like to hire people who had relatives there?

JM: They don't mind hiring one person but they don't like to hire no two or three kinfolks because if somebody pass in the family there'd be a whole three or four people going out of the plant at the same time, and most of them were skilled workers. And that would hurt the plant.

MF: You mean, if there was a funeral or something like that?

JM: Yeah, all four would go and then, you know, like skilled workers, you can't find nobody to fit in their place.

MF: And so then we get up to the time when this picture of you at home was taken. Were you married yet then? You're still living in Lackawanna?

JM: Yeah, I was married when he took that picture. We got a house in Buffalo, on Montclair. We was living in Lackawanna but we used to come to Buffalo to party sometime, you know. So my wife, she wanted to move to Buffalo. I said OK, so we found the house, we bought the house, and we moved. Oh, it were more better.

MF: Well, you look like you're living a pretty sporting life, here.

JM: [Laughs] Well, you work hard you got to do something. Yup, the other pictures show me working hard, so this shows people I really don't look that bad [laughs]. Oh, I love to go dancing and go out for a couple drinks now and then. And go to the movies. And my daughter, she loved to go to the drive-in in the summertime. When I was married I had one daughter. She eighteen now.

MF: And what about the mirror? Tell me about this famous mirror, where you got that, because it's in both pictures.

JM: I got that mirror out on Niagara Falls Boulevard, and the dude told me that if I get that mirror ain't nobody going to find that mirror because he didn't have but one in there. And sure enough, I got it, I ain't seen nobody yet with it [laughs]. Oh yeah, that mirror's my favorite.

MF: What is it about it that makes it your favorite, would you say? How does it make you feel?

JM: Well, I like music a lot, so I be out there dancing and the mirror, looking at myself dance and stuff, in the mirror.

MF: And somehow the style of the mirror fits the . . .

JM: Fits my foot, that's what I be doing in my head and stuff. I be dancing.

MF: OK! Well, let's come back now to what we talked a little bit about before, when the plant began to go down. Do you remember what you thought about it at the time?

JM: Well, the plant caught on fire. What happened, we went on strike for ten weeks and then the strike got settled, and then about three more weeks the plant caught on fire. So I'm getting up ready to go to work Wednesday morning, I get a telephone call and they say don't come in, the plant done caught on fire. So I ran out there and, sure enough, the plant was burned down.

MF: And it never reopened after that?

JM: They reopened but what happened, OK, all the customers took all their patterns out and somebody's making the castings for them. It took two years before they built it back up. And they built it back up, they had about twenty-five people working there but they could never catch back up. So he sold the place and people bought all the stuff out of it. So now it's a warehouse.

MF: Sounds like the way you told that story, was there any suspicion about this, you know, a ten-week strike and then there was a fire . . .

JM: Yeah, everybody think the place got set on fire, really. Because nothing got burned but the foundry where we work at. That's the only thing that really caught on fire, the site of production. And it started at the top of the building, on the top of the building.So, we don't know what happened, but we know that place was so much fire, it was pathetic, it was so much fire the whole place caved in.

MF: And what had the strike been about?

JM: Well, we were striking about the pension plan, something we didn't care about that much, the older guys cared about it, the pension plan and the labor want more money, they weren't happy with the money they were making. And the company was kind of harsh, they didn't want to give us no more money. And finally the company gave it up. They gave it up. And three weeks later, the fire. Well, everybody got an idea that it didn't catch by itself [laughs]. Because we had three shifts. The guys got off about four o'clock in the morning and in the next forty-five minutes to an hour, he said, that's when the fire reports started. And they said it wasn't no small fire, it were a BOOM fire. And it couldn't have caught on fire, a fire starts, you know, gradually started, so this guy that left about forty-five minutes ago to an hour, couldn't a fire started that way, especially on top of the roof.

MF: So what happened to you after the fire?

JM: Well, this guy was telling us we should go to Pohlman Foundry, because they were hiring. So I went out there Wednesday evening and filled an application out and

Thursday morning he called me up and said he got my record and that my status at work was real good and then he got back to me Friday morning, told me to come and take a physical. And I could start working there Monday. And I been there ever since. There was seven of us who went to Pohlman Foundry from Amherst.

MF: And you've been doing similar work at Pohlman?

JM: Yeah, but Pohlman Foundry is bigger than Amherst Foundry. That probably be the biggest foundry there is around this area now. We got Wynn Smith, they got Houdaille, and they make some stuff for Dresser and Ingersoll and then stuff we make for overseas. These molds here a little bit bigger. I'm doing the same thing but at Pohlman they got like automatic machines. Like how we do it now, we don't make the cope and drag yourself. There's two machines, one makes the cope and one makes the drag. And you ain't got to shovel no sand. They got a chute the sand comes right out of, go into the mold. It's much cleaner.

MF: Let's see, now, the purpose of this thing isn't to go into your personal life, but your marriage broke a while back so you're on your own now?

JM: Oh yeah, marriage broke up, definitely. My wife is still at the house on Montclair, yeah. She's got the girl. And I've got a little boy, over at my girlfriend's house.

MF: And is your life pretty much similar to what it was then? What kind of things have changed? You're a little older than you were this time. You still got the mirror but your clothes in this picture are a little more sedate. Are you still the same guy or . . . ?

JM: Oh, I ain't changed. I'm still the same. I still like to go out and dance, go to the movies, do the same things I been doing. Most of my friends are from the plant. And some of them are going all the way back to Amherst Foundry, some of the guys who moved over. Most of them are guys I work with. I go over their house and plus we got a bowling team that we have every Tuesday, winter bowling, bowling league every Tuesday.

MF: So you've been able to keep going, still doing, you know, essentially what you were doing before. But do you have any sense of why all these places closed down so

suddenly or what it means? You know, if somebody came from out of town and they say, "What's happening in this place?" How does it look to you?

JM: Well, I think a lot of these places closed down because, well, everybody say high taxes. And another thing, you got some people making fourteen, fifteen dollars an hour and the company said they can't afford to pay it no more and they want to cut two dollars off, or three dollars off, and everybody started bitching and then they tell you, no, the plant's out of business. Like Trico. That was a shock for me when that place went out of business. There were a lot of people working at that place, too. And they were working ten hours a day, some days, six or seven days a week!

MF: So what do you think is the cause of it?

JM: I think the company, if they could get the same job done for half price, that's where they're going at. That's how come they moved. And they get the same job done. They were making ten, twelve, fourteen dollars an hour. And they can get it for five dollars, what can you do?

MF: And what about Bethlehem, because Lackawanna's really like a bomb hit it.

JM: Oh yeah, a bomb hit Lackawanna. Bethlehem Steel, when they pulled out, it shocked a lot of people. But a lot of people got different jobs. See, one thing I found out, you got a lot of new jobs that are coming in that have never been here before. You got the transit; that wasn't here fifteen or twenty years ago. So they give people jobs. And like they say, if you want a job bad enough, there's some job out there. It may not be the job you want, but there's something out there, you got little odds and ends jobs, but nothing too much to brag about, though. There were a lot of people I know that got so disgusted that they moved from Buffalo. They said they're doing better than staying here. But then, another thing, if you don't know nobody they won't hire you! They won't give you a chance to see for yourself if you are able to do the job.

MF: That's one of the dilemmas, I think, about moving away. You go to someplace where you don't know anybody and it's harder, because at home when you have those networks, that's how you often get those jobs.

JM: Yeah, we had a job posted at Pohlman Foundry, that they wanted skilled maintainer, and the guy they hired, he wasn't no skilled maintainer. But his brother was a foreman there, and that's how he got the job. Now if it weren't for his brother he would never have got the job.

MF: I guess what a lot of people are wondering, whether that's going to continue. You know, everybody likes to think that things are going to be better for their kids but if you take your kids compared to when you were growing up in Lackawanna— let's say your daughter who's eighteen.

JM: Well, this is her last year. She's finishing high school. She wants to go take up computer. But I'm telling you, to me, everybody I hear of is taking up computers. Now everybody can't handle no job taking computers. Too many people are going in that one thing. Yeah, it's more rougher now than it were when I dropped out. And it'll be way rougher if they drop out now. Because when I was coming up all I told my father, I said, "Two things I want to do." He said, "What?" I said, "I don't want to never go to jail and I don't never want to go to the service." So he asked me why. I said, "Because I don't want nobody to tell me when to get up, when to go to bed, what time I got to eat, and all that."

MF: What about your little boy? Do you think you're going to have to push him more than they pushed you in terms of education and stuff like that?

JM: Oh yeah, I think you do because these kids coming up now, they're way different, their head's hard like a rock. When we were coming up, when the news would come on at six o'clock we would come in the living room, we know we don't supposed to talk or nothing because my father wants to hear the news. If we wanted to talk we had to go someplace else and talk because he wanted to listen to the news. But now you got kids, you watching the news, they don't much care, they come "blah, blah, blah, blah," all over the house.

MF: Well, let me ask you this. People they turn on the television they think they got the story, you know, this guy used to be a steelworker and now he's out of work. But, in fact, there are lots of different stories. So here, you got a job the next day. Other

people, I was talking to one guy who got laid off and he's never been able to get back and his health started to go. You never know what's going to happen.

JM: Oh, I'm not cutting you off, but let me tell you what my wife said. When the plant got burned down me and my ex-wife had got divorced already. So she asked me what I'm going to do, do I want to come back home. I said "No, I'm going to get another job." Even if I had no job I'd still say no. But three days later I had the job. So, I thank the Lord I got me another job. I was kind of scared because I know unemployment's only going to last but so long. But I was one of the lucky ones.

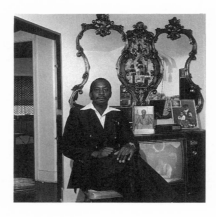

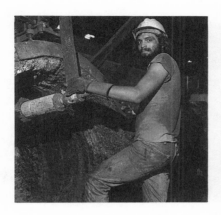 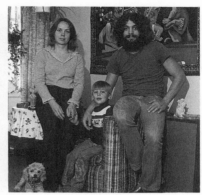

10 / WILLIAM DOUGLASS, JR.

MICHAEL FRISCH: What I'd like to do, Bill, is talk first about the work picture to get a sense of what you were doing and what Atlas Steel was all about, and then we can talk about what's happened since you stopped working at Atlas and what you've been doing since then.

WILLIAM DOUGLASS, JR.: This picture is, this is one of the ladles that we pour the molten steel into before we'd make our castings. That's what I was involved with at the time Milton took this, I did all the pouring of the castings.

MF: And what exactly—

WD: Well, see, this is all ceramic, it comes apart. There's a spout on the bottom, we turn it up with a crane and get it over right over the top of the sand mold, pour the casting. This thing we're looking at is the stopper. See, it's laying on its side now like you'd have a coffee cup on its side. Well, you turn it back up and there's a nozzle on the bottom—a ceramic nozzle, it's like a ball-and-socket joint, pull it up and let the steel out and drop it back down.

MF: And the steel comes from where?

WD: The big electric furnace that we melt scrap steel. Risers off of old castings. Anything from, oh, jeez, two pounds to close to thirty thousand pounds we used to pour.

MF: So this would melt down stuff and it would sort of cook until it was all molten?

WD: Yeah, cook until it was molten and then you would test it to make sure that you had the right properties in it—different grades of steel we would run. And then from the furnace you would dump it into this, this is what we poured it out of. It was a hot, dirty job!

MF: I notice your back's all sweaty there so you were right in the middle of it. Exactly what step in the process is this?

WD: I'm cleaning it out. This is after it's been poured. You dump the slag out and then you get it ready again. You get in there with a big air hammer. Any steel that's left around the sides or on the bottom you have to chip out, patch up any, any holes that you have in there because you could lose it out the side. That's happened before. That's no fun. You just scatter then. Not much else to do, just let it go.

MF: What kind of a business was Atlas? What else is going on in a mill like that aside from . . . ?

WD: Oh, Atlas was a small company. It's a foundry. There's, you know, roll mills and stuff like that—we didn't do any of that. We just did strictly castings. We didn't make any specific product—we were a job shop, we would make whatever anybody needed. Like we'd make castings for Bethlehem and Republic Steel, things that were too trivial for them to bother with. We had contracts with the Coast Guard. We poured huge, huge anchors, bridge struts, anything.

MF: How small is small, at Atlas?

WD: I really don't know, at the top I think we might have employed about 150 people.

MF: Back to this picture, how many guys would be working in a unit like this?

WD: Oh . . . the crane operator, and me guiding the crane operator and doing the pouring, two guys covering the risers up with riser therm.

MF: What's that?

WD: That's—each casting has to have a couple of risers on it so that when it cools, as it shrinks, the casting won't crack. That's just a hole cut into the mold above the casting and the riser would fill up after the casting was full and that would keep the casting from shrinking. Just the risers would shrink, all the shrinking will be done in the risers; then they get cut off later. That was the theory. It usually worked. Sometimes not—then you just start over again, start from square A.

MF: And what is this riser therm?

WD: It's a compound you use. The molten steel come up into the riser and you put this riser therm on it, and it keeps the heat inside the cast and it allows for a slower cool. You just scoop it on, it's very light—you see, the risers are exposed, it's the only part of the mold that you can see. You can see it coming right up. That's how you tell when it's full and as soon as it's full you shut the ladle off, the riser therm goes on top of that.

MF: So you'd have two guys on that?

WD: Well, there'd be the one guy with the pad making sure that the right molds got poured, different molds would do different grades of steel. There might be two guys if we were doing the little pours, the small castings, two guys pulling jackets, wooden jackets around the sand mold just to hold the mold together long enough to pour. They are for small castings. They could be like twelve by twelve or six by six, just four pieces of wood cut to whatever size. It is nailed together, it just holds the top mold and the bottom of the mold together. You would pour one line like that and then you would go to the next line and then two guys would come and pull those jackets off, run ahead of you and stick them on the next line.

MF: And how long a process would a given . . . ?

WD: It would take anywhere from—a quick pour would be ten minutes. A long pour would be an hour and a half. We would have a pour every two-and-a-half to three hours. So as soon as you're done with the first one you're, you're setting up right away for the next one. It was continuous.

MF: So basically it's just melt the stuff down and pour it into different molds.

WD: Into sand molds, right. We'd make the wooden patterns; if they weren't supplied with the order then they would send us the blueprints of what they wanted and we'd make a wooden pattern first as to whatever the casting's going to end up to look like, and then you'd make the sand molds out of the wooden pattern and then the steel would go into the sand molds.

MF: Just to get it a little clearer—let's say you were making an anchor. So that there would be the shape of an anchor that this sand is . . .

WD: Right. It's on a wooden pattern and the flask will go around that. That's the outside that holds the sand in there, OK? They would be just cast steel about a foot high, depending upon how big it would be, like if you needed an eight foot casting then you get eight flasks. The sand would go on top of that, then you would put a plate on top of that when you're done filling it with sand. That anchor would probably be like that. It was white sand and it was treated so that it would harden and then it would pop right off the pattern. Let the sand dry, you would flip the whole thing over, pull the mold out, all right, so now you have the bottom of your mold. Made of sand. It's just a sand imprint of the casting that you need. Then you do the same thing except in reverse to make the top.

MF: And is the sand wet when it's put in there?

WD: It's wet and then you would take a rammer, an air rammer with a big round rubber head on it, went bam, bam, bam, bam. You would stand on top of it and ram that sand down in there to make it hard. See, the sand is mixed before they get it.

With the bigger ones they would all be chemically treated, the sand, there would be no ramming with those. They had four fifty-five–gallon drums that would feed different chemicals into the sand as it came down through a big auger and that was real wet when it came out and that would just solidify and go from there.

MF: So, again, in this picture here, steel would then be poured from here into the patterns. Is it actually cooked in this thing?

WD: No, no, no. It's all—it's cooked in a big furnace, three times as big as this. It would be melted in there and then dumped into the ladle and then into the molds.

MF: Did you start off doing this pouring, or was there something else you did before you went there . . . ?

WD: No, I started right out doing this and then I had bid up. It was all by seniority, by department seniority first, and then by plant seniority. At Atlas, at least, they had different jobs numbered, like there'd be nine through three, nine being the lowest-paid job and three, I think there was the electrician that kept my transformer for the furnace going, was a three, maybe the head mechanic was a three. This was a nine, this was a low rung. I ended up as the chief melter. That was a four. There was only, like I say, two guys in the plant that got paid more than I did, so that wasn't too bad. But the pay at Atlas wasn't anything like the pay in the big steel plants. I mean [laughs], it wasn't anywhere *near* the. . . . Jeez, I think I started at less than four dollars an hour; I ended up at a little over eight. It was one of those jobs where you had to work your overtime to make any money, and at the end there wasn't any. When I started there, it was a ball on fire, they had two shifts running constantly. We used to work Saturdays and every other Sunday. It was almost a continuous furnace operation. I used to start at sometimes four in the morning, to start everything up. I'd be the first one in there. When the guys got in there, the first thing they did, the steel was ready.

MF: What was the melting operation like when you moved to that?

WD: We had an electric acid furnace; it used three big carbon electrodes, come down in a series and strike the steel sending arcs out. Very loud and very hot. Dangerous, too.

MF: And the people who were working on that—do they actually have to stir this as it starts to, like iron puddling?

WD: No, iron is completely different. Here everything goes in as cold steel, there's no preheating of the steel or anything, and there'd be enough turbulence in there from the electrodes themselves that within an hour you would have a pretty nice bath, unless—it sometimes had a tendency to bridge, it would weld itself together, you know. If it did get a little bit sluggish you just shut the power off, dip the electrodes straight into the bath and that churns it. From the time I turned it on, unless it was a real big heat, two hours, two hours and a half at tops it would be tapped out. . . .

MF: And what else does the melting work involve, I mean aside from turning it on?

WD: Oh boy, you have to unload the train cars full of scrap using a crane. Weigh it up because each charge would be a different weight. That was all done by hand. I ran a small monorail with a magnet, an electromagnet. I would lift the stuff up to a platform and I would set it down. Two guys up there, one on each side of the furnace, it would be tipped back and they'd stick a big long steel chute in it and the two guys'd take the big risers and slide them down there as best they could and then the little stuff they would shovel in. An average charge'd be fourteen thousand pounds, so you were pushing a lot of metal. Then, while it's melting, every heat, we worked in carbon and low alloy carbon steels, so every melt would get a certain amount of silicone in it and a certain amount of manganese. So as soon as that's turned on then we would figure out what we would need, weigh that up, get that ready.

MF: So just like cooking, you'd get it started and then you would worry about mixing up the eggs.

WD: Oh, yeah. Silicone, manganese, and aluminum in every heat, and then depending upon what grades you need, how much goes in and what kind of alloys, we would use nickel, chrome, molly, sometimes stellagin. You're getting everything for when it is melted.

MF: You refer to "molly." Is that molybdenum?

WD: Yeah, that's the tongue twister. Too many *b*'s and *d*'s together. We just called it "molly."

MF: Now did you have to select those or did somebody else . . . ?

WD: No, no, no. That was up to us, that was up to us. In the beginning all we had was charts for the different grades of steel. There'd be chrome mollies and nickel-chrome mollies, there would be a certain percentage of each that has to be in the melt and we would just have to figure it out. You would have to use maybe ten or fifteen or twenty percent of that grade steel in the remelt and then the rest virgin, and you'd have to try to figure out what you're going to need. You'd have a target area, at that time we had an eighty percent rate—shoot rate—positive rate that we had to hit. If you don't get it right, then the properties in the steel isn't going to be right. Like we did a lot of things for the coal mines, braces for inside the mines have to be able to withstand a lot of stress. Now if you don't have the right mixture in there, it's going to crack. And that's pretty serious. So we would end up scrapping a lot, just throwing it back in and starting again. Later on they got a little smart and they got us a spectrometer and we would take a sample and grind it and burn it. And that baby would tell us exactly what was in there and we'd have to figure out what we would need to bring it up to specs.

MF: And every melt is going to be a different—every product is going to be different so you have to really get to know those metals.

WD: Not only the different grade, but you'd have to know what you're going to pour. You have to determine at what temperature you're going to pour. Because if you're going to have all big molds, there'd be no problem but you may be out there for an hour and a half, hour and forty-five minutes with a bunch of small molds and you really ought to crank it up.

MF: Is that because it's going to take longer and it would cool down too much? Did it ever sometimes happen that you'd have a long pour and you could see that you're getting towards the end and the stuff just isn't—?

WD: Oh, yeah, quite often. Down at that end we would have a liquid oxygen line and we would use it if you would get icicles in the bottom where you poured from. It

would just clog up, so we would have like twenty-foot lengths of pipe and we would put it on the oxygen line, stick it up in there, turn on the oxygen and just burn that stuff out. You would have heats where when you would go to dump out the slag and there would be a ring of steel inside the ladle, and then, again, you would roll it over and get your oxygen lance out and start cutting that off. Before, that was a real bad job, we used to have these big silver-foil, all metallic outfits, we had to use them for that because sparks went everywhere. The little ones were nothing, I mean every once in a while they would break out or spit a little bit, you'd get used to that, the jackets would start on fire, get all smokey. But the scariest ones were the big heats. I would melt and pour those, and we would have just the people that were necessary to be around the heat while we were pouring it, we'd have two magnets men on top of the crane just in case—I mean you're talking thirty thousand pounds of molten steel.

MF: If you've got to go in with a torch in the middle of one of those . . .

WD: That would never happen. Oh, that's much too dangerous. We would scrap the whole heat—we have a big steel pot that we use to dump the slag in, and we would just dump the steel right into that. We had to get rid of a couple like that. No messing around with those babies.

MF: Now is this something that you'd get a sense of from doing the earlier work, pouring, or did you only learn that when you got to actually go into the melt shop?

WD: I learned it all firsthand right there by the seat of the pants sort of thing. I started out pouring so that I knew what the pourer would expect from the melter, so I had a head start, maybe. I'd say, "Jeez, this guy's got to make it a little bit hotter, this is nuts."

MF: You could tell about the temperature from the way it poured? Now is that also controlled by the melt shop? In other words they're responsible not only for what goes into the pot but when to take it out of the oven, in effect? He's the cook, he's the top chef?

WD: Yeah. The melter, the whole responsibility is his. He's the pivotal man. He's got a big whistle. When the heat's ready, he blasts it three times and the whole plant

jumps. That's what I ended up doing. I even got to—we had at one time bought another, a smaller plant in the City of Tonawanda, and they sent me out there to break that one in and it was the same operation, the same process, but a real small furnace. I got to go out there, set that all up, got that going and then I'd come back to Buffalo.

MF: I use this term cooking, I don't know whether it's just the way I think of it or whether I heard somebody say it. Is that the term you . . . ?

WD: No, we never heard it before! [laughs]. It's just the melt. Each pour, each one is a heat.

MF: You talk a lot about the pouring and what would happen if the stuff broke out—but where is the particular danger in the melting process?

WD: Well, in our operation it was the furnace—all we had was a small furnace that wasn't really as big as they should have had. They added some height to it so that we could melt more but when you melted more you would have to build—there was a door where you charge, where all the metal would go in. We would have to mix sand with different binding agents and build a dam in front of that door because the steel would be up past the door. The more modern furnaces they would lift the top, it would swing over and you would charge it with using the crane but this was a pretty old setup. You didn't have too many runouts there but that dam, we would have to build that by hand. About a year and a half before we shut down, we had quite a fire on our hands—we had molten steel right in the transformer room, the huge oil transformer. Which was quite a dangerous situation so we had to shut all the power down for a whole plant. I shut down everything.

MF: You must really have to rely on the guys you work with. Did you get to know them pretty well?

WD: Yeah, at least at my side of the plant where I worked I got to know everybody real good, got to be friends. I think it was probably because the type of work that we did in there was dangerous and you depend on the other guy to help you. Like a lot of

times those molds would rot out, between every flask you would have to clamp them down and those clamps wouldn't always hold. So you always depended on somebody else to watch your back while you were pouring or if you were covering up you would watch for the pourer—somebody's always watching for somebody because . . . There was an Atlas Steel in Canada, it had nothing to do with us, it just happened to have the same name, and the cable on the crane broke—it's the exact same type of operation and the ladle came down and killed like four or five people.

So I mean, it wasn't something that you thought of all the time, but there was always somebody going to the clinic, you know, for minor things. And you knew that there was a possibility of a major injury so it's just—I really didn't have any enemies in the place. There were a few people that I wouldn't invite over, you know, but they were fine at work. No enemies. We all got along real well. I still see, jeez, probably half a dozen on and off. One guy I see all the time. Yeah, after thirteen years—I was just talking to one of the guys I hadn't seen in a while and he asked me if I ever dreamt about this place. I said, "Not recently." Then right after he asked me that, I *did* dream about it—man, I woke up and I was thinking, "Jeez, that was really some hairy work I did there!" It was like I was really there and it was just like I was watching the pour and I was thinking, "Man, these guys could get hurt!"

MF: Did you ever get hurt bad working there?

WD: I did, I once lost 75 percent of vision of my left eye. I got hit with a little piece of steel, it was some sort of wiring or something, I was unloading a load of scrap and I didn't know what happened, I let the magnet down and next thing I knew I . . .

MF: Do you still have disability from that or did that clear up?

WD: No, I lost 75 percent of my vision in that eye. It's a scar right across, I'm looking through a scar. It really doesn't bother me unless I close my right eye. I got a settlement from the New York State Compensation, but the case is open for I think eighteen years or something like that in case there is any further change. It took about two years and a whole bunch of meetings, lots of examinations, my doctor, two of theirs. And one guy lost two fingers, he got it caught in the grinder or something. But nobody ever got killed or anything. But you know about it and that's

why you get to know these guys and you get to have confidence in them. The other guys, they'd have a tendency to get weeded out pretty quick.

MF: Did that sometimes happen, that somebody would be working there who couldn't cut it and everybody would know that pretty soon?

WD: Oh yeah, that would happen quite a bit. You had to cut the mustard or you were gone. Usually you could tell it in the first week if this other guy was going to cut it. A lot of guys would quit [laughs]. We'd get new guys and they'd get up there to charge the furnace and they'd throw a couple of big risers down and see this big huge pile of steel down there and they would just walk down, you'd never see them again. They used to go through quite a turnover. See, it was a union shop so that management had thirty days when you first started to evaluate you. And any time up to that thirtieth day they could just tell you, "Well, you don't measure up," or "You don't fit in," or "We just don't like you," you know, "take a hike." That happened quite a bit. But there was one guy that I didn't care for too much, he was second-shift foreman. He used to let these guys ride out right to their thirtieth day, and then wait for them at the time clock and he would tell them then. I mean, this guy is getting ready to punch out and just thinking, "Well this is it, I got it," and this big ugly sucker sat out there waiting for him. I thought it was really, really low.

MF: You said this is a small shop, about 150 guys. It's a family operation, you say?

WD: It was incorporated but all the stocks were all family-held. I mean like the old man started it and then the kid took over. The old man's chairman of the board and the kid was president or whatever.

MF: And what did this mean in terms of your experience working there? You know, some people would say, "Gee, a small plant ought to be better, closer relationship to management."

WD: You may get to know the management on a more personal level; whether you have a better relationship with them, I don't know [laughs]. I'll tell you, I got along better with the family that owned the place than I did with the people he hired to

manage it. The owner was a real nice man. Randy Wyckoff. He was a real nice man. The older Mr. Wyckoff, that's the older gentleman—I only met him a few times but he was a nice guy.

MF: What was the union's presence in a shop like that, on the floor?

WD: I used to have an on-again, off-again relationship with the union. They were there when something serious was wrong. They tried to do what they could. I tried fighting for a while myself and then I decided I couldn't, so right at the end I became active, was elected shop steward and got into some of the discussions. They did what they could, really. The working conditions were pretty bad. It wasn't a lot you could do about. They had fans and everything but because of all the sand and all the fumes, by the end of the day it was like an atmosphere you couldn't believe, in there, with smoke and sand, grit . . .

MF: Did you wear one of those breathing . . . ?

WD: When you could, but you couldn't always do it, you know. Jeez, I had one almost melt onto my face one time so [laughs] that was that. You really couldn't do much about the working conditions. God, it was really nasty, we had a lot of guys quit because of that, and I'm telling you I'm glad I'm not in that atmosphere any more. But the union was good and bad, usually good. When things came up, if something was unsafe, you didn't like the way this platform or whatever was set up, you'd first go to your foreman and if he didn't get it fixed, well you'd go right to the union. There's a steward for each department on each shift, so there's always a union rep there that you can go to. Anytime, anything dealing with safety, I mean they would be right on, boom, like that. They'd back you a hundred percent.

There was a lot of things that were not too safe. At Atlas somebody did complain to OSHA enough that they came and they did a full-scale search. It took them months and months. They went through every section, every corner of the plant. Never did find out who actually called them in, but I'll tell you, when they were done they had a list of complaints like a phone book! They were thorough! Oh, they were so thorough, they had me upset! Jeez, they were so picky—some of the stuff was great, good, fix it, it's been years, you know. But some things were so petty I could

not believe. They had me sitting at a table with the OSHA reps at the other end of the table and management, and this guy's telling me [laughs], "You don't have to be afraid to speak out," and I'm telling him, "you ask these guys, I'm not afraid to speak out, but now you're getting really nit-picky. It's getting ridiculous. Take care of the big stuff!"

MF: Did anything improve as a result of that?

WD: Yeah, there were some obvious faults taken care of. We had some ladders, probably fifty- or sixty-foot ladders, steel-rung ladders that they were supposed to have cages around them, that were never caged in. They didn't like their dust collection system, but nothing got done about that. I was glad they came in, though. Most of the stuff was obvious stuff that we had been trying to get fixed. Somebody just got disgusted.

MF: Were people afraid that the plant would be hurt if they picked too much? Kind of catches you going both ways.

WD: Oh yeah, oh yeah. Because they came in when we were down to like a four-day week at that time, with on and off layoffs every once in a while. Yeah, a lot of guys were deathly afraid to say anything to OSHA because they were afraid they were going to lose their job. Not that—they couldn't lose their job because they complained to OSHA, but you know, management has ways.

MF: And also that it would hurt the—. If the company's already kind of getting marginal, then the more they're . . .

WD: Yeah, I was worried about that. Things were slowing down and I felt right away, I thought well, OSHA, that's no big deal, they'll fix a few of these ladders, they'll be out of here, but jeez, when they stuck around I said, "Holy cow!" You want them there, but then you're going, "Oi Vey" [laughs].

MF: Aside from pushing on these safety things, what else did the union do?

WD: Well, there was a lot of stuff they just couldn't help you with, and I used to really get upset with them so I would take things into my own hands then. One of the

main things wrong was that management was doing union jobs. The foremen was working, which they weren't supposed to. They always had a hammer in their hand, clamping molds, doing something. Taking somebody's job away. The only difference was they wore green hats, we wore the yellow hats, hard hats. Like we would have preferred to see these guys even have white coats and ties on so that they couldn't do any of this work, they would be afraid to mess up their clothes or whatever [laughs]. When things were going good it wasn't really costing anybody any time so nobody really cared, even though we bitched about it, the union'd say OK, and they would keep on doing it. But then when things got bad they kept doing it and they couldn't stop them because they didn't stop them, you know, before.

MF: Who did these foremen tend to be mostly? These were guys who came up through the ranks?

WD: Jeez, I don't know. Most of them were there when I got there. Most of them were old-timers. See, as long as I was in that melt department I really didn't have too much trouble. The foremen just sort of stayed away, because that's where all the heat was, and all the sparks. As long as we got our steel out they more or less left us alone. But I got to know all the top management real good. Real quick. Because I would have to answer them for anything that wasn't copacetic. If it was, well, then you just didn't hear from them.

MF: Other ways in which being in a small company may seem to you different than in a large, you know, in Republic or . . .

WD: I would imagine that it would have to be different. Republic, jeez, how many people would they have? A couple of thousand? At Atlas Steel I was Bill, or I was Doobie, my nickname. I can imagine at Republic you're 1747 or something, you know. "Hey, I'm 2742, what's your badge number?"

MF: Was that a nickname you got in the plant or is that one you brought in with you?

WD: [laughs] It was given to me in the plant for our softball team. We played in the Muni League for about four years. I still have my jersey. Everybody had to have a

nickname, we had "Jellyroll" and "Tubs," we had a guy named Dean we called "Hank."

MF: Doobie—where did it come from?

WD: Uh, I used to smoke them illegal doobies [laughs], you know, joints. That's the same time as the picture was taken. I didn't give myself the name.

MF: Was the union involved in organizing things like the softball?

WD: No, it was just some guys at work got together. And Wyckoff sponsored us, he was nice. He bought us the jerseys. The union—the only social activities we had was a once-a-year Christmas party. Other than that we had our once-a-month union meetings, once-a-month grievance meetings with management and whatever other special meetings we'd have to call inbetween.

MF: And you got more involved in the union toward the end, you were saying?

WD: Yeah. Well, I was fed up with everything towards the end. A few of my friends wanted me to run. The two elections previous to that I was head of the election committee. So I was on different committees, I wasn't totally in the dark. They suggested I run. So I did; I don't know what good it did.

MF: So you were shop steward for the melt shop, or for the whole plant?

WD: For the foundry. For half of the plant. It was right near the end and I wanted to get in there to make sure that we would get some use out of the money that we had left in the fund, our union money. Because once the plant folds the international will keep that union going for six months or whatever and then they'll pull the charter on it. Whatever monies are left in the treasury reverts to the international. So our local would get nothing out of it. So we had a giant Christmas party, a real big one. We bought gifts for every kid, for every man in the plant and we had a ball.

MF: So you could see the end was coming at that point.

WD: Oh yeah, yeah. We started spending money. We knew it was coming. Like we did everything we could, we were bending over backwards at the end. I mean they were already under bankruptcy, Chapter 11, by the time I got elected so actually we were powerless, our contract was out the window. They actually didn't have to honor the contract. But they did, they stuck with the contract right up to the end, which really surprised me.

MF: You mentioned the differences between a small mill and a big one, in terms of the wages—that's real interesting, because when they read these things in the newspapers, it's like everybody has the image that—

WD: That they're working steel, make big money, and that everybody that worked in steel when their plant closed got some sort of government assistance to be retrained. Which also isn't true. We got *none*. We got nothing. Unemployment—that was it. There was no retraining, like Republic or Bethlehem, because you had to be able to prove to the government that you lost your job as a direct result of foreign imports. Now, I don't know—maybe it was the international union that decided well, just let the small plants slide. Maybe we can't do both. I don't know if they just let us out to dry, or if they tried and got turned down . . .

MF: So did people have a sense that what—that this wasn't particularly the company's fault, that it was more just . . . ?

WD: I think it was a combination of different things. I think it was cheap steel from outside the U.S. The plant was aging. Maybe a bad investment by the company. Before the final closing, they had two big capital outlays within probably less than two years. They bought a vacuum molding process, a Japanese process. They invested a lot of money in that and then they bought that smaller plant in the City of Tonawanda, which was Atlas Specialties, which didn't work out.

MF: As it went down, was it a sense that they weren't making the money on the business, or was it that there just wasn't the business? In other words, the orders were just really drying up?

WD: I don't think that the orders ever dried out completely. It was just the money flow because of the bad investments. But we had lost a lot of jobs to foreign companies.

MF: Even on this custom work? I can imagine foreign steelmakers sending over girders, but the idea of saying that we need an anchor that looks like this, a thing for this part of a coal mine—the idea of sending an order like that overseas—

WD: But see, it's actually easier for them to make something small over there. These girders, beams, and stuff, you need so much equipment and everything. We used to make little caps for motors and they wouldn't be any bigger than that—you don't need much to melt that amount of steel, you get two guys with a bamboo rod, pick up a ton, can pour that much, you know.

MF: So as soon as the foreign companies could produce the quality, then they could get those orders?

WD: Well no, I don't think the orders ever ran out. We got the contracts to make the anchors for the Coast Guard, I think that kept us going for probably the last year, that was our biggest customer. I work with some of the guys now that I used to work with at Atlas, and one of them was a salesman and he said that the orders were always there, we just didn't have the cash to operate. Like maybe they tried to modernize too late, things were already going downhill. And if you're left behind and *then* make the investment, then you have to go out and either get the old customers that you lost or find new customers, and in the meantime you're digging a deeper hole.

MF: So, during that period the feeling that most of the guys had was what?

WD: Everybody was just trying to stick it out to the end. Our hands were completely tied. Everything was up to the bankruptcy judge. I imagine it couldn't spend anymore without their consent. Our last—it was two years ago in September that Atlas shut down for the last time. I was taking a vacation and the president of the company tried to talk me out of taking my vacation. I asked him, "Isn't it going to be here when I got back?" He told me then, he said, "no, it's not." "Well," I said, "I earned a vacation, I'll take it" [laughs].

MF: What about pension stuff, did that also . . . ?

WD: Ha! [Laughs, bitterly] To this day, I don't know if I am going to get anything. I know that I have my vested rights. I don't know if there is going to be anything left or if there is anything left now and I don't how to find out about it either. I doubt I'll see anything. I worked there for thirteen years, I don't think I'll see anything.

MF: OK, well, let's, we'll leave that sit for a bit. Why don't you tell me about where you're from, where you grew up, a little bit about your family.

WD: I was born in Pennsylvania but I was raised here in Tonawanda, my parents are both from Pennsylvania. My father—his father had a little farm but I believe that he was working on the railroad at the time he came up here, about 1952. I was an infant. He worked at GM, when they opened up here in Tonawanda. He's still there, his brother came up with him, he's still there. My father is union representative, he's been a union rep for all but about three years.

MF: OK. So, you grew up here in—

WD: Sheridan Parkside. Grew right up here in this neighborhood where I still live at. So did my wife, we both attended public schools in Tonawanda, both graduated from Kenmore West, we were high-school sweethearts. I grew up right across the street from the elementary school I went to. My folks still live here in Tonawanda. Same neighborhood on Pyle, right where we grew up. He might retire to Florida, though, or at least winter in Florida once he retires. He was going to retire this year but he keeps putting it off now that he's back into the union real heavy again. He hates to leave any unfinished business [laughs].

MF: And your wife's family?

WD: Her father's also a GM employee, a lifetime GM employee. I'm not too sure, I think her mother is from Farmingham, New York, it's not too far from here, about two hours, it's a farm community. Her grandfather was a preacher, a coal miner and a preacher in Pennsylvania. She has quite a few relatives in the clergy. They're Pentecostals.

MF: Your family is Protestant?

WD: I guess, yeah. We really didn't go to church a lot and when we did go [laughs], it'd be a Protestant, once in a while. Unlike her family. My wife teaches Sunday School on and off. My son's going Wednesday nights to a Rangers, it's like a Boy Scouts. It's through the church. . . .

MF: So you were high-school sweethearts.

WD: Yeah. She's got a twin brother who was my best friend and stuff [laughs]. I used to go help her brother with the papers and after a while I'd stay and *he'd* go do the papers.

MF: What was growing up here like? Did you. . . . ?

WD: When I was in high school I was thinking about girls and sports and the draft. I went to work at GM right after graduation, I didn't want to, I told my father I wasn't ready, but he insisted. I started there right away, I didn't last too long. I wasn't ready for that kind of work right out of high school. I just quit, I told him, "The hell with it." My father didn't understand it.

MF: What was it that you didn't like about it?

WD: It was so impersonal, you were just a number, you were nobody, you were just another machine, as soon as you start the foreman tells you how many parts to do. Well, as soon as he leaves the union man comes over and he tells you how many parts to do. Now these are two different numbers, you don't know what the hell to do. He would say, "Well, this is your production quota," and the union man would come and say, "now if you do more than this number you're going to make the guy on second shift look bad and they're going to expect him to do that amount." I wasn't ready for that bullshit. You don't get training to deal with those situations in high school. I didn't take any shop classes, I took all college prep classes and then I messed up half of those. High school was a nonthinking experience for me.

MF: You mentioned the draft. Was that hanging over your head?

WD: Yeah, I was gone right away. I graduated in '69. So it was '70, or was it the end of '69? I can't remember the exact date. I got sent to Vietnam, I was there eleven

months and some odd days. I used to have it down to the hour. I was an MP, I was in Chu Lai and then Da Nang. I brought convoys out to the LZs. I was never on LZ under direct attack, though, thank God. I didn't see any heavy combat.

MF: Well, when we look at these pictures—you sort of referred a little bit to this when you were talking about your nickname—people have these images of that period that all the hippies were one type, they were all college kids burning their draft cards, and all the working-class guys were another type, they all had crew cuts and hard hats and Archie Bunker.

WD: Yeah, isn't that nonsense?

MF: So where were you—? It looks like you were sort of hippie-ish then and you were smoking some joints. Did you identify with the counterculture at all, did you see yourself as sort of a dropout?

WD: Yeah, I tried everything I could to stay out of the draft. It was funny because I had torn up a knee playing high-school football, and I had gone to talk to some draft counselors and they had given me a doctor to go to and he had made out this real nice-looking report for me and when I came into the doctor's office at the draft board, I swear they must have recognized this guy's name. I was on the bus that afternoon.

MF: And was that just personal or did you have feelings about the war?

WD: Oh, I don't know if it was so much the war as it was the draft. I didn't personally believe that the draft was right. The war I wasn't too sure about, you know, I couldn't decide for myself if it was right or wrong, but I decided for myself I didn't think the draft was right at all. To come and say "I'm going to take two years out of your life, let's go." It still aggravates me to think of it.

MF: And did your feelings about the war change when you were there or did you sort of remain the same?

WD: Oh, jeez, I . . . I met some Vietnamese people that I liked a lot and I met some that I hated. I don't know, I thought that even when I was there that there was no way that we were going to win, from dealing with the Arvens [ARVNs], the Army of the

Republic of Vietnam, the corruption was so deep and they just weren't very good fighters. You had to watch them as much as you had to watch the regular North Vietnamese or the VC. I don't even like to talk about it, I try and wipe it right out. Right away, that's over, that's gone. I got married when I got out. When I came out the place I was working at was closed, so I found another job, an old pipe foundry and they ended up closing, so I had a friend that was working at Atlas, he told me that with the foundry experience they would hire me, and they hired me right away.

MF: So at that point were you just sort of going from job to job and see what comes next?

WD: At the time I started at Atlas I didn't think I would be there as long as I was; I figured that I would just go somewhere else. Maybe back to GM eventually.

MF: And when you came back again with the long hair and stuff, so you still sort of saw yourself as kind of on the fringe in some way?

WD: Yeah, I think I went five years before I got a haircut when they finally let me out. As my own personal protest, I guess.

MF: You were living where when this picture was taken?

WD: That was on Blackmore, just on the other side of the neighborhood. Almost the same, a little bit smaller.

MF: And Jason is about what, five in this picture, so he was born in 1973 or 1974?

WD: Yeah, and five years later we had Danny and five years later we had Betty. We had two preemies, too, that didn't make it.

MF: During the time, say, this picture was taken, you mentioned things like softball. Had you played ball in high school?

WD: No, I was playing in the Muni Leagues during high school, hardball, it was just a little bit better than high-school competition. I played there and it meant that I didn't have to go to school all the time. We had a regular sponsor, we played double-A Muni ball, which was the second highest amateur league in Buffalo. I caught and I played first base. I like to catch better, I like to be in control.

MF: Are you doing sports now?

WD: No, I cut down to two nights a week in softball. Last winter was the first winter we haven't rented a gym once a week to play basketball. We had a regular group of guys, we rented the Delaware Y out one night a week, two hours a night we rented out the gym, and then for a couple of years we rented out the elementary school over here, we'd get anywhere from ten to twenty guys together, just pickup teams. It got to be too crazy, with all the insurance waivers and everything. But it's not their fault, they have to cover themselves. Same thing with softball, every year the price goes up for a franchise fee because of the insurance. So one of my softball teams disbanded because of that, too. It gets harder to find a sponsor. Everybody's getting older, getting more responsibilities, it keeps getting harder to find someone who wants to take over. Go to all the meetings, find a sponsor. Just another step in the aging process. . . .

MF: OK, I guess one thing I wanted to talk about for a bit, there's been a lot of interest in all of these changes in a place like Buffalo, because it was such a symbol of heavy-industry town, GM and Ford and the steel mills, and now it's all going and nobody knows what's going to happen to the city. And all across the country there's this sense the industrial age is ending and we are heading in the not-so-industrial age, whatever that means. Any sense of how you relate to all that about the decline of the steel mills? Do you see it mainly in terms of the foreign competition issue or do you think that they're doing the wrong things, or we ought to be doing things differently?

WD: Gee, I don't know, it's tough. I have friends that have been out of work for a long time. I just think it's a damn shame. I don't know what I can do about it, you know? I just think it's terrible. I don't know if there is too many rules and regulations, too many tariffs. We were talking about the free trade policy with Canada the other day at work. We do a lot of work with Canada, we do a lot of refining for them, they buy a lot of stuff from us. I think maybe that'd be a step in the right direction. I don't know, unfair competition from abroad—I can't say that's unfair if those people can make a product cheaper than we can, then good. But hell, don't put unreal tariffs on our products coming into yours, give us a fighting chance, anyways. I mean, I know in this country we can make anything as well as anybody else. It might cost a

little more but I think we could compete with anybody. Just knock some of those barriers down. I don't know. I got faith in us and the American people, but you got to be given a fair shake.

MF: You hear all this stuff about high tech and computers and of course, one of the biggest things going in Buffalo now is the big banks downtown and so forth. There's a debate about whether we're too quick to throw out industrial skills and say, "Well, all that's the past, now let's put everybody in white shirts and operate computers," or do you think that is the way to go?

WD: Oh jeez, I don't know. Maybe it is a natural evolution that we go from the dust bowl to the rust bowls to high tech. But it would be a shame to lose all those skills and all that knowledge and in the future find that we need it and we can't depend on other countries to supply us with these goods anymore. For Buffalo, I think, just because of our proximity to Canada, goods come in and out of Buffalo all the time on the Great Lakes and we have major access to Canada. Maybe not as a heavy industrial site, maybe as a transport site.

MF: That's a good point. You get totally dependent on these other things and then you've forgotten how to do it. And actually in a place like Buffalo, the interesting thing about it in the past is how many small companies there were making stuff and there are still a lot of small companies that could be, you know, making more of that stuff. When you think about your kids, what do you see for them, looking down the road?

WD: Oh jeez [laughs], I don't know, I keep harping on my oldest one to buckle down in school, not to make the mistakes I did. I mean, they used to say, "Jeez, you got to have a high school diploma!" Now that's nothing, that just shows that you did what you had to do. If I would have found something that I wanted to do that would have taken some schooling, if I was to go I wouldn't mind taking some metallurgy classes, I have some basic metallurgy knowledge but, you know, nothing to show for it. That's what I would go for but like I say, I don't know if I'd even be able to use it anymore. There's a lot of metallurgists out there looking for work.

MF: Jason's heading into high school so he will face some of that stuff. What would you say your expectations are?

WD: I just want him to do well in high school so that he'll be able to do something. It's his choice, but I want him to be able to be happy later on and, you know, you have to enjoy what you're doing. But an education is important, it keeps getting more and more important. I think he has to have an education and he's trying to buck it a little bit, you know [laughs]. I don't care what he does. He could pump gas, be a mechanic, as long as he is happy. I just want other options open for him. I don't want everyone to pass him by, that's all.

MF: When things started going down, has all that been tough in this neighborhood? I mean, there must be like in almost every house somebody's under some kind of gun or has some kind of shadow over them. Not only GM, but where's that place near here, made hand tools—J. H. Williams, a cousin of mine used to work there, it was really ugly. They got bought up by somebody, and then *they* got bought up by somebody else, and then they pulled the rug out.

WD: Yeah, that plant just celebrated its one hundredth anniversary not long ago. They went on strike, and never got back in. They were moving machinery while the boys were picketing.

MF: How does that affect an area like this? Is it sort of in the way people relate to each other? Does everybody kind of hunker down more? Stay to themselves or hang out in the bars more or . . . ?

WD: Well, jeez, probably hang out in the bars less because they can't afford it anymore [laughs]. Go to the new administration building or whatever they call it now and sign up for food stamps. . . .

MF: Other senses in which things have really changed in this neighborhood since when you were growing up?

WD: I think there is more . . . not transients, but there's more people moving in and out of here. They used to be a lot more stable in those days. There is still a lot of people, like our families, that grew up in this neighborhood that are still in this neighborhood. It seems like there are more people coming and moving in for awhile, move out. A lot of activity the first of every month. There is not very much low-

income housing in the town, and there's a lot more corporate owners of these four- and five-family houses than there used to be. That's the clientele they cater to now. They can get guaranteed money, whatever the government will give them for that unit, that's what they'll charge. Duplexes like I own here, most of those are just family-owned. But all of the big ones have been getting swallowed up, there's four- or five- and six-family units, so that's pretty good income.

MF: Other ways the community has changed that you grew up in? Schools? Social life? Bars? All that pretty much the same?

WD: Yeah, I'd say so. I don't know, there used to be a community group, my mother used to belong to it. It was sort of a watch-out-for-your-neighborhood group, sponsor bake sales and stuff. They used to have monthly meetings and put out a newsletter. I don't even think it exists anymore. I don't think that the interest is there. Or maybe it's that people don't have time, a lot of families.

MF: So what happened to you after Atlas went down? You'd seen this coming, so were you already looking for work?

WD: No, I wasn't, but I was working a week later! I work with molten metal still, but now it's gold and silver and alloys—at Premier Metals, downtown, right in the theater district. They make gold wire and plate and solders, alloy for carating gold, and we refine gold and silver, all the jewelers' grindings and floor sweeps or whatever. It's real small, less than one hundred, it's good work and so far it's been real steady. They're just building a new plant out in Alden, so I'll be moving out there pretty soon. They're making a big investment, they're doing good.

MF: That must be a funny feeling, to have gone from steel to gold.

WD: Yes, it is. I used to work with up to 30,000 pounds of molten metal, and now I work with a hundred thirty-pound top. Usually, we're talking troy ounces! [Laughs] I enjoy what I do now. It's a hell of a lot cleaner.

MF: And were you able to get that because of your experience at Atlas?

WD: Well, the reason I got the job was I played softball with the vice president of the company, and he knew that I had experience with molten metals. Atlas closed down, I

went and I opened my unemployment and before I had my waiting week in, I was working. I am *unbelievably* lucky. I don't know if I would be working now, still, if it wasn't for that. But I'll tell you, all the time I knew that Atlas was closing, even up to the one week I didn't work, I was never worried about getting a job. I used to always tell myself, "I'm going to work, I've got to work." What the hell—I'm a worker, I've got to work! What am I going to do? There will be a job, I'm going to work! I've always worked. Since I was old enough to get my working papers, I've worked, I've got to work.

MF: And you are really able to use your old skills down there? Are you a key person in their operation?

WD: I'd like to think so. I've got my own department again. Me, the department! Now it's me and two other guys. I work all the time, work every Saturday. I'm making now just about what I was making when I left Atlas. I started out at five twenty-five two years ago, raises have been coming pretty good. There are a lot of differences: no union shop or anything, your wages depend strictly upon your work, how good you do and how well you get along with the man in charge of giving you the raises. There is no set scale for any job, for any person.

MF: Do you miss some of the union protection, in that sense?

WD: Sometimes I feel odd, talking about pay at this place because I don't know what other people are making and I know that I make more than some people that have been there longer than I have. They give you this little brochure when you start, that tells you [nervous laugh] not to discuss what you earn with the other employees. In a way, yeah, it's strange and it's awkward at times, but I guess that's the way it is. Thank you for the job—I'll be here tomorrow.

MF: The vice president, he was not on your Atlas team, he was on one of the teams you played on the Muni League?

WD: No, it wasn't the Atlas team. See, the vice president grew up with one of the salesmen from Atlas, who is now our credit manager at Premier. So he was playing on his team and they asked me to fill in, it was kind of getting near the playoffs. Jeez,

it'd be about two or three years since I've played for that team. All of a sudden this guy's on the phone, he says, "This is Bill, remember me?" I says, "Second baseman, right?" [laughs]. He says, "Also vice president of Premier Metals, do you want a job?" I said, "*Yeah*" [laughs]. I'll tell you, I was in shock I think for the first two weeks I was at work. It wasn't bad though, there were people there that I already knew. Let's see: Bill, Wally, Doug—three guys from Atlas that I knew. They took me to introduce me to the guy in charge of the vault—hell, I went to school with him. A guy walks by and they said, "I want to introduce you to the maintenance man"—I grew up across the street from him. The guy that was making the intros, I knew his cousins. He said "Well, I'm not going to introduce you to anybody else!" [laughs].

MF: That's great. And they're a pretty nice group of people?

WD: All the people I work for are excellent, excellent. There's some other departments there are some real nasty ones. But all the people I work for on my job are real good. I couldn't be happier in my new job.

[From a follow-up interview a week later]

MF: Last time, we got a real good picture of your work. And I love that story of the guy calling up and you saying, "Yeah, Bill, second base," and he says "Yeah, and I'm also vice president, you want a job?"

WD: I'm glad you brought that up. A lot's happened since we talked. [solemn pause]. The company's fired the president, the vice president, the comptroller, and head of sales—the top four execs, last Tuesday, the day after we talked! Since then, I believe fifteen people have followed. These are all the people, let's see [consults a list on paper], nineteen, we're to twenty now. That's quite a percentage of our work force. There was a meeting Tuesday with the owner and the top four execs, at that time he wanted them to sign a noncompetition contract stating that they would not try to form their own company or try to compete against that company. You know it's like signing away your right to work in your chosen profession, so they chose to walk.

MF: Whew!

WD: In the meantime they have had meetings with me, they've tried to intimidate me, they tried to bribe me to say so far I'm staying. They gave me a real hefty raise

but I don't know, I don't know what's going to happen with these other people, I'm pretty sure they are going to try to get their own company. I need a job, I've got to work, but I don't know if I can work for the people that are running this company now. It's another family-owned company. Now the owner has his daughter and her husband running the company, brought in a man from another company and I guess that they're going to have a lot of other people from this company. It's like a corporate raid. It's unbelievable. Its unreal!

MF: And a lot of the guys fired must be friends of yours.

WD: Just about all of them. They gave me a real hefty raise, they said I was solid in my position, but hell, I don't know if I can believe them or not, you know. It's the same in the whole place. All those people I told you were a pleasure to work for, are gone. I'll tell you, even though the last couple of months in the steel plant we knew the place was going down, I *never* saw morale as low as it is where I'm at now. People are just walking around, they're dragging. It's horrible.

MF: I'm really sorry to hear that.

WD: [Laughs] It's the life of a working man. That's why you're here. That's my bombshell!

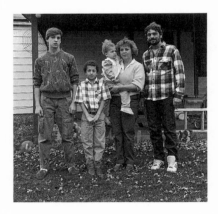

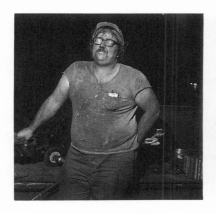 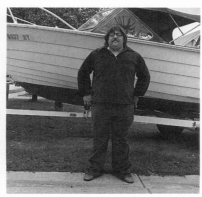

II / FRANK ANDRZJEWSKI, JR.

MICHAEL FRISCH: One of the interesting things about this book is that the people will have these pictures in front of them, so it's like they're going to have you looking over their shoulders saying, "Well, here's what's going on." So let's start with this picture of you taken at work at Atlas Steel, and maybe you could tell us a little bit about what you did there.

FRANK ANDRZJEWSKI, JR.: Well, when these pictures were taken I was a chipper and grinder. Castings when they come over, they have the sand and excess metal on there, and they got to be cleaned out. They got to be chipped, ground, and when I first started, that's what I was doing over there. We made little castings, one pound all the way up to fifteen, sixteen tons, at Atlas. We had regular steel, then we had alloy steels too, special alloy steel castings. We're a jobber place, we weren't on mass production, we make one of these and two of those. I never knew what was coming over, it could be anything—we had people come off the street and have certain things made, like screws for meat grinders. Anything from meat grinders to big construction equipment, we made stuff for submarines, battleships, aircraft carriers, like a steering selector, we make a universal joint for the propeller shaft, we were making bulkheads for nuclear submarines and we were making covers for the electric batteries for the submarines—and anchors, oh man, all the way from five-pound anchors up to ten-*ton* anchors.

MF: And this is all work that is coming out of molds, so that steel would be melted down and your shop would make the molds for it?

FA: Yeah, everything from molding to pattern making. Most of them are wood patterns, but we had some steel ones for the smaller jobs, especially when it came to that V-process system, they call it V-process, vacuum process, where, they got these big . . . Ha! I can't even think what the heck you call it, it's been so long I forgot! . . . Well, you got these big boxes and you put the hose to it and it draws vacuum, and the sand is held, instead of like the old, the other way you have to add glues to pack the sand, it gets hard and you can't use the sand no more. The V-process holds everything under a vacuum, so that once you make your mold you pour the metal, you let it cool twenty-four hours, you put it over a shaker, you take the vacuum motors off, and whoosh—the sand shakes all down and you got the casting there.

MF: Whereas ordinarily the sand is pushed, in the older kind, is like pushed into this wooden pattern, right?

FA: Yeah, over the wooden patterns. The patterns are made opposite, so you have to make all patterns backwards. Clamp them together, and then you got risers on and gates in there so the metal flows through everything. The risers are the big holes you see on top of these molds, that's where they pour the steel into and then see, it fills up and it takes care of your cracks and all your slag material comes up, it's supposed to be up in the risers. *Supposed* to be [laughs]. Then it gets heated, goes to the furnace to be annealed, and then they use either the wheel ringer which tumbles it, or the roto-blast which is a big huge round table, it's got steel shock with grit, it cleans the casting off. . . .

MF: And the tumbler is like what a kid would have for one of those rock things, you put in and it spins it around . . .

FA: [Laughs] Yeah, but a lot bigger. In the tumbler it's only like three or four hundred pounds at most, anything over that went to the roto-blast. And then after that, the risers will be burned off and all the big gates will be burned off, then it will go to the powder wash which is scarfing. Because you got risers maybe thirteen,

fourteen, eighteen inches in diameter, there's no way you can chip and grind that, you would be there forever, so they scarf it down just to leave a little.

MF: OK, so now you're getting towards the final part of the finishing.

FA: Not really! It's a long process! Then after that, then it would go back in the furnace again because the scarfing makes the casting too hard, there's no way you could chip and grind, then it would come to the chipper and grinder. See, the chipper and grinder, we have to chip out all the sand holes and like if there's a part there and some that's missing, we have to clean it up so that the welder can weld it back up. Punch out holes, sometimes you get the excess metal on it and the core doesn't cut all the way through, so you have to open up holes, grind excess metal off, look for cracks, dig out cracks, holes, porosity.

[Little boy comes in door]

Boy: Dad, can we go play?

FA: Yeah, your clothes are on the bed. That's my son, Frank, the third.

MF: When it comes out of the furnace to soften it up is it still real hot or can you still touch it. . . . ?

FA: No, it's cherry red.

MF: So you're doing this grinding when it's still real . . . ?

FA: No, no, not on that. Nobody would work on a red-hot casting, only when we're straightening or something, but as far as grinding, no, nobody would work on a red-hot casting! Sometimes when they're in a hurry castings could still be warm, you got to watch yourself because you might lean on it and, whew, there goes your clothes, started on fire! Other times you get castings that are stone cold, especially the wintertime you know, because the place wasn't heated so overnight the mold castings got cold awful fast.

MF: Now these things on the table behind you in the picture, are those some of your grinding wheels?

FA: Yeah, that's one of the stone grinders that we use, we had all different kinds of grinders, we had vertical grinders, we have small little die grinders, chipping hammers, all different kinds of chisels. Everything was run off of air. On the walls you got piping that runs all the way down from the air compressors, and everybody had their, supposed to have their own air tools, and hoses that you just attach to the wall. So anyway, after it was welded, annealed and ground, then it went back to furnace for a draw, that means to stabilize the molecules on the inside or else it would be too brittle, it would crack too easy. After it came out, and it was cooled out there, it was inspected. And certain jobs had to be sent to x-ray, you know, all government jobs had to be sent out to be x-rayed. See, most of the castings the customer machined their own work, but the metal had to be right, couldn't be too hard, couldn't be too soft, and when they machined it the machined surface couldn't have no sand holes or cracks or tears.

MF: Now in that kind of work is someone looking over your shoulder all the time, or in general are you responsible for making decisions on when you've done enough?

FA: Most of the time you knew what had to be done because you had the jobs before. You basically know that you have to clean the sand, look for sand, porosity, cracks, tears, and sometimes you even notice that parts are missing because some of these other bigger jobs require maybe, forty, fifty different kind of cores that go in there. This forms a casting, it forms all your holes, your basic shape of the teeth, and things like that.

The small jobs went real fast but the big jobs are very time-consuming, you know, a lot of work. Sometimes I may work on one of those big castings two weeks, just chipping and grinding, because they have a problem with sand. Like they never cleaned the mold out after, you'd be amazed how much dust will build up in one mold just in one day. Other times the mold breaks, and the sand would get burned into the steel. It would be like hardened in concrete—I'd rather chisel concrete. Some of those jobs when they were having real bad problems, two shifts working day and night, two shifts working on one casting. This kind of place is bullwork, all bullwork.

MF: What do you mean, bullwork?

FA: Everything is done by hand. Not the heavy lifting, but I'm saying these castings over here [points to bottom right-hand corner of picture] are over a hundred pounds. And you've got to physically pick it up and move it, you don't have your own private little crane. And the cranes are constantly busy shuttling between the furnaces, they have to constantly put a pile here that these castings were annealed, these have got to be burned. See, the regular steel castings they would burn before the annealed. Because they don't have to worry about them cracking. But, especially alloys, 4140s and 8630s and that kind of steel, they would have to anneal it first because if they tried to burn them they would crack. They're alloys, you know, brittle.

MF: So you'd come in at the beginning of your shift and there'd be stuff they delivered. Are a group of you in a room here, is there a chipping and grinding . . . ?

FA: Just one big, long bay, yeah, all the way down the shop—welding booths, scarfing booths, chipping tables, roto-blast, tumbler-blast. Then annealing ovens. And there's something like twelve or fourteen chipping tables, and most of the time the night before you try to load all the tables up, when a crane first came in, they would have to sort the piles out. You know how plants are, they don't want you standing around because you might wait two hours before your crane. So they tried to load the tables up the night before, you can't have twelve, fourteen chippers standing around doing nothing, you know.

MF: Would you tend to work with the same group of guys over a long period of time in your area and get to know them pretty well?

FA: Yeah, yeah. The old-timers, yeah. Just near the end there where they went through a lot of, getting these guys from Manpower or whatever, they'd walk in and see the dirt and dust and most of the time you don't see them anymore [laughs]. But the old-timers, I'd say most of them cared about what they did. They knew what holes to dig out, what had to be looked for, what sand had to come off. On the day shift we had forty-some men just in the cleaning room. One foreman can't stand over all forty guys all day long. So when somebody had been there a while, they really knew what to do. You didn't have to be constantly watching everybody.

MF: Does it get pretty dusty and smoky, because I mean you're grinding so there's a lot of powder in the air? Are you supposed to be wearing goggles and ventilators and stuff like that?

FA: Yeah, I took it off though when he was taking a picture [laughs]. And I had a big face shield, that went on the helmet. I saw him walk in, "Let me take your picture! Let me take your picture!" OK, so I took everything off to talk to him, you know, because he's been in this shop a lot of times [laughs]. When we first started we had the good respirators, the ones with the replaceable filters. But near the end there we had them little paper things, you use them once and throw them away. Because near the end there we were in Chapter 11 for what, four years or five years? Everything is cash on the barrelhead. Those paper ones like that are a lot cheaper. I was surprised we even had safety hats and everything. Because it does get bad when it goes into Chapter 11 and seems like nobody cares, just run your business into the ground.

MF: Well, let's hold on that for a second and come back to the whole story on the slowdown. But just to finish up on this: did you do that all the time you were at Atlas, or did you . . . ?

FA: No, I was a chipper-grinder only for like a year and a half. Then I got into shipping. I was an expediter. See, like the office will have customers call them with the castings they need—which are rush, which are not needed so badly. Because when you handle thousands of castings laying out there, they easily get lost and buried someplace. So the foreman would give me a list of castings and their numbers, and who it belongs to, to see where they are. Instead of somebody working on a not-so-hot rush piece, you know, pick this up and put it on there and let him work on that and get it up to the scale and get it to the shipping clerk. Then it only seemed like a month later that the shipping clerk left, but in the meanwhile I kept asking him questions, you know, "How you do this, how you do that," and he said, "What are you trying to do—take my job away?" And I did. He left, so I took his job.

The shipping clerk job I worked a lot outside and it paid more. I wasn't constantly in the shop for eight, twelve hours—I was inside, outside, loading trucks, unloading trucks. Shipping department would have to receive and ship, too—package, crate the castings, and call for steel haulers for the big jobs that have to go on flatbeds and that. Near the end there it got so bad I was expediter, shipping clerk, everything.

MF: So the shipping clerk, it seems that was a prestigious position?

FA: It was to me at certain times of the year, like at Christmastime and during the holidays. These trucking outfits tend to be a little generous with whiskey and everything [laughs]. But I think the electric furnace was the highest skilled.

MF: I spoke to this other guy who did that, he was in charge of a lot of the melting, a guy named Bill Douglass?

FA: Yeah, he ran the electric furnace. We used to call him Doobie. That was his nickname, Doobie.

MF: So all in all, before things started getting bad, Atlas was a pretty good place to work?

FA: Yeah, yeah. We weren't really on a high pay scale compared to like Bethlehem or General Motors, or Republic, we were like six, seven dollars below normal scale for a steelworker. We were only making like, near the end there we were only making seven seventy-seven. And here Bethlehem, they're making twelve, fourteen. But the thing was with my job, see I knew other things. I knew how to run the furnaces, I knew how to lay brick, I knew how to chip and grind. So when things were really going over there I would get all the overtime I want. There'd be overtime because the furnace has to be relined at a certain time and the doors have to be fixed almost constantly because when you pull the cart out, a lot of times the casting will shift, hit the brick, and not just one brick comes out, big piles of them come out so that they have to be fixed. So, you know I liked my job. I really liked it. Even near the end, I was proud to be a steelworker. But it was the company's dealing, you know. Why would he close this up then go to someplace else and open up another plant, you know, start it all over again?

MF: So you have mentioned this now a couple of times. Generally the slowdown, this is like about four or five years before it closed?

FA: Yeah. They started slowing down. They were losing customers because of bad castings. They had some change in personnel, you know, in the higher-ups, like plant

manager, that they went through, jeez, how many, three or four in a short period of time. I think that's quite a bit. I just think that the higher-ups just couldn't agree on what was wrong. You know like the plant manager, he was bullheaded, it was his way or no way. See, the thing is, in that circle, you have union men that are inspectors, but then you also got the company side, management, which are inspectors too. And everybody's pushing the blame on each other. You see a lot of that bickering every day. You begin to wonder, do they really know what the heck they're doing?

MF: And did the workers tend to get blamed for a lot of this? I mean when the castings came back?

FA: Yeah. Yeah. A lot of times, yeah. Say a bad weld. Most of your welders got a lot of blame for it because you say, "Oh you welded bad," and then the welder would blame the chipper and grinder, "Well, he didn't chip out that hole good enough, didn't get all the sand out." So it gets to be a vicious circle.

MF: But you felt, what, that the problems were that they were pushing the stuff out too quickly? Because it must have been in their interest to move as much stuff out as—if they could get away with it, then their productivity goes up.

FA: See, that was it. They kept pushing and pushing so fast out and letting the quality go, that eventually it all was going to come back. I mean, we were shipping for a long time there—oh jeez, over two hundred tons a month and that's a lot of steel for a place like that. But the thing is it may lay there for months before the customers started machining it. So Atlas thinks they got away with it, but then six months later everything is coming back.

MF: So they must have lost customers that way.

FA: A lot of customers. See, when they went to Chapter 11, then we started having meetings like two or three times a week: expediters, shipping clerk, the foundry foreman, the cleaning room foreman, both day and night shift, the production manager, the plant manager, sometimes even Randy Wyckoff, the president of the company. "Oh, we need these castings and this is going wrong." But it still didn't work out. It still went bad.

MF: This Randy Wyckoff. What's his role in all this? Does he know what the managers were doing? Was he a hands-on guy?

FA: For a while he was. He was a go-getter, he was after everybody, he was chopping heads all over the place and he spent a lot of time at the plant. But Randy was a different person after his son was killed. He was killed in Canada, in a car crash, I think. After his son was killed, it started slowly, but he never was at the plant. Where is he? And customers want him, you know, and customers can't talk to him or anything. See, in a little plant you could notice that, you know. Most of the guys would pick that up and notice how he's changed. Where in a bigger plant like Bethlehem, I mean, it stretches for miles and miles, you know, you probably never even see the president or board of directors or anything from Bethlehem.

MF: So, did the Chapter 11 come after this thing with his son, do you remember?

FA: Jeez, I really can't remember, because before they shut down we were already under Chapter 11 for at least five years I would say. Let's see, I think they went Chapter 11 . . . '79 or '80. They were already in trouble. The year before things were looking real good, we were working six days a week and sometimes I even worked on Sunday, and then around December, it started getting slower and slower but I noticed a change. They started having problems and their lead time, when they told the customers, "Oh, you can have them in six weeks," then it would be a year later when they'd get the castings. The customer was kind of mad by that time. Or they'd send bad castings. They started getting real big castings, a lot of cracks, a lot of tears, a lot of porosity, which is, you know, instead of being smooth, see, you got a whole bunch of pock marks, it's filled with sand and the chippers have to dig that all out. Customers start pulling their patterns and work wasn't really coming in that good. Every now and then they'd cut out the night shift, they'd bring it back, then they'd cut it back out again.

MF: You're talking about a three- to four-year period where it's really kind of winding down. So did people go through that whole period thinking they could close down any day or did they still think they would come out of it somehow?

FA: I think it was like fifty-fifty maybe. Some of the old-timers would say, "Oh no, they're going to be going forever." But the other guys would say, "No, tomorrow,

tomorrow might be it." And the thing was, there wasn't very good communications between management and the workers because management never really told you anything. You know, you'd hear the rumors. Everybody has a rumor: "Oh, this is it for Atlas Steel. They're going to close tomorrow." You'd go to the foreman: "We don't know nothing. We can't tell you nothing." And even when it did close, you only had a day notice, really. That's it. Randy Wyckoff, he didn't even come out. It was the foreman that told us: "That's it for Atlas Steel. Just get out what castings we have, chip it and that's it. No more Atlas Steel."

It makes me laugh because I worked at, I first started here at National Lead, and I worked there a few years and they closed this plant down and built a big one out in Altoona. So my father, he was a crane operator at Strong Steel, so I got on the maintenance crew over there. But I was there maybe four or five years and *they* went out, Great Lakes bought them out and they folded it up, too. So I got a job at Atlas, and then after eleven years at Atlas *they* closed up. Every place I worked for went out of business!

MF: Talk about horses getting shot out from under you. But let's take it step by step. What did you do at National Lead?

FA: I was a setup man. At the upper end, we made the brass bearings, all different size brass bearings for railroad trains. Then the lower part, we made solder—wire solder, bar solder, pig solder. Pig solder's just big huge fifty- or one hundred-pound bars. My job was that I went around setting up all the kettles, putting the right amount—because we might have to add tin, antimony, it all depends what kind of solder we're making and how hard they want it. It was a combination job really: you'd have to do the kettles, take samples, set up the molds, make the stamps, because you have to stamp them with serial numbers, what kind of lead it was, and the heat numbers. Just before we closed I started making the counterweight for a sailboat, built for the Buffalo Police Department.

MF: OK, and then that closed on you?

FA: Yeah, that closed down. And then I went to Strong Steel and got hired on the maintenance crew over there and I was a maintenance helper. It looked all right at

first, but then near the end, the same kind of practice, you know— the father opened the plant, and instead of running the plant, he had a farm, the money he was saving was going to the farm. And then what happened was the father committed suicide, so the son took over, but by the time the son took it over, the business was *so* bad that he sold out to somebody else.

MF: It sounds like the same story as at Atlas—the people in charge have got to really be active and once they let go, then everything just . . .

FA: That's what happened. Randy got tired of fighting about the bills and everything else, and this guy was the same way—it was just all make as much money as he could and run the business into the ground, don't repair or fix anything. Then get out! And, that's what he did. He ran it into the ground.

MF: Going back a bit farther, did you finish high school or did you drop out?

FA: No, I dropped out. I finished high school in the service. I enlisted—first I went to Korea and then I went to Viet Nam.

MF: Were you gung ho or did you just try to get through?

FA: When I first got there. Everybody's kind of gung ho. But then after a while you just get disillusioned and you just want to get back home again. I was glad to get home. It didn't bother me in the sense where some guys, you know, went on drugs, or they're psychotic, they do crazy things. For a while there, the first year, nine months, you know I was drinking more than usual you know. Then I bought a new car and I smashed it up and that was it. That cured me then. Just at that point my father got that gas station, he got it for us, my other two brothers, the two older ones. And then when I came home we did it for a year. Now, after that where did I work? . . . Howlie Oldsmobile, it was piecework. Then I said, "This is for the birds." Because some days you'd make good money then other days you didn't make nothing. So then they had the opening at National Lead.

MF: So around the time you're working at National Lead and then Strong and then Atlas, at that point you would have said to yourself, what—"Now I'm sort of arrived at what I'm doing, I'm a steelworker"—and feel good about that?

FA: Well, I was proud to be a steelworker, but I mean I kept trying to get better. Of course now I know it wouldn't have made no difference, but I kept trying to get into places like Bethlehem because it paid top money. I was a steelworker but I was on the lower end of the pay scale, these smaller shops don't pay like Bethlehem or General Motors.

MF: OK, now tell me a little bit about your family. Were your parents immigrants, or your grandparents?

FA: My grandparents were immigrants from Poland, both sides. My mother's father and mother and my father's mother and father both were immigrants from Poland. Now my father's side I don't know, because by the time I was like five or six years old they already both passed away. But my mother's parents, they were married in Poland, but my grandfather came here first and got a start. After World War I he sent for his wife and brought her over here, to Buffalo. He was a steelworker at Strong Steel after the war, I don't know how long it was, we just said, "Oh, yeah, you worked there forty years, fifty years," you know. They talked broken English.

MF: Your folks both born in Buffalo, too?

FA: Yeah, my parents were born here in Buffalo. My mother and my father went to a Polish school, so they were brought up to speak and understand Polish. Where we weren't. We went to an English school and English was spoken at home. My father could speak real good Polish fluently but he couldn't write Polish too good. My mother, though, could speak and write in Polish. My parents got married and they lived in the front of my grandfather's house because it was two-family. They had a big front and a little back. The first four of us were born on Perry Street and at that time my father was already working at Strong Steel but he didn't make very much money during those days.

Then my father took a chance underneath the GI bill and bought a home out here in Depew, on Airview Terrace and then we moved out here. When we moved out here, there's nothing here. I mean all these homes were being built but there are no paved streets, no stores, nothing. We were like the third or fourth family that bought a house on that street. All the other houses, they were either being erected or halfway

done or nobody had bought yet. Boy, I remember, behind us, all around us were big huge mounds of dirt and everything. The rest of my brothers and sisters were born over there. My father was sickly because he was hurt in the war and as he got older all his war wounds caught up with him, and he died of cancer. The doctors diagnosed wrong and they were treating him for high blood pressure and all the time he was dying of cancer, that's what it was. My mother is still living there.

MF: And how many of you did there end up being?

FA: I've got seven brothers and five sisters.

MF: Thirteen! And you're the oldest?

FA: I'm the oldest, I'm forty, yeah, and the youngest is seventeen. There was like ten of us at any one time all living at home. So, I learned how to cook, how to sew, how to bake, I know how to take care of babies and everything. I was only seven or eight years old, I was already taking care of kids, you know, because my mother didn't have no sisters or a lot of relatives on her side, and see, the four boys were born first then it was four girls, so the fifth one was a girl, but she was too young to help. So my mother showed me—well, if I didn't take an interest my mother would have never been able to teach me, you know. But I took an interest in baking, cooking, and all that and that's why I can do it now. I can cook or bake anything.

Anyway, it was a regular circus [laughs], all these little kids running around, it got to a point where whenever we went someplace it was up to me to keep track of all the kids and make sure nobody got lost or got hurt. One day my brother, he said, "You're just like Wally from *Leave It to Beaver*" [laughs], you know how little Beaver follows Wally around. So he gave me that name and it stuck ever since, and everybody has always been calling me Wally because of that. Even my mother now, my mother hasn't called me Frank in I don't know how many years, it's always Wally.

My father was the kind that when we were little we learned to do things for ourselves. When we were small it was always he had to be showing us, mostly me—you know, you're going to do it and that's it, because sooner or later you're going to need it and fall back on it. So, we did our own remodeling—we put an addition to the back of the house, put a dormer to the front of the house and put all new

windows and aluminum siding, brick, and we did all the work ourselves. So, it was a good thing that my father was the kind of guy that knew a lot of stuff or if he didn't he could always buy a book to learn how to do anything. I like to go get books that I keep for myself, if I don't know how. You can become a jack-of-all-trades but a master of none, as the saying goes. That's why I was kind of prepared for when I went in the service, I was used to making your own decisions, you know.

MF: So family life must have been really something with the big group that you had.

FA: Oh yeah, yeah, because we come from a hunting and fishing, camper family. We went to the Adirondacks, we went to the Catskills, Allegheny, and my father had a cabin down in Cassadaga, but as far as hunting we went all over. Deer hunting. But we never went out of state hunting because that involves a lot of money, we weren't that rich, just enough to take a few trips every now and then during deer season or bear season. Even one of my sisters would start to go hunting, she still does now, even to this day. But they love fishing and camping. We love going out camping and out to the cabin. Sometimes we had forty to fifty people out there.

MF: When you went hunting, was that for food, too?

FA: Oh, yeah, yeah. We eat duck, pheasants, deer, even tried bear but we really don't care for it. It's too tough and too wild. But mostly deer. And if we had a nice buck—

MF: I guess with thirteen people in the family it—

FA: [Laughs] It don't last long. You know sometimes we would only end up with one deer and maybe sometimes two or three. But I think the butchers are dishonest, a lot of them, because you could take out a hundred eighty-pound deer and he'd come back with one little box of meat, it seems like you would have only one or two nice roasts and a couple of steaks and then you had bags and bags of ground beef. The first time we butchered a deer ourselves and here we got four roasts out of it and a whole bunch of boneless steaks that we make, and only two little bags of ground beef. So you begin to wonder. See, the regular meat, if you do it right you can't tell the difference between beef, it tastes just like a steak you bought from the store. But you can't do that with ground beef, that's the problem. The ground beef, what you

usually do is mix it with Italian sausage and a little ground beef and then you make meat patties out of that. Then you can't tell.

MF: Getting back to the time this first set of pictures was taken, were you living out on your own then, had you gotten married yet?

FA: Let's see . . . No, when these pictures were taken I wasn't married yet. I was still living at home. When I got out of the service in 1968, well, let's see, about 1970, my father started getting sick. So, when that happened, I was the oldest and my mother didn't have no job, and that time I wasn't married, so I figured, well, I'll stay home. This way my mom will have somebody to take care of the house, watch the kids, and she'll have some money coming in. But, well, I met my wife-to-be the year my father died, because he died in January of 1979. We were serious and so in August of 1979 we got married. We found our own apartment.

MF: And at that time you had this boat you're posed in front of, it looks like what, about an eighteen-footer or something like that. Did you use it for fishing?

FA: Twenty-foot. Yeah, fishing, water skiing. Just skating around, mostly on Lake Erie, but sometimes we used to go to Chautauqua or one of the Finger Lakes. My brothers and my brothers-in-law and sisters, we had good times. We used to go to Chautauqua for picnics and drive around the lake and sometimes fish.

MF: There seems to be a lot of interest in boating around here.

FA: The fact is for being such a high unemployment area, ChrisCraft's sales on like eighteen- to thirty-foot boats last year had a record sale and Buffalo had the highest area. And most of the sales on other boats are not for the little boats—they're up to the twenty- and twenty-five-foot range. And that's hard to explain.

MF: So what do you think the boat represents to people? Is it like freedom and power and just the ability to . . . ?

FA: No, it's relaxation. I'll tell you, if I had my boat now I'd go out in the lake and I'll stay out all day, I don't care whether I catch nothing or not. When I get out on the

water I feel like a different person. Maybe some people don't find it relaxing, but I do. I love the water.

MF: So you don't still have that boat? What was its name?

FA: See, I got out of the service in 1968 and that's the year I bought it. Boat, motor, trailer, and everything. But what happened was, I got married in 1979 and then Frankie came along a year later and then the bills started piling up, we had to borrow a lot of money, you know, because we actually had nothing—I lived at home, she lived with *her* mother, and my mother didn't have anything to give to us either. Oh, what a job it was, people don't realize, you don't think of pots and silverware and everything—it adds up to a lot of money. Linens, curtains. All the money was going to pay for the stuff that we borrowed money for. So the boat sat so long covered up that it dry rotted. I sold the trailer and the motor and everything else, but the boat itself I had to cut it up for firewood because it got rotted like that. Didn't have a name for it, really. You know, twenty-foot to me is small. If it was a bigger one I'd pick a name. Before I had problems with her I was going to name it after my ex-wife. . . .

MF: But before that you must have really felt like you turned a corner. You know, you got married and you're starting a family and you're out on your own. So the layoff is just a few years after that. Had both your kids been born by then?

FA: Yeah, yeah, at the time we were laid off we were still married. That's what started it all. She went out and got a job and once a woman gets a job, that was it, she took off, the grass is greener on the other side. When she took off, that was my last week of unemployment! She left me no money, no nothing, and with the kids and the kids were sick.

Just a good thing I come from a large family. So I called my mother-in-law and she brought food over and took care of the kids until they got better. In the meanwhile I got on welfare. But I'd rather have a good paying job. Being on welfare is like being in prison. You don't get nowhere! They make you feel like they pay you so much money, but all you have enough for is to pay your rent. As far as food stamps: how can you live with three people on forty dollars a week? Sometimes even less because if they give you a couple more dollars in your money grant they take it out of your food

stamps. You only get so much allowed towards your rent, so much towards each one of your utilities. I mean it's ridiculously low—there is nowhere around here you're going to find rent for a hundred sixty-nine a month. You won't even find it for two fifty. So you're in a box, by the end of the first week, it's all gone. You pay your rent, you might pay your electric bill or water bill and that's it for the money. I mean, sometimes I think they're ignorant. Because the thing is, they're sitting there with their thirty-thousand, forty-thousand-dollar-a-year job, and they want me to raise two kids on two dollars and something cents an hour.

MF: You said that being on welfare is like being in prison. Is that like a psychological thing, too, in the way other people perceive you if they know you're on welfare?

FA: Well, most normal people now, I think they're more understanding. They also know that the ones that cheat make it bad for people like me. Most people don't put you down now if you're on welfare. Just the welfare people themselves do—the caseworkers, they make you feel like you're some kind of idiot. I told one, "Well, if it wasn't for people like me you wouldn't have a job, where would you be then?" But even in the unemployment office they give you a hassle. Some are decent, but then you get other ones that are real pricks, you know. They really try to belittle you, they want to try to make you feel like you're that high.

MF: Does your ex-wife help at all with the kids now?

FA: No, not really. She just tries to make it look good. She thinks she's a "Miss Jet Set." She wants to be a part-time mother. As far as support she don't buy nothing at all for the kids. I support them 100 percent.

MF: Well, it's interesting that a lot of your own background taking care of kids really became important. A lot of guys if all of a sudden they are left with two kids, they wouldn't know.

FA: That's why I fought for them. I had to go to court. She's still around town, I gave her visitation rights, the lawyer said it's hard to take away complete visitation rights. So I have custody of the kids, but I'm letting her get divorced by default. Right now I

don't really have money to go to court. So I don't show up in court and she gets her divorce. I know what it costs to hire a lawyer. If I happen to come into some money I can go back and change it. May third I'll be a free man.

MF: So, you're really in the position a lot of single-parent women would be in, too. You've got to put in a lot of energy just to deal with making the welfare get you through from one thing to another. And you're doing full-time childcare, which doesn't leave much time for doing too much else. So, have you been applying for jobs all the way through?

FA: Oh, yeah. I keep trying but raising two kids, I mean there is no way I could do it on minimum wage. I've been putting applications in these other places that pay better, but some of them closed up too, they cut back, laid people off, there is no hiring. There were some places I went to and put applications in and next thing I knew they hired people, but I didn't even get a word. Well, I see he's forty already but this other guy's, he's twenty-five. We'll hire him instead. But how are you going to prove that it's age discrimination?

MF: And this is mostly industrial work that you're looking at?

FA: More like warehouses, there ain't too much industrial work really around. The thing is, all the places that deal with truck terminals all require tractor-trailer driver licenses. Because of insurance, you may have to move the trailer or truck away from the dock, you have to have a license just to do that. If I had a tractor-trailer license I could get a job in any of these trucking outfits because I worked with a lot of them for the past eleven years. But it's the money—because you have to hire a tractor-trailer to take the test on, see, they don't supply it, you have to supply it. So, you have to hire one out and you're talking five hundred dollars, six hundred dollars. Just to go one time and you might not pass.

I just hope something breaks. In August, Justine will be six so then I have to go on that program where you have to take a minimum-paying job. But the thing is how can you raise a family? Even if you were forty hours at minimum-paying jobs at three dollars you don't even bring home a hundred dollars. And what are you going to do for medical benefits? That's the worst thing—you don't have no benefits. I mean you

have to let your kid die if you don't have any medical coverage. So what kind of country is this? Every goddamn backward country has a nationwide health program where it don't cost you nothing and you could go into any hospital, where here you can't afford to get sick.

MF: That connects to something you were mentioning before. There have always been people who are having better times and worse times. But now I think there is more of an awareness that this whole city, like Buffalo is really going through a major change. It's not just that you're out of work, it's that the whole industrial structure is gone and everybody is wondering about whether anything is going to take its place. So I'm wondering about your thoughts about that—what do you think about what the decline of these industries means, whether there is a way out of that?

FA: I really don't know because it is such a vicious circle. Well, like a plant closing, it affects everybody, you have to remember that that plant buys products from other shops, and the next store will buy parts from somebody else, that means they got people working. That means if you got people working those people will have money taken out of their paycheck for taxes and everything. That means revenue for the city and state and everything goes right along, towards welfare, towards unemployment, benefits, plus you have people working.

MF: Do you think—. I guess what you hear people saying sometimes is there are two ways of looking at it. One is to say, that with all these plants closing the society is seeming to go in two directions, some people are up there and other people get more and more invisible, so we've got some real problems. And the other way to look at it is that it's like growing pains—it used to be that everybody was a farmer but then industry came along and now—some people say, well, a young country has industry but just like you don't expect to be a hockey player when you're fifty we shouldn't expect to have—we've outgrown that phase.

FA: No, I don't believe that. No, because the idea is [laughs] being a hockey player and steel industry are two different things. A man gets old he can't play no more. But there is somebody to replace him though. The same with the steel industry, we still need the steel products. *I* believe it's a greed for profit. They're not satisfied with 100

percent profit, they want a 300 percent profit, and if they could build a plant like they built that General Motors plant down in Mexico, you only have to pay them one seventy-five an hour. If they can make a 300 percent profit, they'll fire every U.S. worker and build a plant in Mexico or ship it to England or build a plant in Japan or in China. General Motors was saying in the paper that we lost ten million dollars. They didn't lose a damn thing, it's just that they set their goal for two hundred sixty million but they only made two hundred fifty, so, oh well, we lost ten million dollars. I know that's what they're doing. How come, now, the majority of car parts are made down in Mexico, Japan, England, Korea? But did you notice the cheap labor which you are having it built, do you notice that it reflects any cheaper price in the car? No! Every time you turn around it's another five hundred dollars they add on to the cost of the car.

MF: So, do you think the government should be doing more to insure that we have . . . ?

FA: I think so. Look at the cheap steel coming in here. The Japanese government subsidizes the steel industry. They push selling radios and TVs and all transistorized stuff and all that, because the money they make off of that, that subsidizes steel so that the steel industry is going to ship to us cheap steel which we couldn't match. I can't see why our government can't learn from their government and try to do the same thing. You're telling me we can't produce cheap radios and that and try to do what the Japanese did? Our biggest thing was the steel industry. And when that went down, boy, the country went right downhill.

But even the government, the government is crooked too. All you've got to do is look at Ollie North and them characters. Just like I believe about Kennedy! Kennedy was killed by our own people. Because he was anticrime, and he wanted to get rid of the mob. Plus, he started all these welfare programs and everything, and I believe our own government, the crooks in our government got rid of him. There was a lot more involved than we'll ever find out. And Reagan, when he first came in he was so gung ho, he was oh, the cowboy. Since he's been in office our country, as far as I'm concerned, went steady downhill. Now, the peanut guy wasn't that good. All of them promises, oh yeah, better jobs, better education, better this, better that. Oh, we've got to lower the national debt and everything else. Now this guy Reagan said that, too, and what, it's tripled? Tripled. The national debt.

MF: Let's bring it back to the community like Buffalo which is clearly struggling and yet trying to get something going. What's your sense of things? Do you think there's much chance for a place for Buffalo, given everything around it, or some of these new directions like the downtown renewal . . . ?

FA: Well, I'm *hoping* it does, because, I mean, everything they plan, new shops, new buildings, new office buildings, new marinas, trade center, it means jobs. But the thing is, though, you could only have so much R&R areas, and people have to have jobs in order to pay for it. I would even say, legalize gambling! People would probably say, it'll become another Las Vegas. But hey, Las Vegas will probably be here forever, so will Reno. You're talking about crime—we have crime now, what's the difference, you know? You have the prostitution, you've got the murderers, you've got the rapists, you've got the killers. We have our alcoholics and our drug addicts. Gambling isn't going to bring any more [laughs, then serious]. The point is that most people are afraid that, well, if you legalize gambling it's going to bring all the undesirables here. But we have them here right now! But gambling is big money, I mean you're talking billions of dollars it would be annually.

MF: Is that the only option? Do you think it would still be possible to revive heavy industry in a place like this if there was a real commitment to it?

FA: I don't think so. Because we went through Pittsburgh, last year sometime, and I never saw—I mean miles and miles and miles and miles of steel plants, just closed up. Nothing moving, nothing going. Now it will be all the high-tech jobs. We have a few, like we have Moog, you know, but they're very hard to get into. I tried, but you have to have a certain field, like you've got to be a machinist with papers, you know?

MF: Do you think there's still a chance you could get a major retraining or something?

FA: Well, I want to try going for retraining. I want to try to find a school and go become a machinist. I mean, steelworking is out, I know that's completely out now. They're not going to revive no more steel plants. Because once all this steel industry went down that was it. One thing relates to the other, you close up steel mills and how many thousands of other businesses go out.

MF: You said something before about, you know, that you're a working-class guy and you grew up in a working-class family. In the old days, working class often meant people whose lives were totally different from, let's say, the middle class. But then in the period you're growing up in, you're moving to the suburbs, you know, in fact out here you had a boat and working-class people have televisions and their kitchens look like anybody else's kitchen, you know, it's not that big a divide. I guess the general question I have is, how do you think of yourself now, what do labels like that mean and don't mean?

FA: Well, working-class people are people that physically do work. More like work in a warehouse or steel plant or menial tasks, you know. I don't consider doctors as working-class people. I mean now, it's just that—I think there is no middle class. You either have it or you don't, now. Like before, when jobs were good and that, you can say you do have your three classes of people: you had your rich people which go around in the Mercedes Benz and Rolls Royces and that. Then you have your working class people that drove a Chevy or Plymouth, you know, but they had a TV, they had a paycheck every week. Then you have the poor class which didn't have nothing, or just barely, they didn't have a car.

MF: So in that sense then your industrial workers would have been more in the middle class?

FA: Yeah, I would say more in the middle-class industrial, because they had a paycheck every week and they had money to buy food and buy clothes. It seems like working-class people—they may not have much, you know, but everybody tries to help share with each other. But it seems to me like these higher class people, making all this money, they don't give a damn, you know. What can I say, I don't know how to express it right: Either you're poor or rich now. I just want to say that a lot of people do hold it against the rich people. They make fifty million dollars a year, they don't pay no income taxes. It does kind of make you mad. If I got to pay and I don't even make ten thousand dollars, you should pay it too, you should pay a lot more than I am.

The same way with workers from General Motors or the Ford plant. When I go to the store, I have to pay the same price for bread that they have to. And these higher

prices reflect *their* pay scale, not my pay scale. Here they're making $20.00 an hour and I'm only making $6.00 an hour. I can't see why the government can't have a store for indigent people. I could start with say $160.00 in food stamps and I could make it work like $300.00. This way kids could have milk every day, they could have the foods so that they could have the right amount of vitamins and minerals that they need exactly every day to grow. I ain't a doctor, but I read some books on health and medical, about nutrients, you know, vitamins and that. Now, I read that so many kids depend on going to school just to get a decent lunch. In ten or fifteen years from now we could become a nation of retards because there's not enough kids physically getting enough food and proper vitamins and minerals that they need to stimulate their brain growth. The government should do something about that. In real hard-hit areas they should open up stores for people who are in a low pay scale, even if they are working, but you know working for minimum job and they have a family.

MF: So let's see, just by way of wrapping, as you look back on your years as a steelworker at Atlas, what was it, altogether, ten years?

FA: Eleven years. Just got my vested rights. Ten years, I made that, it guarantees so much. But I was there right to the end. And the only reason I was there at the end was because my shipping job was a red-star job and that means nobody could bump me, even if a guy's got twenty years there he can't bump me. Right to the end, yeah. I was the last one out [laughs]. The last day I was the last person out of that plant. I think I left, it was seven, eight o'clock. Because some of the trucks came in late, and they wanted the last-minute casting jobs, so they could get their money. It was weird. I'm the last person out and I got to close the gate behind me when I left.

MF: So do you have any final things to say to whomever you might imagine might be reading all these things? What do you want to say to those folks about the generation of steelworkers like you and what's happened and where things are going?

FA: Well, we're going to think of the past, well, our times are hard, but we are still proud, we still have our own private life and we still, no matter how hard times get, if you have a family and you stick together you can make the best of it. This is supposed

to be a free enterprise country, so you never know, things might be bad for a long time for you but you're always looking, it could get better. But as long as you just have a little something to hold onto. You don't want people to feel sorry for you, but you want people to know the truth—you don't want the government to come along and say everything is hunky-dory, yeah, we never had it so good. Bull! That's bull! I mean, tell the truth, because people are getting fed up now. Before they used to sit back and listen to whatever the government said, but now more and more people they get aggravated and they form little groups and do protest. Tell the truth, you're better off telling the truth. If you're telling the truth you can't go wrong. It might hurt, but you're better off.

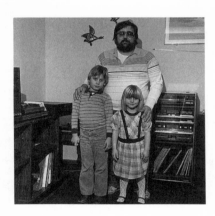

PART FOUR

THE CINDER SNAPPER

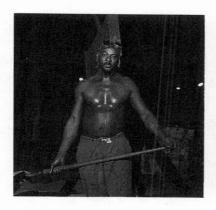 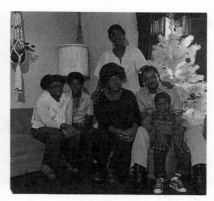

12 / JOSEPH KEMP

MICHAEL FRISCH: I thought it would be interesting to start with the pictures about work and then later we'll talk some about your family and how you're doing now. Could you just tell me what's going on in this picture of you at work, where you are, what you're doing, and we'll get into the story from there.

JOSEPH KEMP: Well, I'm on number four furnace and I'm getting ready to sweep the slag out of the runners. We just finished casting.

MF: Now, this is at, the company is Hanna Furnace?

JK: The Hanna Furnace Corporation. They had four furnaces, they had three in operation.

MF: And what was their business generally?

JK: Specialize in pig iron. That's the only thing. I guess it's the only plant here—I think Bethlehem tried to make it but it would mess up their furnace, that pig iron.

MF: Would you describe what these furnaces were like?

JK: Well, they melt down pellets, stone—you need all that stuff just like you're baking a cake—to make steel. Then they cook it for approximately four hours,

about, then you run it off into ladles. Then they pour it into the pig machine and they make little balls, the balls weighed approximately forty pounds each, you know. That's pure pig iron. We'd cast twice a shift, twice in eight hours.

MF: And it just comes out the bottom of the furnace or out of the . . . ? Is that what the runner was that you mentioned?

JK: That's what the runners were. The runner I was working is the cinder runner, my job at Hanna Furnace was cinder snapper. That's what they called them, cinder snapper. That's running the cinder off the iron, before they tap the hole.

MF: The cinders are the stuff that's floating on the top?

JK: Floating on the top. That's slag. Tap that off and then they cast. When they finish casting, the bottom part of this run out to slag. Then they plug it up, they use a mud gun, they plug it with mud. They make special black clay for plugging the gun and they make special clay for packing a blowpipe, the pipe that take the wind in it. Fifty-eight thousand pounds of wind it takes into the furnace, it just rolls in. It's twelve blowpipes around the furnace, you understand? It's got a peep sight on it, you can look in, see the fire bubbling up and down. So like that's mainly what the furnace is about. But it's really something to work on, you understand, you can imagine working in the summertime and you're wearing heavy clothing, leggings, goggles, strings, you know, you protect yourself.

MF: The heavy clothing—in this picture that's what we don't see. So when that stuff was actually pouring out you wouldn't have looked like this?

JK: No, I would be fully dressed. I'd have on a long wool coat, you know, because sometimes water can hit it and will spread out and everything, so we would be fully dressed. The worst thing is the cinders, cinder burn is a burn that will last five or six days. It's not like an iron burn, iron will hit you and pop right off you. So we had finished up when he took that picture. We just got finished casting, you see the goggles and the skull cap, but I come out of all those heavy clothes because it was summertime and it was too hot there to work in them. We usually have two or three sets of clothing over there to change, you know. I still have my leggings on because the runner has probably got a little slag in it so I'm going to clean the runner out and I'm going to set it down again and when my hole cools off, I'm going to run a rod in

it, and let the rod stay in it. I set myself up but when I get ready to flush the monkey again, that's what they call it, the monkey.

MF: The monkey? Like an animal monkey?

JK: Like an animal monkey, you got it. They call it the monkey. They flush the monkey. I'll flush it maybe an hour before they get ready to cast or maybe thirty minutes, depending. When I flush it, I'm running the slag off. So after we finish casting I set myself up again to do the same thing over again. That's what they called flush the monkey, you understand, that was my job, to flush the monkey. So I had my bar already in it, this seals around my bar. It's hardened around my bar. So I had to pull. So I get fully dressed, I go out there and pull it out. Stuff started coming down, so I had a plug, fifteen minutes, ten minutes depending on how much come out, how fast it come out, then I plug it back.

MF: And you could tell by what it looked like when the time was to do that, or when it would just start to dribble out?

JK: No, it's going to come out rolling. You'd have to make how much you want to take out. You estimate, well, I'll let it run for fifteen minutes. Sometimes she blow— whoo! And then you'd plug it back because it's blowing all over everything, you understand? Maybe a little water might have run in somewhere, anything. So you plug it back.So when you get ready to open it up again, the hole is about six inches. You look up in and it's red. You take a bar, hit it, tap it, and start running off. After you finish casting, clean up your runner and everything, set up yourself, you put up a bar in it. If you don't put a bar in it before it hardens then the iron comes right in the mouth of it and it's sealed like that with the slag so you have to take the bit on the drill, use the long bit in the pipe and drill it.

MF: How big is this thing we're talking about, a couple of stories?

JK: Oh, man. Well, you seen the ones at Bethlehem, right? Maybe not as big as the one at Bethlehem, but it was big enough to turn out enough iron to operate a plant, tonnage-wise, you know, and that was it. The furnace actually don't never get empty, you know. They might take forty tons out, a hundred tons, eighty tons—forty tons in each ladle, fifty tons in each ladle, depending on what the tonnage was for that day.

MF: And what keeps that furnace going? What heats up the furnace? Is that electric or are they using coke, or what?

JK: Coke. They getting it from Donner Hanna Coke, they were supplying us with coke.

MF: Is that related to the same company, like a subsidiary?

JK: No, well, I guess—. I don't know if they were affiliated with each other or not. But, it was the Donner Hanna Coke and it was the Hanna Furnace, so they might have been affiliated or whatever. The office could have been. Matter of fact all of them could have been hooked up together. I really didn't know.

MF: What did people think of the company generally? Was it a basically good management?

JK: Oh, they was good people, they was good people. They come up on the floor once in a while. But the basic one that was here, that was managing the plant here, you know, you might have saw them three or four times a week, he'd come up there. I wasn't used to having no beef with them. You worked for the corporation so, you know, you worked for them, you know the rules, regulations. You had the books and things. You know what to do and what not to do and things like that. So there's no hassle. Matter of fact you didn't have nothing to discuss. You go and listen to them, if you didn't like it, you'd tell them, say, well, boom, that's all. I got along beautiful.

MF: Did they make stuff to order or are they just producing a basic product that they would sell to mills? One of the things that's interesting at different plants is how much, certainly in the steel mill, everything is custom-ordered.

JK: Well, Hanna Furnace, it was something like, you take the sugar and mix it with everything, you can use sugar with everything. So I guess the pig iron, they mostly make it with the steel. They make the steel even harder, you understand? The regular iron they made the pig-iron bars out of, it was very hot, you understand? It would come out so fast we didn't have a chance to make the slag. But sometimes they made a low form maybe for special order. That was a forty, sixty, the quality of the iron,

they mostly use it for the casts of a car. It's hard, hard, hard. Slag will come out of it, sometimes it might overrun, you would have to shut the furnace down. You got an eight-hour thing cleaning it up off the floor, digging, take all the sand out of the runner. Sometimes it would even take the runners up. You see, iron would be mixed with it and it cling to the side. Sometimes you'd have to pull the whole piece out and put another piece in.

MF: Now you said that after it comes out of the furnace it goes to this pig machine which is, that's like a set of molds?

JK: You make them out of sand. They use sand for all their molds. That's the only thing will stand it is the sand. They take the ladles and they even brick them because that iron would burn right through the ladles. They bricks them, they cement them up around all the way to the top, you know. A little iron ever found a hole, it would seep through. If you got even water on it, it's gone, it would blow it away. Just a little dab of iron hit the water, it would blow the whole thing away. It's really a danger to work at a steel mill, it's danger if you don't follow the procedure, make sure everything is correct. So like that's the reason everybody that worked on the furnace they learned what to look at, because like, fire burn iron, iron melts itself, I imagine a lot of people don't believe it. It really was a hectic job but it was a good paying job. It was a good paying job and if you worked together, it was smooth as silk.

MF: Now your crew would be responsible for that whole range of things?

JK: Well, see, the keeper, the helper, the cinder snapper, and the laborer. So you figuring approximately a four-man team. Bethlehem had six-man, they had a first helper—no, first laborer, second laborer, and third laborer. So we had the helper, the keeper—when they say, ok, it's time to tap it, he's the one to do the tapping—they stay on that side of the runners, the laborer's on this side, the cinder snapper's on this side. So like, you know, you figure it was a four-man operation but maybe the stove attendant, he was up there and the foreman. You figure six people are on the floor. Sometimes the big boss, Billy, might be seven or eight, you know.

MF: Did the four or five become a pretty close team? Did they tend to work with the same guys each shift?

JK: Uh-huh. As a matter of fact, that's the way we worked. It rotated like that. The same crew, mostly every week because we swung-shift once a week. Seven to three this week, three to eleven next week, eleven to seven the next week. So we always had that long weekend off. Most of the one's you worked with during the day, you'd be working with them from eleven to seven. It was good you worked with the same crew because, like, everybody helped out. If a guy had to stay an extra eight hours then you sort of help him fix up for the next shift, you know, and things like that. I almost always worked with pretty good guys, they were young guys, and we sort of looked out for each other, you know. Like everybody might go out and party a little too much, one might be, "Oh, man, I don't feel too good," "Ah, go and lay down for a minute," you understand? You know, basically, what be done we'd be doing every day. You do the same routine every day, every shift. Sometimes you can go in and you can put a little extra work in it and then you cruise the rest of the day, because the slag—matter of fact I have flushed my monkey four times without even touching my runner, because when I went in I sanded it down good, I dried all my sand, and the way I set it up. If the sand's wet that stuff'll pop that wet sand out. See, water, the only thing wrong that would do you any harm would be water. That would be *water*, see. So like, if there's no water there, you go in, set yourself up, you're in good shape for that day.

Sometimes I would have fifty-eight hours in four days. Because one guy didn't show up. See when guys knew what type of iron you're running they won't come that day, so they report off, fifteen minutes before due time. The man's running around, "Well, your man ain't going to show, your relief ain't going to show. Come on, come on. You want to stay?" And that's when you have the pretty good shift. I worked one year, worked three extra eight hours a week. Plus your forty. I didn't care, I didn't care because like, I got into the groove of it. As far as I saw it, it was a very good place to work. I put my best effort into my work. If I goes in, if there's something that's got to be done, I do that first and get it out of the way, and then I blaze on through. After I finished casting I can go and sit over in the cafeteria from the time they finished casting until the time they get ready to cast again, because I set myself up when I go in. The guys, they just look around in my spot, my area, "Well, I know who's working today—Joe Kemp," because I always kept that area washed down, because I feel that if you had to run, have a nice, clean, spot to run.

But working with steel, it was draining, you know. That took a lot out of you,

especially in the summertime. I brought my lunch back many days, you know—it's too hot, all this wool and stuff on you, you don't want nothing to eat, you want to get somewhere and lay back, let your body . . . go back to a body, that's what I call it. And then in the wintertime it was even worse. You break off the furnace, you try to take a shower, and try to get from Lackawanna before these ten inches of snow fall, and that's when you're catching a cold [laughs] . . . and things like that.

So you know, it was something, but like I said, it was a *beautiful* job, because they did pay you half decent. Matter of fact, everybody you run into now, that's all they can talk about. I run into a lot of them, say, "Aw, man, we thought we were a lot of dogs working at Hanna Furnace." I say, "Yeah, man, we made the dough, we made the dough." And you had good benefits, you understand. It was a beautiful job. I wish they was around right now.

MF: What do you think people liked about it the most, aside from the money? The feeling that they were making a big product, or they were in charge of things, or what?

JK: Well, I think those people at our plant, I think they felt that it was like a big family thing. You know, most of the guys hung together that worked on the shift, they stopped off here and had a brew, you know, and most of them lived right in Buffalo and Lackawanna, so you had someplace to go. If you got tired of Buffalo, run to Lackawanna; the guys from Lackawanna run to Buffalo, you do a little partying. And I think that was the most of it. It wasn't a great, big plant where it was thousands and thousands of people.

MF: The guys who were working there, black, white, what's the percentage?

JK: Oh, about, I think about almost half and half. They didn't care, you know. They were groovy guys, they'd sit and chat, share your lunch, whatever they'd bring. Want to have a little party, then you bring the beer, I'll bring whatever. That's what I like about it—all the guys that I work with, we had something in common, you know. "Oh, y'all be to town?" The guys from Blasdell says, "I'm coming into Buffalo." I said, "Well, when you come in, I'm going to be at this bar here," I say, "Well, call me," you know?

MF: Tell me a little bit about how your background, how you got there. You're from Buffalo?

JK: No, no. I'm from Georgia. Macon, Georgia. Ninety-seven miles from Atlanta. My people still there in Macon. Well, my uncle live in Waynesboro, Georgia. My brothers they live up in a place, it was between Augusta and Macon, seventy miles to Macon, fifty-nine miles from Augusta. They lived there, they called it Jewel. And my other sister, an aunt, and my mother's sister, they all lived in Macon, Georgia, you know. I used to flag the bus coming down the hill, you have to make sure that Greyhound stops, you have to go to flag it when you see it from the top of the hill and by the time you get down there to the bottom, he stops, right then, hop a ride right on into Macon, seventy miles, so boom.

MF: So when did you come to Buffalo?

JK: I came here in '59, July the third of 1959. I was working with some people, they was making furniture, they was West Indians, so we come to Lockport [a small city near Buffalo]. I was eighteen, nineteen, somewhere along there. Well, I was getting ready to go back home, so I said, well, it was the third, I said, "I'm going to go over to Buffalo and visit my cousin for the Fourth and then I'm going back." I was planning to only stay just that week. So then my cousin said, "Well, stay until I finish school, I'm going to graduate in two weeks." So I stayed. They say, "Well stay, I'm going to get married" [laughs]. That's how I ended up in Buffalo.

And I've been working ever since. I started working at the International House of Pancakes out on Sheridan Drive when they first built that one out there. That was the first one they built. Then I left here and went to Massachusetts, I worked for International Pancake House up there. Went to Boston and lived in Boston a year, in Massachusetts. Came back, I used to work at the University Club of Buffalo, down Delaware and Allen. I started, we would move tables, set up for banquets and this and that. Then I started helping the chef in the kitchen, we went buffet-style, you know. Maybe they'd have five hundred to sit down at six o'clock, two hundred sit down at three o'clock. Filet mignon, salmon fish, and things like that. So we did it buffet-style. They had the kitchens on each floor, the waitresses come through, fill the plate, they serve them. Matter of fact, I can pat myself on the back, I've had a job ever since '60 'til '83, they closed the plant. I had a job from '60 to '83. I didn't care where

it was. When I worked at International House of Pancakes, I had walked from Sheridan Drive home on many nights because the bus was gone [laughs]. It's snow on the ground but I walked.

Summer too. My buddy and I, we used to rent those ice-cream trucks with the little cones. This was just summer work. I got laid off and, boom. So Tastee Sweet, they had eight, nine, or ten trucks, you know. And we used to go out there a month ahead of time or two months sometimes, we would rent one, and then when the season started we got a truck already rented. Oh, we did a route, yeah, let's see: used to start in the Fruit Belt, about twenty kids is coming out, I'd be there turning my machines on, make my ice cream, and I used to just give them all a cone apiece. Then we'd start there, we start right after twelve, right after lunch. We used to get to South Park right after the kids out there had dinner, then they had a dessert. Go down South Park, Perry, then work all around through there, and go to Lackawanna, then work Lackawanna, then we'd come back in, be about 11 o'clock at night.

They used to charge thirty bucks a day, OK, the first month it would be thirty bucks a day, then the next month they would drop it twenty-five dollars, and the third month they would drop it more. So you figure you would take in about, maybe, between a hundred and thirty to a hundred and sixty dollars a day, you know, depending on how hot it was. They charge fifty cents a cone now, fifty cents apiece— just think what we would be getting! Oh, man, we was only getting ten cents! But we still made dough, though. A dime wasn't much then, but you think about it, we would dump a thousand cones a day! That's a lot of cones. Then there's your milkshakes, your banana boat, your ice cream sundae that you made, your Nutty Buddies. See, you had all that different topping, strawberries, it was set up for everything. Me and my partner, he would drive and I would serve, and then I would drive and he would serve, like we used to have a ball [laughs]. They used to call me the ice-cream man, you know, I'd walk down the street and the little kids say, "There goes the ice-cream man, Dad!" The guy looks at me, "What you mean the ice-cream man?" Because most of them be working when I go through with the truck, you know. Oh, we used to have a good time. Them was good years, them was good years!

That's what I say about jobs. I always said to myself when I was working at the University Club, I said, "Well, I'm going to stay here 'til I get me a real good job." So I knew this guy working on construction for J. B. Connover, out of Pittsburgh. He told his supervisor, he said, "Well, listen, I got a man, he paints." The guy knew I was painting houses, you know, like a sideline. So the guy said, "Well, listen, bring him

on out." So I'm painting, oh cool. "Listen, you want to go to Pittsburgh for two weeks and paint? They pay seven dollar and twenty-five cent an hour there." So me and him went there—went maybe from a dollar sixty-five an hour to eight bucks. Fourteen dollars for Saturday and Sunday. Pittsburgh action. So I started working for J. B. Connover. The home office was in Pittsburgh but we worked out of here, I got paid from New York State here. Matter of fact even when I went to Pittsburgh I got paid from New York State where it wouldn't mess up my unemployment or anything. We painted the pipe line, the blast furnace over at Bethlehem, I worked for U.S. Steel down there in Pittsburgh, we did the roof.

MF: So how did you get to Hanna from that?

JK: My insurance man. My insurance man, that had my car, he was foreman at Hanna Furnace. But he's an insurance man anyway, you know, so he told me, he say, "Listen, that painting call you?" I said, "No." So he went in the office and they called me and I went right on out there and it didn't take but about ten minutes to sign all the papers and I started work the first day, it was just like that, boom. Well, they was mostly hiring the service guys anyway, right? I'd never been in the service, but like, boom—by him being there twenty-five years, the foreman, I imagine they had the choice to snatch one guy a year, so I started in Hanna in '74.

MF: OK, and that brings us back to where we started. I want to look at your family picture now and talk about that. So this is your wife, then?

JK: Um-hum, this is my family, yeah. The boy, Joe, he's still in school. He's with his mother, we got divorced quite a while back. He's thirteen, he'll be fourteen this year. He's in the ninth now, he plays football. And, let's see, my oldest girl, she's got two girls. She's going to do nursing, she's going through the thing now. My middle girl, she's the first one to have a baby, she's got the oldest grandbaby; she's working now. And that's my baby girl, there, she's got the three boys right now, she's not doing anything else. I got seven grandkids.

Those kids, I told them, "You finish now with school, you understand, because now you can't get pregnant, do this and that right," you know. A lot of people say, "Well, I don't want to talk to my kid like that." I say, "Well, if they your kids, you have to! Because it's the responsibility going to be on you." So they both finished

school, these two here.And then, plus, you know, a lot of people say, "I don't want my kids to have to. . . . " I say, "*I* do." Just like me, work, to get what you want. A lot of them try to give them too much and then that throws them into that, "I ain't got to do nothing for this." I say, "No, no, you get hired first, *then* come on over, I'll see what I can do," you know what I'm saying?

When I was down at home, in Georgia, the people didn't say nothing like they do here. Down there you go to school because you be out one day and that truant officer come around, he said, "That kid ain't in school," they go find him, they have you jacked up, too. The people now say, "Don't say nothing to my kid." Down there— shoot! You go in and do whatever, so when you get home I don't care who keeping you, your aunt, your uncle, or whatever, it might be like three or four people got on you before you got home. And then when you go home, you sitting there and then, "Go out there and get me a switch." You know, you're a kid, you try to get the littlest one you can, right? Then it's, "Oh, this one, it ain't going to work." They go out there and give 'em three of them little wee willows, just plait them together [laughs]. . . . It was really something.

MF: Well, that's a long road between there and here.

JK: It's a good road, though. I ain't never regret it no kind of way. Because like now I really understand it to the fullest, you know? But I always wished this, I wish somebody would have kept a farm down south and every year you would take these kids down there and see how those people used to grow their own food, chickens, hogs, milk the cow, and things like that. Go to the well, draw a bucket of water, rake the tadpoles and the little frogs off the water, go get water for wash, water for bathing, water for drinking. Wood to start a fire to cook with, wood for the fireplace, and things like that. Your job out in the field, pull the little weeds on up out of the cotton, you know. Go to the hard potato bed, get you a couple hard potatoes, you know. I did a little growing peanuts and things like that. Sugarcane, all this stuff.

MF: So you don't have any family down there now?

JK: Oh, yeah, but they stopped farming that land when the government started paying them not to plant certain types of so much stuff, and after a while it broke

completely on down. And then the peoples there they started to working, you know, out. Lot of road construction, mobile homes, and things like that. I started going down there, I say, "All this land and you don't grow nothing? You ain't got no chickens? Ain't got no hogs?"

It would be nice if somebody would have saved this, if somebody would have had a farm now. Then they could see. Matter of fact, they would even enjoy it, too, they would enjoy it. Because I imagine half the kids here have never seen a cow for real, you know. And how you milk them—they probably wouldn't know where the milk come from, in the cow [laughs]. I was talking to some guys and I was saying, I said, "Well, listen," I said, "When I was home we got things off the vines," I said, "They could grow wild on the fence, or they stake 'em up and they grows like that, all these dry beans is green before they put them in the bag," I said. "What you talking about?" Oh yeah, we had a big little argument about that. I said, "Man, it's no use talking to you," I say, "*All* the beans was green before they was dry. Black-eyed peas," I said, "don't you know black-eyed peas come out of shells?" I said, "Listen, black-eyed peas, lima beans," I said, "all that stuff it comes in a shell, we used to shell them, put them in a pot and cook them, you know." "How do you know when they're ripe?" I say, "Aw, come on, really." Because like, potatoes, sweet potatoes, peanuts, sugarcane, lima beans, all that stuff they used to grow, because they'd get a lot of canning then, you know. I imagine today all the kids know about is grape jelly, strawberry jelly, watermelon rind preserves, you know. But figs, plums, blackberries, raspberries, all that stuff grows wild, it grows wild.

But you know, I wouldn't trade nothing in for that. Because it's really something today you can tell the kids about, you understand? And there's a lot of grown people, really, I'm talking about, and they're thirty, they say "I never seen cotton"—they didn't even know how the cotton would grow. Well, I come up through it, I picked a little cotton, three dollars a hundred pounds. Down there our family used to pick a bale of cotton a day. Half a bale on Saturday. It was what they call this sharecropping. My uncle, he run the woodyard, got a woodyard, you understand. [Low voice] Plus he'd bootleg a little corn liquor [laughs].

You know, you can sit around here, I don't care if nothing don't come on TV or nothing, I can sit around here and just let my thoughts float back that way, and I'm talking about *really nice*. Very nice, you know what I'm saying?

MF: Other things, differences between there and your life in Buffalo? What about church, was that a big part of your life?

JK: Oh, yeah. Like down in my hometown where it was a necessity, you went to Sunday School, you went to church because that's the way the people was, you know. Sunday, you went and most of us come out and mostly the family'd sit down, have dinner, and all day was a Sunday for your grandmother, your aunt, or whatever. But after I came up here you know, you say, "Well, I'll go next Sunday." And you put it off, and you put it off. And then you know it's a whole bunch of Sundays, really, and that's how I got away from church.

Because like, when I went to church down home in Georgia, when the man preached it, he didn't talk about, "Well, I saw you standing on the corner with a wine bottle in your hand," and this and that and this and that. Our pastor used to preach about good things, where these preachers up here they preach about the ones out on the corner, the prostitutes. And I say, "What?" [Laughs] Why should you worry about *out*, what about what's *in* there today? For Sunday, you preach and you don't worry about who's on the corner drinking wine yesterday. If they in church today, good, good. That's what I say! [Laughs]

And then, plus, down there there wasn't really a whole lot of money flowing, so like, boom, the people took what you had to give. They didn't come out with a set thing, well, you got to give five dollars. What the heck! I remember my wife, she was a member of the church up here, my wife used to come home and said, "Well, I got to count the doors now." I said, "Count the doors now, to what?" She said, "Well, we got to give a dollar for each doorknob." I said, "You tell that preacher you got to get him a job, really!" Oh, we had a four-bedroom crib then, you know, you'd pay them doorknobs, you'd pay them about thirty bucks. So like that's what really throwed me off of religion.

But it's—Buffalo been an experience, but one thing I learned, Mike, you know what? If you be yourself, I don't care what city or where you be, if you be yourself and behave, that's it, you got it. When people look, they say, they theirself, then you got all the respect and everything that goes with it. That's all you got to do.

Me, myself, I always did more than one thing. When I was working at the plant, I was doing remodeling work. My two days off, I might stop and go make two hundred dollars depending on what type of job I was doing. I figure a room take me forty-five

minutes to paint it, trim it, if it's a two-toner. If it's a one-toner it take me thirty minutes because I carry all my stuff around in a little shopping bag. It was ideal work. And like a lot of people they used to say, "Well, Joe, I need so and so did, but I ain't got much money." I said, "Well, listen, don't even worry about the money, I'll take care for you, you know." I been rewarded in it—they'd say, "Well, listen, Joe, come by the house, I'm going to buy a new bedroom set, I got some twin beds, you got kids, do you want it first?" So I made out all right. Like I say, I didn't get paid for everything I did but, you know, I got some nice rewards because I did a little something for this lady and next thing I know I got five people. It was very rewarding.

MF: We're getting a pretty good picture of your life in Buffalo during that period. And we talked a lot about when you were working at Hanna. I wanted to get a little bit now about what happened when the job went down, when the plant went down.

JK: Well, Hanna Furnace, you could see something happening. They had three furnaces in operation when I started there, eight years before, then they broke it down to two, so then they were just running but one. I guess it was easier to ship pig iron than to make it. I imagine there wasn't no really great, great demand like there used to be for pig iron, because like, we were getting so much steel from across the water, you understand. But like they just took it down to the bottom now, really. They stockpiled. I don't know how much tonnage they had on the ground, maybe 350,000 tons. Maybe a half a million. Matter of fact, when they tore the furnace down, all four of them, you know, they still had so much tonnage on the ground, they were still trying to sell out. That's big business, big business, you know how big business goes, so boom! [Laughs] And that's where that was.

MF: Where was the company headquarters?

JK: I think Detroit. They're still in operation somewhere because about four years before they closed out they did give them the option to go to Texas and things like that. But I guess people, they had families and they really didn't want to relocate because they didn't have the same option that they had in New York State, because Texas paid no unemployment. Well, I guess they caught all them people off guard. Really, they caught them all off guard, because they didn't figure that these plants were closing. I came in in '59, I remember when Bethlehem, they had about 29,000

people working out there. When our plants started closing, Shenango, Hanna Furnace, Donner Hanna Coke, Republic Steel, I think it must have been about seven of them or eight closed that same year.

MF: And the union wasn't able to do much about it? Was the union an important part of life working there?

JK: That was the best thing it was, the union, the union gang. For my eight years I worked there, when I started, the union was pretty good, pretty good. But then everything started being broke down. You know, you paid the union dues and they wouldn't have a picnic that month or nothing. I think the last two years they skipped the picnics [laughs], and to me, I say it like this, I say the guys in the union probably was letting management took over. They weren't performing their job that you elected them for. They're supposed to go in there and be your mouthpiece to the best of their ability for you, you know what I'm saying? In the early years, they'd tell them, said, "Hey, this is the way it got to be." But then the guys got, well, the company want you to do this and that, but like, you know, they had first privilege, all that, the place is going to close and everybody wanted to hang on to their job as best as possible. So like, that will weaken you. See, they usually had rumors around that the plant was going to close, and eventually they was going to lay off and this and that. They was laying off back and forth right up until the time.

MF: So around that time, the last few years you were working there, when everybody is worrying about their job, and that's when you were having all those problems with your leg.

JK: Yeah, it was '82 when I lost it, then the plant was paying me, because I was on that insurance, and then they sent us a letter saying they're going to close January of '83. I was hoping they would stay open, see, because I needed ten years to come out with a disability. If I could have stayed on the payroll for another year and a half, I would have made them pay me, maybe an extra six or seven hundred dollars a month, along with my Social Security disability, you know? I could have worked, I had my driving license and everything and I could've worked in the clockhouse. And by my being on a bid job, a class six, you understand, I still would have got my basic pay. I was hoping, I really didn't want the plant to close.

MF: Do these problems with your legs go way back?

JK: No, before I went into the plant I used to paint, I used to climb ladders and everything and I—I never would have thought that I would have lost a leg. It was bothering me for a period of time then, but like, you know, say from '80 to '82, boom: I had a clottage taken out of my right leg, I think it shocked the doctors, they went, "Gee, you're rather young." I said, "Well, what is it?" Hardening of the arteries. My doctor, he explained it good, you know, said, "Well, your veins not smooth inside like veins supposed to be." So, from that time up until I lost it, you know, back and forth in the hospital. I had sixteen operations on my leg. I went back to work three or four times. They'd do another bypass, then I'd go back to work later, boom. They put new pieces in, taking them out of this spot, putting them into this leg, and so they got all the way down to the foot and I laid in the hospital for thirty days and they couldn't figure out a way how to do nothing else, so they said, "Well, we got to take it off." This was in June of '82. They chopped it off on a Wednesday, and they let me home on a Monday. That was it. I wasn't able to go back to work, and then the plant closed in January of '83.

MF: Well—most of the folks I'm talking to, the plant closes, that's like one big adjustment, they say I've got to find something else to do. But you had two adjustments, because you had that work going down, and you had to get used to a new situation with your leg.

JK: Well me, I had been doing a little remodeling, while I was working at the plant. I used to drop ceilings, paneling, wallpaper, paint, stuff like that. So like, you know, there wasn't much I could still do but I could still click me a dollar. Because like if somebody wanted a room painted, they say, "Well, Joe, you can't do it, you only got one leg." But see, I had an arrangement for that, I had my screwrollers that I stick in my roller, and I could still climb up on a stepladder and just catch the corner on there. I did two-toning and things like that. But it got to be a strain on me, really, and like, boom—I said, "Well, I got to make do with what I get." I used to be able to move things, but then they said, "Well, we don't want you to be trying to lift nothing, move nothing." So I said, "Well, what the heck." I would shovel a little snow, where I had my car, but that was it. But basic things, you know, I would do and I get around pretty good.

But now I'm slowed down. Because I used to take a walk quite a bit, but then this other leg here started giving me trouble. And then my blood it went up, they couldn't get my blood to stay stable. So now my next thing is to save the leg, so I have to try to see these doctors and let them x-ray it, x-ray the whole leg. They open up your main artery and x-ray it, hook up the wires, so you have to lay down, lay flat on your back for six hours after they do that. So, it'll be a one-day thing, I'll probably stay in the hospital overnight, come out later on that evening. I guess I'll make it. It's hard, though. It's certainly hard to get by on the small amount they giving you, you know, but you have to adjust yourself to it.

MF: So now you're getting mainly the Social Security disability, is what you get by on?

JK: Mostly it was coming just through my insurance. And my wife, she had a different type of insurance so I would use a piece of hers, but now she's going to change it again, I don't know if I can use any of this. They told me if I wanted to I could go with a supplemental Blue Shield, you know, that go with my insurance, but they want a bundle for that. It really puts a strain on me, you know. That two years— if I could have got my two years before the plant closed, it undoubtedly would be a little better space for me.

MF: And what are you doing these days? A guy that's worked as much as you have, it must be a real adjustment because you've been so active. . . .

JK: Yeah well, ain't too much I'm planning on doing. I'm going to get out of here and fly to Philadelphia in June. Hop in the car with my brothers and go down home to Georgia. But like my leg won't let me do as much walking as I anticipated, and it won't let me get around as much. I hope I can get enough to where I can get me a little old two- or three-hundred dollar car and when I finish fumbling with these doctors and prescriptions, then I [laughs] check out everything else. That's the reason I want to try to get myself back into the best of health. If my leg gives me trouble then I won't even bother about driving. I would try to get me the car anyway, but I wouldn't be driving. But other than that, you know, I'm just hanging in there.

MF: You were talking about a lot of the changes in the city during the time that you've been here, and you talk about Georgia, that there's a whole way of life that it's

hard to explain to kids now. Well, it's almost like the whole way of life of these plants, you know, to the next generation in cities like Buffalo, that's going to be as hard to explain, because they're not going to see a lot of these steel mills and factories around. What do you think about this move away from the industrial world?

JK: Well, the only thing I can tell them, the best they can do: get you some education, try to learn you a skill, because you will never see this industrial movement no more. Not right here in Buffalo, you'll never see that no more. You'll see hospitals, or computers, or nursing, restaurants, or office jobs, like that, but you have to have a skill to get them. I think the plants here is finished. Finished in Buffalo.

MF: Do you think this was inevitable, that it would have happened no matter what anybody did?

JK: Well, to me, they could have been saved. A lot of these jobs could have been saved anyway, but the thing is that nobody want to be in with the tax preference, didn't nobody want to be in with the air pollution, didn't nobody want to cooperate with each other, you know, to the best meaning for the people. I guess they wasn't looking at the people's side of view. Say, "Well, you know, after you phased us out, look how many thousands and thousands of people it's going to affect," see—they weren't looking at that. They was looking at: Step one—we owe more taxes, you're supposed to put air pollution in. These big corporations they say, "Well, we got so many places we'll come out cheaper to ship than to be paying taxes and things like that." You look from 1960 to 1980, you figure, something was going to phase out, some of it's going to phase out—with the air pollution and everything. But here's the thing about it: if you've done suffered with it thirty or forty years, you might just as well keep it around. Because they didn't stop making a loaf of bread at a dollar and six when all the jobs left, they still kept it at the same. See, if they said, "Well, you took the bread back to forty-nine cents again," then it all would have been different. But like, nothing changed *but* the job situation, see.

And that left a lot of people hanging. I figure with the amount of people that was out of jobs in Buffalo, that's the one individual, so I didn't count their families. When you start evaluating now with their families, you're talking about, oh, quite a few people. Because the hand that feed them, if he got four under him and he's the one

that got laid off, so that's five. So that was really the breakdown on it. You know, there was so many guys that was under twenty years. The old-timers, they came out with something, you know what I'm saying, while the young dude put in fifteen years or seventeen years in the plant, and the best thing he can do is get his six months unemployment, his severance pay and try to find him another job. So if he got hung up in the traffic trying to find another job, he done spent that little severance pay and unemployment money, you know. Then he's really in trouble.

That's the reason I say the future is, they won't be using their muscles, they'll be using their brain. If you have to relocate, go somewhere else, they would look at your papers and say, boom—well gee, this guy is qualified for this. They'll look at the qualifications of it, you understand.

MF: There's an interesting kind of dilemma in places like Buffalo: there aren't that many jobs but there is that community base. Being in a community where you know people, because half the jobs you get come from who you know, you sort of run into a guy on the corner and that could lead to a job. In fact, a lot of people who took advantage of those other placements, or went down to Texas, they got down there and they are stranded.

JK: I know it. But here's the thing about it: if you didn't have twenty years or better, you're still stranded *here*, see? I think things happened too fast for people to really evaluate, it happened so fast. Truly, Mike, too many people lost too much at one time, see. They needed all the plants to be in circulation in order for one to work. Donner Hanna Coke made the coke, we made pig iron, Shenango makes the molds, Republic makes the steel. See, you needed all this to make the cake [laughs], that's it. If one went, then that would mean like one or two, down to where we had to lay off and lay off and lay off. The people wasn't ready for it, they wasn't prepared for it either. Well, you know, like, boom.And this place, I've seen it go. Straight 'cross the mouth, like that, straight 'cross the mouth. I would never thought it would come like that.

MF: You think since the plants . . . ?

JK: Oh, man, I'm talking about the city *itself*! Buffalo, well, between Canada and Buffalo, I think Lake Erie might just fill up! Because really, we don't have the type of

industry going here to keep a lot of people around, you understand? I don't worry about who they're getting for President, I worry about the people of Buffalo. I worry about the people we elect downtown that I have to deal with. I don't have to deal with the President, the hell with that! I don't have to go to Washington, D.C. [laughs].

MF: Well, do you think Buffalo's going to come through all this?

JK: Listen, I think Buffalo will survive. It'll survive. To me myself, Mike, I look at it this way: With the right type of people in there, willing to put a little money into some things, I think that would probably make it survive, you know. Build a facility for the people that live here, anyway, and jobs. Like one thing—I believe they want legalized gambling in the city because this is a city that sits on the border with another country. When they legalize gambling and things like that, you might just see this city boom back up and then the skills the kids have might just be ready for the work here. When they say bartending school, gambling school, I be watching small things, when they say, won't you learn this—I say, if opportunity knocks your way, learn this; if you never get to do it you still know about it, boom.

MF: What about other changes in the community? Do you think this has had a broader effect on the community around, in the neighborhoods?

JK: Yeah. More and more people complaining. They don't care no more. Well, I won't put it that they don't care, but they lose their interest in it because they don't have the dough to maintain these things like they did when they was working at the plant. I run into a lot of guys now that say, "Ah, man I miss Hanna Furnace." I *know* you miss Hanna Furnace, you had a decent paycheck coming every Thursday, you have to miss that, you know. It's nothing to understand, really: why I used to make five hundred dollars and now I'm only getting a hundred and nine. But hey, you've got to adjust to that, you have to just break that down, adjust yourself to it, say, "Well, I can't do what I used to do on this type of money."

A lot of them, I think they feel guilty. They feel guilty, "Well, I couldn't get my kid this." And then it's "I guess I'll go buy it because my kid be mad because I couldn't. . . . " What the hell! If you can't do this, get something else, explain it to your kid.

You got to explain, you know! A kid is a kid, but he can understand why he didn't get this. If he understands, then he knows why. Like, understanding is the best part of this, so boom. If someone sees you trying, someone going to give you a helping hand, anyway. They see you trying. Bottom line of it, you know. If I see somebody trying to push their car by theirself, give them a hand, you know. So the best thing I can do is tell the people, "Listen, show your people, explain, you know." Hey—this is a new day. And this way we're going to have to adjust, adjust to it.

MF: Looking ahead, when you look at your kids, particularly the young boy coming up or the younger girls, do you think that somehow things are going to even out? Are you basically optimistic looking ahead or do you think we're headed for more real trouble in this?

JK: Well, I'll say they are, the kids, if they don't make themselves very educated. You're going to need it. Go for a skill that will be needed when you get older, when you finish school. Don't go for one that's out of date and they got enough people already in this category to last for fifteen or twenty years. This is it: the new generation is going to be the one that will keep Buffalo going if they become skilled-wise. You're going to have to learn a skill, Mike; if you don't learn a skill, you're through, you're through.So like the best thing I could tell the average one that worked in these plants is to explain to their kids, "Listen, you have to go get you a skill, something that will pay you. Anybody can get the minimum wage, but you want a job that they're going to be calling for, something skilled." Not the mediocre jobs for the banks, tellers and things, I'm talking about something to make dough. Something with a little skill.

Kids will just have to put more into it, and work on apprenticeship thing or work while you learn or learn while you work, because the average job, now they ask for, is he experienced? Here I just got out of college, how am I going to be experienced? Well, see, like that come from working in a place a few weeks here, a few weeks there, and you just build yourself up to where you're experienced. I think that's the only way out. As for a kid, make sure he got his head in those books, cramming it all in, and it *got* to be a skilled job, you understand. Something that you sure you're going to be good at, and something they have a demand for.

It's going to have to be a lot of pushing, Mike. But, you know, everybody gets so scrambled up in their surviving and for their kids surviving that they forget about it.

And there some of them get too tired, and they give up and they feel I can't do this and I can't do that. But when the thing break down, they got to bring the kids down and tell them, "I know you want to go to this college but, listen, you're going to have to try to figure out another way," or a better outlet for them. Take the service. Go to college with Uncle Sam. Let him pay for that. Go there, trade off this for that.

And all the people that had those jobs in the plants—really, if they wasn't old enough to come out and retire, they should work on them training programs, just whatever you can cram into your brain. You might have to relocate but sometimes it be worth it, too, you know. Got to keep a family together. Keep a dude and his wife together and slowing down a lot of the heartaches, you know. Trying. That's the only thing I can tell you to do now is *try* to do the best you can. And that's it. That's the bottom line. That's all of it [laughs]. You wake up you're crying in the morning, you go to bed crying, too, but just do the best you can, and say, that's it. That's it! Do the *best* you can! The *best*! That's it. Do the *best*! When you know that you done did the best, you going to lay on down and go to sleep then. That's it. That's it, you know. But I can tell them don't anybody give up. You can't give up. You can't give up. You know. You can't give up.

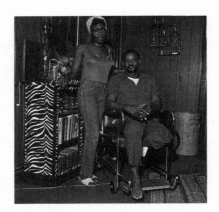

AFTERWORD

Milton Rogovin's original "Working People" series—the basis for this book—was exhibited at the Smithsonian Institution's Museum of American History in the spring of 1992 and shortly thereafter at the Baltimore Museum of Industry. Museum staff have reported that one of the most common responses from visitors was the question "What has happened to these people since the pictures were taken, and what are they doing now?"

Portraits in Steel had been conceived as an answer to that question. But the necessarily long time it takes a book to move from conception to publication means that the question must remain an open one—the new photographs and interviews were completed by the end of 1988, five years before the book will finally appear. Having come to know the book's subjects through their text and photo portraits, readers may be interested in some brief updates made on the eve of publication. As it happens, these extend and underscore some of the themes running through the lives presented in the book.

The saddest to report is the death of Mark Cieslica on September 6, 1990. The youngest of those involved in the project, Mark and his wife, Lynn, spoke at length of his struggle for health and its impact on their family in the aftermath of the plant closing at Shenango. Many of his coworkers there have spoken of his courage in the face of an irreversible deterioration, and how this mirrored his fighting spirit on the job during years of strength. On behalf of Lynn and the men of the chip shop at

Shenango, I dedicate the book to the memory of Mark Cieslica, who embodied so many of the strengths of character that animate the photographs and words throughout this collection.

As for the others, in late 1992, those who were having the most difficulty at the time of their interview are still in difficulty. Dick Hughes has not been able to find steady work, and has had to move from the home described so affectionately in his interview to a trailer park in a nearby community.

Frank Andrzjewski is still out of work too, and still taking care of a young family, responsibilities made more difficult by some substantial health problems. And Joe Kemp, undiminished in spirit, struggles on heroically against worsening circulatory problems, still hoping to save his remaining leg.

Those who were more fortunate are still at work. Doris McKinney Craig, recently remarried, has moved ahead in her career in occupational therapy, while Bill Douglass, James Mathis, and Mary Daniels are employed in metal work. Bill works for a new gold refining company established by the friends whose firing from Premier Metals provided the "bombshell" in our final interview. James still has his mirror and works in the foundry he mentions toward the end of his conversation. And Mary was able to return to the work she loves, this time at American Brass, one of the few remaining large metal operations in Buffalo.

At last report, the remaining group of older workers are all well and keeping on— Ken Sion still delivering microfilms, and Effie Edwards, Ben Boofer, and Ralph Wils in something as close to retirement as active lives and circumstances permit.

In sum, the most notable thing to report by way of update is how little has changed in late 1992—for these workers and their families, for cities like Buffalo, or for a United States still having difficulty comprehending and responding to the profound forces transforming our lives, communities, and world.

Listed below are the names and dates for the portraits in the Photo Gallery, in the order in which they appear there.

Benjamin Boofer: pages 24, 25, and 26, 1976; page 27, 1987.
Ralph Coxson: pages 28 and 29, 1976; page 30, 1987.
James Barner: pages 31 and 32, 1976; page 33, 1987.
Frank Andrzjewski, Jr.: pages 34 and 35, 1976; page 36, 1987.
Mary Daniels: pages 37 and 38, 1976; page 39, 1987.
Hubert Morrison: pages 40 and 41, 1976; page 42, 1987.
Mark Cieslica: pages 43 and 44, 1976; page 45, 1987.
Ralph Friedenberg: pages 46 and 47, 1976; page 48, 1983.
Doris McKinney: pages 49, 50, and 51, 1976; page 52, 1987.
William Douglass, Jr.: pages 53 and 54, 1976; page 55, 1987.
Ralph Wils: pages 56, 57, and 58, 1976; page 59, 1987.
Effie Edwards: pages 60 and 61, 1976; page 62, 1987.
Kenneth Sion: pages 63 and 64, 1976; page 65, 1987.
James Mathis: pages 66 and 67, 1976; page 68, 1987.
Dick Hughes: pages 69 and 70, 1976; page 71, 1983; page 72, 1987.
Paul Trembeth: pages 73 and 74, 1976; page 75, 1987.
Joseph Kemp: pages 76 and 77, 1976; page 78, 1987.